AN ART LOVER'S GUIDE TO

FLORENCE

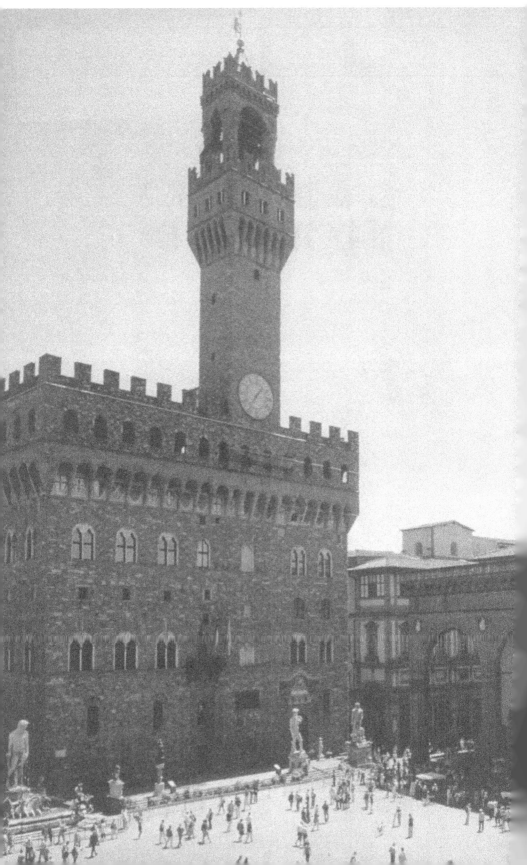

AN ART LOVER'S GUIDE TO
FLORENCE

JUDITH TESTA

NIU
PRESS
DeKalb, IL

© 2012 by Northern Illinois University Press

Published by the Northern Illinois University Press, DeKalb, Illinois 60115

Design by Julia Fauci

Library of Congress Cataloging-in-Publication Data

Testa, Judith Anne, 1943–

An art lover's guide to Florence / Judith Testa.

pages cm

Includes bibliographical references and index.

ISBN 978-0-87580-680-8 (pbk. : alk. paper) — ISBN 978-1-60909-063-0 (e-book)

1. Art, Italian—Italy—Florence—Guidebooks. 2. Art, Renaissance—Italy—Florence—
Guidebooks. 3. Florence (Italy)—Guidebooks. I. Title.

N6921.F7T47 2012

709.45'511—dc23

012005427

Frontispiece— Piazza della Signoria,
with Loggia dei Lanzi at right. Nicolo Orsi Battaglini / Art Resource, NY

Map (page 2)—Hartt, Frederick; Wilkins, David, *History of Italian Renaissance Art, 7th Edition*,
©2011, p. 13. Reprinted by permission of Pearson Education, Inc., Upper Saddle River, NJ

CONTENTS

CHAPTER 4

The Brancacci Chapel in S. Maria del Carmine

Where Renaissance Painting Was Born 70

CHAPTER 5

The Piazza della Signoria

Power Politics and Sexual Politics in the City Center 81

CHAPTER 6

Orsanmichele

A Multipurpose Architectural Masterpiece 96

CHAPTER 7

The Ospedale degli Innocenti

Europe's First Foundling Hospital 112

CHAPTER 8

The Monastery of San Marco

Piety and Politics in a Cloistered World 119

AN ART LOVER'S GUIDE TO
FLORENCE

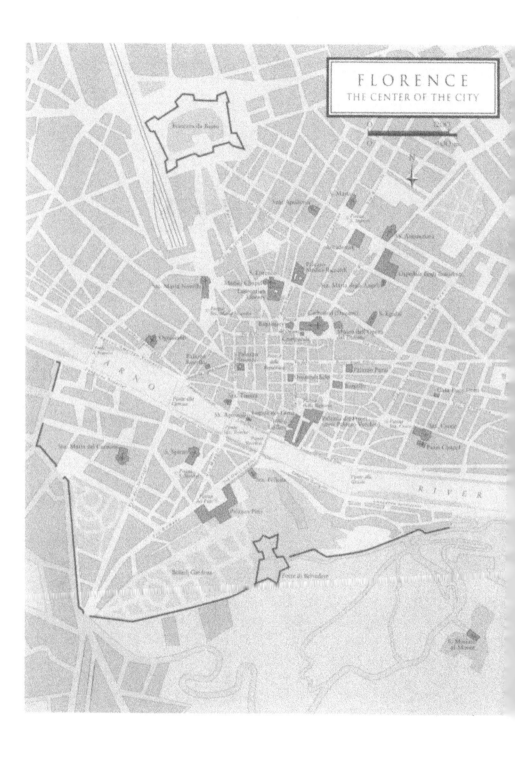

FLORENCE
THE CENTER OF THE CITY

N

INTRODUCTION

On a visit to Florence some years ago, I spotted a man carrying with him a list of the most important works of art to be found in the city. At the top was his title: "MASTERPIECES CHECKLIST." When I asked him how he used this compilation, he explained that he was locating the works on his list, glancing at them, making a check mark next to their names, and then moving on. He shrugged regretfully, as if to say: too much art, too little time. If there was ever a way for an art lover *not* to see the great art of Florence, this gentleman had hit upon it. Great works of art deserve more than a cursory glance.

But where to begin? What works should the visitor stop and really observe? No city other than Florence contains such an intense concentration of art produced in such a short span of time: from the 1300s through the 1500s. The sheer number and proximity of works of painting, sculpture, and architecture in Florence can cause visitors who try to see them all to experience an artistic overload labeled in the 1980s by Italian medical researchers as "Stendhal's Syndrome." Named after the nineteenth-century French author who first described it, the malady consists of symptoms such as dizziness, panic, confusion, fainting, and overwhelming exhaustion caused by trying to see too many works of art in too short a time. Although this may sound like a joke, Florentine hospitals treat hundreds of visitors each year for these symptoms. A visit to Florence, whether brief or extended, should be enjoyable, exciting, and inspiring, not bewildering and exhausting. Armed with an idea of which works to see, along with information about them and no obligation to see everything, the visitor can successfully navigate the Uffizi and the Bargello museums, as well as the city's streets and piazzas, churches and palazzos.

In the course of teaching university classes that covered Renaissance art in Florence, I naturally had to be selective, confining myself to the greatest works of the period and—often with regret—omitting others both interesting and worthwhile but that would not necessarily have made it onto a Masterpieces Checklist. As I continued to study and teach the artistic history of this astoundingly rich period, I came to realize that the major works of art always fell into two, and sometimes all three, categories of religion, politics, and sex. Although most works are religious in content, they almost always have some political dimension, and a few of them also contain a sexual content at times ignored or minimized by those who write about them.

The purpose of this book is to offer art lovers a fresh perspective on the rich and brilliant art of the Florentine Renaissance by presenting it in terms of three basic human concerns—politics, sex, and religion—because all of them inform Renaissance art. During that period, art was not something separate from life, on display merely to be admired. It was a part of people's lives, bound up with both their public and their private experiences. Those three words, "politics," "sex," and "religion," often conjoined in our time to indicate topics better not discussed in polite company for fear of causing arguments or offense, are nonetheless powerful forces in every society, and they often manifest themselves in works of art. So why not acknowledge all of them in the discussion of Renaissance art? These different meanings often intertwine in the great artworks of Florence, and awareness of this intermingling of meanings can deepen the visitor's pleasure in viewing those works.

"Politics" is here defined in the broadest sense, not as political parties with narrow competing interests and philosophies of governing (although there was no lack of that kind of factionalism in Renaissance Florence) but more in its original sense of civic politics, that is, matters applying to the *polis* or city-state—in this case the republic, and later the duchy, of Florence. In an era when no clear separation of church and state existed, it's not surprising to find religious art commissioned by secular individuals and institutions and imbued with their political goals. To some degree, all art exists within the political sphere defined in this way, although it's not necessarily limited by it, and great art transcends the temporal political situation for which it was created.

What may be more surprising to modern viewers of art in Florence is how openly sexual certain works of art are, and how cleverly artists and their patrons used sexual themes for political purposes. That religious art can often have a political meaning hardly comes as news to scholars of Renaissance art,

and many guidebooks at least pay lip service to noting the political aspects of so much of the art of that period. But dealing with the sexual level of meaning in works of art—sometimes obvious and explicit and at other times hidden or disguised—is another matter. Guidebooks generally steer clear of it, and a surprising number of art historians also prefer to omit or dismiss the topic, even when doing so means to ignore important aspects of the works under discussion. I believe that discussion of the sexual level of meaning in certain works of art is important, and that exploring it can help the viewer reach a fuller understanding of those works. The sexual significance of artworks can be discussed without being offensive or disrespectful toward the other levels of meaning—including in some cases the religious meaning—of those works.

It is amazing, for example, how many scholars have passed over in silence the sexually explicit gesture of Titian's *Venus of Urbino*, the relationship of Michelangelo's personal passion for the male body to his magnificent marble statue of David, and the homoerotic implications of the feathery wing of Goliath's helmet that crawls up the inner thigh of Donatello's bronze *David with the Head of Goliath*. Certain scholars fly into a rage at the mere mention of the homosexual aspects of that work. Few scholars acknowledge that Botticelli's seemingly dream-like *Primavera* may offer specific and very different sexual "lessons" to male and female viewers. Some of the sculptures located in the secular space of the Piazza della Signoria show politics, religion, and sex interacting in surprising ways, but most scholars ignore the "web of desire and violence" (to borrow art historian Frederick Hartt's phrase) that entangles three of the figure groups displayed there: Donatello's *Judith Beheading Holofernes*, Cellini's *Perseus and Medusa*, and Giambologna's *Rape of a Sabine Woman*—all works of art intended for public viewing around the political center of Florence.

This book offers the reader the chance to pause in front of a work— whether a painting, a sculpture, or a building—and consider what it's about. Why was it made, and for whom? What did it mean to the person or people who commissioned it, and what messages did they intend it to convey? If its content is religious, might the work also convey political messages? If the work seems clearly secular, or mythological, could it also have some religious meaning? And if a work of art *looks* sexy, might that have been the artist's (and the patron's) intention?

Most guidebooks cover a much larger number of works of art than I do in this book, but they offer only brief descriptions, with little discussion of the

historical background—the political issues that so often interact with the religious motivations involved in the creation of those works. And guidebooks devote even less space, if any, to the sexual connotations of certain works. In this book, in contrast, I concentrate exclusively on the greatest artworks of Renaissance Florence, presenting them not merely as aesthetic objects but also in terms of what they meant to the people who produced them and for whom they were made. Although the selection of works discussed to some extent reflects my personal preferences, primarily and more importantly it reflects a broad consensus about which works constitute the best of the enormous embarrassment of riches that is art in Florence—the works every lover of art would want to see and savor.

The book begins with a chapter that sketches the historical background of the period. Readers who start at the beginning and continue straight through will find occasional repetition of some portions of this material, since it is at times necessary to emphasize certain information more than once because of its relevance to more than one work of art. In subsequent chapters, a strict chronological approach isn't practical because some sites contain important works from different decades and even different centuries. I've therefore chosen a roughly but not absolutely chronological arrangement, starting with the cathedral and the adjoining baptistery, both sites of some of the earliest achievements of Renaissance architecture and sculpture. From there, the book moves to the birthplace of Renaissance painting: Masaccio's frescoes in the church of S. Maria del Carmine. A chapter on the Piazza della Signoria follows; this was the site of the Florentine government (known as the Signoria) throughout the city's history, and it's the location of a series of important sculptures that range in date from the first half of the 1400s to the late 1500s. Orsanmichele is next, located halfway between the religious and political centers of Florentine life and participating in both. Subsequent chapters cover the Ospedale degli Innocenti (Foundling Hospital), the monastery of San Marco, the Medici and Rucellai palaces, and the family chapels of the Sassetti and Tornabuoni families. The final chapters cover two great but very different works of Michelangelo, separated by thirty years of eventful Florentine history: his monumental marble David, completed in 1504, and the Medici Chapel, left incomplete in 1534, a brooding ensemble of architecture and sculpture related to the Medici family's dynastic ambitions but perhaps equally expressive of the artist's own state of mind as he witnessed the death throes of the Florentine republic.

A word about omissions. Florence has numerous museums, but I include only the two I believe contain the most interesting and accessible works of art: the Uffizi and the Bargello. Although the Bargello is relatively small, the Uffizi is immense and trying to see everything in it is a formula for utter exhaustion and a possible case of Stendhal's Syndrome. I've therefore chosen to concentrate on a very small number of works in both museums, although obviously many more are worth one's time. But by stopping to look closely at just a few works, visitors can slow themselves down and appreciate how marvelous these particular works are, in both their content and their form. Because there's so much *great* art to be seen, I've felt justified in omitting a prominent site: the Palazzo Vecchio, or Palazzo della Signoria. Florence's city hall is full of frescoes laden with political meaning, but the paintings are mediocre in quality, and many are so grandiose in their propagandistic efforts to glorify the Medici family that they're ludicrous. The decision to omit the Galleria Palatina—the museum housed in the Palazzo Pitti—is a personal one, based on my belief that the way the museum is arranged, with works of art hung close together and one above the other all the way to the ceilings, without regard for chronology, makes a visit there a difficult and trying experience. Furthermore, although the Pitti contains many fine paintings, none of them are of "must-see" status.

Art history isn't an exact science. There are relatively few objective, hard facts about works of Renaissance art, beyond such matters as the medium, dimensions, subject matter, artist's name and date (when the work is signed and dated), the identity of the patron (when known through documents), and the current location. The *meanings* of works of art from this period are subject to a wide variety of interpretations, and there's often a good deal of disagreement among scholars about the meaning or meanings of individual works of art. For all the works of art discussed here, but especially with regard to works such as Botticelli's *Primavera* and Michelangelo's Medici Chapel, where scholars have offered a variety of often arcane interpretations, I've included the interpretations that I believe make the most sense and that seem to me to clarify the meanings of the works rather than to obscure them still further.

Another concept that may be unfamiliar to many modern viewers is the possibility that works of art can have more than one meaning, depending on when and where they are displayed, and who is viewing them. The idea that a painting or sculpture can convey only one meaning or message would have been foreign to Renaissance viewers, and especially to the sophisticated

patrons who commissioned those works. For example, by changing the location and the inscription on Donatello's *Judith Beheading Holofernes*, the government of Florence transformed the statue group from a private statement of the Medici family's support of the Florentine republic to a public avowal of the republic's opposition to Medici tyranny. Botticelli's *Primavera* could be interpreted as a general celebration of marriage, a work that memorializes a specific, politically inspired marriage and that offers distinctly different messages to the bride and the groom, or as visual poetry without reference to a subject any more specific than springtime itself. As a contemporary of Botticelli commented about the meaning of one of the artist's works (now lost): "Some give one explanation and some another; no one is of the same opinion, so that it is the most beautiful of painted images." It helps to keep this in mind when viewing the visual riches of Renaissance Florence.

HISTORICAL BACKGROUND

A TIME OF TURMOIL

The background against which the achievements of the Italian Renaissance in general, and the Florentine Renaissance in particular, took place is neither simple nor terribly attractive. We confront an endless series of broken treaties and treacheries, savage pillaging and pointless battles that settled nothing, murders, massacres, assassinations, plots and counterplots, lies, deceits, and political double-dealing on a scale that leaves the modern reader's head spinning. And not just the modern reader. The perpetual discord and disunity of Italy in the fourteenth through sixteenth centuries and the perpetual vulnerability of Florence were also the despair of those who lived through the times.

Dante's *Divine Comedy*, written in the first half of the 1300s, resounds with the author's rage and frustration at the political conditions and circumstances that led to his lifelong exile from Florence. The two greatest historians of the era, Francesco Guicciardini and Niccolò Machiavelli, both complained about the problem. Guicciardini begins his *History of Italy*, written in the 1530s, with a bitter acknowledgment of "those events, which have occurred in Italy within our memory, ever since French troops, summoned by our own princes, began to stir up very great dissentions here." Machiavelli, who wrote his *History of Florence* in the 1520s, ends his work on this dark note: "Soon after the death of Lorenzo de' Medici [in 1492], those evil plants began to germinate, which in a little time ruined Italy, and continue to keep her in desolation." In the final portion of his most famous work, *The Prince*, Machiavelli also laments Italy's disunity, discusses the failings of previous rulers, and concludes by suggesting

that Lorenzo de' Medici, the grandson of Lorenzo the Magnificent, whose death Machiavelli had mourned in his *History*, has the power and strength to restore Italy's pride, but this hope proved futile.

Why was Italian unity so elusive? An obvious reason is geography—Italy is a "porous" peninsula. Its boot-shaped protuberance into the Mediterranean Sea offers eight thousand miles of coastline pocked with hundreds of harbors both large and small, and even the Alps that bind the peninsula to the north are full of passes, many of them in use since ancient Roman times. As a result, invasions have been a part of Italian history since its beginnings; the nineteenth-century English historian Thomas Hodgkin's study, *Italy and Her Invaders*, runs to eight thick volumes. This vulnerability was compounded by internal geography as well. The Appenine mountain range, running nearly the entire length of the peninsula, divides the eastern and western sides of Italy from each other, and many smaller ranges also made long-distance travel difficult. A lack of navigable rivers complicated the development of trade routes and communications and encouraged the growth of numerous mutually incomprehensible local dialects. The result of all this is what Italians call *campanilismo*—a narrow attachment to the small region within the sound of one's own church bell and a corresponding indifference or hostility toward happenings and people elsewhere.

Another barrier to unity was created by profound differences that developed between the northern and southern parts of the peninsula. During the medieval centuries, cities such as Naples, Salerno, and Palermo had been commercially successful as well as brilliant cultural centers, but through conquest they became part of the empires of France and Spain. Both conquerors exploited and impoverished Sicily and southern Italy without improving either region. A further advantage for the northern part of Italy was its proximity to the rich markets of northern Europe—France, England, the Netherlands, and Germany. The north, and Florence in particular, pulled ahead economically and culturally in the 1300s, and the south never caught up.

Italy had a further, unique, problem: territories controlled by the papacy extended like a broad belt across the peninsula, and the popes saw no advantage to themselves in a united Italy. As popes functioned like secular rulers in those centuries and contested with emperors over whose authority was supreme, Italy's various city-states, communes, and principalities lined up on one side or the other, wherever they felt their own best interests lay. Those who supported the Church were known as Guelphs, those who favored the emper-

ors were called Ghibellines, and such allegiances were taken dead seriously. Italian cities fought each other, and towns were often torn apart internally by Guelph-Ghibelline violence. Close family ties added to the intensity of bitter factionalism within cities, to the point where both the heads of families and the heads of states found it more satisfying to damage a neighbor's interests than to unite in the service of a larger cause.

In Italy the power of the emperors, who were all of northern European origin, faded after the 1200s, leaving the Italian cities free to turn their energies against each other. Years of Guelph-Ghibelline conflicts had left a legacy of bitterness, as factions competed for power, murdering or exiling their enemies and generating a complicated tangle of constantly shifting internal and external alliances. "O servile Italy, breeding ground of misery, ship without a pilot in a mighty tempest," mourned Dante, who dreamed of an emperor who could unite the peninsula.

But no such figure appeared. Instead, with southern Italy and Sicily under the control of France and Spain, local strongmen further north established dynasties and even little empires of their own. The Visconti family of Milan carved out a huge territory in north-central Italy, which later passed through marriage into the hands of the Sforza family. The della Scala held Verona and a string of nearby northern cities, the Malatesta ruled Rimini and its surroundings, the Este held Ferrara, the Montefeltro controlled Urbino, and the Gonzaga took over Mantua.

Here and there in Italy, republics survived, principally in Venice and Florence. Although Florence, full of factions and civic unrest, could hardly claim the same title as Venice (it was anything but *serenissima*), the Florentine republic achieved some stability in the second half of the 1400s under the subtle and largely hidden hand of the Medici family. Aristocrats did not dominate, as they did elsewhere in Italy—they were allowed little role in the Florentine government. The Medici cleverly cultivated support among the upwardly mobile as well as among the *popoli minuti,* the modest artisans and poor people who formed the majority everywhere, while also becoming major patrons of the arts and laying the foundations of an enduring family dynasty.

The development of the peaceful arts of painting, sculpture, and architecture in the Renaissance did nothing to curb the era's appetite for violence. The frequent clash of arms and armies is the backdrop to all that beauty. Between 1350 and 1421 Florence, hungry for territory and power, conquered Prato, Pistoia, Volterra, Arezzo, Pisa, and Livorno. Some of the conquests were fairly

easy, but others were accomplished only with protracted and bloody struggles. While the della Scala family of Verona destroyed itself with interfamilial warfare, Venice seized control of Treviso, Vicenza, Verona, and Padua, and Milan swallowed up dozens of smaller towns and cities. In the south of Italy, Sicily conquered Naples and later waged wars against Florence, Genoa, Milan, and Venice. The dukes of Milan twice tried to conquer Florence, and the king of Naples once made the same attempt.

In a complex treaty signed in 1454, Milan, Venice, Florence, Naples, and the papacy agreed to bury their differences and individual ambitions in order to present a united front against the threat posed by France, which, on various pretexts, had laid claim to both the kingdom of Naples and the duchy of Milan. But the treaty failed to bring either unity or lasting peace. There were too many signatories, too much bad blood, distrust, and individual ambitions. The king of Sicily went to war against Genoa, and Sigismondo Malatesta, the ruler of Rimini, picked a fight with the pope. Venice tried to conquer Ferrara. In 1476 conspirators stabbed the duke of Milan to death in a church on the day after Christmas. In 1478 Pope Sixtus IV became embroiled in a plot to destroy Medici power in Florence, a botched effort known as the Pazzi Conspiracy. This escalating conflict brought Florence to the brink of war with papal ally Naples. And these are only a few of the more prominent conflicts of the 1400s. There were innumerable smaller ones.

And as if all these internal struggles weren't enough, the threat of Turkish conquest came closer. In 1453 the Turks conquered Constantinople, the last outpost of Christianity in the east, and in the 1470s they raided as far north as the Friuli region of Italy. In August of 1480, they distracted Pope Sixtus IV from his war on the Medici and Florence by overrunning the coastal city of Otranto in Puglia, destroying churches, hacking the city's bishop in half, and carrying off much of the town's population as slaves.

As both Guicciardini and Machiavelli note in their histories, a series of disasters quickly followed the death of Lorenzo de' Medici in 1492, with the first among them the long-feared invasion of Italy by the French, as King Charles VIII pressed his claims to the kingdom of Naples. The French king had been invited into Italy by the duke of Milan, Ludovico Sforza, who hoped the French would conquer Florence on their way to Naples, thus eliminating one of Milan's chief rivals, an example of the kind of self-serving treacheries that kept Italy divided. In 1494 a popular rebellion against the Medici forced the family to flee Florence, and the fanatical Dominican monk Girolamo Savonarola filled the

power vacuum left by their departure. He became a behind-the-scenes dictator whose theocracy lasted until 1498, when the Florentines tired of his harangues and, with the active support of Pope Alexander VI, burned him at the stake.

The death of Savonarola didn't bring about the immediate return of the Medici family. The city enjoyed a few years of the restored republic before the long arm of the Medici reached them again, this time in the form of Cardinal Giovanni de' Medici, the second son of Lorenzo the Magnificent. With copious bribes and other blandishments, Lorenzo had persuaded Pope Innocent VIII to make Giovanni a cardinal when the boy was only thirteen—an event that could stand as a symbol of much that was wrong with the Renaissance papacy.

In 1512 Cardinal Giovanni convinced Pope Julius II to restore the Medici to power in Florence, a return helped by the military power of the Spanish, who by then had added themselves to Italy's long list of invaders. When, in 1513, Giovanni de' Medici succeeded Julius II and became Pope Leo X, Medici ascendancy in Florence was assured. The election in 1523 of another Medici pope—Clement VII, the illegitimate son of Lorenzo the Magnificent's brother Giuliano—further tightened the family's hold on power, as the second Medici pope, like the first one, appointed his relatives and supporters to Florence's important political offices.

In 1527 the extraordinary ineptitude of Pope Clement VII brought down on Rome the hugely destructive pillaging of the city by imperial troops that became known as the Sack of Rome. Although the Florentines saw Rome's misfortune as a grand opportunity and again ejected their Medici rulers, this final effort to rid the city of the Medici collapsed in 1530 after a long siege of the city by Spanish troops. After that, all pretense of maintaining the Florentine republic ended, and in 1532 a new constitution came into effect that established Alessandro de' Medici, the illegitimate son of Pope Clement VII, as the first hereditary duke of Florence.

Nevertheless, determined opposition to Medici rule lived on, and adversaries of Alessandro—an inexperienced, cruel, and arrogant youth of twenty when he came to power—continued their efforts to restore the republic, but even the assassination of Alessandro in 1537 failed to dislodge the tenacious Medici. The only successor to be found, since the ruling branch of the family had become extinct at Alessandro's death, was from another branch of the family, a teenage boy providentially named Cosimo. This capable youth became Duke Cosimo I de' Medici, who over the course of his thirty-seven-year reign fully installed an autocratic regime.

THE FLOWERING OF FLORENCE

The fame of Florence today as a capital of the arts still rests mainly on the achievements of its artists in the fifteenth century. During the first decades of the 1400s, Florence took cultural command of Italy. Siena faded, and other larger and more important political entities such as the kingdom of Naples, the duchy of Milan, and the republic of Venice did not become dominant cultural forces. Mantua, Urbino, Ferrara, and several other centers also joined the Renaissance later in the 1400s, but Florence reigned supreme until Rome became the center of the High Renaissance in the early 1500s. It remains amazing that a city of less than a hundred thousand people produced such a disproportionate number of the great sculptors, architects, and painters of the early Renaissance.

Florence took half a century to recover from the bubonic plague epidemic—two-thirds of the city's population died between 1348 and 1355—but by the beginning of the new century, the city was on its feet again economically, with its banks and textile industries flourishing. The city government then began to think about what we'd call urban renewal: tearing down crumbling old buildings, repairing those that could be saved, and building new ones. Other projects that had been interrupted by the plague could now be completed. The fact that Florentine recovery coincided with the opening of a new century added to the impetus for regeneration and renewal.

The government of Florence in the 1400s was a republic. There were no aristocrats who wielded hereditary, absolute power. The Florentines' deep suspicion of anyone holding too much power for too long had led to the development of a cumbersome but reasonably effective system of governing by committees of officials elected every two months. This might sound like a recipe for governmental chaos or paralysis, but there were safeguards against those possibilities. In addition to a central governing committee called the Signoria, made up of the city's most powerful men who were members of a few prominent families and who also belonged to one of the city's major guilds, Florence also had a senior official known as a chancellor, chosen by the Signoria and holding office for a longer period, who directed the affairs of state.

Among the most influential chancellors of the early 1400s was Coluccio Salutati (d. 1406), a man of scholarly as well as political achievements. In 1397 he brought to Florence a famous Greek scholar, Manuel Chrysoloras, who inspired among educated Florentines an interest in the Greek language as

well as in ancient philosophy, literature, and art. This interest may have been among the first sparks that fired the intense enthusiasm for the ancient world that would characterize Florence in the fifteenth century. Salutati was also the first to compare Florence's republic to that of pre-imperial Rome, and its limited democracy to that of ancient Athens. Those powerful parallels to the classical world would resound throughout the fifteenth century.

Despite its admiration for antiquity, Florence was above all a mercantile republic, and the guild system, which originated in the twelfth century, was central to the city's political and social functioning. Guilds were similar but not identical to modern trade unions. Rather than supporting the common laborers in Florence's various industries, who had little or no power, the guilds represented the interests of merchants, manufacturers, bankers, lawyers, doctors, and artisans, with power heavily concentrated in the hands of the first three professions. There were seven major guilds, and these were the most active in governing Florence: the Calimala (woolen cloth manufacturers), the Lana (wool merchants), the Seta (silk merchants), the Cambio (bankers and money changers), the Giudici e Notai (judges and notaries), the Vaiai e Pellicciai (furriers), and the Medici e Speziali (physicians and pharmacists). Three of the seven major guilds represented Florence's most important industry, textiles, with banking, Florence's other most prominent profession, not far behind.

Even though the visual arts enjoyed a prominent place in Renaissance Florence, artists had no guild of their own. Painters belonged to the Guild of Physicians and Pharmacists, perhaps because both medicines and pigments consisted primarily of ground-up organic materials, and also because the two groups shared a patron, St. Luke, said to have been both a doctor and a painter. Sculptors in stone and wood, along with carpenters, belonged to one of the fourteen minor guilds, the Pietra e Legname (stone- and woodworkers), while sculptors trained in bronze casting belonged, inexplicably, to the Silk Guild. Goldsmiths had a guild of their own.

Although fifteenth- and early sixteenth-century Florentines who wrote about the various versions of their republic loved to present it as a free society, it was far from being genuinely democratic. Only a tiny percentage of the population was eligible to vote, and women were excluded entirely. In reality, pre-ducal Florence was an oligarchy, its government dominated by members and supporters of a few powerful families, and the policies pursued by these governments were often just as severe as those of the later Medici dukes.

Behind the external forms of the Florentine government lay a dense network of personal associations, beginning within each family and extending outward to include relatives by marriage, neighbors, friends, and "patrons," members of the most prominent families, distinguished by their wealth and political influence. Within each patronage network, members supported one another's interests in both commercial and political activities. Patrons protected and advanced the interests of their clients, who in turn owed their patrons loyalty and political support. Although every important family had its circle of clients, beginning in the 1420s the Medici presided over the largest and most influential patronage network. Despite the Florentines' dedication to the ideals of their revered republic, for the most part they accepted the increasing political domination of the Medici because of that family's success in ruling from behind the scenes, taking good care of its clients, and leaving the forms of the republic intact.

About fifty years ago, American scholar Frederick Hartt offered an intriguing explanation for the sudden, great flourishing of Florentine art and culture in the early decades of the 1400s: he claimed it developed as a heroic, defiant response to a series of military crises. In the first two decades of the 1400s, Florence had to fend off attacks from two directions. In 1402 the duke of Milan attacked from the north, around 1408 the king of Naples invaded from the south, and in the 1420s there came a renewed threat from Milan. Florence warded off the first two attacks, but the third conflict dragged on until mid-century and nobody really won. During those decades, Florence viewed itself as a solitary heroic defender of freedom and democracy against the menacing advance of tyrants. It was against this background of warfare and constant external threats that the art of Renaissance Florence came into existence.

Besieged Florence remained convinced that it not only could have the proverbial guns and butter but also could offer vigorous support of the arts. The Florentines viewed art not as a luxury, dispensable in times of war, but as an essential expression of both religious and patriotic virtue. During the first quarter of the 1400s, the city commissioned numerous and expensive works of art. These were not private works for homes and individuals but public artworks commissioned by civic agencies, guilds in particular, and placed outside where they would be seen by every citizen. The major art projects of the early Renaissance in Florence, up through the 1450s, are either sculptures designed to adorn already existing buildings—the cathedral, for ex-

ample, with its bell tower and baptistery and the multipurpose building called Orsanmichele—or architecture designed for public, communal use, in particular the completion of the cathedral with the construction of its dome. Even a private, religious commission of the 1420s, the fresco cycle in the Brancacci Chapel of S. Maria del Carmine, makes reference to contemporary political controversies. The turn of a new century must have been part of what roused the Florentines to a determination to adorn and improve their city, and this, combined with external threats to Florentine liberty, inspired the city to a new kind of art, in a style resonant with echoes of classical antiquity, the style we now call Renaissance.

THE (MOSTLY) MAGNIFICENT MEDICI

What would the Florentine Renaissance have been—or to put it differently, would that Renaissance have been at all—without the patronage of the Medici family? No doubt the rebirth of interest in classical art and culture that we call the Renaissance would have happened in Florence even in the absence of the family who did so much to inspire, nurture, and underwrite it, but it would have been different and a lot less "magnificent," to use a favorite term of that era. Even though it's true that the Medici made their fortune as bankers in Florence, it's equally true that they helped to make Florence's fortune. Although other prominent families also contributed, the Renaissance in Florence is inextricably bound up with the Medici.

Who was this family whose name has entered the English language as a term for a discerning and lavish patron of the arts? Although they liked to assert their noble origins, claiming descent from a French knight who came to Italy in the year 800 in the retinue of Emperor Charlemagne, the family actually had much more modest origins in the Mugello valley, north of Florence. Once they'd established themselves in Florence, there's no evidence the Medici were ever anything other than businessmen; they were buyers and sellers of merchandise and, above all, bankers.

Their family coat of arms—in fact an insignia, since they weren't of aristocratic background—consists of six *palle*, red or gold balls, on a shield. This could be the emblem of a family of pawnbrokers or, as their name suggests, of doctors, if we interpret the balls as pills. But there's no trace in Florentine records of any members of the family engaging in pawnbroking, practicing

medicine, or running a pharmacy. If there were, their names would have been registered with the guilds that oversaw those professions. Instead, their name first appears in the registers of the Cambio, the money changers and bankers guild. From the start, the Medici were money men.

Giovanni di Bicci de' Medici (1360–1429)

The first historically significant family member was an unassuming but astute and ambitious banker named Giovanni di Bicci de' Medici. Although not born into wealth, he used his modest inheritance to found a small bank, which he parlayed into a major financial institution with branches in numerous other Italian city-states, including the papal domain of Rome. As much as possible, Giovanni di Bicci avoided becoming involved in local Florentine politics, and instead he kept his eyes open for other opportunities. In the early 1400s, when the papacy returned to Rome after some seventy years of exile in the French city of Avignon, only to have the unity of the Church promptly shattered by three rival claimants to the Chair of Peter, Giovanni di Bicci supported one of those claimants, John XXIII (Baldassare Coscia), who rewarded him with numerous favors, chief among them the transfer of lucrative papal accounts to the Medici bank. When he died, Giovanni di Bicci left his family an amount estimated in today's currency at about eighty million dollars. His financial acumen set the Medici on a path to becoming one of the wealthiest families in Europe.

Giovanni also interested himself in the arts, the beginning of a Medici family tradition. In 1419 he provided some of the funds for the building of Florence's foundling hospital, known as the Ospedale degli Innocenti, the first independent work of the promising young architect Filippo Brunelleschi, from whom he soon afterward commissioned the church of S. Lorenzo. Giovanni was among the judges who, in 1401, chose Lorenzo Ghiberti to execute a pair of bronze doors for the cathedral baptistery, and he also may have taken part in the decision to entrust Brunelleschi with the construction of the cathedral dome.

Cosimo de' Medici Pater Patriae (1389–1464)

If Giovanni di Bicci remains an obscure and rather colorless figure, there's nothing obscure or colorless about his son Cosimo. Although he continued his father's personal habits of modesty and prudence, rarely putting his hand

directly into the seething cauldron of Florentine political life, Cosimo none-theless amassed an extraordinary amount of personal power and behind-the-scenes political clout, thanks in part to the intricate network of relatives, friends, associates, and clients who were indebted to him. He inherited his father's talent for banking, along with a genuine love for that line of work, and he once observed that he enjoyed banking so much he'd have remained in the business even if it hadn't been profitable. But it *was* profitable—very—and it made him the richest man in Florence.

Cosimo's enormous wealth, broad client base, and control over an international banking empire translated into great political influence, but both wealth and influence had negative consequences for him. They aroused the bitter resentment and envy of other leading Florentine families, not only other bankers such as the Strozzi and the Peruzzi but also the Albizzi and the Pazzi who belonged to the city's old nobility, of which the Medici were never a part. Cosimo's opponent Rinaldo degli Albizzi wrote of him in 1433: "Little is wanting to him but the actual scepter of government, or rather he has the scepter, but hides it under his cloak." Despite all his caution, Cosimo fell victim to a coup engineered by the Albizzi and their faction in 1433, when his enemies had him arrested and confined to a tiny cell atop the tower of the Palazzo Vecchio, nicknamed with black Florentine humor the *alberghetto* (little hotel). Refusing to eat for four days out of fear of being poisoned, Cosimo kept a cool head and befriended his jailer, who agreed to let him escape.

He then fled to Venice, where he set himself up not as an escaped prisoner but as a voluntary exile, letting it be known that he was thinking of founding his bank's new headquarters there, thus depriving Florence of its major financial institution and threatening his native city with economic ruin. Cosimo's enemies expected that his bank—the foundation of his power—would quickly fail in his absence, but instead the bank flourished, thanks to the determined efforts of those who ran it, all of them Medici kinsmen and close friends. It didn't take long for the Florentines to realize how much they needed Cosimo. He was recalled to Florence a year later, in 1434.

Once back in Florence, Cosimo lost no time going after those he claimed had plotted a conspiracy against his life. He had the male members of the Strozzi, Peruzzi, and Albizzi families exiled, along with many of their supporters, and although he personally ordered no executions, he turned a blind eye to violent and often murderous attacks of his allies on his adversaries. The present-day tendency to see the Renaissance as a peaceful golden age must

always be qualified by an awareness of what a violent era it really was. Wars and feuds were endemic, and vengeance was always in vogue.

For the next thirty years, Cosimo de' Medici was the de facto ruler of Florence without ever holding any major public office, a man who had perfected the art of ruling without seeming to rule. He exercised his influence behind the scenes—through the financial power of his bank, indirect control over the electoral process, and an intricate system of clients and patronage that might be compared to the modern political "machines" run during the nineteenth century by Tammany Hall in New York City and, more recently, by the elder Mayor Daley of Chicago.

In 1414 Cosimo married Contessina de' Bardi, the heiress of another of Florence's banking families, and through his marriage he acquired directorship of the Bardi bank. He and Contessina had two children, Giovanni and Piero, and despite his reputation for private virtue, Cosimo also fathered a son named Carlo with a slave woman. As if to atone for his own sin, Cosimo guided Carlo to a career in the church, while grooming Giovanni and Piero to follow in his own footsteps.

Despite his modest demeanor and seemingly simple way of life, Cosimo knew how to dazzle with magnificence when the occasion required. He paid for the lavish ceremony that accompanied the consecration of the cathedral in 1436, crowned at last by Brunelleschi's stupendous dome. In 1439 he persuaded papal officials to hold a Church council in Florence rather than Ferrara by promising to pay a large portion of the expenses. The event brought a crowd of wealthy foreigners to Florence, to the great benefit of local innkeepers, brothel owners, food providers, and tradesmen, as well as artists, who copied the visitors' exotic dress.

In 1459 Cosimo had Pope Pius II as his honored guest in Florence, and the canny banker made sure Pius was received with exceptional ceremony and elaborate pomp, all paid for from Cosimo's purse rather than from the city's coffers. The pope, very impressed, later wrote that Cosimo was "royal in everything save the name." But name made all the difference. Florence would never have tolerated Cosimo as a dictator. His power depended on the goodwill of the people, skillfully manipulated by him to his own advantage, and it bore little resemblance to the hereditary, absolute power wielded by dukes and kings.

Despite the shows he could put on for visiting dignitaries, Cosimo understood that temporary decorations for special occasions are ephemeral; what stamps a man's name on a city are his more permanent commissions. As a

result, Cosimo became Florence's most generous patron of the arts. He continued to fund the architectural projects supported by his father, and he rebuilt the monastery of San Marco, paid for several of its altarpieces, and founded its library. He paid for many other altarpieces in Florentine churches. His most significant architectural project began in 1444, when he commissioned a residence for himself and his family. The Palazzo Medici, although modest by the standards of ducal and royal palaces, was nonetheless at the time by far the largest and most luxurious private home in Florence. Cosimo also became a principal patron of the great sculptor Donatello, supporting the eccentric and financially irresponsible artist throughout his life and commissioning some of his finest works.

Less visible but equally important, Cosimo supported scholars and philosophers, including not only native Italians like the philosopher Marsilio Ficino, but also many Greeks who had fled Constantinople in 1453 when that city fell to the Turks. He gave them stipends along with access to his personal library and that of the monastery of San Marco. Their presence gave new impetus to the study of classical culture in general and Plato's works in particular, as well as making the study of Greek something of a fad among educated Florentines.

Cosimo enjoyed a long life and died in 1464 at age seventy-five. He refused to make a will, saying it was unnecessary, as he trusted his children's abilities and affection. Not long after his death, the grieving Florentines granted Cosimo an unheard-of honor: he was named *Pater Patriae*—father of his country, and the words were engraved on his simple tomb slab in the floor of the church of S. Lorenzo.

Piero di Cosimo de' Medici, "The Gouty" (1416–1469)

It would have been difficult for anyone to fill Cosimo's shoes, and his physically frail son Piero never thought he'd be called upon to do so. But Piero's more robust brother, Giovanni, died unexpectedly a short time before Cosimo's death, leaving the forty-eight-year-old Piero, a gout-ridden semi-invalid, as the heir apparent. He struggled through five years as the head of the Medici family, never seeming comfortable with his role as the unofficial ruler of Florence.

Nonetheless, Piero possessed a talent for capitalizing on his ill health. His trick was to make sure that rumors of his illness spread throughout Florence, in order to lull his enemies into thinking his end was near. Then, when his

opponents were certain they'd seen the last of him, their allegedly moribund rival would strike. On one occasion, assuming Piero's weakness, rival factions within the city tried to unseat him, but Piero's quick-thinking son Lorenzo foiled an assassination attempt on his father, and the remainder of Piero's short tenure was peaceful. He died in December 1469, at the age of fifty-three.

As an art patron, Piero had little time to rival his father in magnificence. His finest project was the commission given to Benozzo Gozzoli around 1460 to fresco the walls of the Medici family chapel in their recently completed palazzo with scenes displaying the journey of the Magi. Piero also funded many festivities of the sort that later critics claimed the Medici sponsored to keep the people happy while quietly depriving them of their liberties. The most memorable was a tournament that took place in February 1469, where the stars of the show were Piero's sons, Lorenzo and Giuliano. The display of Medici magnificence in the form of gorgeous clothing, glittering jewels, thoroughbred horses, and tailor-made armor left the citizens of Florence so dazzled that several included detailed descriptions of the event in their diaries. Lorenzo was being prepared to step onto the stage of Florentine history—and once he did, the city would never be the same.

Lorenzo di Piero de' Medici, known as "Lorenzo il Magnifico"
 (1449–1492)

By the time Piero died, it seemed customary for another Medici to succeed him as the semihidden hand behind the Florentine government. Two days after Piero's death, an unofficial committee of prominent citizens, handpicked and rounded up by loyal Medici supporter Tommaso Soderini, summoned Piero's older son, Lorenzo, to a meeting where it was agreed that the young man, just twenty years old, would "take charge of the city and the State," as his grandfather and father had done. In his brief personal memoir, written a few years later, Lorenzo claimed he took on this responsibility unwillingly but, he added, with a perfect grasp of the relationship between great wealth and political power: "It is ill living in Florence for the rich unless they rule the state."

Lorenzo would rule the state for twenty-three years, carefully preserving the forms of the republic, until his death in 1492, a period that corresponded with some of the most brilliant decades of the Renaissance in Florence. The sixteenth-century historian Guicciardini called Lorenzo "the needle of the Italian political scales," the one man capable of preserving Florence's autonomy

in a divided and contentious Italy. During his rule there was at least a relative degree of stability and peace throughout the peninsula, and above all, Italy remained free of foreign invasions and domination. But we should be cautious of seeing this period as a Florentine golden age of tranquility and prosperity. It was neither. During those same years the Medici banking empire tottered, and Lorenzo had to fend off assassination plots and use his outstanding diplomatic skills to overcome a constant stream of internal and external threats.

Among the most serious was the Pazzi Conspiracy of 1478. This was a plot to overthrow the Medici that involved not only the Pazzi family of Florence (bitter banking rivals of the Medici) but also a nephew of Pope Sixtus IV, several mercenary military leaders known as *condottieri,* and a couple of amateur assassins, along with the pope himself as a silent partner. The plot took place in April 1478 and was intended to kill both Lorenzo and Giuliano de' Medici. Instead, it resulted in the murder of the politically insignificant Giuliano while the de facto ruler of Florence—his brother, Lorenzo—narrowly escaped. Efforts by Pazzi family members to rouse the citizens to revolt against the Medici failed, and Medici vengeance was swift and merciless. As soon as they were caught, the conspirators, among them the archbishop of Florence, were hanged or hacked to pieces.

Pope Sixtus, furious that the plot had failed and using the execution of the archbishop as a pretext, excommunicated Lorenzo and placed all of Florence under an interdict, meaning that none of the sacraments could be celebrated in the city. The pope also declared war on the Florentine state. In 1479, with the war going badly for Florence, Lorenzo secretly traveled to Naples to negotiate face-to-face with the pope's most important ally, King Ferrante of Naples, a ghoulish character known to murder his guests and keep their mummified corpses on display. Using every bit of his personal charm and diplomatic skills during his four-month mission, Lorenzo persuaded Ferrante to break his alliance with the pope, and he returned to Florence a hero. The war ended with a treaty signed in 1480, and Lorenzo eventually reconciled with Sixtus, sending a delegation to the papal court to seal his allegiance to the papacy. Soon after, several Florentine artists, including Botticelli, went to Rome to paint frescoes on the walls of Sixtus's recently completed Sistine Chapel.

Machiavelli was surely not the first to notice that Lorenzo seemed a bundle of contradictions. As that shrewd Florentine statesman observed: "There were two separate people in him, almost like an impossible conjunction conjoined." Lorenzo was physically homely, yet both men and women found him irresistibly

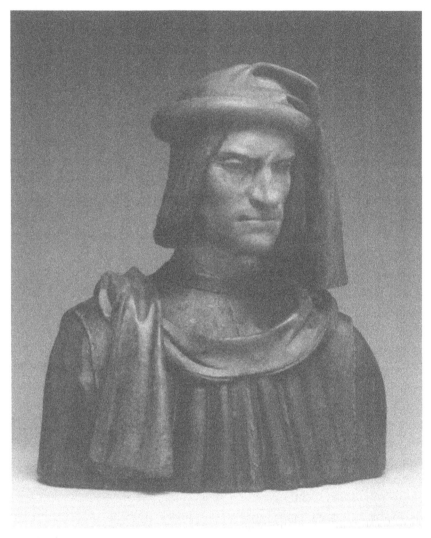

Verrocchio, *Lorenzo de' Medici.* Samuel H. Kress Collection, National Gallery of Art, Washington, D.C.

attractive. He could be arrogant, temperamental, and dismissive, but he could also charm just about anybody. He could be obnoxiously ostentatious and disarmingly casual. Despite his enormous wealth he lived quite simply, ate ordinary food, dressed soberly, and made himself available to the city's citizens. He carried on a wide-ranging and complex correspondence, and he dealt with diplomats

and heads of state from all over Europe, but he could also be found on the floor playing with his children. He was capable of sincere piety and of unscrupulous or morally heedless actions that made a mockery of religion. He wrote high-minded philosophical treatises and serious, classically inspired poetry while also composing clever carnival songs notorious for their sexual double entendres.

His arranged marriage to the haughty Roman aristocrat Clarice Orsini was unhappy, and Lorenzo was never a faithful husband, but he nonetheless performed his marital "duties" with religious—some might say revolting—regularity. In the first ten years of their union, his wife gave birth to ten children, six of whom survived to adulthood, and unlike many men in his family, he evidently fathered no bastards. He negotiated advantageous marriages for his daughters, groomed his second son for the clergy, and tried to turn his oldest son into a worthy successor. That last was Lorenzo's most conspicuous failure.

Throughout his life Lorenzo struggled with serious illnesses. Reports from his own time claim his main problem was gout, but descriptions of his numerous symptoms suggest that, in addition to gout, he suffered from kidney stones and acute arthritis. Although at the time of his death there were the inevitable rumors of poisoning, his symptoms in his last days sound more like a deadly combination of ulcerative colitis and a perforated stomach ulcer, both probably related to the unrelenting stresses of his life. He was only forty-three when he died. His premature death was not the cause of all the subsequent crises and disasters that befell Florence and Italy, but his departure removed a wise and strong hand from the affairs of the peninsula.

Some modern scholars minimize Lorenzo's cultural contributions, claiming that his reputation is mostly the result of later Medici legend making. They note that Lorenzo never had much interest in banking, and that several branches of the Medici bank collapsed during his years of leadership; that he abused his position of power by helping himself to public funds for his own use and by trying to defraud his cousins of their inheritance; that as an art patron his tastes ran mostly to expensive bric-a-brac; that he commissioned only one building, his country villa at Poggio a Caiano, and no important paintings or sculptures. Such claims are open to dispute, though, in at least one significant regard. It's clear that Lorenzo was instrumental in providing something less tangible but just as important as actual patronage—an atmosphere in which the arts flourished. Whatever his personal contributions, while he lived, Florence was the cultural capital of Italy and all of Europe.

Piero di Lorenzo de' Medici, "The Fatuous" (1472–1503)

If only Lorenzo's eldest son, Piero, had inherited his father's dazzling intelligence and political shrewdness instead of his mother's limited intellect and every ounce of her Orsini arrogance. Worried by his son's violent temper and perhaps also by his preference for stableboys as sexual partners, Lorenzo married off his son at the extremely young age of sixteen to a distant relative of his wife named Alfonsina Orsini. Whatever Piero's temperament or sexual preferences, he did one thing Lorenzo wanted: he fathered a son, born a few months after Il Magnifico's death, and named Lorenzo in honor of his grandfather.

By the time Lorenzo il Magnifico died, it seemed inevitable that the indirect rule of the Medici would continue in the person of Piero. But the young man (he was twenty, the same age Lorenzo had been when he took on the leadership of Florence) quickly proved incapable of replacing his father. It took him only two years to undo what four generations of his family had carefully built up: a power base founded on the dispensing of patronage and behind-the-scenes influence wielded indirectly and tactfully while maintaining the façade of the Florentine republic. Despite their dedication to the ideals of republicanism, the Florentines had accepted Medici rule when it was exercised indirectly and expressed itself in terms of a network of mutual obligations. What the citizens would not accept was an arrogant, tyrannical head of the Medici family, and this was precisely how the headstrong Piero behaved.

Having come to power at a moment of great instability in Italy, Piero proved cowardly as well as incapable of competent leadership. When the French king Charles VIII and his army—invited into Italy by the duke of Milan and determined to lay claim to the kingdom of Naples—threatened to invade Florence, Piero proved unable to conduct even minimal negotiations. To the amazement of the French he quickly gave them everything they demanded, including entry into the city with billeting for troops and possession of a series of fortresses essential to Florence's defense. This was too much for the government and the citizens of Florence. Although the French army moved on, a fierce rebellion ensued in November 1494, which forced Piero and the rest of his family out of Florence. For the moment at least, the era of Medici rule was over.

Piero spent the rest of his life trying to regain what his own foolishness had lost. Allying himself with anyone he could find with troops to spare who was willing to support his cause, he made repeated attempts to occupy Flor-

ence and regain his position of power, but without success. In 1503 he died by drowning. There had been Medici who died by assassination, from disease, and from old age, but Piero was the only man in the entire history of the family whose death was an accident.

From Confusion to Duke Cosimo I

The next thirty-five years saw repeated attempts by the Medici to regain political control of Florence. They returned to power in 1512, thanks to the efforts of Il Magnifico's son Cardinal Giovanni, aided by Spanish troops and the papal army of Julius II. The Medici cardinal chose his youngest brother, Giuliano, as the ruler of Florence, but when Giovanni became Pope Leo X in 1513, he appointed his nephew Lorenzo—the son of his deceased brother Piero—in Giuliano's place. When Lorenzo died in 1519, Leo chose another relative, his cousin, Cardinal Giulio de' Medici, as the head of the Florentine state. Giulio was elected pope in 1523, taking the name Clement VII, which meant that the number of Medici males available to take over the rule of Florence was now very small—just two young men, both illegitimate. One, named Ippolito, was the son of the deceased Giuliano (the youngest son of Il Magnifico) and the other, a nasty piece of work named Alessandro, was most probably the son of the pope himself.

Pope Clement attempted to rule Florence from Rome, as his cousin Pope Leo had done, but unrest in the city continued to grow, and Clement's appointment in 1523 of his nephew Ippolito as the city resident ruler did nothing to resolve the situation. When the Sack of Rome occurred in 1527 and Clement fled, the Florentines took advantage of the power vacuum in Rome to throw off Medici rule once again. For a brief heady period the republic was restored, but in 1529 the Medici returned again, this time with military support obtained by Pope Clement from his former enemy, the emperor Charles V. The city resisted for a year, but in 1530 Florence surrendered. Alessandro de' Medici was appointed head of state with an absurd title, Duke of the Florentine Republic, a symbol of the depths to which the Florentine government had sunk. The more than four-hundred-year-old republic was gone, this time forever.

Alessandro was assassinated in 1537 by a distant relative. Horrified members of the family and the government tried to keep his death a secret while they cast about for someone to fill his position. The only available candidate was little more than a child (or so they thought), a seventeen-year-old boy

descended from the union of two branches of the Medici family who bore the seemingly heaven-sent name of Cosimo. His father, known as Giovanni delle Bande Nere, had been a noted military leader from the cadet branch of the family descended from the great fifteenth-century Cosimo's brother; his mother, Maria Salviati, was a granddaughter of Lorenzo il Magnifico and thus a great-great-granddaughter of Cosimo *Pater Patriae*.

But those who plucked Cosimo from obscurity to be the next duke of Florence had no idea who they were dealing with. From the very start this shrewd, intelligent, and utterly ruthless young man had a clear idea of what power meant and how to wield it effectively. He soon shook off the ambitious counselors who had hoped to rule Florence through him, and he dispatched his defeated enemies by having them exiled, imprisoned, or beheaded. Although never loved by the Florentines, over time he made himself respected, and even those who opposed his heavy-handed rule had to admit that he left Florence in a better condition than when he found it.

He gave the city a stable and efficient if thoroughly dictatorial government, overseeing improvements in agriculture and irrigation in the surrounding countryside, and building up Florence's defenses as well as its military and naval capabilities. He took an interest in science, music, literature, and art, even making personal visits to the studios and shops of Florentine painters and sculptors, observing their progress, and assuring them of his interest in their work. No one had to convince him of the value of the arts to his regime, and he kept architects, sculptors, and painters busy with his commissions, although many of the artists he employed were of mediocre quality. During the course of a reign that lasted almost forty years, Duke Cosimo I de' Medici transformed Florence into a modern authoritarian state that would be ruled by his direct descendants for the next two centuries.

The CATHEDRAL *of* FLORENCE

THE CUPOLONE AND THE CONDOTTIERI

BRUNELLESCHI'S BIG DOME

The story of the construction of Florence cathedral and its *cupolone*, or big dome, is an epic drama as well as one of the most important chapters in the history of Western architecture. At every stage the project bristles with overweening human ambitions, bitter personal conflicts, and seemingly insoluble engineering problems accompanied by life-threatening working conditions; all of it set against a background of political intrigue and acrimony, epidemics, and sporadic warfare that sometimes found Florence fighting for its survival. But just as the Capitol building in the United States continued to rise throughout the darkest days of the Civil War, so work on the dome went on, whatever the fortunes of Florence.

In 1294 the Florentines decided to rebuild their cathedral, then known as S. Reparata and now called S. Maria del Fiore (St. Mary of the Flower), because a lily is the symbol of Florence. Arnolfo di Cambio, a distinguished local architect, drew up the plans, and construction went forward during the first half of the 1300s but halted in 1348, when an outbreak of bubonic plague killed more than 60 percent of Florence's population. During the late 1300s, subsequent architects enlarged Arnolfo's design and made important changes. An adventurous plan was adopted in 1367, one that proposed a double-shelled dome that dispensed with the support provided by the external buttresses characteristic of both French and northern Italian Gothic architecture. The new plan called for an octagonal dome of unparalleled size—138 feet in diameter and

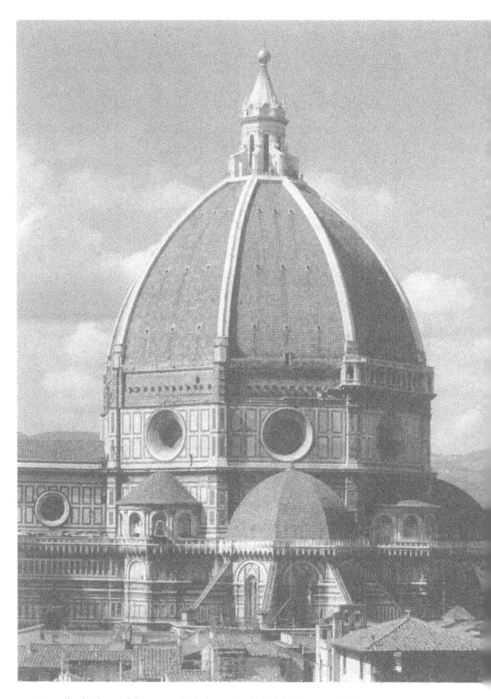

Brunelleschi, dome of Florence cathedral, exterior. Scala / Art Resource, NY

almost 300 feet high. There was only one problem: nobody in Florence or anywhere else had any idea how to erect such a huge dome. That's why successive architects concentrated on any other part of the cathedral, and why others were fired when they failed to make their promised progress on the dome.

As the 1400s opened, the cathedral had been under construction for more than a hundred years, but all the Florentines had to show for the effort was a 140-foot-high hulk crowned with a gaping hole. Even though the nave and transepts had been vaulted, the bell tower completed, and colored marble decoration applied to the exterior side walls, the unfinished interior remained open to the elements as if it were a ruin rather than a building close to completion. As a result, the proud Florentines were becoming the laughing stock of Tuscany. Despite their intention to show their superiority by building an immense dome, the Florentines were aware that further ridicule would be heaped on them if their attempt to build a dome ended in failure.

Why was Florence so hesitant to erect this particular dome? Medieval architects had been building them for centuries, and the ancient Romans had created vast domed spaces. The reasons for the Florentines' anxiety lay in the unprecedented size of their projected dome. At that time all arches—and a dome is an arch turned 360 degrees on its axis—were built using a wooden framework called centering. A horizontal wooden beam was secured across the opening at the point where the arch begins to curve, or spring, and a wooden framework was then erected on this crossbeam to support the bricks or stones composing the arch.

From this it follows that an arch is limited in size only by the size and strength of the timber available for centering. If giant redwoods grew in Tuscany, there would have been no problem in constructing the centering for the dome. But the opening in Florence's cathedral was nearly 140 feet across, and no tree found anywhere near Florence was both tall enough and strong enough to bridge that gap. It was therefore considered impossible to build a wooden framework sufficiently wide and sturdy. Furthermore, architects of the time believed that the sheer weight of such a gigantic timber construction would cause it to self-destruct even before any stones were laid on it.

As author Ross King explains it, there were other problems, encountered by all dome builders but particularly acute in the case of such a large dome: compression and tension, known as "push and pull" energies. Compression, or downward push, does not create insoluble problems, since stone has enormous compressive strength, as anyone who has ever tried to crush even a small

stone with any force less than a hammer blow can testify. In a dome, however, stones in the lower portion are also thrust or pulled outward by the weight of the stones above. To visualize this, think of the way an inflated balloon bulges outward at the bottom if pressed on from above. Under light pressure the balloon will stretch, but under heavy pressure it will burst. The problem with large domes made of stone held together with mortar is that, like the bursting balloon, they tend to fly apart at the base. Such was the problem that had brought construction of the dome of Florence cathedral to a standstill.

Frustrated in their efforts to find a *capomaestro* (chief architect) capable of constructing a dome, the cathedral's Board of Works, known as the Operai, turned to other civic projects, chief among them a competition held in 1401 to design a new set of bronze doors for the cathedral's baptistery, a focal point of communal devotion located just across from the front entrance of the incomplete cathedral. The Operai chose goldsmith Lorenzo Ghiberti to execute the project, a decision that would, oddly enough, have enormous consequences for the construction of the cathedral dome.

The runner-up and eventual loser in the competition to execute the baptistery doors was a furious Filippo Brunelleschi. Convinced that the competition had been rigged in favor of Ghiberti, whom he despised, Brunelleschi gave up his previous profession of sculptor-goldsmith and stomped off to Rome to study ancient Roman architecture. Given his long-standing interest in mechanical problems, he probably was thinking that such study someday might enable him to solve the problems involved in constructing the cathedral dome.

Brunelleschi remained in Rome on and off for thirteen years, sometimes alone and other times in the company of his friend, the sculptor Donatello, tramping through the city's ancient ruins, examining, measuring, sketching, and digging around in them to such an extent that the two men developed a reputation as treasure hunters. But the treasures Brunelleschi hoped to recover were the architectural and engineering secrets embedded in those gigantic structures.

For a thousand years, nobody had understood or even attempted to understand how the Romans had built their enormous vaults and domes— many people still thought the dome of the Pantheon had been built by devils. But Brunelleschi was determined to figure it out, and he slowly developed his own ideas on how ancient architectural elements and construction techniques could be used in building the dome of Florence cathedral. Even though Brunelleschi never quite succeeded in understanding how the em-

peror Hadrian's architect had constructed the 142-foot-diameter dome over the rotunda of the Pantheon, its existence offered proof that it *could* be done. Brunelleschi thought the Romans had built the dome without the use of centering, and although modern architectural historians have proved him wrong, it was a fruitful misconception.

Even though he had little or no experience as an architect, the self-taught Brunelleschi came to be regarded in Florence as an expert on ancient Roman dome-building techniques. As early as 1407, records show him in discussions with the Operai concerning construction of the dome, but neither he nor the cautious Operai was yet ready to proceed. Nonetheless, acting on Brunelleschi's advice, the Operai made an important decision in 1410: they authorized the construction of a 30-foot-high octagonal drum on which the dome would rest. This raised the height at which the dome would begin to 170 feet—taller than even the highest French Gothic cathedrals.

By 1417 Brunelleschi was back in Florence for good, and the Operai again paid him for some plans, so it seems he was now deeply involved in the project. But as with the bronze doors for the baptistery, the Operai, much to Brunelleschi's disgust, insisted on a competition. For this contest there were eleven entries, most of them plans so primitive they caused laughter among the members of the Operai. The most notorious was the Dirt Pile: an unspecified individual proposed that the area to be covered by the dome be filled up with an enormous quantity of dirt and the dome built around it. Then, with the dome complete, a rumor would be floated that the dirt contained gold coins, and every man, woman, and child in Florence would rush to the cathedral with a basket, ready to carry off the dirt in hopes of finding the coins. With competition of this caliber, we might assume that Brunelleschi's plan would have been adopted without delay, but Ghiberti also submitted a plan, and although the Operai awarded the commission to Brunelleschi, it seems Ghiberti had convinced some members of the Operai to name him co-architect, a turn of events that again left Brunelleschi fuming.

As it turned out, Ghiberti was busy with his bronze doors and played no significant part in the dome project. Nonetheless, Brunelleschi's plan was so radical and daring that not every member of the Operai believed it could be built. Perhaps they wanted to keep Ghiberti around for insurance, in case Brunelleschi's construction came crashing down. On several occasions during his discussions with the Operai, the arguments became so heated that a shouting Brunelleschi had to be removed, carried bodily from the room.

Little wonder that many in Florence considered him a lunatic and his dome-building ideas a fantastic and dangerous dream.

But the plan Brunelleschi proposed was no madman's fantasy. His idea is a work of genius that began a revolution in architectural and engineering practice: a dome of unparalleled width and height to be constructed entirely without the traditional framework of wooden centering. Three months after winning the competition, the architect presented the Operai with a list of specifications outlining what he planned to do and how he was going to do it. As envisioned in the model of 1367, Brunelleschi proposed a tall, double-shelled dome. But where the architects of the 1300s had offered no solutions for how to construct such a dome, Brunelleschi, the consummate technologist, had thought it all out in advance.

Because he realized that the dome had to be as light as possible in order not to crush the recently constructed drum, and steep enough that it would exert minimum outward thrust, he conceived his two shells as both steep and surprisingly thin, given their enormous scale. The thickness of the inner cupola is seven feet at the base, and it tapers so that the topmost portion is only five feet thick. An outer cupola placed over this, "to preserve it from the weather and to vault it in more magnificent and swelling form," in Brunelleschi's words, is even thinner: less than three feet at the bottom and only one and a quarter feet thick at the top. A space four feet wide separates the two shells, which are connected to a complex skeleton of cross-braced ribs, eight of which are visible on the exterior—where they resemble the long white spokes of an enormous umbrella—with sixteen more concealed between the two shells.

Where the ribs converge at the top is a fifty-foot-diameter opening known as an oculus (the Latin word for "eye"), later to be topped by a lantern, which holds the ribs in place, and through its open design also admits light to the interior of the church. Further light was to come from seventy-two small windows in the shells of the dome. Such openings not only would provide illumination but also would let the immense structure "breathe," so that moisture and heat would not build up between the two shells. The windows in the outer shell are still there, but those inside were closed in the sixteenth century so the interior of the dome could be covered with paintings. Had these remained open, they would have provided a dazzling crown of light that would have transformed the appearance of the cathedral's now rather dark interior.

In addition to the system of cross-braced internal and external ribs, Brunelleschi also stipulated the use of a series of gigantic chains to counteract

the outward thrust exerted by his dome. These aren't the simple ones familiar to us, made of metal links, but staggeringly complex devices consisting of concentric rings of stone beams laid horizontally around the octagonal circumference of the dome. These long sandstone beams rested on and interlocked with shorter beams, laid transversely, rather like railroad ties, at one-yard intervals. Along with four such sandstone chains there would be another made of wood, encircling the dome twenty-five feet above the stone chains. This one would consist of twenty-four chestnut wood beams, each about twenty feet long and a foot high and wide, three for each segment of the octagon, spliced together with complicated oak-and-iron clamps. These chains would secure the vertical ribs like tight belts.

Finally, Brunelleschi specified how he planned to solve the previously intractable problem of laying the masonry of the dome without the use of centering—we might call his solution the principle of progressive self-support. The dome would be built in a series of horizontal courses, something like the snow blocks of an Eskimo igloo. Each course would be bonded to its predecessor in such a way that it would carry its own weight once the mortar hardened. It was then strong enough to support work on the next course, continuing around until each ring was closed and, by being closed, became able to support the next course, and so onward and upward. The masons would work from scaffolds that could be suspended from recently completed sections of the dome, and the beams supporting the platforms could be lifted as work progressed. Thus, each portion of the structure reinforced the next one as the dome was built up layer by layer.

Brunelleschi also specified that he had designed the machinery necessary for hoisting all this material into place, but he gave no details, for fear that others would steal his ideas, a lifelong preoccupation of his. At the end of his lengthy memorandum, he admitted he had not yet solved every problem that might be encountered in the course of construction but, he insisted, experience gained in the actual work of construction would provide the solutions.

Work began at dawn on August 7, 1420. Foremost in the masons' minds must have been the frightening fact that none of them yet knew whether the structure they were to build could really be erected according to Brunelleschi's plan. Their new *capomaestro* had spent a lot of time explaining to the nervous masons, some of whom had never worked more than a few yards above the ground, what they were supposed to do. Not always a patient man, Brunelleschi persisted until he was certain his workmen understood their job.

According to one story, in his efforts to clarify what the dome would look like, he bought a large turnip at the local market, cut it in half and placed it on the ground, declaring that his dome would look like that, an earthy image that succeeded where more abstract ones had failed.

Early in 1421, Brunelleschi introduced an ingenious hoisting device of his own design to raise the enormous blocks of stone, a machine so large and complex it had taken two months to complete, with the carpenters sworn to secrecy about how it was constructed. Placed on a tall wooden platform at the center of the octagonal space below the dome-to-be and powered by teams of oxen, the hoist would eventually raise aloft marble, brick, common stone, and mortar weighing an estimated seventy million pounds. It proved so popular that the Operai had to issue orders forbidding the masons and adventurous Florentines from hitching rides on it.

Another machine soon followed, nicknamed the *castello* (castle), which moved loads sideways, since the hoist could only move things straight up. The castello was used in 1471, long after Brunelleschi's death, to place the eight-foot-high hollow bronze sphere atop the lantern, the last act in the decades-long drama of the dome's construction. The artist commissioned to make the bronze ball was Andrea del Verrocchio, who had as an apprentice in his shop a young man named Leonardo da Vinci. Because he made a series of drawings of the hoisting devices, Leonardo was long credited with inventing them, a misattribution that must have left Brunelleschi spinning in his grave.

In 1426 Brunelleschi is said to have designed a time-saving device: a little cookshop with an attached latrine, installed between the shells of the cupola in order to spare the masons the effort of going down for their noon meal. As for the latrine, it replaced slop pails and would surely have made the masons' cramped working environment more pleasant. Since by this time the masons had to scale the equivalent of a twenty-five-story building each time they went to or from their work, this must have been a convenience they particularly appreciated.

Brunelleschi designed many more machines for building the dome, and although a few of them survive, and drawings for others exist, how they functioned is now often impossible to determine. The machines preserved today in the Museo dell'Opera del Duomo in Florence look more like mysterious and sinister torture devices than building aids. The impression arises that nobody but Brunelleschi himself and his closest associates knew how these things worked. Even the members of the Operai were in the dark, and they simply had to trust that Brunelleschi knew what he was doing.

A reading of the earliest biography of Brunelleschi, probably written in the 1480s by Antonio Manetti, leaves one with the impression that the author was as mystified as everyone else by the details of Brunelleschi's building methods. "Between the shells of the cupola," Manetti wrote, just as if he actually knew what he was talking about, "both toward the inside of the church and on the tiled outside surface as well as [hidden] in its [shells], are diverse provisions and devices in various places. The hidden [devices] are much more numerous than the exposed: for protection against wind, earthquake, and its own weight—which could be harmful [with respect] to what is below in a [particular] place, and more with respect to the things piled up above [in their relation] to the things below." Huh?

According to a story told by Manetti, the architect's passion for secrecy enabled him to take revenge on his perennial rival, Ghiberti. In 1426, when work on the wood chain was about to begin, Brunelleschi took to his bed. Responsibility then fell to his co-*capomaestro*, Ghiberti, to oversee the construction of the chain, something he had no idea how to do. Work halted while Brunelleschi remained in bed, masons grumbled, and Ghiberti dithered. But as soon as Brunelleschi heard that Ghiberti had begun constructing and raising a portion of the chain, he made a miraculous recovery. He staged a dramatic arrival on the site, clambered up into the dome to inspect Ghiberti's work, and pronounced it worthless. He ordered it removed and replaced with construction completed under his personal supervision. The Operai responded by tripling his salary and dismissing Ghiberti. Although Brunelleschi's triumph seemed complete at that point, Ghiberti was eventually hired back, probably at his own insistence, but with sharply reduced authority, responsibilities, and salary.

The method by which Brunelleschi figured out how to regulate the gradual curvature of the dome and calculate the ever-increasing angles at which the stones, bricks, and massive stone beams were to be laid remains one of the dome's unsolved mysteries. Once the dome had reached the height of seventy feet above the drum, another crucial problem arose: the shells would now curve inward beyond the critical angle of thirty degrees—above which gravity and friction alone would not keep the mortar in place until it hardened. Brunelleschi now switched from stone to brick in order to lessen the weight, and he designed wooden molds for specially shaped bricks, which were to be laid in interlocking herringbone patterns, also of Brunelleschi's design, but based on his studies of ancient Roman brickwork.

These were terrifying times for the masons, who now had to work on walls that leaned inward at an alarming angle almost 250 feet above the ground. Domes built with wood centering at least had a network of scaffolding to break a man's fall and to obscure the view of the abyss below. To calm his increasingly anxious masons, Brunelleschi designed a portable parapet to go around their narrow working platforms, less for safety than for screening the drop. According to cathedral documents, the purpose was "to prevent the masons from looking down." Despite the perils, there was only one fatality during the construction of the dome.

Brunelleschi declared the dome complete in 1436, although much remained to be done, including the decoration of the raw masonry just above the drum (which was never fully carried out), the tiling of the exterior shell, and the design, construction, and installation of the lantern. Given Brunelleschi's extraordinary achievement, it seems incredible that the Operai insisted on yet another competition to design the lantern. Brunelleschi won this one, too. Although Brunelleschi's lantern seems small in relation to the bulk of the dome, it required more than a million pounds of stone to be raised to the top of the cupola. As huge blocks of marble, some of them weighing five thousand pounds, began to pile up near the cathedral, nervous Florentines imagined their precious new dome collapsing under all that extra weight. But Brunelleschi dismissed their fears, noting that the lantern would strengthen rather than crush the dome by acting as a common keystone for the arched ribs of the vault. Once again, he was right. No part of his dome has ever collapsed, and it has never needed major repairs.

The great architect did not live to see his lantern take form, although it was eventually built from his handsome, classically inspired designs. He witnessed the consecration of its first stone by the archbishop of Florence in March 1446. When he died less than a month later, just short of seventy years old, he received the rare honor of being buried inside the cathedral. Although Brunelleschi never married, he had an adopted son and heir, Andrea Buggiano, who carved a memorial monument—a roundel containing Brunelleschi's portrait with an inscription composed by the chancellor of the republic of Florence that loftily compares Brunelleschi to Daedalus, the fabled engineer of ancient Greek mythology, a reference that brings to mind the idea that the cathedral dome raised without centering was an achievement comparable to Daedalus's miraculous flight.

Brunelleschi's actual floor tomb was so modest that its location was soon forgotten. It was only rediscovered during archeological work on the cathedral in 1972. The simple inscription on it reads: "Here lies the body of the great ingenious man Filippo Brunelleschi." An equally fine epitaph might be the words written by another eminent Florentine, the art theorist, scholar, and gentleman architect Leon Battista Alberti. In dedicating one of his books on art to Brunelleschi in 1435, he praised the brilliant achievement of the cathedral dome: "Who would ever be so hard of heart or envious enough to fail to praise Filippo the architect on seeing here such a large structure, rising above the skies, ample to cover with its shadow all the Tuscan people?"

After more than half a millennium the dome still "rises above the skies" and is still the very signature of Florence. It is the city's most striking feature, visible from innumerable points within and around the city and in clear weather from as far away as Pistoia. Until the development of new kinds of ultra-strong building materials in the twentieth century, it remained unrivaled in size. Even Michelangelo's dome of St. Peter's, although taller, is ten feet narrower; Wren's cupola for St. Paul's in London is smaller by thirty feet, and the dome of the U.S. Capitol in Washington, DC, is less than two-thirds the size of Brunelleschi's creation. Brunelleschi's achievement has become so closely identified with the Florentines' sense of self that it remains a powerful symbol even today. In a still current expression, a citizen strongly dedicated to the city is called a *fiorentino di cupolone*—a Florentine of the BIG dome.

Visitors can follow in the footsteps of Brunelleschi and his masons and climb to the top of the dome, although the ascent is not for anyone who is unaccustomed to extended stair-climbing, made dizzy by heights, or rendered nervous by enclosed spaces. There are 463 steps to the summit. Imagine making the better part of that climb twice a day—once up and once down—as Brunelleschi's masons did six days a week for sixteen years. Today's visitors begin their ascent via a spiral staircase in the southwestern pier, one of the four that supports the dome. The first 150 steps lead only to the top of the pier, where the visitor emerges onto an interior balcony that encloses the base of the dome. Nowhere does the vast span of the dome seem greater than from there.

From this balcony a small door leads into the gradually narrowing space between the two shells of the dome, where another set of steps, constructed along with the cupola, threads its way upward. Between the two tilting walls of the inner and outer shells is a maze of low doorways, cramped passages, and other, irregularly ascending staircases, all of which had their functions and were

used by the builders. Only from within these constricted spaces is it possible to see close up the various devices and techniques employed by Brunelleschi. The great stone chains, the wood chain, and the complicated whirling pattern of herringbone brickwork are all visible. Small windows pierce the outer shell, letting in light and air and offering brief glimpses of the city below.

A final set of steep steps scales the uppermost part of the dome, and shallow iron steps lead out onto the viewing platform at the base of the marble lantern, as far as anyone is allowed to go. The climb rewards the visitor with unparalleled views of the city of Florence and the Tuscan countryside. It also has the effect of removing the feeling that the dome is a miraculous creation and replacing that impression with something better and more accurate: the realization that the great dome is the product of an extraordinary human mind brought into being by a remarkable team of workers. It was built by human hands, at enormous cost and with almost inconceivable effort, amid wars, plagues, and personal and political intrigues, with a relatively limited understanding of the properties of materials and of how the forces of nature act on those materials. Not the least of the effects of a trip to the top of the dome is a renewed sense of awe for the skill and intellect of that "great ingenious man Filippo Brunelleschi."

INSIDE THE CATHEDRAL
THE FRESCOED MONUMENTS TO JOHN HAWKWOOD
AND NICCOLÒ DA TOLENTINO

About the last things we'd expect to find inside a cathedral are secular monuments to the military prowess of the mercenary generals of Italy known as condottieri, professional warriors who sold their services to the highest bidder. Nonetheless, two such monuments greet the visitor to Florence cathedral. On the left (north) wall, in the third bay past the entrance, are two over-life-size frescoed equestrian portraits painted to look like sculptured images: the earlier, by Paolo Uccello, is from 1436 and portrays Sir John Hawkwood; the second, painted by Andrea del Castagno in 1456, shows Niccolò da Tolentino. Their grand scale and conspicuous placement make them the most easily visible images within the cathedral. That Florence memorialized these two decidedly unholy men on sacred ground is evidence of their importance to the city. God, Christ, Mary, and the saints might save people's souls, but the members of the Florentine government regarded the two condottieri as

Left: Uccello, *Monument to John Hawkwood*; right: Castagno, *Monument to Niccolò da Tolentino*, Interior, Florence cathedral

saviors of their republic, protectors of their precious political independence, despite the fact that condottieri in general were widely disliked and distrusted by the Florentine citizenry. Who were these men whom the Florentine government admired enough to award them the rare honor of burial within the city's cathedral? And was simple admiration the government's only motivation for commissioning such monuments?

John Hawkwood

During the second half of the 1300s, Sir John Hawkwood was the most feared and successful mercenary general in Italy. The fourteenth century was a time of continual strife, as hundreds of Italian political entities large and small

fought one another for power and territory. Hawkwood was the embodiment of that strife. It may seem odd that an Englishman of no great rank could attain such power in Italy, but the chronic disunity of the peninsula and the eagerness of one power to damage another played directly into Hawkwood's hands.

The future scourge of Italy was born around 1320 into a modest family in the English territory of Essex. As a young man he served in the English army, and he received his knighthood from King Edward III. Those years of military life convinced him that his future lay on the battlefield. In 1360 he collected a group of men-at-arms and moved into Italy, where he began his Italian career in 1362–1363, fighting for the marquis of Monferrato against Milan. In 1364 he assisted Pisa in its long-running conflict with Florence. After several minor campaigns in various parts of central Italy, in 1368 he entered the service of Bernabò Visconti, the duke of Milan.

Hawkwood's new employer was a distinctly unsavory individual. The head of the largest and most powerful state in northern Italy, Bernabò had come to power by poisoning his older brother. The father of a remarkable fourteen sons by his wife, he nonetheless lorded it over a household that, according to a chronicler of the time, "appeared to be more the seraglio of a sultan than the habitation of a Catholic prince." Along with his legitimate heirs, he had two dozen illegitimate children by his various mistresses and innumerable others born to servant women. A modern historian bluntly labeled him a sex maniac.

Indifferent to his employer's morals, Hawkwood fought successfully for Milan, upholding the Visconti standard against Pisa, Florence, and other enemies of the Milanese. In 1372, resenting the interference of court officials in his strategies, Hawkwood resigned his Milanese command and offered his services to another major peninsular power, the papacy. Despite the removal of the papal court to France for most of the 1300s, the popes maintained an interest in their Italian territories. By the mid-1370s negotiations were well under way for the return of the papacy to Rome, so it was an ideal time for Hawkwood to enter the papal service. He promptly engaged in successful battles on behalf of the papacy against Milan.

By 1374 Florence was the only significant Italian power that had yet to hire Hawkwood to fight its wars, although the Florentine government had repeatedly bought him off with money in exchange for promises (repeatedly broken) to refrain from attacking Florentine territory. But in his last two years of service with the Church, the shrewd Hawkwood had begun to realize where reliable power lay in Italy, and it wasn't with the barely solvent papacy or with

the treacherous and lecherous Visconti of Milan—instead, it was with the bankers and merchants of Florence. In 1375 Florence bought him off with the enormous sum of 130,000 florins, payable in four installments, in exchange for five years of promised nonaggression by Hawkwood's forces.

But the restless Hawkwood and his soldiers kept moving. Early in 1377 Bernabò Visconti made his former general an irresistible offer: he would reemploy him as the commander of the forces of an antipapal league, and he'd also give the fifty-seven-year-old soldier one of his illegitimate daughters, a seventeen-year-old girl named Donnina, in marriage. Hawkwood accepted, since the military commission would give him something to do other than roam around aimlessly with his destructive troops, and the marriage would not only bring him personal wealth but also make him a son-in-law of the most powerful prince in Italy. But even marriage to one of Bernabò's daughters was not sufficient to keep Hawkwood faithful to Milan. In 1388 he quarreled with the duke, and in an about-face typical of mercenary leaders, Hawkwood entered the service of Milan's archenemy, Florence.

Despite many misgivings the Florentines had decided that Hawkwood was their best hope of prevailing in their ongoing struggles against both the papacy and the duke of Milan, and once again Hawkwood proved his military worth. He fought for Florence against Naples and also against Giangaleazzo Visconti, who had by then overthrown Bernabò and become duke of Milan. In 1390 Hawkwood humbled the Milanese in a series of battles where the English-born general's tactics were considered especially brilliant. In 1392 Florence concluded an advantageous peace with Milan and amply rewarded its now seventy-two-year-old commander. They gave him a villa near Florence, provided dowries for his three daughters and a pension for his wife to be paid after his death, and exempted him from the city's most onerous forms of taxation. Hawkwood died in 1394, at the age of about seventy-four or seventy-five—a remarkable old age for a man who'd spent more than forty years almost continuously on the field of battle.

After a magnificent state funeral, Hawkwood's body was given a further honor: he was buried in the choir of the city's still unfinished cathedral. The Signoria then commissioned a marble tomb for him, but in 1395 they substituted a less expensive memorial, a fresco painting on the north wall of the cathedral, perhaps for economic reasons but also because the king of England had requested Hawkwood's bones for burial on English soil. Some forty years later the fresco had faded, or perhaps it had been damaged by Arno floods or by water coming in through the huge hole in the cathedral's roof—Brunelleschi's great

dome hadn't been started when Hawkwood's memorial was painted. In 1436, the same year that Brunelleschi completed the dome and that the cathedral was rededicated as S. Maria del Fiore, the cathedral's Operai hired the painter Paolo Uccello to replace the old fresco with a new one.

Uccello painted his fresco in imitation of a bronze equestrian monument, which accounts for the drab greenish palette of colors. When the work was almost complete, some cathedral officials angrily objected to the angle of view: the horse had been painted as if from below, and they claimed it showed too much of the horse's stomach and the animal's more than ample sexual organs. They ordered Uccello to repaint the horse from a less offensive angle, which he did, since he wanted his payment and the Signoria withheld it until the artist had gelded the animal to their satisfaction.

Uccello portrayed Hawkwood carrying a commander's baton and wearing parade armor, not actual fighting armor but in the antique style that links the wearer to the military glories of ancient Rome. A painted inscription in Latin further underlines the link, as it is based on a famous Roman funerary inscription, the epitaph of Fabius Maximus (d. 230 BC), whose strategies defeated Hannibal's armies in Italy. It reads: "IOANNES ACVTUS EQVES BRITANNICUS DUX AETATIS SVAE CAVTISSIMVUS ET REI MILITARIS PERITISSIMVS HABITVS EST" (John Hawkwood, British knight, esteemed the most cautious and expert general of his time). Italians found the name Hawkwood unpronounceable and mangled it in various ways, finally settling on *Acuto*, which means "acute" or "sharp" in Italian—an appropriate name for a man who lived by the sword. It's unlikely that Uccello had read Plutarch's biography of the Roman hero Fabius Maximus, the source of the epitaph, but no doubt some members of the Signoria had, as enthusiasm for antiquity among the educated elite was starting to flourish in the early 1400s.

Considering his grandiose mount, costume, and equipment, Hawkwood's face as Uccello painted it comes as a shock. Perhaps Uccello, who of course had never seen Hawkwood, worked from the face in the original fresco, which may have been portrayed from a death mask. With grayish skin, shriveled cheeks, and hollow eye sockets, the general looks more dead than alive. But there's a certain poetic rightness to his appearance. To the opposing forces who faced him, and even more so to the terrified peasants and townspeople who encountered his marauding army, he must have seemed very much as he appears in this painting. Like the pale rider of the biblical Apocalypse, John Hawkwood was death on horseback.

Niccolò da Tolentino

Not to be confused with St. Nicholas of Tolentino, Niccolò Mauruzzi was born around 1350 into a family of minor nobility in the central Italian city of Tolentino. As a result of bitter disputes with relatives, in particular his stepmother, he fled the city in 1370 and began a long, violent career as a mercenary, first as a common soldier and later as a commander. His biography reads less like a life than an endless list of battles, plots, counterplots, and betrayals.

After many years spent as an undistinguished soldier of fortune, in 1406 Niccolò's luck changed. He joined the military company of Gabrino Fondulo, who sent him to Parma to propose an alliance. Instead, he became involved in a plot to eliminate Carlo Cavalcabò, the lord of Cremona, who was a guest in Parma and whose position one of Fondulo's allies coveted. At a grand banquet in the castle of Parma, Carlo Cavalcabò and all his family were killed. Niccolò, now in charge of his own band of mercenaries, proceeded to sack the towns formerly controlled by the Cavalcabò family.

Around 1412 Niccolò and his band of soldiers passed into the service of another ambitious northern Italian condottiere, Pandolfo III Malatesta, the lord of Fano. For the next twelve years Niccolò occupied himself with a series of skirmishes, fighting in the service of various Italian rulers ranging from Filippo Maria Visconti of Milan to Queen Joanna of Naples and grabbing whatever booty he could in the process. In 1424 he entered the service of Pope Martin V, but he was not entirely successful in his battles on behalf of the papacy. He suffered several losses, and in 1425 he was briefly taken prisoner by two rival condottieri.

More raids and battles in the service of other Italian lords followed, along with continued service to the papacy, and Tolentino also fought on and off for the republic of Florence. At that time, the early 1430s, Cosimo de' Medici was one of the most powerful men in Florence, a member of the *dieci di balia*, the city's ten-man war council, which was responsible for hiring Niccolò da Tolentino to fight for Florence. The condottiere's success in that role convinced Florence to appoint him *capitano generale* (commander in chief) of its forces in 1432.

In that same year, Niccolò da Tolentino achieved what became his greatest moment of glory and his chief claim to fame: he "won" the battle of San Romano. Up until that point Florence's war with Lucca had been going badly; they'd lost a number of battles, and one of their condottieri, Bernardino della Ciarda, had defected. Attacked by the Sienese allies of Lucca while separated

from the body of his troops, Niccolò and a small force withstood enemy assaults for many hours until a cavalry charge by his co-commander, Michelotto da Cotignola, routed the enemy forces. In reality, as far as historians can figure out, nobody really won the battle of San Romano. Both the Florentines and the Sienese claimed victory.

That battle, fought on June 1, 1432, was the high point of Tolentino's military career. Two years later, in 1434, while still in the employ of Florence, he was captured by the Milanese during a battle and thrown into one of the infamous dungeons of Duke Filippo Maria Visconti. As Tolentino was being transferred from one Milanese prison to another, he suffered a fall that left him so severely injured he died a few months later, in March 1435. The Florentines requested the return of his body, and since the dead condottiere could no longer do them any harm, the Milanese agreed. The government of Florence organized an elaborate state funeral held in the city's cathedral on April 14, 1435. Niccolò's remains are buried in the cathedral, but his heart was removed and buried at the convent of Sant' Agostino, in his home city of Tolentino. He left his family an enormous inheritance, which included a huge horde of coins and more than two thousand pounds of silver—not a bad haul for a lifetime of doing what mercenaries do: fighting other people's battles.

Although both sides claimed to have won the battle of San Romano, Florentine art eventually provided a more decisive verdict than the battlefield. Paolo Uccello's three large panel paintings portraying the struggle (one, in the Uffizi, is discussed in Chapter 13) and Andrea del Castagno's painted monument to Niccolò da Tolentino in Florence cathedral make Niccolò a hero in a way that no written chronicle of the battle ever could.

Castagno's equestrian portrait of Niccolò da Tolentino appears to the left of Uccello's portrait of Hawkwood. Completed in 1456, exactly twenty years after the Hawkwood fresco, it resembles the earlier work in certain ways—as it had to, since the Signoria ordered that the fresco look similar to Uccello's earlier effort. It is on the same scale, and it shows the horse and rider in profile and in parade armor atop a painted image of a sarcophagus containing a laudatory inscription. But beyond those general resemblances, Castagno created a very different work. In place of the greenish faux bronze of the Hawkwood monument, Castagno's horse, rider, and coffin appear to be made of off-white marble, with green relegated to the background. In comparison to Hawkwood's smooth, motionless mount, Tolentino's horse is powerfully muscled and tosses its head to the side in a restless movement. The figure

of the condottiere himself—in contrast to Uccello's cadaverous image—looks very much alive. He wears an enormous ceremonial hat, and his face has the proud, hard-bitten features of a professional soldier.

The base, painted to resemble an elaborate marble sarcophagus, contains an inscription: "HIC QVEM SVBLIMEN IN EQUO PICTUM CERNIS NICO-LAVS EST TOLENTINUS INCLITUS DUX FIORENTINI EXERCITUS" ("Here you see the great Niccolò da Tolentino, painted high on horseback, the famous general of the Florentine army"). To the left and right of the inscription are small male nude figures, each bearing a large shield. The shield on the left depicts the Marzocco, the sword-bearing lion, symbol of the republic of Florence; the one on the right displays Tolentino's own armorials, an arrangement of rope variously known as the Knots of Solomon or the Gordian knot.

Although the memorial to Tolentino is straightforward enough, the question remains as to why the Florentines waited twenty years before commissioning it, especially since his burial in 1435 would have provided an obvious occasion for the project. The reasons for the long delay can be found in the political events of the mid-1430s, in particular the hostility toward Cosimo de' Medici that had resulted in his arrest and exile from Florence in 1433. Although Cosimo quickly reestablished his authority after his return in 1434, hostility toward Niccolò da Tolentino persisted, and the controversial condottiere remained a focus of anti-Medicean sentiment. He was too closely associated with Cosimo's personal interests to be presented as a champion of the Florentine state, and an immediate monument to him may have struck Cosimo as politically inexpedient. Two decades later, such sentiments would have faded.

Although no documents survive to tell us precisely who commissioned the fresco of Niccolò da Tolentino, the Medici were most likely involved. A man named Bernardetto d'Antonio de' Medici, who was not as powerful or prominent as Cosimo de' Medici, but still a respected member of the extended family, was *gonfaloniere di giustizia* at the time that the Signoria, the ruling body of Florence, sent a memo to the Operai of the cathedral in October 1455 declaring that a painted monument to Tolentino should be placed inside the cathedral, next to the Hawkwood monument, "paying heed to the honor and glory of all Florence."

How the commission was awarded to Andrea del Castagno is also unknown, but he was among the city's leading painters, and Andrea probably had a powerful backer in Cosimo de' Medici. By 1455 Cosimo was the ruler of

Florence in everything but name, and as we've seen, he had personal connections with the dead condottiere. He'd been *gonfaloniere di giustizia* in January and February 1435, just prior to Tolentino's death. He counted the condottiere as a friend and he was responsible for the transferal of the body to the cathedral of Florence for burial, so there can be little doubt that both the battle and its hero were of personal importance to Cosimo.

But the de facto ruler of Florence wouldn't have needed to intervene directly. As usual, he could apply his influence behind the scenes, as his relative Bernardetto de' Medici was *gonfaloniere di giustizia* in September and October of 1455. Although the document sent to the cathedral's Operai from the Signoria does not specify a painter by name, it's likely that Bernardetto, through Cosimo, already had Castagno in mind. As an early biographer observed, Cosimo knew how to promote his own agenda without having his name attached to his ideas, so that "the initiative appeared to come from others and not from him." The Tolentino monument can be seen as an example of wide-ranging Medici influence, indirectly glorifying the family while promoting the glory of the city.

The Tolentino and the Hawkwood monuments, with their coats of arms and inscriptions, remind the viewer both of the identity of the deceased men and of their connection to the republic of Florence. Prominently displayed in the public and sacred space of the cathedral, the frescoes declare: "Here lie the bodies of two great defenders of our state." These assertive additions to the cathedral interior were ideal instruments to convey political messages. For the defense of the state, Florentine governments throughout the fifteenth century had found it necessary to rely on condottieri and the soldiers they commanded, despite the fear, suspicion, disgust, and outright hostility these mercenaries inspired among the common people. The two frescoes present images of condottieri as their governmental employers wished them to be seen by the citizens whose taxes paid for their services—as dignified, valiant, and praiseworthy heroes rather than the greedy, thuggish, faithless fellows they all too often were.

Chapter 3

The CATHEDRAL BAPTISTERY

HISTORY OF THE BUILDING

No building in Florence is older or more revered than the cathedral baptistery. Florentines of the Renaissance, intent on glorifying their city's past and perhaps further persuaded by the eighteen massive classical columns that help support the interior, insisted the baptistery was an ancient Roman building later taken over for Christian use. Although modern scholarship long ago refuted that claim, the actual date of its founding remains uncertain. It was probably built in the sixth or seventh century but maybe as early as the fourth or fifth. The building was reconstructed in 1059, and the geometrical decoration in colored marble on the exterior was carried out between that date and the 1200s. Within the spacious interior an unusually large dome displays an extensive cycle of thirteenth-century mosaics, the only such cycle in Florence, illustrating Old and New Testament stories as well as a Last Judgment.

It seems more than mere coincidence that this building was the first one chosen for adornment when the new century of the 1400s opened. Far more than the still incomplete cathedral, the baptistery was the heart of Florence. This was where citizens of all classes brought their children to be baptized, the ritual that signified their entrance into both the community of the faithful and the commune of Florence. The date of the competition to provide the baptistery with a new set of bronze doors—won by Lorenzo Ghiberti in 1401—marks the birth of the Renaissance, and Ghiberti's second set of doors, known as the Gates of Paradise, show that movement in full bloom. Ghiberti's masterpieces have as their worthy fourteenth-century predecessor the

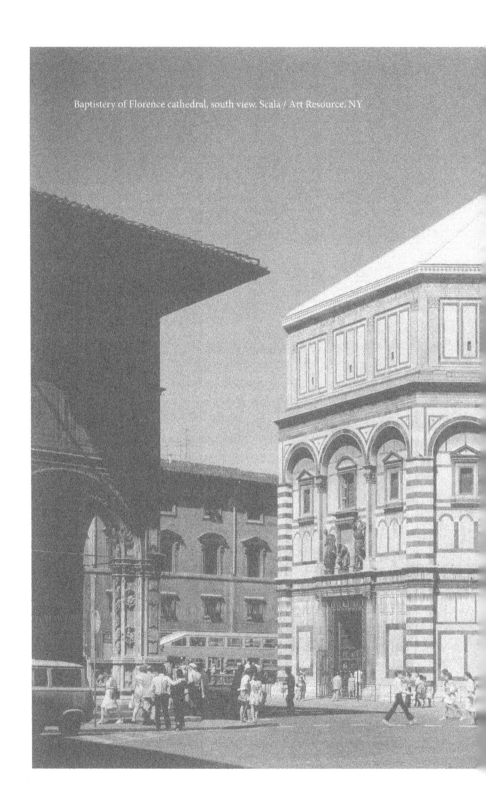

Baptistery of Florence cathedral, south view. Scala / Art Resource, NY

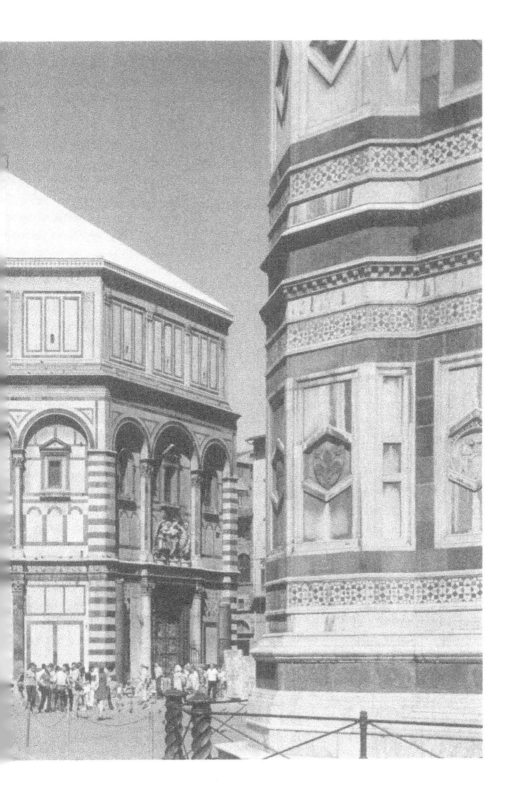

baptistery's first set of bronze doors, by Andrea Pisano, depicting scenes from the life of John the Baptist. And it's no accident, either, that the executors of the will of the deposed anti-pope John XXIII, long a supporter of Florence, chose the baptistery as the site for the former pontiff's tomb, a political statement of Florence's support for his aborted papacy.

THE THREE SETS OF BRONZE DOORS

Doors by Andrea Pisano

The 1330s were a period of relative peace and prosperity for Florence, a decade when several major projects were underway: work on the unfinished cathedral resumed in 1331, and construction of the cathedral's bell tower started in 1334. Shortly before that, in 1330, Andrea Pisano began a set of bronze doors, although they weren't put in place on the main (east) entrance of the baptistery until 1336. They now adorn the baptistery's south entrance. The artist signed and dated his doors in an inscription along the top: "ANDREAS UGOLINI NINI DE PISIS ME FECIT A D MCCCXXX" ("Andrea son of Ugolino son of Nino of Pisa made me in the Year of the Lord 1330").

Andrea's doors contain twenty episodes from the life of John the Baptist, the patron saint of Florence, along with eight panels showing theological and cardinal Virtues. The doors should be read from top to bottom, first on the left side and then on the right. On the left are ten episodes concerning the public life and preaching of the Baptist, while the right door displays ten scenes of John's martyrdom and subsequent events, ending with the saint's burial. The Virtues occupy the eight lower panels. The compositions are simple and sturdy, with figures highlighted in gold set against rudimentary landscapes and buildings. The pair of doors illustrates the two aspects of John the Baptist: his role as the last prophet and his fate as the first martyr. Florentines were deeply devoted to their patron saint, and they must have been impressed by this detailed celebration of his life and death.

Ghiberti's First Set of Doors

Florence thrived on fierce competitiveness in business, politics, and the arts. Shortly after 1400, as the city continued its recovery from the deadly epidemic of bubonic plague that had devastated much of Europe half a century

earlier and celebrated the ending in 1398 of a bitter conflict with the duchy of Milan, government officials encouraged the commissioning of civic art. Unaware that the problem with Milan would flare up again in even more deadly form just a few years later, Florence was enjoying a time of peace, economic prosperity, and political pride.

The city's guilds were always eager to enhance their own prestige and were ready to cooperate in commissioning art that would, as historian Frederick Antal put it, "give tangible expression to . . . democratic ideology," projects that would enhance the appearance of the city and become objects of civic pride. What was needed was a major work that would be highly visible, and another pair of bronze doors for the baptistery was the perfect project. Keep in mind that in 1400 the cathedral itself was an embarrassingly unfinished shell; nobody had yet figured out how to construct a dome on the scale required by the building's enormous dimensions.

The Operai of the cathedral opened a competition in 1401 to choose a sculptor to execute the new set of bronze doors. The city's powerful wool guild, the Calimala, was in charge of artworks involving the baptistery, and its members supervised the competition. A committee of thirty-four judges, including both clerics and businessmen, rendered the final decision. Each artist was required to submit a bronze relief panel illustrating the Sacrifice of Isaac by Abraham. This Old Testament story in which God instructs Abraham to sacrifice his only son as proof of his faith and then, at the last moment, sends an angel to prevent the slaying and provides a ram as a substitute, contains enough drama to stimulate the creativity of any artist.

Even though seven artists, five of them from places other than Florence, submitted their versions of the subject, it most likely would have been politically unacceptable at that moment for the committee to have chosen a foreigner to execute a work intended for a building that was the focus of so much of Florence's patriotic pride and religious devotion. The competition thus ended with a pair of Florentine semifinalists: Lorenzo Ghiberti, only about twenty-two at the time (he was the youngest contestant), and Filippo Brunelleschi, just a few years older. Although records of the judges' deliberations don't survive, we know they chose Ghiberti, whose panel was one-third lighter than Brunelleschi's and, except for the figure of Isaac, cast all in one piece. Brunelleschi's heavier offering required several more pieces. Perhaps these practical considerations—using less of an expensive material in a sturdier final product—appealed to the judges more than the aesthetic qualities of

Ghiberti's panel. Brunelleschi, always a sore loser, complained that Ghiberti had used all kinds of tricks to convince the committee to award him the victory. Modern viewers can make their own judgment, as the two competition panels are still preserved, and they're exhibited side by side in Florence's Museo Nazionale del Bargello.

Whatever their reasons, the judges' decision had extraordinary unintended consequences. Ghiberti spent the next half century designing and executing two sets of bronze doors for the baptistery, while the disgruntled Brunelleschi gave up sculpture and went to Rome to study ancient architecture. Had he won the competition for the doors, he might never have conceived the brilliant plans that eventually enabled him to build the dome of Florence cathedral. The cathedral and the baptistery that faces it constitute the city's spiritual and artistic center—the place where the Renaissance was born—and the judges' decision allowed both Ghiberti and Brunelleschi, through their respective achievements in sculpture and architecture, to assist in its birth.

The expenses involved in creating the doors were enormous. According to Ghiberti's own account, the doors cost twenty-two thousand florins, a sum historian Antonio Paolucci describes as equal to Florence's yearly defense budget, and only slightly less than Florence paid a few years later to purchase the city of Sansepolchro. Try to imagine a work of art today whose cost equals the annual budget of the Pentagon. Despite his youth, Ghiberti knew how to drive a hard bargain. His contract for the doors, signed on November 23, 1403, provided him with the substantial annual salary of two hundred florins, with the costs of all material and other labor to be borne by the Calimala.

Meanwhile, art commissioning by committee continued, and Ghiberti learned, when he signed the contract, that the subject matter had been changed from Old Testament subjects to the life of Christ. The doors would consist of twenty-eight panels, each just under two feet square, with each scene fitted into an elaborate four-leaf-clover shape known as a quatrefoil. This old-fashioned format, French in origin and popular in the Gothic period, was chosen so that Ghiberti's doors would be consistent with Andrea Pisano's earlier set from the 1330s.

Ghiberti spent the next twenty-one years on the project. That might seem an excessive length of time for an artist to spend on one work, but the scale of the project and the complexities of the bronze-casting technique required it. In addition, Ghiberti was an artist of fanatical meticulousness. He worried over every tiny detail, melting down any panel that emerged from the casting

in less than perfect condition and going through the whole lengthy process again. Although he had a number of assistants, the panels maintain a uniformity of style and a consistently high quality, which confirms that Ghiberti worked personally on each relief, as his contract stipulated.

The change of subject matter has logic behind it, particularly when we think of it in relation to the doors by Pisano, dedicated to John the Baptist. John brings to an end the period of the Old Law and fulfills Isaiah's prophecy by preparing "the way of the Lord," that is, Christ, whose life then continues the story of salvation on Ghiberti's doors. To make sense of the narrative, however, the visitor needs to read Ghiberti's doors differently than Pisano's, starting at the bottom and going across both panels from left to right. The lowest register contains images of the Church Fathers: Saints Augustine, Jerome, Gregory, and Ambrose; above them are the Four Evangelists. The life of Christ begins in the third register from the bottom with four scenes from the infancy and childhood of Jesus. It then moves on in the fourth and fifth registers to events and miracles of Christ's adult life. The top two registers contain scenes from the Passion, with the final two panels, at top right, illustrating the Resurrection and Pentecost.

The individual scenes are full of slender, supple figures brought out from the dark bronze background by being washed with gold. Through the square borders that frame each quatrefoil flows a tide of vegetable and animal forms—branches, foliage, fruit, birds, lizards, and insects—all rendered in gilded bronze with Ghiberti's painstaking attention to detail. At each corner intersection of the borders Ghiberti modeled a tiny human head. Forty-seven of them probably represent prophets and prophetesses, some old, some young, some calm, some agitated. Many show the influence of Ghiberti's study of ancient Roman sculpture. But one of the heads—three panels up from the ground and in the middle of the left door—is clearly a man of the Renaissance, approaching middle age, with heavy eyelids, clean-shaven chubby cheeks, a thoughtful expression, and a fashionable turban. This is Ghiberti's self-portrait, and it supplements his signature, "OPUS LAVRENTII FLORENTINI" ("The Work of Lorenzo of Florence"), which appears just above the panels of the Annunciation and the Adoration of the Magi.

The completed set of doors was put in place in 1424, on the east entrance to the Baptistery, the most important one, since it faces toward the front of the cathedral, and Pisano's doors were moved to the south entrance. Everybody loved the new doors, and it's of interest to note that work on this costly project

continued uninterrupted through several severe military crises: another at-
tempted invasion in 1402 by the Milanese and a similar attempt on Florentine
liberties by the kingdom of Naples in 1408. Both invasions were turned back,
and Ghiberti's gleaming new doors stood as a witness to Florence's survival, as
well as the city's belief that God had indeed intervened on its behalf.

Ghiberti's Second Set of Doors: The "Gates of Paradise"

"When Michelangelo stopped by one day to admire Ghiberti's work, someone asked
what he thought of it, and he answered, 'They are so beautiful, they might be the
Gates of Paradise.'"—Giorgio Vasari, *The Lives of the Artists*, 1558

With such a glowing endorsement from the greatest artist of the age, it's no
wonder the bronze doors that now adorn the east entrance to the baptistery of
Florence cathedral remain one of the glories of the city and one of the great,
defining achievements of the early Renaissance. The doors celebrated by Mi-
chelangelo are the culmination of more than half a century of dedicated labor
by Ghiberti. The artist's first set of doors had scarcely been put in place when
the Calimala commissioned a second set, and this time there was no question
of a competition—Ghiberti would be the artist to create them, a process that
took the artist craftsman twenty-seven years. He began in 1425 and declared
the new doors complete in 1452.

For the program of images, the prominent humanist scholar and political
leader Leonardo Bruni proposed a selection of twenty-eight Old Testament
scenes that would have matched the format of Ghiberti's first set of doors.
But then the committee of the Calimala reduced the number to twenty-
four, and finally Ghiberti himself (if we can believe the account he gives in
his autobiographical *Commentaries*) declared he "was given permission to
carry it out in that manner which I believed would turn out most perfectly
and most ornate and rich." The doors would consist of ten large panels,
about thirty inches square, and never mind those outdated quatrefoils. This
set of doors would resemble neither the pair from the 1300s nor Ghiberti's
previous set. The artist had rethought the entire format. He abandoned
both the quatrefoils and the notion of gilded figures set out against a dark
bronze background. Instead, each square is completely gilded, as if Ghi-
berti weren't creating sculptural reliefs but setting himself the challenge of
painting in gold on gold.

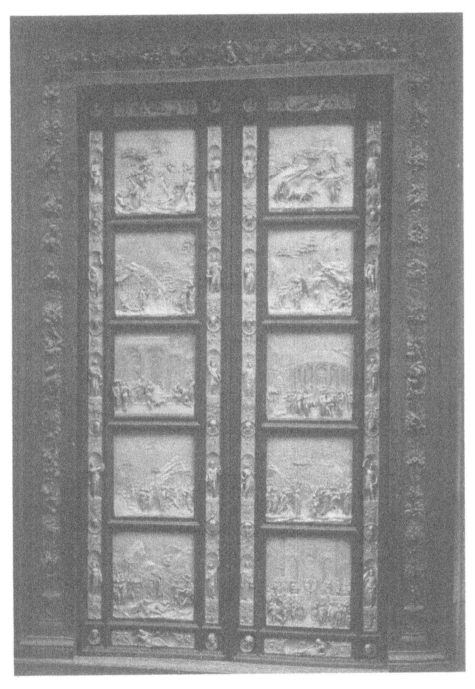

Ghiberti, "Gates of Paradise," east door, baptistery, Florence cathedral.

By the time he began his second set of doors, Ghiberti had mastered the new science of one-point perspective invented by Brunelleschi, and his scenes now feature convincingly constructed buildings and correct spatial recession. Later, Ghiberti wrote proudly of his achievement: "I strove with every measure to respect nature and to try to imitate nature. . . . In some stories I put about a hundred figures. . . . I worked with the greatest diligence and the greatest love."

If Ghiberti's first set of doors was an impressive achievement, his second set is a dazzling tour de force. Every panel is a masterpiece of condensed story-telling, the figures elegant and often sensuous, the compositions striking, the level of detail breathtaking. His first set of doors still had ties to the medieval past, but the new set is truly a work of the Renaissance. The panels of the Gates of Paradise should be read from the top, left to right. The subjects are (1) Adam and Eve, (2) Cain and Abel, (3) Noah, (4) Abraham and Isaac, (5) Jacob and Esau, (6) Joseph and His Brothers, (7) Moses, (8) Joshua and the Battle of Jericho, (9) David and Goliath, (10) King Solomon and the Queen of Sheba.

The first panel, at upper left, shows Adam as a beautiful, reclining nude, a worthy miniature ancestor of Michelangelo's monumental Adam on the ceiling of the Sistine Chapel, and God as a noble Father who gently raises Adam to life. Eve, whose creation occupies the center of the scene, floats out of Adam's side like a seductive figure in an erotic dream, as lovely as any classical statue of a goddess. On the far right side of the composition Eve appears again, this time leaning back and gazing in regret toward Paradise, lost through dis-obedience to God's command; Ghiberti tucked that latter event into a grove of beautifully detailed trees in the left background. In the sky, God appears again, now in a spiraling swirl of angels.

The only panel representing a single event is the last one executed: the Meeting of King Solomon and the Queen of Sheba. Magnificent Renaissance architecture with tall arches, cross-vaulted ceilings, and ancient Roman-style columns pro-vides a backdrop for a crowded yet orderly scene. Sheba and Solomon face one another and clasp hands at the center of the composition, on the steps of a build-ing that at once resembles a royal palace and a church. On either side, groups of people mill about, those in the far background small in size and executed in such low relief that they seem sketched on the surface, and those in the foreground larger and in such high relief that they appear almost like independent pieces of sculpture. Intricately detailed armor, elegantly flowing robes, and astonishingly individualized faces—one can pick out African, Arab, Roman, and Semitic facial types—make this panel a fitting climax to Ghiberti's achievement.

Viewed as an ensemble, albeit one that extends across more than a century, the three sets of doors display a coherent religious meaning. The earliest, by Pisano, celebrates the Precursor; Ghiberti's first doors illustrate the life of the Savior whom John identified; and Ghiberti's Gates of Paradise brilliantly condenses events from the Old Testament, including those that prefigure the coming of Christ. The baptistery as a whole thus tells the story of human redemption as Christians of the day envisioned it.

As in his earlier set of doors, the panels showing biblical scenes aren't the only elements of interest. Although the ten scenes are set in plain bronze frames, each door has a border consisting of gilded figures in golden niches alternating with heads that emerge from circular frames. Here, too, Ghiberti included his self-portrait, in almost the same spot as it appeared on his first set of doors. With gentle humor, the artist portrayed his wise, kindly old face and now bald head in the perfect position to serve as a doorknob. On either side of his self-portrait and running across both doors is a Latin inscription: "LAVRENTII CIONIS DE GHIBERTIS / MIRA ARTE FABRICATUM" (["The Work of] Lorenzo, [Son of] Cione Ghiberti, Made with Marvelous Art").

The signature used here opens a window onto an intimate aspect of the artist's life: the question, evidently important to Ghiberti, as to whether he was an illegitimate child. In 1370 his mother, a farm laborer's daughter, had married a man named Cione Ghiberti. Although Cione was from a respectable family, he was described as "a thoroughly useless person, a sorry wretch nearly out of his mind." Some years later his wife left him and fled to Florence, where she became the common-law wife of the goldsmith Bartolo di Michele, whom she married after Cione's death in 1406.

Lorenzo's birth date is unknown, as is the exact date when his mother left her husband, so it remains uncertain whether the artist was Cione Ghiberti's legitimate child or Bartolo di Michele's illegitimate one. For years the artist evaded the problem of his paternity, signing himself as he did on his first set of doors, using only the name "Lorenzo." But perhaps troublesome questions about his legitimacy arose at some point, as Ghiberti later began claiming he was Cione's legitimate son, born while his mother was still living with her first husband, and in 1442 he started signing himself as "Lorenzo di Cione Ghiberti," the form of his name that appears on the Gates of Paradise and the name by which he's known today.

Ghiberti's second set of doors created such a sensation that the cathedral authorities and the Calimala soon decided to do some further door moving. They had Ghiberti's first set of doors removed from their prominent place on

the east side of the baptistery and transferred to the north side and had the new golden doors installed at the main entrance, on the east. Here, dazzled Florentines would gather in the mornings, to watch as the rising sun transformed Ghiberti's panels into a glowing field of molten gold. Surely Michelangelo, nearly a century later, wasn't the first to observe that the doors resemble the traditional vision of the golden portals of paradise, but he was so famous that his nickname for them—the Gates of Paradise—has persisted to the present.

In November 1966, some five hundred years after they were completed, Ghiberti's doors nearly perished in the flood of biblical proportions that deluged Florence when the Arno River overflowed its banks and surged twelve feet deep through the streets of the stricken city. The force of the floodwaters tore Ghiberti's heavy panels from their oak supports and slammed them into the iron fence erected in modern times to protect the doors from vandalism. After years of restoration work (the panels were in need of conservation anyway, due to damage from automobile exhaust and other forms of modern pollution), the city decided not to return Ghiberti's doors to the baptistery. Instead, the restored panels are displayed individually in the cathedral museum, the Museo dell'Opera del Duomo.

A Japanese company sponsored the restoration, and that same group paid for the creation of an exact copy of Ghiberti's doors, complete with brilliant gilding. Since 1990 those doors have adorned the east entrance of the baptistery. Some modern-day Florentines grumble that the new doors are too shiny—they were accustomed to the original pocked and pollution-darkened panels. But somewhere, the spirit of Lorenzo Ghiberti must be smiling to see his "marvelous art" again catching the rays of the morning sun and turning the entrance of the baptistery into the gates of heaven.

INSIDE THE BAPTISTERY

The Other Pope John XXIII

If you were to ask someone today, "Who was Pope John XXIII?" the respondent no doubt would identify Angelo Roncalli, the jovial and beloved "Papa Giovanni" who held the papal office from 1958 to 1963. But there was an earlier John XXIII (1410–1415), a pope entirely different from the saintly Roncalli, a man accused of an astonishing variety of personal and papal misdeeds and whom the Catholic Church long ago struck from its record of

legitimate successors to the Chair of Peter, declaring him an "anti-pope"—the theological equivalent of a nonperson. Although the name John XXIII therefore remained available, the previous John tarnished it so thoroughly that almost 550 years passed before another pope claimed it.

And yet, the disgraced and dethroned anti-pope John XXIII lies buried in one of the most imposing tombs of Renaissance Italy, a handsome marble-and-bronze ensemble inside the Florence baptistery, designed and built in the 1420s by two of the city's leading artists, Donatello and Michelozzo. No other pope is buried in Florence, and nobody has subsequently been buried in the baptistery, long considered the city's most sacred site. How and why such a tomb came into existence is a story full of drama, political machinations, threats of violence, and even a hint of sexual spice, a tale that seems more like an adventure novel than a page from late medieval and early Renaissance history.

The first pope to take the name John XXIII was a disreputable Neapolitan nobleman named Baldassare Coscia whose family, sometimes described as sea captains, could more accurately be described as pirates. Born around 1360, at first Coscia joined his family's business of plundering other people's ships, but he soon saw a more efficient and less physically dangerous way to acquire wealth: he decided on a career in the Church. He made a show of studying theology, first in Rome and then in Bologna, but mostly he dedicated himself to the pleasures of food, wine, and women. Thanks to family connections (he was a relative of Pope Boniface IX, a fellow Neapolitan), he rose quickly in the hierarchy. He became a papal chamberlain in 1392, papal legate and archbishop of Bologna in 1396, and a cardinal in 1402.

Despite his dubious family background, Coscia was no ruffian, and he proved an effective papal diplomat. He developed a reputation for financial acumen, and it was in connection with Church finances, as well as his own, that Coscia first became acquainted with the Medici family of Florence, who in the late 1300s were just beginning to establish their position as important bankers. Giovanni di Bicci de' Medici had opened a bank branch in Rome, as well as operating a home office in Florence, and business relations between the Medici and Coscia began in the 1380s. In addition to transactions involving the Church, Coscia kept a personal account with the Medici bank, and large sums of money changed hands between the two men, leading to rumors that Medici money bought Coscia his cardinalate.

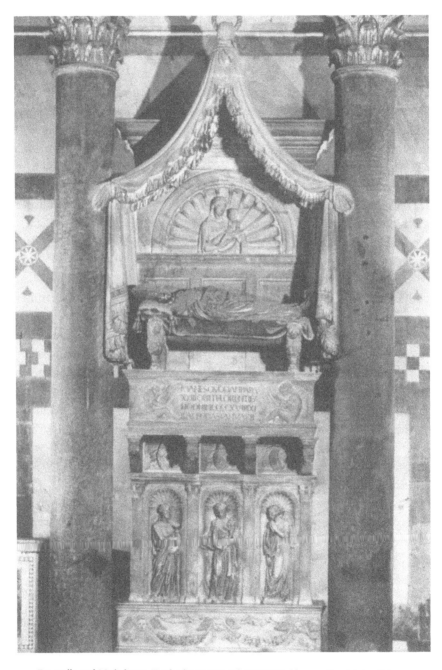

Donatello and Michelozzo, *Tomb of Anti-Pope John XXIII* (Baldassare Coscia), baptistery,
Florence cathedral.

Before looking any further into Coscia's life, it should be noted that the late 1300s and early 1400s were particularly complex and uneasy times in the history of the Catholic Church. Although the nearly seventy years when the papacy was resident at Avignon in France rather than in Rome had finally ended in 1378, the return of the papal court to Rome failed to end the conflict between French and Italian interests within the Church. The election in 1378 of an Italian pope ended the succession of French popes who had ruled from Avignon, but it alienated the French cardinals, who then elected a Frenchman as an alternative pope, thus beginning a most embarrassing episode in Church history—known as the Great Schism, or split—in which the Church splintered into two and eventually three competing factions, each with its own pope and each declaring the other two popes illegitimate. Finally, in 1417, the Council of Constance resolved the issue of papal succession, thrusting all competing claimants to the papal throne into limbo as anti-popes and electing the Roman aristocrat Oddone Colonna as Martin V, supreme pontiff of a reunited Catholic Church.

Baldassare Coscia stood in the thick of the intrigues that abounded during the period, and he played a crucial role. Although the details are so complex that historians despair of untangling all of them, a few episodes stand out. The popes who succeeded Coscia's relative Boniface IX were so disgusted by Coscia's personal behavior that they deprived him of his office as cardinal, and they may even have excommunicated him. But one of the anti-popes—Alexander V, whose election Coscia had helped to secure—reinstated him, and when Alexander died in 1410, Coscia was elected pope, taking the name John XXIII. One week later, on May 24, 1410, he was finally ordained as a priest.

As pope, John strengthened his ties with the Medici, making the head of the Medici bank in Rome depositary general of papal finances, an exclusive and influential position. This made the Medici bank the dominant firm in the handling of papal financial transactions, pushing aside rivals for the vast volume of lucrative papal business. This move by John XXIII was the single most important source of the Medici family's extraordinary prosperity, and the origin of their generations of political power.

This John XXIII had a tumultuous papacy. He had been elected by a schismatic Church council held in Pisa, a council that claimed to have deposed the two competing popes and that previously had elected Alexander V. When Coscia was chosen to succeed the deceased Alexander, however, he found himself reigning from Bologna, as one of three popes. As a result of the

intrigues, backstabbing, and sudden switches of allegiance among the secular rulers supporting one or the other of the popes, in 1413 John XXIII was forced to flee, and he took refuge in the one place where he knew he had reliable friends: Florence.

While residing in Florence, John was pressured into convening a Church council in the distant Germanic city of Constance. But when he arrived there, he was confronted by angry northern European cardinals determined to end the Schism by forcing his resignation. He refused to resign. Fearing for his life, John fled Constance in disguise and turned up next in Austria, having made a long trek on horseback through the Black Forest. His Austrian protector failed to shield him from more powerful princes, however, and had to surrender the hapless pope into the custody of the now thoroughly infuriated Council of Constance, whose members appointed a tribunal to collect evidence against him.

Not surprisingly, the evidence produced was negative. John was charged with ambition, heresy, tyranny, simony (the sale of Church offices) and "bad conduct," which included the alleged murder of his predecessor and, while in Bologna, the seduction of some two hundred women. In 1415 John was found guilty, deposed, and thrown into prison in Germany. After two more years of debate and the deposition of the two other claimants to the papacy, the Council of Constance, as noted above, elected Martin V in 1417, putting an end to the Great Schism.

Meanwhile, the Florentines watched with dismay as their favored claimant to the papacy disappeared into a German jail. What prompted their concern had nothing to do with religion and everything to do with John's consistent financial, political, and military support of Florence. In addition to putting a Florentine bank (the Medici) in charge of papal finances, while he was papal legate in Bologna John had helped Florence gain control of Pisa, and he had also sent aid to the Florentines in 1408, in support of their struggles against King Ladislaus of Naples. John's deposition triggered a lengthy debate within the government of Florence over whether to intercede on his behalf, but the officials decided that such intervention was too dangerous to Florence's own interests. In the end it was Giovanni di Bicci de' Medici who secured the pope's release by paying an enormous ransom.

In 1419 an exhausted and defeated Baldassare Coscia, now around sixty years old, crept back into Florence, accompanied by a Medici bank representative who had escorted him from Germany. It so happened that at this same

time the new pope, Martin V, was reluctantly residing in Florence because he lacked the military strength to enter Rome and impose his rule on that chaotic city. The Medici smoothed over what could have been an extremely awkward situation, persuading Coscia to submit himself to the authority of Pope Martin, while also persuading the new pope to bring Coscia back into the good graces of the Church and to restore his title as cardinal.

Coscia had little time left to enjoy his reinstatement—he died six months later, on December 22, 1419, after writing and signing his will on the last day of his life. In it he named four prominent Florentines as executors, one of them Giovanni di Bicci de' Medici, and gave his executors the power to choose in which church he would be buried. Among his many bequests was the donation of a particularly precious relic to the Florentine baptistery: an object said to be the right index finger of John the Baptist, the same finger John had used to point out Christ, saying "Behold the Lamb of God." Since the Baptist was the patron saint of Florence and the city's baptistery was dedicated to him, the gift smacks of a quid pro quo. It's clear that Coscia wanted to be buried in the baptistery, although he was too shrewd to say so directly. It was among the most hallowed sites in Florence, and therefore the best place for him to assert his persistent and soon-to-be posthumous claim to a legitimate papacy.

He had left it to his executors to plead his case before the committee composed of members of the Calimala, the guild that had responsibility for works of art in the baptistery. The executors declared that, on his deathbed, Coscia had confided to them his wish to be buried in the baptistery, and that he wanted a chapel built there as well as his tomb. They petitioned the Calimala for permission to erect both. Responding for the nonplussed Calimala, committee chair Palla Strozzi declared they would never allow a chapel to be built inside the baptistery, as that would destroy its beauty, and that any tomb constructed there would have to be *breve et honestissima* (small and very modest). It was no small honor in itself, Strozzi concluded, to be permitted burial in the baptistery.

The monument the executors of Coscia's will caused to be built amply justified Palla Strozzi's concerns. Neither small nor modest, it aggressively declares the validity of Coscia's claim to the papacy, and it remains an enduring testament to the unlikely alliance between the scheming, sensual Neapolitan adventurer Baldassare Coscia and the cautious, conservative, but equally ambitious and politically astute Florentine banker Giovanni di Bicci de' Medici.

The Tale of a Tomb

The Burial Monument of Anti-Pope John XXIII (Baldassare Coscia)

How a disgraced and deposed pope—the former pirate and clerical profiteer Baldassare Coscia, whose papal name John XXIII was struck from the list of legitimate popes, and who had been declared an anti-pope—came to be buried in one of the finest tombs of Renaissance Italy, located in the baptistery of Florence, is discussed above. This essay will consider that tomb and its meaning, as well as the political significance of the unusually elaborate funerary rites that preceded the placement of Coscia's body in such an exceptional monument in such a privileged place. (While the tomb was under construction, Coscia's body was buried temporarily in the cathedral.)

Politics played a more important part than religion in the honors done to Coscia. When the deposed pope died in Florence in 1419, he was connected to the city by complex bonds of personal friendship, political alliance, and financial relations. As a result, the city was eager to honor him, and his funeral rites extended over nine days, mingling Florence's civic affairs with papal politics to create what might be called politicized religious theater. There were three requiem masses, each for a different set of mourners—Church dignitaries, Florentine citizens, and Coscia family members—and all marked by splendid processions. In addition, there were numerous smaller rites, vigils, and prayer services. No one else in Florence had ever received anything remotely like this elaborate and extended send-off.

Why were the Florentines so eager to honor Baldassare Coscia? Although all the other anti-popes from the era of the Great Schism were quickly forgotten, Coscia owes his presence in an enduring memorial to his close connections with Florence, which had begun well before his brief papacy (1410–1415), and which had included putting the Medici bank in charge of papal finances, a position the Medici continued to hold even after Coscia's papacy came to its inglorious end. But there's a further reason that Coscia received so much attention in death: it was the Florentine government's way of showcasing their belief that Coscia, as John XXIII, had been the true pope, without their explicitly saying so. As noted, Florence had as its reluctant guest the recently elevated reigning pope, Martin V. Although he was now the undisputed head of the reunited Catholic Church, Martin lacked the military forces to enter Rome, and the Florentines knew it. In part, Coscia's elaborate funeral was Florence's way of insulting Pope Martin without actually declaring against him.

The tomb that Coscia's executors eventually caused to be built would insult Martin V even further. There's little doubt about the symbolic importance of the site chosen. If the executors had wished to emphasize Florence's loyalty to the reigning pope, they certainly would not have chosen the baptistery for Coscia's burial but would have buried him modestly, perhaps in the monastic church of S. Maria Novella, where the deposed pope had been forced to humble himself before Martin V in return for being reinstated as a cardinal.

Furthermore, the prominently placed inscription on the tomb can be interpreted as endorsing the legitimacy of Coscia's papacy. Abbreviations filled out, it reads: "IOANNES QUONDAM PAPA XXIIIIUS OBIIT FLORENTIE ANNO DOMINI MCCCCXVIIII XI KALENDAS IANUARII." With the date modernized, it states: "John XXIII, former pope, died in Florence in the Year of Our Lord 1419, on December 22." When Martin V heard about the inscription, he was furious. He knew the word *quondam* could be interpreted as meaning "former," which would imply that Coscia at one time had been a legitimate pope, the last thing Martin wanted to admit. At an uncertain date, but probably around 1430, he sent a papal emissary to the governing body of Florence to insist that the inscription be removed and that one beginning "Baldassar Coscia Neapolitanus Cardinalis" be substituted. But the Signoria brusquely informed the envoy that what was written was written and would not be changed. The offending epitaph still stands.

The site within the baptistery chosen for Coscia's tomb suggests that the executors of the ex-pope's will already had a major monument in mind, despite the warning by the Calimala to keep it "small and very modest." The tomb is located between two massive, ancient Roman columns in the center of a tripartite division of one of the walls of the octagonal baptistery, to the right of the altar. In order not to be dwarfed by the columns, the tomb would have to be both tall and robust in width—and it is. At twenty-four feet high, it was for centuries the tallest monument in Florence.

It consists of six elements. At floor level is a plain platform and above it a base carved with angel heads and wings between floral garlands. On top of this are three niches containing figures of the theological Virtues: Faith, Charity, and Hope. Above the Virtues, the seven-foot-long sarcophagus is supported on sturdy consoles, its defiant inscription written on the kind of scroll that might normally contain a papal letter, held open at either end by seated baby angels. Between the four consoles are three shields with coats of arms. Then comes the effigy of the deceased, laid out on a bier supported by

lions, the traditional symbol of Florence. This is the only part of the ensemble made of bronze rather than marble. Although the bronze of the bier is left dark, the effigy is brilliantly gilded, making it stand out from its support. Atop a low wall behind the effigy is a half-circle sunburst containing an image of the Madonna and Child. Surmounting the entire ensemble is a beautifully carved tasseled canopy that appears to hang down from a ring placed at the height of flanking column capitals, and which is parted to reveal the Madonna and Child and the effigy.

The three coats of arms below the sarcophagus are an intriguing study in the politics of identity. The left compartment displays the Coscia family armorial: a human leg. Although this startling image might seem a more suitable emblem for a military surgeon, or perhaps Hannibal the Cannibal, it's a play on the name Coscia, which in Italian means "thigh." Above this rests the papal insignia of the triple crown. The center compartment holds the papal arms alone, and the right-hand one repeats the Coscia arms topped by a cardinal's hat. In modern terms, this is a display of armorials that covers all the bases.

Although scholars continue to argue about the exact dating of the monument, and the precise roles played by the two artists involved, Donatello and Michelozzo, most agree that work began shortly after 1422, when the executors of Coscia's will first requested permission to build the tomb, and that it was completed by the late 1420s, since Pope Martin complained about the inscription around 1430. The division of labor between the two artists remains elusive, but everyone agrees that the single bronze portion, the bier with its masterful portrait effigy of Coscia, is the work of Donatello, among the finest sculptors of the time and a brilliant conveyor of character through faces. Although the gilded effigy is tipped slightly forward and the figure's head turned outward, the figure is so high above the viewer that it is difficult to appreciate the details of the face and costume. A spotlight presently trained on the effigy makes it somewhat easier to see.

Considering the Florentines' stubborn belief in the legitimacy of Coscia's papacy, it is of interest to note that the effigy wears a bishop's robe and miter rather than papal regalia, perhaps as a concession to the reality of Coscia's situation. Coscia's face is difficult to see, which is unfortunate, because Donatello created a vivid portrait of a man who appears not so much dead as in restless sleep, seeming almost to twitch as if enmeshed in bad dreams. His heavy-lidded eyes, with deep bags under them and bushy eyebrows above, look ready to open at any moment. Tufts of hair spring out from beneath his

miter and a large mole blooms on his left cheek. Thick, sensual lips and flabby jowls give him a dissipated look that accords with what we know about him. Some scholars insist that Donatello must have worked from a death mask, but others claim—and I agree—that Donatello had plenty of chances to see Coscia in Florence while he was alive. For all we know, Coscia may have sat for a portrait sketch. In any case, the artist avoided the inertness of a death mask, and he brought to vivid life every feature of the deceased man's face.

The individuals who had the most to say about how the Coscia tomb would eventually look were both members of the Medici family: Coscia's old friend and business associate Giovanni di Bicci de' Medici and Giovanni's son and successor, Cosimo. Of the three executors named along with Giovanni in Coscia's will, two had died by 1427 and the third had lost interest in the project, giving the two Medici a free hand. Although the tomb preserves the memory of John XXIII, it may also serve as a subtle piece of Medici self-promotion.

We don't know how the modest tomb originally stipulated became the most lavish funerary monument of its time in Florence, but the two Medici probably played a crucial role in the transformation. They understood that in Florence the most effective way to increase the power and prestige of one's family was through patronage of monuments that didn't directly glorify the patrons but, instead, expressed both piety and civic consciousness. A magnificent monument to the "quondam" pope who had consistently supported their city—and also had done so much to found their personal fortune—must have seemed the perfect tribute.

The BRANCACCI CHAPEL *in*
S. MARIA DEL CARMINE

WHERE RENAISSANCE PAINTING WAS BORN

The shabby exterior of the monastic church of S. Maria del Carmine looks so unpromising that visitors might be tempted to walk right past it. But if they do, they'll miss one of the city's greatest treasures: the spot where Renaissance painting was born. Inside, in the right transept, now entered separately from the church through a door to the right of the church façade, is a chapel endowed in the mid-1300s by a member of a family of wealthy silk merchants named Brancacci. It was dedicated to St. Peter, both the name saint of Pietro Brancacci, the chapel's founder, and the patron saint of the Brancacci family. Pietro Brancacci declared in his will that he desired the establishment of a family chapel in S. Maria del Carmine as "a certain and acknowledged testimony to the standing of the family and a symbol of its solid prosperity."

The endowing of family chapels was a practice that benefitted both the donor and the religious institution—cathedral, monastery, or parish church—where the chapel was located. The family that contracted with the church to decorate a chapel had to purchase the space or, more precisely, pay for obtaining patronage rights to it. In addition to paying the individual church for the privilege of having a private chapel, the donor also saved church officials the expense of providing frescoes for the walls, the altarpiece, and other furnishings for the chapel's altar. The commissioning family, in turn, gained spiritual benefits as well as prestige and public recognition for their efforts and expenses.

Families like the Brancacci might undertake the decoration of a chapel for a variety of reasons, only some of them religious. It's obvious that those who donated a chapel expected God to reward their gift by granting them faster access to salvation, and two religious developments of the Middle Ages helped link the hope of salvation to the patronage of chapels. One was the development of the doctrine of Purgatory, a place of temporary punishment for those who had not paid the full price of their sins, a concept that first appeared in the late twelfth century. The second was the sale of indulgences, by which the Church offered the remission of punishment for sins already forgiven—in recognition of good works, prayers, or money offered by the sinner. The patronage of a chapel was one important way that wealthy Florentines believed they could be granted an indulgence and lessen their time in Purgatory.

Secular motives also played an important part. Depending on the size of the chapel, its position within the church, the amount of decoration it contained, and the prominence of the church that housed it, the commission gave public notice of the patron's wealth and high social status and sometimes signaled his place in the Florentine political hierarchy as well. The sacred subjects chosen by the patron to appear on the chapel walls and in its altarpiece could convey specific messages, most of them religious but some surprisingly secular, as seems to be the case with at least one of the frescoes in the Brancacci Chapel.

It wasn't until the 1420s that a member of the family, Felice di Michele Brancacci, dedicated energies and money to decorating his family's chapel. At that time he was both a successful businessman and a prominent figure on the Florentine political scene. He'd held a number of important offices, including governor of two of Florence's subject cities, Pisa and Livorno; he'd been the city's maritime consul, and between 1422 and 1423 he served as the head of a Florentine embassy to Egypt. He endured some harrowing trials and dangers in the East, which he recounted in his diary, and he was extremely grateful to have come home alive. Perhaps he undertook the decoration of his neglected family chapel as a thank offering to God for his safe return. But Felice Brancacci may have had a further motive beyond his family's devotion to St. Peter for his choice of subject. Peter's authority had been assumed by the popes, and the government of Florence had long been Guelph, or pro-papal, in its policies. A program of paintings devoted to the life of St. Peter, sponsored by a leading citizen, would be a way for him to express political as well as spiritual support for the papacy.

To decorate his chapel, Felice Brancacci hired two painters, both named Tommaso. As a way of distinguishing them, one was called *Masolino* (Little Tommy), and the other acquired the peculiar nickname *Masaccio*, which could be translated as "Ugly Tom," "Bad Tom," or maybe even "Tom the Slob," since Vasari relates that the artist "devoted all his mind and thoughts to art and paid little attention to himself." Whatever the meaning of his nickname, his significance as an artist is undisputed: Masaccio is the founder of Renaissance painting, and his work helped set the course of Western painting until the late nineteenth century.

To his contemporaries, what seemed so exceptional about his art was its realism. A chronicler of the 1400s declared his works in the Brancacci Chapel to be "not the images of things, but the things themselves." Even modern viewers, accustomed to photographs and all the advances in realism painters have made over the centuries, can see how accurately this artist captured the appearance of both human beings and the natural world. But this doesn't exhaust his achievement. Like all great artists, Masaccio was more than merely a fine craftsman, he was also an interpreter of the human psyche.

The wall paintings in the Brancacci Chapel have a complicated history. Although work began in the mid-1420s, Masaccio and Masolino left the project incomplete a few years later, perhaps because funds ran out. Masolino left for Rome, and Masaccio accepted a commission in Pisa, before he, too, went to Rome where, only in his late twenties, he died in 1428. In the early 1430s Felice Brancacci found himself on the losing side of the struggle for power between the Albizzi and the Medici. He was married to a daughter of one of Cosimo de' Medici's chief rivals, Palla Strozzi, and Cosimo had both Strozzi and Brancacci exiled in 1435. Brancacci and Cosimo continued to exchange letters, but each felt betrayed by the other, and their breach was never healed. Persisting in his refusal to support the Medici regime, Brancacci was declared a "rebel" in 1458 and although the date of his death is unknown, he died in exile. The ban on the family was not revoked until 1474, a decade after Cosimo's death. In the early 1480s a collateral branch of the family hired Filippino Lippi to complete the chapel project. Filippino was the illegitimate son of the Carmine's most notorious monk, Fra Filippo Lippi, who, as a young novice and aspiring painter had most likely watched and been inspired by Masaccio.

As originally executed, the paintings on the walls of the Brancacci Chapel formed a biography of St. Peter, beginning not with his physical but with his spiritual birth, when he first became a follower of Jesus. Due to damage

from fire, dampness, and the changing tastes of later generations, many of the Brancacci frescoes have been damaged or destroyed. All those on the ceiling and upper walls are gone, replaced in the 1600s by frescoes in the florid Baroque style. The entire ensemble almost disappeared in 1680 when Marquis Francesco Ferroni offered to buy the chapel and rid it of "those ugly characters dressed in long robes and cloaks." Fortunately, Duchess Vittoria della Rovere, widow of Grand Duke Ferdinando II de' Medici, intervened and prevented the destruction of the frescoes. The determined Marquis Ferroni's alternative plan, to saw the offending frescoes off the walls and display them elsewhere, was also vetoed by the duchess. A restoration, completed in 1988, made visible glowing colors and expressive details long covered by layers of soot and dirt.

The first two episodes, located on the upper walls and now destroyed, showed Christ calling Peter and Andrew from their fishing to become "fishers of men" and the episode of Peter walking on water. Two more lost scenes illustrated Peter's denial of Christ after the Lord's arrest, and Christ appearing to Peter after the Resurrection, telling Peter to "feed my sheep." What remains is one scene of Christ's ministry that involves Peter, a series of scenes devoted to Peter's own ministry during the early days of Christianity, and two paintings of Adam and Eve, whose sin, according to Christian doctrine, made Christ's sacrifice necessary.

The most famous painting in the chapel, in the long upper register on the left side, is Masaccio's *Tribute Money*. Found only in Matthew 17:24–27, this is a seemingly trivial episode in which Jesus performs what could almost be described as a magic trick rather than a miracle. When Christ and his apostles came to Capernaum, an official demanded they must pay a tax, or tribute, before entering the city. Jesus told Peter to go to the nearby lake and catch a fish, and that the fish would have a gold coin in its mouth, which it did. Peter then paid the tax collector, and the little group entered the city.

The story isn't especially dramatic or inspiring and is rarely illustrated, so we might wonder what caused the patron to include it. Possibly the episode held political significance for him, although exactly what that significance might be isn't certain. One possibility is the controversy that erupted in Florence in the mid-1420s concerning the right of the state to tax church properties. During previous decades, the Florentine government had often imposed heavy taxes on church properties to help finance its wars against Milan, Pisa, and Naples. In the middle of the 1420s, members of the Florentine clergy approached Pope Martin V to protest the taxation of their church by the state.

Masaccio, *Tribute Money*, Brancacci Chapel, S. Maria del Carmine. Scala / Art Resource, NY

Any additional levies, they warned, would have dire consequences, resulting in "the total destruction of many churches, hospitals and monasteries and in the great displeasure of God. . . ." And due to previous taxes, the aggrieved clerics lamented, "it has been necessary to sell chalices, books and other church furnishings."

At the same moment the program of frescoes was getting under way, another taxation controversy was also taking shape. Florentines were engaged in a lively debate over whether their government should institute the *catasto*, one of the earliest examples of a graduated income tax, in order to finance a decades-long war with Milan. The *catasto* itself was a kind of census, in which every Florentine citizen had to declare his income, the number of people in his household, and his expenses; his tax rate would then be calculated on the basis of this declaration. The system went into effect in 1427. Like any new form of taxation, it wasn't popular with most Florentines, but there were those who insisted it was necessary. Brancacci's choice of the Tribute Money as one of the subjects in his cycle devoted to the life of St. Peter suggests that, although he was a wealthy and powerful man, he supported one or both sources of revenue, and he may have selected the rarely represented story of the Tribute Money because it shows that even Jesus paid his taxes.

Masaccio transformed the incident into a drama played out by vivid, individual personalities inhabiting a real space. Since Masaccio was the first painter to whom the architect Brunelleschi taught his new technique of one-point perspective, a system for correctly rendering three dimensions on a two-dimensional surface, the figures move in an environment that contains a perfectly rendered building on the right side and a mountainous landscape that extends for miles into the background. The sturdy figures cast shadows in a light that seems to come from the actual windows of the chapel. In this rationally constructed work we're looking at the earliest example of a Renaissance painting.

At the exact center of the composition stands a serene Christ faced by the tax collector who, with an easy-to-recognize gesture, extends his open palm toward Jesus. Witnesses to this confrontation of sacred and secular authority, the apostles gather around their leader in a semicircle. They're rough, intense types who react with emotions ranging from perplexity to anger. The apostle framed between Jesus and the tax collector curls his lip in a snarl. Jesus gestures toward Peter, who frowns and looks incredulous, pointing toward the lake as if to say, "You want me to do WHAT? Are you crazy?" Nonetheless, Peter obeys, and on the left he crouches by the lakeside, taking a coin from a fish's mouth. The narrative then skips over to the far right where a glowering Peter hands the coin to the tax collector.

A curious feature of the painting is the inconsistency of costumes. Jesus and eleven of his apostles wear the "long robes and cloaks" that the Marquis Ferroni so disliked, while the bare-legged tax collector, portrayed twice—first demanding the tribute money and then receiving it—displays a short, belted tunic similar to the ones worn by men in Florence in the fifteenth century, although with tight-fitting hose or trousers, not bare legs. Instead of being swathed in biblical robes like the other figures, the apostle just to the right of the tax collector wears a magnificent rose-colored cloak. This, too, is Renaissance clothing, the kind of wool cloak a rich Florentine gentleman might wear on a chilly day. The man's short, neatly trimmed beard also distinguishes him from the other followers of Jesus, who either have long shaggy beards or are clean-shaven. Although legend has it that this figure is Masaccio's self-portrait, it's more likely a portrait of the patron, Felice Brancacci, planted foursquare, right next to the tax collector. If the figure really is Brancacci, his presence there is a clear indication of where his sympathies lay on the contentious political issues of taxation of the church by the state, and the taxation of citizens through the *catasto*.

A better possibility for the artist's self-portrait appears in the scene of St. Peter Enthroned, part of the scene called the *Raising of the Son of Theophilus*, a work begun by Masaccio but left incomplete by him and finished by Filippino Lippi. On the far right side of the composition, which is Masaccio's work, stands a group of men in dark clothing. Those in the foreground are usually identified as portraits of the art theorist Leonbattista Alberti and the architect Brunelleschi, the latter a personal friend of Masaccio's. From behind them, a youthful, clean-shaven man eyes the spectator with a bold glance—this is most likely Masaccio's self-portrait. His dusty-looking mop of tangled black hair agrees with Vasari's description of a man too involved with his art to be bothered with personal grooming.

Masaccio's other masterpiece in the Brancacci Chapel is his *Expulsion of Adam and Eve from Paradise*, which appears near the entrance to the chapel, just to the left of the *Tribute Money*. The painting is extraordinary both for its conspicuous placement on the entrance arch and for the nudity of the figures. No other Italian chapel is introduced by realistic, life-size nudes. This visual howl of despair is among the most powerful renditions of the theme ever painted, a terrifying image of humanity's separation from God. As they stumble through the gate of the Garden of Eden and out into a desolate world, Adam and Eve convulse in anguish. Eve, frantic with shame, attempts to cover her nakedness with her hands, and lifts her face in a scream, crying so hard that her features seem almost to dissolve. Overcome with remorse, Adam hunches over, his stomach sucked in with sobs, burying his face in his hands and weeping. The recent restoration removed the fig leaves a later and more prudish generation had added, revealing that Masaccio had truly exposed Adam's nakedness, depicting his sexual organs with a clinical accuracy unheard-of in earlier art. The angel who hovers above the couple does not prod them but merely points the way out—Masaccio's method of showing Adam and Eve's understanding of the ultimate tragedy that has overtaken them.

Directly across from Masaccio's devastating *Expulsion* is Masolino's *Temptation of Adam and Eve*. This, too, is a dramatic moment—the origin of all human guilt and misery—but under Masolino's bland brush the first couple stands stiffly against a black background, their bodies almost flat, their faces expressionless. Although painted at virtually the same time as Masaccio's figures, they look as if they could have been created twenty or more years earlier.

Masolino does better with the other scenes he completed. At a right angle to Masaccio's *Tribute Money*, on the altar wall of the chapel, is a smaller scene

Masaccio, *Expulsion of
Adam and Eve from Paradise.*
Brancacci Chapel, S. Maria del
Carmine. The Art Archive at
Art Resource, NY

of *St. Peter Preaching*. The solemn saint raises his hand in a dramatic rhetorical gesture, but despite the presumed effectiveness of his preaching (according to the Acts of the Apostles, one of Peter's sermons converted three thousand people), an elderly man and an attractive young woman have nodded off to sleep. The curious anachronism of several Carmelite monks in attendance at Peter's sermon can be accounted for by the Carmelites' claim to be the oldest of all monastic orders. Directly across the chapel from the *Tribute Money* is Masolino's *St. Peter Healing a Cripple* and the *Raising of Tabitha*. These miracles, which took place in two different cities, are presented as if occurring next door to one another, against a lively background that resembles the piazza in front of S. Maria del Carmine—a proud, detailed portrait of an actual Florentine neighborhood.

Viewers are sometimes puzzled by the indifference of Renaissance artists to what might be called archaeological accuracy. They place biblical figures in settings that are contemporary with the artist and patron rather than with the event portrayed. One answer is that neither artists nor patrons had any clear idea of the topography or architecture of the Holy Land. A more important reason is that placement of biblical events in contemporary settings brings them up to date, giving them greater immediacy and relevancy to the lives of the viewers, a sense that these events are happening *now*, rather than in some distant past.

Masaccio's three further contributions to the chapel program are, like Masolino's *St. Peter Preaching*, smaller scenes that flank the altar. Across from *Peter Preaching* is Masaccio's marvelous evocation of *Peter Baptizing Converts*. Peter stands at the edge of a river, pouring water over the head of a rapt, kneeling man, while other converts mill about waiting their turn. They stare into space, worry about when to remove their clothing, and in the case of a man who has stripped to a loincloth, shiver with cold. But the man being baptized is oblivious to physical discomfort. His magnificent physique and beautiful solemn face, visible behind his dripping wet curls, make him resemble an ancient statue come to life and converted to Christianity. Rarely has the transforming experience of baptism been so vividly conveyed.

On the lower register of the altar wall on the left is the scene of *Peter Healing the Sick with His Shadow*, an event described in Acts 5:12–14 and also painted by Masaccio. The saint moves toward us down an ordinary Florentine street, staring straight ahead as if in a trance, while cripples gaze toward him with faces full of poignant hope, trying to move their bodies into the saint's

miracle-working shadow. On the opposite side of the altar, Peter distributes alms to the poor, ignoring Ananias sprawled at his feet, struck dead by Peter for refusing to give the full proceeds of a sale to the Christian community. The recipients of Peter's charity have a dignity and individuality comparable to the apostles in the Tribute Money. The central figure, a young woman wearing a gray dress and carrying a bare-bottomed baby, accepts Peter's largesse without any obvious show of gratitude, but she fixes her eyes on the saint's face.

Filippino Lippi's two large and two small scenes of Peter's ministry and martyrdom take up the lower registers on the side walls of the chapel. On the left, beneath Masaccio's *Expulsion*, is the scene of St. Paul visiting St. Peter while the latter was imprisoned in Antioch. According to the *Golden Legend*, a medieval compendium of pious legends and saints' lives, Paul had arranged Peter's release on the condition that Peter perform a miracle: bringing back to life the king's son, who had been dead for fourteen years. The next scene, beneath Masaccio's *Tribute Money*, shows Peter performing that miracle while a group of men in Florentine costume—portraits of Filippino's contemporaries—observe the event.

Across the chapel are further scenes, drawn from both the Bible and the *Golden Legend*: Peter and Paul arguing with the Roman emperor Nero and the magician Simon Magus, the *Liberation of St. Peter from Prison*, and the *Crucifixion of Peter*. In his confrontations with Simon Magus, Peter demonstrated the divine power of Christ in contrast to Simon's false wizardry, but he failed to convince Nero, who ordered Peter put in prison and later crucified. Filippino no doubt based his profile portrait of Nero on an ancient Roman coin, but he made that unattractive emperor even more ignominious and ugly, the personification of pagan cruelty and blindness. To the left we see the *Crucifixion of Peter*, with the saint crucified upside down as he had requested, having declared himself unworthy of dying in the same manner as Jesus.

The scene of *St. Peter Liberated from Prison*, located below Masolino's *Temptation of Adam and Eve*, is part of a different narrative, related in Acts 12, where Peter, still in Judaea rather than Rome, was imprisoned by King Herod and miraculously liberated by an angel. Filippino made an effort to have his figure of St. Peter resemble Masaccio's and Masolino's images of the saint, but his luminous and quietly commanding angel possesses the ideal, otherworldly beauty that heralds the approach of a new era in art: the High Renaissance.

Perhaps because Filippino, working in the 1480s, was striving to harmonize his own more expressive and turbulent style with that of the two early

fifteenth-century masters, his contributions to the Brancacci Chapel may seem somewhat awkward and inhibited. The inclusion of so many contemporary portraits in biblical scenes is a bit distracting as well.

In contrast, Masaccio's scenes have a freshness, a degree of accurate observation, and an insight into human behavior that sets them apart not only from Masolino's and Filippino's efforts but from all previous paintings. By the 1500s Masaccio had become a revered figure to later Renaissance artists, and the Brancacci Chapel had become his shrine, a "school" where many celebrated artists of succeeding generations studied his paintings. Among these disciples were Leonardo da Vinci and Raphael, as well as Michelangelo, who claimed to have learned more from Masaccio's paintings than from any living teacher. Despite Michelangelo's celebrated indifference to mere realism—he set his sights on the creation of perfect forms that inhabit ideal spaces—he recognized in Masaccio a kindred spirit, a bold and creative intellect whose work changed the course of Western art.

The PIAZZA DELLA SIGNORIA

POWER POLITICS AND SEXUAL POLITICS IN THE CITY CENTER

For centuries, the Piazza della Signoria was the political heart of Florence. Dominated by the impressive early fourteenth-century Palazzo Vecchio, the city hall, also called Palazzo della Signoria, the seat of the communal government, this great open square also served as the site of public ceremonies that ranged from the reception of visiting dignitaries to tournaments and the executions of heretics and criminals. From time to time the piazza also hosted a *parlamento*, an assembly of Florentine citizens, and it was the designated gathering place for the people in times of civic emergency. Bordering the piazza to the south of the Palazzo Vecchio stands the tall, triple-arched Loggia della Signoria, better-known today as the Loggia dei Lanzi, built between 1376 and 1382 as a backdrop and shelter for government officials during public ceremonies. Its current name derives from the lance-carrying guards stationed there during the reign of Duke Cosimo I de' Medici in the sixteenth century.

Given such a politically charged setting, it isn't surprising to find that much of the sculpture adorning the Piazza della Signoria—in front of the Palazzo Vecchio and within the Loggia dei Lanzi—is also resonant with political significance. The works include both religious and mythological subjects whose meanings underlined the authority of the government at various periods, but on a deeper level they may also refer to another kind of politics, what feminist writer Kate Millett labeled sexual politics: the power relationships between men and women. Becoming aware of the variety of responses during

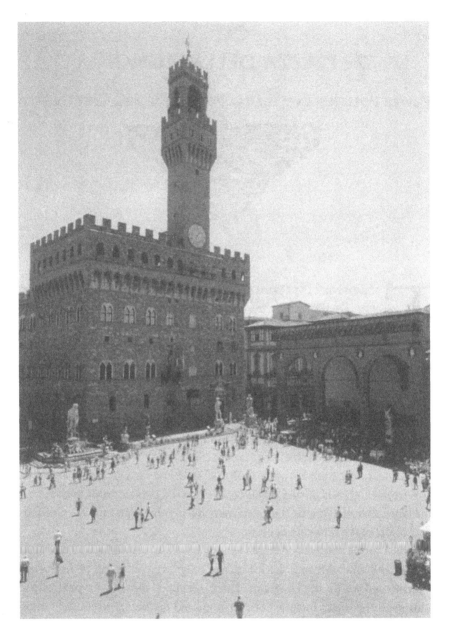

Piazza della Signoria, with Loggia dei Lanzi at right. Nicolo Orsi Battaglini / Art Resource, NY

different eras to the figures that form this ensemble of statuary can help the modern viewer understand how the meaning of such works can change with the changing political and social climate.

DONATELLO'S *JUDITH BEHEADING HOLOFERNES*

Despite being dwarfed by the bulk of the Palazzo Vecchio just behind it, Donatello's statue group stands on a high pedestal and radiates impressive power. Although we don't know with certainty who the patron was, we can assume the work was commissioned by Cosimo de' Medici, since the earliest description of it comes from the 1460s and places it in the garden of the newly completed Medici Palace, a private space behind the courtyard that held another work by Donatello, his bronze *David*.

The Book of Judith, in the Catholic Old Testament but not in the Jewish or Protestant bibles, contains an account of how Judith, a beautiful and virtuous widow, saved her city from an Assyrian army led by Holofernes. Dressed in her finest clothing and gleaming with jewelry, she entered the enemy camp where she promised to betray her city. Left alone with Holofernes in his tent, she pretended to be sexually available, but instead she made sure he became "exceedingly drunk." When he'd fallen asleep, she grasped his sword and "took him by the hair of his head . . . and struck twice upon his neck and cut off his head." Although Donatello followed the biblical story, the work is particularly shocking in the way it links sex and violence, for here a woman murders a more than half-naked man.

A fifteenth-century source states that the work once had a Latin inscription on its pedestal—"Kingdoms fall through luxury; cities rise through virtues; behold the neck of pride severed by the hand of humility"—and that Piero de' Medici had added to the base the words "Piero, son of Cosimo Medici, has dedicated the statue of this woman to that liberty and fortitude bestowed on the Republic [of Florence] by the invincible and constant spirit of its citizens." Both inscriptions have disappeared, along with the pedestal on which they were incised. But when the statue group was confiscated by the city government in 1495, after the expulsion of the Medici family, the inscription about how humble cities (personified by Judith) can triumph over proud tyrants (personified by Holofernes) was apparently preserved, since it could now be interpreted as referring to the defeat of the tyrannical Medici by the heroic republican government. That government then added an inscription, still

Donatello, *Judith Beheading Holofernes*, Piazza della Signoria.

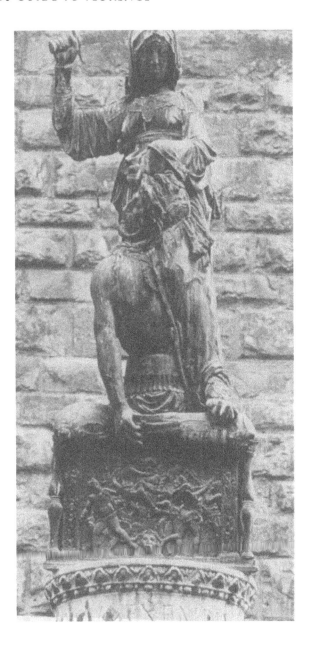

visible on the base of the statue group, which makes clear the work's signifi-
cance as a civic symbol in its new location: "EXEMPLUM SAL[UTIS] PUB[LICAE]
CIVES POS[UERUNT] MCCCXCV" ("The citizens set up [this] exemplar for the
welfare of the public 1495").

The now-vanished inscription naming Piero di Cosimo de' Medici may
have been added in commemoration of a specific political event: Piero's foiling
of a conspiracy against him in 1466. As his father, Cosimo, had done before
him, Piero ruled Florence from behind the scenes, and it would have been a
typically clever Medici gesture for Piero to turn a personal victory over his
political opponents into something quite different: a victory for the Florentine
people. Or perhaps Piero felt more comfortable around the psychologically
disturbing *Judith* if the work were given a political meaning, one that made
his sometimes-ruthless family, the real rulers of Florence, the friends rather
than the enemies of liberty.

Whether Donatello was thinking of politics when he created the statue
is questionable. Perhaps he was thinking of sexual rather than civic politics,
since in this work Donatello boldly portrayed a subject that feminist art
historian Mary Garrard called "the universal male nightmare": a powerful,
murderous woman in control of a helpless man's fate. Earlier representations
of the subject always downplayed or omitted its violence, but here the sculptor
shows the chilling moment when Judith pauses in the midst of her bloody
deed: after the first sword blow and before the second.

Holofernes is naked to the waist, stripped to his underdrawers, and seated
with his bare feet and legs dangling over the edge of his bed. Judith, fully
clothed and with her head swathed like a nun, stands with her left foot resting
on the inside of Holofernes' right wrist, as if taking his pulse with her toes. Her
right foot, placed between his parted thighs, is firmly planted on his genitals.
Reflecting the biblical account, she holds him upright by his hair. As his head
lolls against her left thigh in a ghastly parody of intimacy, we can see that
she has already struck once, cutting deeply into her victim's neck and leaving
a gaping gash. She raises the sword high above her head for a second blow
and stares downward, her lower teeth clamped on her upper lip. In her fierce
dignity, determination, and solemnity she resembles an ancient priestess per-
forming a human sacrifice.

Judith shared the fate of Donatello's bronze *David*; both were confiscated
by the Florentine republic after the expulsion of the Medici in 1494 and were
relocated in the Palazzo della Signoria. But the *Judith* group subsequently led

a wandering life. At first it was placed in front of the Palazzo della Signoria as a symbol of republican liberty and a grim reminder of the fate of tyrants, with tyrants at that time meaning the Medici. Without making any alterations to the appearance of the work itself, but by moving it to a spot just outside the entrance to the city hall and changing its meaning through a new inscription, the Florentine government transformed a private Medici commission into an ideal public exemplar of the virtues of the republic.

Then, on January 25, 1504, the city council held an important meeting: they were to decide on the location of Michelangelo's colossal marble *David*, recently completed for the city. A statement by Francesco di Lorenzo Filarete, a member of the council, helped to seal the *Judith*'s fate. He proposed to replace it with Michelangelo's *David* because "the Judith is a deadly symbol and inappropriate in this place . . . and it is not fitting that the woman should slay the man, and, worst of all, it was placed in its position under an evil star because, since then, things have gone from bad to worse."

Filarete, who evidently considered it acceptable for a man to kill a woman, evoked the traditional warning about the deadly power of women who appear seductive but then murder unsuspecting men; he even suggested that Florence's recent misfortunes (political and military reverses that included the loss of Florentine control over Pisa) should be blamed on the city's decision to display the *Judith* in such an important public place. The solution was therefore to move the ill-starred statue to a less conspicuous location. The group was moved several times, and it eventually disappeared inside the Palazzo della Signoria. After a cleaning, the work is again on display outdoors, in its old location in front of the city hall, and Michelangelo's *David*, now in the Accademia Museum, has been replaced in the Piazza della Signoria by an inferior copy. (For a discussion of Michelangelo's *David*, see Chapter 15.)

The frequent moving of the *Judith* may have something to do with the statue's disturbing and even frightening qualities. Judith doesn't murder a monster but a strangely attractive villain, a man with a well-muscled body and a handsome face. It is all the more shocking, then, that he's at the mercy of a woman who's about to finish severing his head. The artist's turning of the tables on his own sex by showing a woman taking such calculated, bloody vengeance on a man may have made it a bit too easy for Florentine men to picture themselves in the place of Holofernes, which may help explain Francesco Filarete's hostility toward the work and the collective decision to move it to a less conspicuous location.

Donatello's statue group might well have been intended, on the public level, as a straightforward image of patriotic virtue and courage vanquishing tyranny, a symbol of the Florentine republic triumphant over its enemies, a meaning the Medici family of the 1400s would have been eager to endorse and display in the courtyard of their residence. But when Florence ousted the Medici and placed the statue group in front of Palazzo della Signoria, it became a symbol of the fate of tyrants—with the tyranny now identified as that of the same Medici family who had originally commissioned the work of art.

What Donatello's hair-raising treatment of the subject says about his own attitudes toward women we can only speculate, but when we read the papers, watch the television news, or go to the movies we are reminded of how often and how closely sex and violence are linked in our own culture, and we can appreciate anew the power of Donatello's image.

CELLINI'S *PERSEUS AND MEDUSA*

Today, the Loggia dei Lanzi contains a miscellaneous collection of sculptures ranging from several unmemorable ancient Roman works to an equally mediocre one from the mid-nineteenth century. Only two statues now in the Loggia were placed there during the Renaissance: Cellini's *Perseus and Medusa* and Giambologna's *Rape of a Sabine Woman*. Both are brilliant examples of the sculptor's art as well as being perfect examples of the sophisticated, mid- to late sixteenth-century style known as Mannerism, which valued complexity, artificiality, and virtuoso technique over straightforward realism. The two works present a potent mixture of mythical, political, and sexual implications.

Benvenuto Cellini created the masterpiece of his career, the twelve-foot-high bronze statue of *Perseus and Medusa*, at the order of Duke Cosimo I de' Medici, a distant relation of the original Cosimo de' Medici (d. 1464), who had been the de facto ruler of Florence while preserving the appearance of the Florentine republic. By the time Cellini began the work in 1545, however, that republic was dead, and Duke Cosimo was the hereditary ruler of Florence under a new, absolutist political order. Furthermore, in that same year, Cosimo I and his family had moved from their old home, the Palazzo Medici, into newly renovated apartments in the Palazzo della Signoria, a move dictated by political as well as practical reasons. Not only was the old palazzo too small for the duke's growing family and enormous retinue, but the new ducal

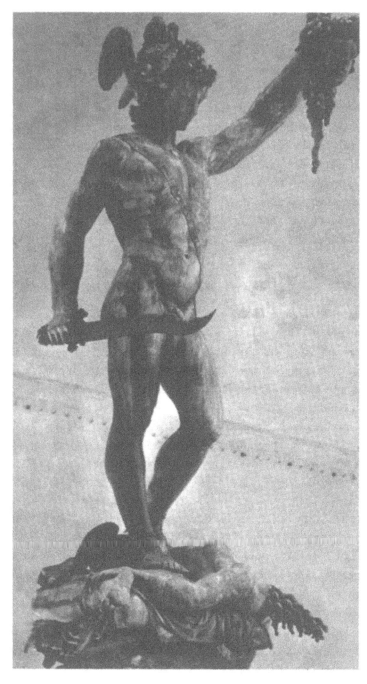

Cellini, *Perseus and Medusa*, Loggia dei Lanzi, Piazza della Signoria.

residence would make the Medici family inseparable from the city's government. Cellini's statue, placed in the Loggia de' Lanzi and practically under the duke's windows, would form part of the public affirmation of Cosimo's rule. Donatello's *Judith*, associated with the virtues of the defunct republic, needed a corrective in the form of a statue embodying the authority of the current, dictatorial Medici regime.

Cellini labored over the *Perseus* for nearly a decade, completing it in 1554. The artist complained of enduring endless difficulties with the work, ranging from disagreements with the duke and his wife to interference by jealous fellow artists, the blunders of incompetent apprentices, and a critical lack of bronze. While the work was being cast, Cellini tells us in his *Autobiography*, he rose from his sickbed to supervise the final, crucial step and had to throw his entire collection of pewter dinnerware into the molten bronze in an effort to assure there was enough material to fill the mold.

In ancient Greek mythology, Medusa is a terrifying female monster whose hair is a mass of writhing snakes. She is so ugly that merely glancing at her turned men to stone. Resident on an isolated island in the middle of the sea, she'd been ruining Greek shipping—since ships manned by crews of stone sailors quickly sank. With the help of the gods, the hero Perseus killed Medusa by cutting off her head. For Duke Cosimo, the myth provided a powerful political symbol. Perseus represented himself, or more broadly the new, authoritarian Florentine state, while the defeated Medusa stood for any and all enemies and what their fate would be if they opposed Cosimo's rule.

Cellini wasn't much interested in political allegories. He wanted to create a statue of such stupendous size and power that it would deflect attention from the most famous statue in Florence, and perhaps in all of Italy, which at that time stood just yards away, having replaced Donatello's *Judith* in front of the Palazzo Vecchio in 1504—Michelangelo's *David*. The long shadow of the greatest artist of the Renaissance had loomed over Cellini throughout his life. Michelangelo, also a Florentine and twenty-five years older, was still alive, and Cellini saw the *Perseus* as his chance to top even that formidable rival. He reveals his conscious sense of competition with Michelangelo not only in the statue's monumental size and nudity but also in the band across Perseus's chest, where Cellini signed his name, just as Michelangelo had placed his own signature on a band across the chest of Mary in his famous *Pietà* in St. Peter's.

What's most striking about the group is how thoroughly Cellini sexualized the myth. Medusa, far from being a repulsive monster on a remote island, is a

voluptuous naked woman curled in a pretzel-like contortion on a rumpled col-lection of sheets and pillows. Cellini turned the island battlefield of the myth into what looks like a recently and roughly used bed. Medusa's face is beautiful, despite the snakes for hair, and her body is sensuous, with large breasts and ample curving hips and thighs. As Perseus stands over her corpse, it's impos-sible to miss the phallic connotations of his sword, jutting out at precisely the level of his groin. In positioning the sword there, the artist was no doubt aware of the Italian word *spada* (sword) as a slang term for the male organ. Unlike other renditions of the subject, Cellini's version of the myth raises the question of what this pair was doing *before* Perseus cut off Medusa's head.

To penetrate this particular web of desire and violence, it's helpful to know something of Cellini's life, because it's unlikely that any other artist of the time could have produced such an extraordinary rethinking of the ancient Greek myth. Many Italian artists of the Renaissance were colorful characters, but their lives pale before the one led by Cellini. Born in 1500, he survived to the age of seventy-one, but only because he had more lives than a cat.

Celebrated today as a brilliant goldsmith and sculptor, he was also a sol-dier, street fighter, prison inmate, frequent assailant, and on more than one occasion a murderer; an enthusiastic lover of young males as well as both a lover and an abuser of women; a relentless self-promoter; and the author of the most famous of all Renaissance autobiographies. Documents of the time reveal that Cellini is also the only famous artist of the Italian Renaissance to be tried and convicted twice (in 1523 and 1557) for what was then considered a crime: homosexual relations, known in that era as sodomy. As a result of the artist's plea to Duke Cosimo I de' Medici, his prison sentence for the second offense was commuted to house arrest, and it was during this confinement that Cellini penned his famous *Autobiography*.

We are well advised to take Cellini's own account of his life with some large grains of salt. At first, the reader might be seduced into believing that Cellini's world really was populated by the worst imaginable collection of slip-pery scoundrels, damn liars, bloody-minded villains, misguided fools, hissy fit–prone women who nonetheless enjoy being forcibly subdued, seductive adolescent boys, and absurdly demanding patrons, all of them intent on keep-ing Cellini from fulfilling his glorious artistic destiny. In the life he fashioned in his *Autobiography*, the artist is never at fault; others (especially women) are always to blame for his misfortunes. Although he admits to no murders of women, several of the violent assaults he describes in his *Autobiography*

are against females, always in a sexual context, with the justification that the woman had infuriated him beyond endurance and deserved punishment. In one case he insists the woman was literally "asking for it." He claims she enjoyed his beatings so much that she kept coming back for more—a dubious claim, to say the least.

We may find a reflection of Cellini's self-described violent behavior toward women in his unprecedented way of representing the myth of Perseus and Medusa. As Donatello did in his *Judith*, Cellini shows the hero standing over a defeated adversary, but the Holofernes of Donatello retains some vestiges of dignity—he's semiclothed, sitting upright, and with his head still mostly attached to his shoulders. In contrast, Cellini's Perseus stands directly on top of Medusa, holding aloft her head with its blood-gushing neck like a trophy, while at his feet more bronze blood spurts from her naked torso, an effect so astonishing, according to a viewer of Cellini's time, that one feels the need to stand aside for fear of being splashed by it. Medusa herself is reduced to a headless but seductive mass of tangled limbs that seem to be writhing, as if the decapitated creature were still alive, the hero's struggling but helpless sexual conquest, bound forever to the bronze base.

Cellini asserts in his *Autobiography* that his decision to render Medusa as he did was his own—Duke Cosimo had merely asked for a statue of Perseus holding Medusa's head, and he'd said nothing about her body. Cellini's degree of personal identification with the episode can be seen in his possessive way of referring to the figure of Medusa as *mia femina* (my woman), a possessiveness underscored by the fact that the model was his sixteen-year-old mistress. In viewing Perseus's victory and Medusa's utter and ignominious defeat, it would be difficult to imagine a more complete reversal of Donatello's image of a woman's triumph over a man, or a work more in keeping with the dominant authoritarian ideology of the time.

After surviving the Sack of Rome in 1527, Cellini had returned to Florence in the mid-1530s, during which time he designed coinage and bronze portrait medallions for Duke Alessandro de' Medici. The sculptor mentions going to the duke's quarters for a portrait sitting only to find his patron in bed with a young male relative named Lorenzino who, Cellini casually notes, later murdered the duke. All in a day's work for Cellini, who sometimes bedded his own handsome apprentices. Cellini's second conviction for sodomy was based on the artist's intimate relationship with an apprentice whom he was accused of using "as his wife."

After another tumultuous stay in Rome, Cellini came back to Florence for good in 1545. By then Duke Alessandro had been assassinated and his successor was Duke Cosimo I de' Medici, who was eager to hire Cellini to create works that would enhance his own prestige and advertise his authority. Among those works was the greatest commission of Cellini's career: the *Perseus and Medusa*. Although Cosimo reportedly approved of it, the statue of a naked, sexually menacing young dandy is perhaps less suited to symbolize the political ambitions of the rather prudish duke than to represent the grandiose exhibitionistic Cellini himself: handsome and self-absorbed, ambitious and aggressive, eager to be admired, at once sensual and violent, a lover and a murderer.

GIAMBOLOGNA'S *THE RAPE OF A SABINE WOMAN*

When the marble sculptural group now known as *The Rape of a Sabine Woman* was placed in the Loggia dei Lanzi in 1583, it still lacked a name. Although there is no record of who commissioned it, the son and successor of Duke Cosimo I, Duke Francesco de' Medici, is the most likely patron. Giambologna's three-figure composition wasn't conceived with any particular subject in mind, and the artist remained indifferent to what his group might be called, considering it a formal exercise. What interested him was the challenge of integrating three over-life-size nude figures into a visually compelling composition that would be interesting from multiple points of view, a conscious emphasis on complexity and artifice typical of the Mannerist style. When pressed, the sculptor declared that the group could represent a number of different mythological stories, but even though there are many myths that involve three or more characters, all the myths he mentioned involve rape.

Giambologna's sculpture shows two males and one female: a crouching older man seems to be making an ineffectual attempt to prevent a standing younger man from making off with a struggling young woman whom he holds aloft, and whose outstretched arms and thrown-back head create a sense of urgent drama. The three figures are intricately locked together in a series of complex poses. The woman pulls away from the man who holds her and appears anxious to free herself from his grasp. Her flailing arms, frowning brow, and mouth open in a cry all suggest she's anything but a willing participant. The fact that everybody involved is naked adds to the sexual titillation offered by the statue group, and most viewers in Giambologna's time probably understood it as a portrayal of the beginning of a rape.

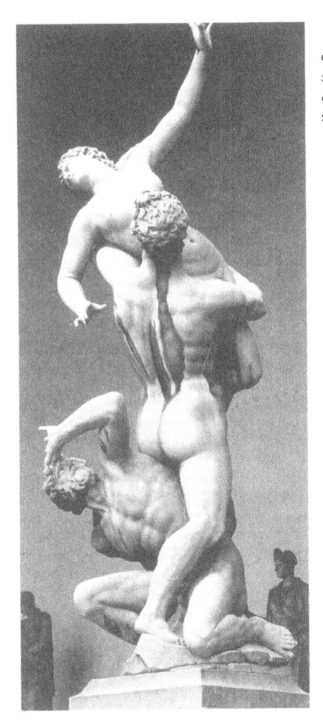

Giambologna, *Rape of a Sabine Woman*, Loggia dei Lanzi, Piazza della Signoria.

After Duke Francesco decreed that the statue group should be placed in the Loggia dei Lanzi next to Cellini's *Perseus* and also insisted that it be given a name, the poet and art critic Raffaello Borghini suggested the work be identified as a scene from the early mythic history of Rome: a story known in English as "The Rape of the Sabine Women." But we should be cautious about interpreting the meaning of the work purely on the basis of its English title. The title Borghini proposed, *La rapina della Sabine*, means the plundering or carrying off of a Sabine woman. The Italian word *rapina* doesn't mean "rape"; the term has a different and more complex significance. It derives from the Latin word *raptio*, defined as the carrying off by force of someone's property (which for both ancient Romans and Renaissance Italians included women), and it referred to theft, without having the modern meaning of sexual violation. But when women are being "carried off" by men, the violent sexual aspect of the deed is implied, even when that isn't explicitly shown—a theme featuring triumphant males that fits in well with Cellini's *Perseus*.

The legend of the Romans and the Sabines was a popular subject, familiar from its frequent representation on wedding banners and marriage chests. The account of how the earliest Romans, in need of women to continue their line, carried off the women of the Sabine tribe to be their wives and the mothers of their children was among the most revered stories from ancient Rome. It served as an object lesson that emphasized several themes dear to the heart of upper-class Renaissance men—the importance of carrying on one's family lineage and the necessity for female submission in marriage. In sixteenth-century Florence the story could serve yet another purpose: it confirmed the political authority of those in power. Borghini, in his essay suggesting a title for the group, noted that the Roman abduction of the Sabine women marked the origin of marriage and reminded his readers that ancient Roman weddings included loud cries of "Talassio," the name of the Roman male who'd carried off the most beautiful of the Sabine women for himself. It doesn't seem coincidental that, in his text, Borghini gave that same name to the young man in Giambologna's sculptural group.

We know that numerous poems celebrated the placement in the Loggia dei Lanzi of Giambologna's statue group, and that Florentines greeted its appearance with great enthusiasm. Even after the group had been officially named, writers of the time engaged in a variety of speculations on the event the work supposedly depicted, in order to interpret it in different ways, some sexual and some political. As noted above, the Italian word *rapina*, which Borghini used in the title he

gave the work, means robbery or plundering rather than sexual violation. The related Italian verb *rapire* (which, in some contexts, can mean the sex crime of rape) also has a figurative meaning closer to the English word "rapture" and can refer figuratively to being "carried away" in an ecstatic or enchanted state.

Two volumes of poetry published in 1583 and 1584 in Florence offer the viewer several alternative possibilities concerning the meaning of the group. One poem about the sculpture suggests that the artist was aroused by the erotic content of his own statue: "This, my Giambologna, is your Sabine, for whom you burned with desire." Another suggested the work shows a version of the Pygmalion legend: Giambologna falling in love with his own creation. In that reading, the male lifting the woman isn't the beginning of either a rape or a kidnapping but an image of the enraptured artist himself, lifting up a marble woman toward the heavens and asking that she be brought to life. Still another poem links female sexual subjugation not to marriage but to political success, comparing Duke Francesco de' Medici to the virile young Roman male and Florence to the captured Sabine woman, praising the duke, "who with such valor, with such wisdom, possesses her."

The latter poem reminds us of what art historian Margaret Carroll has pointed out, that this kind of mythic rape scene, in which a woman is forced to submit to a "heroic" male, was a favorite theme of absolute rulers, who saw in such scenes a parallel to their own domination of their subjects. It was easy for aristocratic rulers such as Duke Francesco de' Medici to identify themselves with ancient Greek and Roman heroes, superhuman beings who possessed unlimited power and ignored the laws that bound lesser mortals. By installing Giambologna's sculpture in Florence's largest and most political public space, the Piazza della Signoria, Duke Francesco proclaimed, as his father had done, the power of the Medici dynasty—no longer a hidden, velvet-gloved hand behind Florentine politics but a fully visible iron fist.

ORSANMICHELE

A MULTIPURPOSE ARCHITECTURAL MASTERPIECE

HISTORY OF THE BUILDING

Nowhere in Florence do city politics and religious fervor intertwine as closely as in the multipurpose building known as Orsanmichele. Part shrine, part grain storehouse, and part showplace for the wealth and political power of the city's guilds, it covers a square block. This imposing and unique three-story structure towers over neighboring buildings and stands roughly halfway between the two focal points of Florentine religious and civic life: the cathedral and the city hall.

Its curious name derives from the original building on the site: a small Benedictine monastery founded around 750 and dedicated to the Archangel Michael. Because it was near a stretch of land used for market gardens, the monastery acquired the name San Michele ad Hortum, or St. Michael in a Garden. As Latin developed into Italian, the name became San Michele in Orto, and this finally contracted into Orsanmichele.

The monastery was destroyed in 1239 during an outburst of factional fighting. Because it had occupied a site at the heart of medieval Florence, near the city's two principal grain markets, the government saw an opportunity to appropriate the property and put it to communal use. In 1240 it became the site of the city's municipal grain market. By concentrating the sale of grain and flour at Orsanmichele, communal officials transformed the piazza into a place where citizens could always turn for sustenance in times of need.

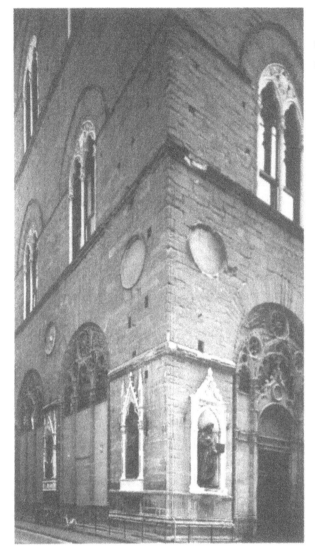

Orsanmichele, corner view
of exterior.

The open space of the square remained in use until 1284, when the city government commissioned a loggia to cover the area, in order to protect both the merchants and their products from bad weather. It was a large structure, almost the size of the area occupied by the present building, with a wooden roof raised on sturdy brick supports. In memory of the vanished monastery, an image of St. Michael was painted on one of the brick piers, and another

carried an image of the Madonna. Special devotion to the image of the Virgin developed, and in 1291 a lay religious group called the Confraternity of the Madonna of Orsanmichele was founded to sing *laude* (hymns) in front of the painting. Soon afterward miracles began to be attributed to the image, and the area around it became crowded with gifts and votives. But the Virgin failed to intercede in Florence's endless internal warfare. In 1304 the grain loggia and its miracle-working image, along with a good portion of the city center, fell victim to a fire started during one of those conflicts.

The city finally decided to rebuild in 1336, during a period of peace and relative prosperity. The government attached great importance to the rebuilding of Orsanmichele, stating in its legislative decree that it was "located in the very heart of the city, in the place where the image of the glorious Virgin Mary is worshiped, and serving many uses and needs of the commune of Florence." The new structure, where the Virgin could be more suitably honored and grain better stored, "would contribute greatly to the city's honor, beauty, and appearance," all considerations of great importance to the image-conscious Florentines.

The government put the politically prominent Silk Guild in charge of supervising the construction of the new building, following the plans of a team of three architects: Francesco Talenti, Neri di Fioravanti, and Benci di Cione. The new building was a much more ambitious structure than the previous one, designed to fulfill several purposes. The ground floor would become a worthy home for the miracle-working image of the Virgin. The two upper floors would be used to store grain for times of military emergency or famine. When the first stone was laid in 1337, people threw gold medals and coins into the foundations to ensure good luck.

As construction was going on, an important political development increased the already deep devotion to the Madonna of Orsanmichele and added devotion to another saint: Mary's mother, St. Anne. On July 26, 1343, Florence freed itself from the rule of the French nobleman Walter of Brienne, known as the duke of Athens. In 1342 the city's ruling class of wealthy merchants had invited Walter to run the city in hopes that he might be able to break the grip of the severe fiscal crisis that threatened to destroy the Florentine economy. The crisis, mostly of Florence's own making, began when the English crown defaulted on huge loans the city's bankers had allowed it to run up with Florentine banks, and the city had incurred further debt through its efforts to conquer the nearby city of Lucca. Although Walter of Brienne had been chosen to rule for a limited time, the lower classes approved of the harsh taxes he

imposed on the wealthy, and unexpectedly proclaimed him *signore* (lord) of the city for life. Outraged by this usurpation of their traditional power as well as their new ruler's heavy taxes, those who had invited Walter to Florence now turned on him, and his rule was cut short after ten months by a conspiracy that forced him to resign his office and flee the city.

The Florentines—or at least those who wanted Walter of Brienne gone—attributed their regained liberty to the favor of the Virgin Mary and to further intercession by her mother, St. Anne, whose feast day is July 26, the day of Walter's fall from power. The city government therefore decreed that the ground floor of Orsanmichele would contain two altars: one to the Virgin and one to St. Anne, making the site into the sanctuary of two saints now associated with the city's most precious ideal: political liberty. Seven years later, in 1349, while the epidemic of bubonic plague was still raging in the city, the Florentine government commissioned Andrea Orcagna to construct an enormous, richly decorated tabernacle to hold the newest image of the miracle-working Virgin of Orsanmichele, painted in 1347 by Bernardo Daddi. They hoped that such a splendid shrine would regain the Madonna's favor for Florence and cause the plague to abate. It eventually did, although not before carrying off almost two-thirds of the city's population, including the painter Bernardo Daddi.

In 1357 the government ordered the grain market, which until then had continued on the ground floor of Orsanmichele, to be moved to a different site. Officials concluded it was unseemly for the bargaining and other financial transactions associated with grain sales to be competing for space with altars and religious functions. Furthermore, such activities spoiled the beauty of what was rapidly becoming a major site of religious devotion. The upper two floors, however, continued to be used for grain storage well into the sixteenth century, and they remained accessible by a staircase in the northwest corner of the interior. Two pillars along the north wall contain chutes, which are still visible, through which grain could be sent down for delivery to the market or for distribution in times of famine or military blockade of the city.

During the years 1366–1367 and 1378–1380, the open arcades on the ground level were filled in with tracery. Then, around 1380, Simone Talenti—a son of Francesco, one of the designers of the building—was hired to enclose the ground-floor loggia, bricking in the lower parts of the arches but leaving the splendid Gothic tracery at the tops, with stained-glass windows set behind the tracery. The lower level of Orsanmichele was thus turned into a dimly but colorfully lit space reserved for religious functions.

Back in 1339, when work on Orsanmichele had been underway for only two years, the Silk Guild had sponsored an important piece of legislation, one that extended the functions of the new loggia being built under their supervision and also made a significant contribution to the artistic history of Florence. The guild suggested that the external pier surfaces be decorated with niches that would each contain an image of the patron saints of the city's official political party, the Parte Guelfa, and of each of the city's major guilds. The guilds would be responsible for hiring artists to design and decorate their tabernacles and for supplying them with an image of their saint.

The program to surround the new loggia with the patron saints of the Parte Guelfa and the guilds transformed Orsanmichele into a unique site. Here, the politically powerful guilds, whose membership included some of the city's most influential individuals, could display works of art that added to their prestige and advertised both their piety and their sense of civic pride. What art historian Frederick Hartt called the "march of the statues" began in 1339 and continued into the first two years of the 1600s, but with most of the statues completed in the first half of the 1400s. As the guilds competed with each other to hire the best artists and employ the most expensive materials, their efforts resulted in some of the finest examples of Italian sculpture. These works provide a vivid picture of the progression from the Gothic style of the late Middle Ages to the brilliant accomplishments of the Renaissance.

THE "MARCH OF THE STATUES"

Standing halfway between the cathedral and the city hall, Orsanmichele is located near the heart of Florence, so any adornment of its exterior would be bound to attract attention. In response to the government's urging, the guilds and the Parte Guelfa constructed a total of fourteen niches—four each on the long north and south sides, and three each on the narrower east and west sides. Although it's unlikely they realized it at the time, by their actions they initiated a revolution in sculpture. In the statues that adorn Orsanmichele, we can watch the Renaissance come into being and grow to maturity.

At first, though, the decree didn't have much effect. For the remainder of the 1300s, only three groups fulfilled their obligations—the Silk Guild, the Wool Guild, and the Guild of Doctors and Pharmacists. Florentine individualism quickly asserted itself, as each guild had a niche constructed following its own design, so no two are alike. The Silk Guild jumped in first, completing

a niche in 1340, although their statue of St. John the Evangelist wasn't put in place until around 1377,* the delay no doubt because of the devastations of the plague epidemic of 1348. The Wool Guild followed shortly after; their niche was completed around 1341 and a marble statue of St. Stephen by Andrea Pisano was placed in the niche at the same time. The Guild of Doctors and Pharmacists completed their niche and statue around 1399 with a Madonna and Child group, a bland Late Gothic production by Niccolò Lamberti, housed in an elaborate niche.

As the new century opened, Florence faced an external threat to its survival even worse than the plague or the financial crashes and internal conflicts of the 1300s: the aggressive duchy of Milan seemed poised to engulf Florence, replacing its cherished republic with an aristocratic dictatorship. Under Duke Giangaleazzo Visconti, the Milanese had taken over most of northern Italy, with the exception of the republic of Venice, and had even conquered territories to the south of Florence. Milan controlled the roads to Rome, and its control of Lucca and Pisa cut off Florentine access to the sea, which strangled the city's maritime trade.

We might think that Florence, faced with the most serious military threat in its history, would have pushed any plans for the ornamentation of public buildings down to the bottom of its agenda. Instead, the opposite happened. As the 1400s began and the city prepared for war, the government sponsored a competition (discussed in Chapter 2) for a new set of bronze doors for the cathedral baptistery, to be financed by the Calimala, the Cloth Importers Guild, and also ordered the remaining guilds, long laggard in commissioning their niches and statues for Orsanmichele, to fulfill their obligations under the threat of losing their spaces on this prestigious building. Galvanized into action by the government decree as well as by the crisis facing the city, the guilds made plans and hired artists, and the remarkable march of the statues began.

The threat posed by the duke of Milan dissolved, almost miraculously, in 1402, when the duke died during an outbreak of the plague in the Milanese military camp, and his shaky "empire" disintegrated along with him. But only a few years later, beginning in 1408, the Florentines faced an equally serious threat from the south posed by King Ladislaus of Naples, who was bent on adding Florence to his domain. The city refused any compromise, and by 1414

* Most of the dates given for the statues are approximate, as there is disagreement among scholars concerning the precise dates at which they were begun and/or put in place.

Ladislaus seemed poised to attain his objective. Once again, though, fate intervened. A series of earth tremors terrified the superstitious Neapolitan king, who then fell victim to a fever and died. Florence had escaped and embarked on a few years of prosperity before the whole deadly cycle started all over again. The Milanese came back in 1420, led by the late Giangaleazzo's equally ambitious and even more brutal son, Duke Filippo Maria Visconti. This time, no dramatic interventions of fate occurred, and the expensive, destructive, inconclusive war dragged on for decades.

It is necessary to recount all this so we don't forget that a state of almost continuous warfare or the threat of war forms the background against which most of the statues of Orsanmichele came into existence. After an interruption of almost two generations, the guilds, following a bit of prodding by the government, came to a collective realization that those statues weren't merely expressions of their individual corporate pride—they were a common religious and patriotic responsibility.

In 1404 the Guild of Judges and Notaries commissioned a marble figure of St. Luke for their niche from Niccolò Lamberti. Not to be outdone, the Cloth Importers Guild, despite the huge expense they'd already shouldered for Ghiberti's baptistery doors, commissioned that same prominent artist in 1405 to produce a bronze statue of St. John the Baptist for their niche on Orsanmichele. Although the work is eight feet tall and was the largest bronze statue in the city at that time, Ghiberti's figure still displays a swaying, Late Gothic grace, the body obscured by the flowing curves of drapery. But true Renaissance masterpieces would soon follow.

In 1408–1409, just as the threat from the king of Naples was growing acute, the Guild of Stone- and Woodworkers, to which sculptors belonged, hired Nanni di Banco to create a portrait of their patron saints: a group of four Christian sculptors martyred under the emperor Diocletian for refusing to carve a statue of a pagan god. Known as the "Santi Quattro Coronati," or Four Crowned Saints (their crowns are the spiritual ones of martyrdom), the figures resemble ancient Roman statues of senators and represent a sharp break from the still Gothic style of Ghiberti's John the Baptist. Their clothing falls around their bodies in realistic folds, and their individualized faces are based on Roman portrait heads. In their stoic dignity and quietly conspiratorial glances, it seems clear that the artist and his patrons intended observers to see a parallel between the martyrs' defiance of imperial authority and the contemporary Florentines who stood united in their defiance of a king. The work was so ad-

mired that in 1410 the Shoemakers Guild hired the same sculptor to portray their patron, St. Philip; and around 1417 the Guild of Horseshoe Makers had him sculpt their contribution to Orsanmichele, a statue of St. Eligius.

Among the finest statues created for Orsanmichele are those of Donatello, considered, along with Lorenzo Ghiberti, one of the greatest sculptors of the early Renaissance. Although less concerned than Ghiberti with the perfection of surface details, Donatello was unparalleled in his ability to give his figures a sense of inner life. His St. Mark, commissioned in 1411 by the Linen Workers Guild, truly brings us into the Renaissance. In both face and figure the statue resembles a classical philosopher. The noble, bearded saint stands at ease, his weight shifted onto his right leg, while his left leg, bent at the knee, protrudes through the folds of his toga. This may not seem remarkable, but it marks the first time such a natural stance had appeared in a work of Western sculpture in more than a thousand years. Donatello seems to have been well aware that he was reviving an aspect of ancient Roman art, for he carved his figure standing on a pedestal in the form of a pillow. Since the base of the statue is near eye level, we can easily see the weight-bearing foot compressing the pillow, while the other foot barely grazes the pillow's surface. Although covered by a heavy garment, the body of St. Mark seems to vibrate with energy beneath its carved clothing. The severe face, full of determination, stares down at the Florentines, offering them an ideal of spiritual strength under stress.

The statue of St. George, commissioned by the Guild of Armor and Sword Makers around 1420, confronted Donatello with the problem of how to portray in marble a figure encased in his patron's product: a suit of metal armor. An actual metal helmet once covered the statue's bare head, and his right hand held a large metal sword that protruded menacingly into the street, but both have long ago corroded away. As a result, the boyish saint looks even more vulnerable than he would have originally. Donatello, never one for clichés, avoided the common image of a burly warrior, instead showing St. George as a slender youth. But the real surprise is the saint's face. Instead of a fearless hero we see a sensitive, reflective young man with a slightly weak chin, whose brow puckers with nervous tension. Courage, Donatello tells us through his St. George, doesn't consist in being too foolhardy to be afraid but, rather, in overcoming fear by gathering one's inner resources to meet whatever dangers must be faced. In many ways St. George is a perfect emblem of the beleaguered Florentines.

Around 1412, the Guild of Butchers ordered a statue of St. Peter, probably from an artist named Bernardo Ciuffagni, and about 1420 the Guild of

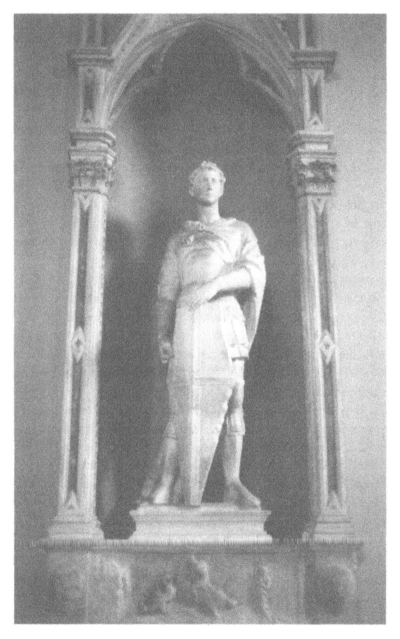

Donatello, *St. George*, Museo Nazionale del Bargello (from Orsanmichele).

Furriers hired Niccolò Lamberti to fill their niche with a statue of St. James. Perhaps these less wealthy guilds couldn't afford the services of the city's major artists. Although their statues are not masterpieces, neither are they an embarrassment in comparison with the works of Donatello and Ghiberti. There's a uniformly high level of craftsmanship throughout the series of statues.

In 1419, another major economic force in the city, the Guild of Money Changers and Bankers, brought back to Orsanmichele that master of bronze casting Lorenzo Ghiberti. He was to create a bronze statue of their patron, St. Matthew, whom Christ had called as a disciple from his career as a money changer. The superb figure shows how the artist had moved from the Late Gothic style of his earlier statue of John the Baptist (1405) to the new Renaissance style of Nanni di Banco and Donatello. The saint stands in the same kind of weight-shift pose first seen in Donatello's St. Mark, and his body seems to move beneath his garments. His stern face and the open gospel book he displays, with its pages turned outward toward the viewer, both suggest the kind of spiritual authority and inspiration offered by Donatello's St. Mark.

As the military crisis of the 1420s continued, so did the march of the statues. The wealthy and politically powerful Parte Guelfa made its contribution in 1422, hiring Donatello to produce a stunning gilded bronze statue of St. Louis of Toulouse, by far the most expensive addition to Orsanmichele. The Wool Guild, no doubt envying the Parte Guelfa's gleaming statue, became dissatisfied with its earlier contribution of a marble St. Stephen from around 1340 and replaced it with another statue of the same saint, this one cast in bronze by Ghiberti in 1429 and costing ten times what the marble one had cost nearly a century earlier.

By 1430, then, all the niches of Orsanmichele had been filled. Since that time, there have been only three changes to the statue population. In the 1460s the Parte Guelfa sold its niche to Mercanzia, the merchants' tribunal of the city, which replaced Donatello's *St. Louis of Toulouse* with an even more striking work, Verrocchio's *Christ and Doubting Thomas* (discussed below). In 1515 the Silk Guild replaced its nondescript marble *John the Evangelist* with a more impressive bronze figure of the saint in the High Renaissance style by Baccio da Montelupo, and in 1601 the Guild of Judges and Notaries removed their marble St. Luke of 1404 and replaced it with a bronze St. Luke by one of the era's leading sculptors, Giambologna.

Today, only a few of the statues adorning Orsanmichele are original—to protect them from weather and vandalism, most of them have been replaced

by copies. With a few exceptions, the originals are in the small museum located on the upper floors of Orsanmichele. Donatello's *St. George* is now housed in the Museo del Bargello, his *St. Louis of Toulouse* is at the church of S. Croce, and the Silk Guild's *St. John the Evangelist* is in the Ospedale degli Innocenti.

When looking at the on-site copies, and even more so at the originals, we can sense the power these works exercised. From their positions near eye level on a public building of great significance to the Florentines, located on a quadrant of heavily traveled streets, they offered inspiration during some of Florence's darkest and (to adopt Winston Churchill's phrase) finest hours. Created at considerable expense, throughout periods when the republic of Florence was sometimes fighting for its very survival, the procession of statues that brings us from the medieval to the modern world went marching on.

VERROCCHIO'S *CHRIST AND DOUBTING THOMAS*

On June 21, 1483, the day Verrocchio's *Christ and Doubting Thomas* was unveiled in its niche on Orsanmichele, the Florentine pharmacist Luca Landucci wrote in his diary that it was "the most beautiful thing imaginable and the finest head of the Savior that has yet been made." Whether or not we agree with Landucci, the statue group has some exceptional qualities. This is the only work added to Orsanmichele in the second half of the fifteenth century, and—with the exception of Nanni di Banco's *Four Crowned Saints*—the only addition that consists of more than one figure and that contains a narrative. Verrocchio's group is worth a close look, as it's not only a masterpiece of bronze casting but also an intriguing example of how political considerations can determine the subject matter of a work of religious art.

Today, Verrocchio often seems overshadowed from two directions: by his great predecessors Donatello and Ghiberti and by his most famous pupil, Leonardo da Vinci. Nonetheless, he was among the most successful, versatile, and innovative artists of his generation. Renowned as both a painter and a sculptor, by the mid-1460s he had become a favorite artist of the Medici. For Florence's most influential family, Verrocchio created the tomb of Cosimo de' Medici (1464–1467) in the church of S. Lorenzo, and around 1470 that of Cosimo's sons, Giovanni and Piero, in the sacristy of the same church, as well as a bronze statue of David (in the Bargello) and the delightful *Putto with a Dolphin* of ca. 1480–1485, now in the courtyard of the Palazzo Vecchio. Although not as directly connected with the Medici as those other commissions

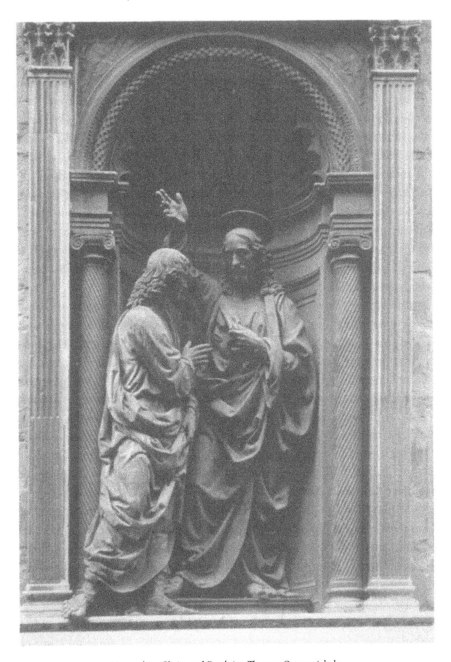

Verrocchio, *Christ and Doubting Thomas*, Orsanmichele.

to Verrocchio, the *Christ and Doubting Thomas* also could be said to have been produced at the behest of the Medici, although indirectly.

The beautiful Renaissance-style niche on Orsanmichele where the Christ and Doubting Thomas group was to be displayed had belonged originally to the Parte Guelfa, Florence's major political party, and it had contained Donatello's showy gilded statue of St. Louis of Toulouse. But sometime between 1451 and 1459 the Parte Guelfa, in decline as a result of the increasing power of the Medici, sold the rights to its niche to the Mercanzia, the tribunal that adjudicated disputes among the city's merchants. The sale was finalized in 1463. The Mercanzia immediately formed a committee of five supervisors to oversee the project, but they made no progress until 1466, and not until 1467 did they authorize a first payment to Verrocchio. After a long delay in the 1470s caused by a dispute about payments, Verrocchio finally completed the work in 1483. The original statue group is now in the museum of Orsanmichele, and it has been replaced on the exterior with a copy.

Although for many works of Renaissance art it remains impossible to know how and why the subject matter was chosen and who did the choosing, in the case of this work we have a considerable amount of information. Thanks to the well-preserved records of the Mercanzia, we know the identity of all the committee members at the time the decisions were made. The original group of 1463 had one member from each of the five major guilds: the Calimala (Cloth Importers), the Cambio (Bankers), the Lana (Wool Merchants), the Seta (Silk Merchants), and the Medici e Speziali (Doctors and Pharmacists). The men were Cosimo de' Medici's son Piero, Leonardo Bartolini, Dietisalvi Neroni, Pandolfo Pandolfini, and Matteo Palmieri. In 1466 some changes occurred. Girolamo Morelli replaced Pandolfini, who had died; Neroni was exiled from Florence for taking part in an anti-Medici conspiracy; and the seventeen-year-old Lorenzo de' Medici replaced his father, Piero, who was both too busy and too infirm to continue serving. The next time we hear about the committee is in June 1483, when Bongiano Gianfigliazzi replaced Morelli and Antonio Pucci replaced the deceased Palmieri.

Why should we pay any attention to the names of these men? With the exception of the two Medici, the others are pretty much forgotten today, but what they all have in common is their membership in the inner circle of Medici political power. (This was also true of Neroni, until his involvement in the anti-Medici conspiracy of 1466.) The ties between Piero and Lorenzo de' Medici and the other members were strong and of long standing. Pucci, for

example, appears standing just to the right of Lorenzo de' Medici in Ghirland-aio's fresco of the *Confirmation of the Franciscan Rule* in the Sassetti Chapel in S. Trinita, painted in the 1480s. (See Chapter 11.) The Pucci had been Medici allies for several generations. Girolamo Morelli had lent money to Piero de' Medici during a plot against him in 1466, and in the 1470s he became one of Lorenzo de' Medici's most trusted advisors. Palmieri and Gianfigliazzi were also loyal Medici supporters throughout their lives. We can now see that the men who planned and subsequently directed work on the *Christ and Doubting Thomas* were Piero and Lorenzo de' Medici and their closest allies and advisors. The Medici didn't need to be the direct or sole commissioners of a work of art for them to have a decisive say in its creation.

Now that we know who the committee members were, and we're aware of their closeness to the Medici, we might ask why they chose the unusual subject of Christ and Doubting Thomas as the subject for the sculpture to fill the niche now belonging to the Mercanzia. Their choice represented a break from the tradition at Orsanmichele of filling the niches with images of the guilds' patron saints. One reason was the close association in fifteenth-century Tuscany of the subject of Doubting Thomas with justice. Christ and Thomas were thought to personify two essential aspects of a just judge: clemency on the part of Christ and the desire for clear evidence and truth on the part of Thomas. Since the Mercanzia served as a judicial body, the subject would have been especially attractive to them as it concerned both proof and the presentation of irrefutable evidence. Furthermore, as an image of justice, the Doubting of Thomas could also serve as a symbol of a just government. At one time there was a painting of the subject over the door leading to the Signoria's council chamber in the Palazzo Vecchio.

But another equally—if not more—compelling reason exists for the choice of subject matter: St. Thomas was a favorite of the Medici family. Although more closely associated with St. Lawrence and SS. Cosmas and Damian, the Medici were also the chief patrons of the church of S. Tommaso Apostolo, which once stood in the city's main marketplace. A family member, probably Cosimo, had commissioned a fresco of Doubting Thomas for the façade of the church. In 1435 when Cosimo, in one of his rare forays into direct participa-tions in the government, was serving as *gonfaloniere di giustizia*, he'd had the feast of St. Thomas declared a communal holiday.

There may have been still another aspect to Medici interest in the subject of Christ and Doubting Thomas. Throughout the 1470s and 1480s some of

the most prominent philosophers in Florence were clients—and thus support-
ers—of the Medici, among them Cristoforo Landino and Marsilio Ficino. The
two men waged an ardent if highly intellectual campaign to prove through
their writings that Lorenzo de' Medici was a wise philosopher ruler who
governed the Florentine state justly and for the common good. Given such
efforts, it wouldn't be surprising if Lorenzo and his allies saw in the statue
group of Christ and Thomas a symbol not only of justice in general but also of
the justice of Medici rule.

Whatever the political interests and biases that led to the choice of a sub-
ject, and whatever its propaganda advantage to the Medici, the enduring value
of Verrocchio's statue group lies in its artistic qualities, in the way the artist
expressed the drama of the event and its spiritual dimensions. The story of
Doubting Thomas appears in the Gospel of John 20:24–29. Thomas had been
absent when Christ appeared to the apostles for the first time, and when the
others told him they had seen the Lord, Thomas insisted: "Unless I see in his
hands the print of the nails, and place my hand in his side, I will not believe."
The story continues eight days later, when Jesus again appeared to them. He
told Thomas to observe and touch his hands and the wound in his side, which
the apostle did. Convinced at last, Thomas exclaimed: "My Lord and my God!"
Jesus then answered: "Because you have seen me, Thomas, you have believed.
Blessed are those who have not seen and have yet believed."

In taking on the challenge of turning this narrative into sculpture, Ver-
rocchio encountered a number of problems. The most basic one was the lack
of space for two figures in a niche intended to hold only one. The sculptor
solved the problem by casting his figures without backs, which decreased their
volume. Verrocchio furthermore ignored the tradition that a figure or figures
should be fully inside the niche. Instead, he placed the figure of Christ slightly
off center at the back of the space and positioned Thomas outside on the ledge,
so he appears to be stepping into the niche. The classically designed niche,
flanked by columns and topped with a pediment, suggests actual architec-
ture—as if Thomas were entering the room where the miracle took place.

Verrocchio illustrates the dramatic moment, charged with deep spiritual
significance, when Thomas reaches out to touch the wound in Christ's side,
and Jesus opens his robe with his left hand to allow this, raising his right arm
in a graceful gesture that seems almost like a blessing. The artist underlines
the exact moment by having the words "My Lord and my God" appear in
Latin in gilded script on the hem of Thomas's robe, and Christ's response,

"Because you have seen me, Thomas, you have believed. Blessed are those who have not seen but who have yet believed," also in Latin and gilded script, appears on the hem of Christ's garment.

The open pose and the placement of the figure of Christ slightly higher than that of Thomas give Jesus preeminence along with a sense of serenity and spiritual majesty that is absent from the tense, almost scurrying figure of Thomas. Neither face is overly dramatic in expression, but the face of Christ has an authority and dignity worthy of the moment portrayed. The viewer who looks up at that face can easily forget about the political aspects of the work and understand why Landucci declared it the most beautiful portrait of Christ ever made.

The OSPEDALE DEGLI INNOCENTI

Europe's First Foundling Hospital

No problem of the Renaissance era moves the heart more than the abandonment of newborn children. Innocent, helpless, forsaken, and most often female, left by the roadside, in a ditch, or on a doorstep, the prey of animals and ill-intentioned individuals eager to sell them to brothels, their plight inspired a desire to see these *gettatelli* (little throwaways) cared for properly. Although throughout the medieval centuries and on into the Renaissance, many European cities built multipurpose charitable institutions to care for the poor at all stages of their lives, Florence was the first to commission an institution exclusively for the care of orphaned and abandoned children.

Begun in 1419 and located in Piazza Santissima Annunziata, the Ospedale degli Innocenti (Hospital of the Innocents) is also the first independent work of the architect Filippo Brunelleschi, soon to become the designer of the dome of Florence cathedral. The commission came from the powerful Guild of Silk Merchants, whose members were as eager to impress their fellow Florentines with their wealth, political clout, and charitable piety as they were to help ease the lot of Florence's poor.

Although the institution that developed from the Silk Guild's ambitions is a large complex of interconnected buildings, the only portion visible from the piazza is the front, and there the Silk Guild had Brunelleschi concentrate his efforts. The result is a handsome and truly monumental façade—a grand loggia whose arches are twenty-six feet high and over sixteen feet wide. When

Brunelleschi, *Ospedale degli Innocenti*, facade, Piazza Santissima Annunziata.

first built it must have provided an impressive contrast to the buildings around it, as its arches are the height of an average two-story building of that time.

The large scale creates a degree of spaciousness and dignity greater than required for the building's purposes. This makes it clear that the Silk Guild members regarded the Innocenti as a symbol, a structure that expressed the political power and high social position of those who commissioned and administered it, as well as their intention to sponsor a building whose beauty would be an adornment to their city. In constructing and supporting such an institution, the guild members accomplished several related purposes: by addressing a serious social problem, they created opportunities for engaging in the Christian virtue of Charity, and this, they believed, would lead to divine protection of their city.

The stimulus for building the Innocenti came in 1410, from a provision in the will of Francesco Datini, a wealthy merchant who had already endowed a hospital in his hometown of Prato and who also had business interests in Florence. His will set aside one thousand florins to be used for the construction of a hospital in Florence specifically to care for abandoned children. As early as the 1200s, the government of Florence had given the Silk Guild responsibility for endowing charity hospitals, and furthermore, that group had undertaken no important building projects since their sponsorship of the construction of Orsanmichele in the first half of the 1300s. So, when they became aware, nine

years after the date of Datini's will, that no use had yet been made of Datini's money, guild members took action.

In early 1419 the Silk Guild began buying up the properties needed for a new hospital. They chose a site in a less built-up part of the city, at right angles to the revered church of the Santissima Annunziata, home to an image of the Virgin Mary that was reputed to perform miracles. Guild members may have liked the idea that the maternal role of Mary could then extend to the babies left at the hospital, but equally important was the proximity of the new hospital to the Annunziata itself, a church that was one of the city's main pilgrimage sites and the scene of civic ceremonies as well as religious festivals and spectacles. The guild wanted its charitable work to be seen by as many people as possible, to show that they were saving children just as the nearby church saved souls.

The guild's property buying was an obvious display of serious intentions, and as a result, Datini's will was altered on July 26, 1419, to make the Silk Guild's project the beneficiary of the Datini bequest. Only ten days later, the guild awarded a contract to begin laying the hospital's foundations. Although there's no mention of who was to design it, the documents make clear that Brunelleschi was in charge of decisions on the building site, so the design of the project must have been his as well.

It may seem odd that construction of the Innocenti at first concentrated on the façade rather than on the hospital building itself. The reason for this appears to be the eagerness of the leaders of the Silk Guild to see—and have the rest of the city see—conspicuous evidence of their impressive building activity, and nothing about a building is more visible than its façade. Brunelleschi's sole contribution was to design the visible portion of the hospital: its façade, the loggia behind it, and the story directly above. He provided no ground plan for the rest of the hospital complex. Already involved at Florence cathedral in experiments with methods of creating a large dome without the use of wooden centering, Brunelleschi stayed with traditional methods at the Innocenti, building frameworks of centering to create the small domed spaces behind each of the nine original arches of the hospital's façade.

Histories of Italian Renaissance architecture always mention the façade of the Innocenti as the first important work of early Renaissance architecture. And yet, an open loggia like that of the Innocenti was the standard form of a medieval hospital façade, since the loggia provided shelter for people waiting to enter. The ancient Romans also built colonnaded loggias, and similar forms appear on the fronts of several of Florence's Romanesque monuments, among

them the church of S. Miniato al Monte, from the eleventh century. We should keep in mind, though, that Brunelleschi and others of his time thought that medieval buildings such as S. Miniato were actual ancient Roman structures. The modern distinction between the medieval Romanesque style and ancient Roman art did not exist in the 1400s.

What is it, then, that makes the Innocenti a Renaissance building? Unlike medieval buildings, constructed according to rule-of-thumb proportions rather than on any precise theoretical basis, Brunelleschi's plan uses a modular system in which all measurements of the structure are based on precise and simple proportions: one to one, two to one, and so on. The idea that harmonious proportions reflect the celestial "music of the spheres" goes back to classical Greece, and it also appears in Roman writings, although no one is sure where Brunelleschi came upon the idea.

The dimensions of the Innocenti façade are based on a module of space: the distance between each of the columns equals the distance between the columns and the back wall, which is also equal to the height of the columns—in other words, a cube of space. The capitals of the columns that form the arcade are in the ancient Greek and Roman style known as Corinthian, and classical-style pilasters anchor each end of the long loggia. A glance at the busy surfaces of the medieval baptistery highlights the contrast with the simple, elegant surfaces of the Innocenti façade.

Brunelleschi's connection with the Innocenti project ended in January 1427, when he received the final portion of his salary and the guild's thanks for his "effort and time." Despite Brunelleschi's reputation for being temperamental, there's no evidence of any falling-out between the architect and the Silk Guild. Probably the increasing pace of his work on the cathedral dome made it necessary for him to terminate his efforts at the Innocenti. Around that same time the Silk Guild became aware that the original plan wasn't big enough. The project up to 1426 was indeed minimal: there was no separate dining room, no kitchen, no infirmary, no laundry facilities, not even a separate room where the wet nurses could gather now and then to get away from the hordes of howling babies to be housed in the long dormitory directly above the loggia.

With Brunelleschi's departure a new chapter in the building's history began. Francesco della Luna, a wealthy silk merchant and prominent Silk Guild member with architectural ambitions, was the force behind a major expansion of the hospital. Under his direction, the guild bought several more properties and demolished the houses on them in order to build a new courtyard and wing.

Further additions included an expansion of the façade by adding one bay on the north end, thus ruining the symmetry of Brunelleschi's design, a problem corrected in the nineteenth century by the addition of a blind arcade on the southern end; the construction of a women's courtyard to the south of the hospital wing; another wing on the southern side of that courtyard containing toilets; a room for the nighttime reception of children; a common room for the nursing women; a long refectory hall, a service space between the refectory and the kitchen, and the main kitchen itself. Still more additions consisted of a rectangular block at the rear of the central courtyard that contained a service kitchen for the infirmary, another courtyard with toilets, a laundry room under the infirmary, a covered passageway leading out to the chicken coops, and a passage from the central courtyard to the garden in the back.

The façade, which is about eight feet above the ground, finally received a staircase in 1457, built by Bernardo Rossellino. Before that time, access to the loggia had been from staircases at either end of the portico. Brunelleschi probably intended a staircase, since such a high loggia would have been dangerous for an institution full of crawling infants and small children running around. The blue-and-white terra-cotta plaques of swaddled babies were added to the façade in 1487 by Antonio della Robbia. Although empty roundels were part of Brunelleschi's original design, the babies weren't. They've nonetheless become the building's most easily recognizable feature, and today one of them forms the insignia of the American Academy of Pediatrics.

Building the enlarged Innocenti proved enormously expensive, and Datini's bequest covered less than one-tenth of the final costs. How did the guild raise the necessary funds? Giovanni di Bicci de' Medici, founder of his family's fortune and banker to the papacy, contributed to the financing. Like the members of the Silk Guild, he was eager to spend money on works of public architecture both for his own prestige and for the benefit of the city. Individual Florentines sometimes left money to the Innocenti in their wills. A consistent source of income was a tax imposed on members when they assumed Silk Guild offices, with the amount varying, depending on the importance of the office. Further income derived from the hospital's garden, which stretched for almost a thousand feet from the rear of the buildings. There, sharecroppers grew grain, wine grapes, and a variety of fruits. Some produce went to the hospital and the sharecroppers, with choice bits going to Silk Guild members, but most of it was sold, providing some of the funds to cover building costs. After the hospital was complete, the garden helped defray its operating costs and feed its residents.

Although some work still remained to be completed, the Innocenti finally opened in 1445. On February 5 of that year the first foundling, a baby girl, was furtively abandoned in a ceramic basin-manger between statues of Mary and Joseph, set up in the loggia for that purpose, a tender idea that turned the foundling into a living Infant Jesus, but which also left the child outdoors. This manger was soon replaced by a wheel on the left sidewall, half of which protruded from the wall. A person wishing to leave a child while avoiding contact with the Innocenti officials could do so there, giving the wheel a push that would propel the baby inside. This option for leaving a child at the Innocenti continued until 1875.

The Silk Guild members who commissioned and continued work on the Innocenti assumed that children left in the care of the hospital would have a better chance at life than they would have had otherwise—this was the whole point of a foundling hospital. They also assumed that most of the infants would be children of the desperately poor. But within a few years of the Innocenti's opening, both assumptions proved wrong. A large proportion of the babies left at the Innocenti turned out to be children born to slave and servant women of middle- and upper-class Florentine families, children most often fathered by the males of the household, although this was only rarely acknowledged. And as word of the hospital's existence spread, the wards quickly became overcrowded, which resulted in unsanitary conditions where children died even more frequently than in society at large. According to Richard Trexler, an American historian who studied the Innocenti's extensive records, in 1445 an infant of under one year had a 26 percent chance of dying at the hospital. By 1451 that chance had risen to 58 percent.

There were many reasons besides illegitimacy for giving up a child to the Innocenti: the devastations of war, famines, epidemics of plague and other sicknesses that killed one or both parents, and extremes of poverty. Sometimes the Innocenti officials wrote down the anguished words of individuals bringing in a child—their explanations, regrets, and guilt, their pleas to keep a certain amulet or token with the infant in order that they might recognize and reclaim the child at a later time, a hope that almost never materialized. When we admire the handsome façade of the Ospedale degli Innocenti, it remains worth remembering that the building owes its existence to a world of endemic warfare, chronic food shortages, epidemics, coerced sex arising from slavery and servitude, and the desperation born of extreme poverty—the darker side of the brilliant world we're more apt to recognize as the Renaissance.

Children abandoned at the Innocenti didn't stay there long, since it would have been impossible for the hospital to continue indefinitely admitting unlimited

numbers of children and raising them there. When a baby arrived, it was quickly cleaned and clothed (most arrived naked and wrapped in rags), and then fed by one of the staff wet nurses. Within a few days, or a few weeks at the most, the new arrival was sent out to a wet nurse in the countryside, often the wife of one of the men employed at the hospital. Infants usually stayed with the same nurse, hired and paid by the Innocenti, until they were weaned, between the ages of eighteen months and two years. The children were then returned to the hospital to await assignment to foster parents, with whom they remained until around age five or six. At about six years old, the children were put up for adoption, the boys usually as apprentices and the girls as domestic servants. Those who weren't adopted could live at the Innocenti until age eighteen.

The Innocenti soldiered on for more than four centuries, doing the best it could with its limited resources and an ever-increasing number of children. Boys who remained at the hospital learned various artisan skills, and girls were taught to sew and cook. The hospital even provided girls with modest dowries, offering them the option of either marriage or becoming nuns. Children leaving the hospital were given the last name Innocenti, and today, as a testimony to the hospital's enduring presence in civic life, more than a thousand individual Florentines still bear that name.

As Italian historian Eugenio Battisti observed, every aspect of the Innocenti suggests a political program designed to bring credit to its sponsors: both the majestic façade with its refined, classical details and the ambitious scale of the overall plan with its sophisticated system of internal communications and its wide variety of services. But whatever its shortcomings, and whatever the personal vanities and political ambitions of the sponsors, the hospital performed a valuable charitable function, offering help to the smallest and most vulnerable among the city's inhabitants.

The part of the Innocenti complex directly behind the façade, which used to be the dormitory for infants, is now a museum, but many other sections are still used by organizations concerned with child welfare, including UNICEF, thus extending the hospital's mission over the course of seven centuries. Although the "baby wheel" is long gone, and modern Italy has one of the world's lowest rates of illegitimacy because of Italians' consistent use of contraceptives, above the walled-up niche where the wheel used to be is a moving inscription in Latin, adapted from Psalm 27: "Our father and mother have forsaken us; the Lord has taken us in."

Chapter 8

The MONASTERY *of* SAN MARCO

Piety and Politics in a Cloistered World

Few places in Florence seem more distant from the concerns, pressures, and values of the secular world than the Dominican monastery of San Marco. Although its exterior is undistinguished and it faces a busy piazza that swarms with cars, buses, pedestrians, and students from the nearby art academy on bicycles, the interior is one of the city's most serenely beautiful spaces. Constructed on harmonious lines and filled with luminous, deeply spiritual frescoes painted by Fra Angelico and his assistants, San Marco still offers a tranquil retreat from the stresses of urban life. But for all the seeming otherworldliness of its monastic ideals, continued by the present-day Dominicans who still occupy a portion of the complex, both the circumstances surrounding the construction of San Marco and many of the paintings that fill its interior have connections with Florence's political life. This monument to Dominican piety is also a monument to the power of the Medici family.

Inside, San Marco looks much as it did in the 1400s. The public entrance leads to the main cloister, a spacious open square, with white stucco walls behind an arcade whose arches spring from columns of the gray-brown local stone known as *pietra serena* (serene stone). The cloister grounds are carpeted in grass and contain stately cypress trees—a perfect place for visitors to sit for a while in the shade. The interior hasn't changed a great deal, either. The whitewashed walls punctuated here and there with Angelico's exquisite frescoes, the chapter room, the grand staircase, the high-ceilinged corridors

leading to three separate dormitories (one for novices, one for professed clerics, one for lay brothers), with each cell containing a devotional image painted or planned by Fra Angelico, are all still there, with the recently restored wall paintings looking as fresh as the day they were completed.

But cloistered serenity can be deceiving. San Marco had a complicated and turbulent beginning that involved a good deal of what we'd call "politicking." The site originally held a monastery occupied by an order of Silvestrine monks, and if we can believe the Dominicans who wanted the land and buildings, the Silvestrines had allowed their property to fall into a scandalous state of disrepair, while the monks there were living dissolute, unchaste lives. As early as 1418 the Dominicans petitioned Pope Martin V to expel the Silvestrines and turn the property over to them, but their pleas brought no results.

Meanwhile, in the same neighborhood, the Medici family was accumulating money, prestige, and political power, their road to riches launched in the early 1400s by the transfer of lucrative papal accounts to the Medici bank. By the early 1430s Cosimo de' Medici had become such a powerful figure in Florence that his position aroused the envy of his rivals, who had him exiled in 1433. When he returned triumphant a year later, and the Medici again established their political ascendancy over Florentine life, the Dominicans found their perfect patron in Cosimo. The wealthiest and most powerful man in Florence was ready to embark on a generous program of religious philanthropy.

Despite his worldly nature, Cosimo also had a spiritual side, and he was attracted by the austere life of the Observant Dominicans, who followed a more rigorous observance of St. Dominic's Rule than the rest of the order. Having learned that a group of Observants from a Dominican house in nearby Fiesole wanted to take over the Silvestrine convent in Florence, he put his considerable influence behind their efforts. When the new pope Eugenius IV was in Florence in 1435, at the request of Cosimo de' Medici and his brother Lorenzo the pope reopened the debate concerning the Silvestrines and ordered an investigation into that order's behavior at San Marco. To the dismay of the Dominicans and the Medici brothers, the papal commission concluded that the accusations against the Silvestrines were unfounded.

This put the pope in a difficult position. He didn't want to disappoint the Medici, who constituted the most important political power in Florence, or the Observant Dominicans, who were strong supporters of his papacy, so he compromised by granting the Observants a small church on the far side of the Arno, a decision that didn't satisfy anybody. The Medici brothers then

persuaded the Signoria, the governing body of Florence over which they exercised a significant degree of control, to petition Eugenius IV to give the little church on the other side of the Arno to the Silvestrines and the convent of San Marco to the Dominican Observants.

The Medici had maneuvered the pope into a position where he had little choice but to do their bidding. If he left the Silvestrines at San Marco, he'd displease both the powerful Medici and the Florentine populace who supported them, and he'd be seen as allowing the convent to fall to ruin. On the other hand, if he granted San Marco to the Dominicans, he not only would satisfy a religious order that supported papal authority, he'd also gain the approval of the Florentines and please the Medici, whose support he needed, and who had declared themselves ready to finance the rebuilding of the convent. The Medici were, furthermore, the generous hosts of the pope who at that time was living in Florence, and in Rome they were bankers to the papal curia and thus to the pope himself. At this point it no longer mattered whether the luckless Silvestrines were as bad as the Dominicans claimed they were: this was an instance where financial and political considerations trumped religious ones. As of January 1436, the Silvestrines were out of San Marco and the Observant Dominicans were in.

Work began that same year on the rebuilding of San Marco, under the direction of Michelozzo, a favorite Medici architect, with funds coming directly from Cosimo and Lorenzo de' Medici. According to the official *Cronaca*, the chronicle of the monastery, construction proceeded with such speed that by 1443 the convent was ready to be occupied. We don't know precisely when Fra Angelico and his assistants began painting the more than fifty frescoes that cover many of the wall surfaces inside San Marco, but a date of around 1440 seems likely.

Fra Angelico remains one of the most beloved of Italian Renaissance painters, an artist known for his gentle, ethereal depictions of angels, saints, and the Holy Family. Perhaps because of his later nickname (he wasn't called Angelico in his lifetime), the tendency persists to see him as literally angelic, rather than as a talented and devout monk, and also a practical man. He was already well into adulthood and a successful, widely known painter before he discovered his religious vocation and entered the Dominican order around 1420. He is first recorded as a friar at the Dominican convent in Fiesole in 1423, where he became known as Fra Giovanni. The initial mention of him residing at San Marco, the convent so closely associated with his name, occurs

in 1441, a move probably dictated by his responsibilities as the artist in charge of producing the paintings for the convent's interior.

Although modern scholars love to posit the existence of a "theological advisor" to artists involved in creating large programs of religious subjects (a learned individual who dictates to the artist what he should portray), there's no need for any such figure with regard to Fra Angelico. He was a fully professed member of the Dominican order, familiar with theology as well as with the order's Rule, so the prior of the convent must have given him a relatively free hand. The artist may have consulted with the prior, and perhaps also with his fellow monks, in choosing the subjects to be portrayed, but there's no comprehensive program to the frescoes at San Marco, beyond their fidelity to Observant Dominican traditions, and an important subtheme of homage to the convent's benefactors, the Medici.

Angelico's frescoes—beautiful as they may be—were not intended as decoration but more as aids to meditation and prayer. In the case of the frescoes in the individual monks' cells, that prayer and meditation would be private, but in all but one of the instances where the frescoes adorn the public spaces of the convent—the hallways, the chapter room where the convent conducted its daily business, and the church—those communal prayers took place before images that brought to mind the Medici.

The answer to the question of how Fra Angelico referred to the convent's secular patrons in religious paintings without disturbing the spiritual balance of those works becomes clear when the viewer identifies the saints portrayed in the paintings. On the back wall of the chapter room Angelico painted a large Crucifixion with several unique features that pertain both to the Observant allegiance of the San Marco community and to their debt to their Medici patrons. As we'd expect, St. Dominic has a prominent place, kneeling in prayer at the right of the Cross. Beyond him on the right is a group of monastic figures, most of them not Dominicans instead, they're the founders of especially rigorous forms of monastic life of the kind led by the Observant Dominicans. On the left Angelico placed St. Cosmas and St. Damian and, to their right, St. Lawrence and St. Mark, none of them often portrayed in Crucifixion scenes. But there's logic to their presence here. St. Mark is the convent's patron saint, and the others are Medici patron saints: Cosmas and Damian were the particular protectors of Cosimo, and St. Lawrence of Cosimo's brother Lorenzo. Since the chapter room was central to the life of the convent, the site where the entire community met every morning, the monks had daily reminders of Medici patronage before their eyes.

Similar reminders occur in a fresco in the east corridor, the location of the friars' dormitories. An image of the Madonna and Child with eight saints, the work is surprisingly sumptuous. The figures stand before a wall adorned with classical-style pilasters, and the Virgin and Child are seated on a throne-like bench covered with a richly brocaded cloth. The painting also includes saints flanking the Virgin's throne. There are several expected figures: the convent's patron, St. Mark, and the order's founder, St. Dominic, as well as the Dominicans' greatest theologian, St. Thomas Aquinas. But here, as in the fresco in the chapter room, the other saints all have Medici connections. Cosmas, Damian, and Lawrence appear again, this time joined by St. Peter Martyr, probably to honor Cosimo's son Piero, and St. John the Evangelist, the patron saint of Cosimo and Lorenzo's father, Giovanni, and of Cosimo's son of the same name. Through this work, three generations of Medici men would be remembered in the friars' prayers every morning when they grouped around the painting.

We might wonder what Fra Angelico, himself an Observant Dominican, thought of this luxurious image occupying such a highly visible place in the convent. A subtle clue appears in the text readable in a book held open by St. Dominic, who stands on the far left. The inscription begins with a customary command of that saint: "Have charity, preserve humility, possess voluntary poverty." But the text continues with some unexpected words: "I invoke God's curse and mine on the introduction of possessions into this Order." It is difficult to imagine that either the prior, who had accepted Medici money on behalf of the convent, or Cosimo and Lorenzo de' Medici, who provided the money, would have wanted such a statement included in the fresco. Perhaps smuggling it into this painting, whose luxurious setting suggests the "possessions" that St. Dominic warned against, was Angelico's own idea, a small, nearly unnoticeable protest against the Medici largesse that had rescued the convent from ruin, but perhaps at the price of compromising Observant ideals.

The frescoes in the monks' cells are quite different from these public expressions of gratitude to the convent's patrons. All the subjects are drawn from the life of Christ or Mary, the two great objects of Dominican devotion, and all are painted in an austere style, with no references to the Medici. Among the most characteristic is the *Annunciation*, in Cell 3. The composition is severe and simple—Mary occupies a room as plain as the Dominican cell in which the fresco is painted. A small, paper-thin figure in a pale pink garment, Mary seems to huddle against the wall rather than kneel on the bench in front of her, the very emblem of humility and supreme obedience to the will of God,

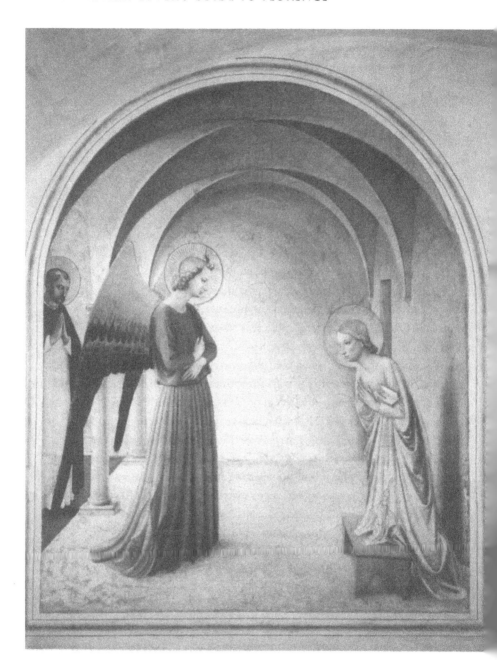

Fra Angelico, *Annunciation*, Cell 3, Monastery of San Marco. Scala / Art Resource, NY

virtues every Dominican strove to emulate. The Angel Gabriel stands looking down at her, an unusual arrangement, as Mary is almost always shown at a higher level than the angel. Between them is empty space that's not, on closer inspection, empty at all, but full of a radiant light that powerfully suggests the miracle taking place there.

Just outside the loggia where Mary receives the angel stands a Dominican monk in an attitude of prayer—another exemplar for the monk whose cell contained the painting. Many of the paintings in the monks' cells show a similar figure accompanying the biblical scene. These witnesses to the religious narratives may be reflections of the Observant Dominicans' close attention to a widely circulated thirteenth-century Dominican treatise on prayer, *De modo orandi*, which offered instruction on the proper way for Dominican monks to commune with the divine.

The monks' cells were more than a place to sleep—they were also used for prayer, meditation, study, and preparations for preaching, the latter among the most important duties of Dominican friars. The Dominicans appear to have invented the use of private cells for individual monks, rather than having a single, large dormitory for all the monks, a space used only for sleeping. The prior and members of the San Marco community must have believed that paintings in the monks' cells would play an important role in their devotional lives. Although we have no information about how the subjects were distributed, it would be reasonable to think that those original, fortunate friars who were Angelico's fellow Observant Dominicans each chose a favorite theme for his cell, and Angelico provided it. The decision to decorate each cell in a monastic dormitory with a fresco had never before been considered by any other Dominican convent, or by any other religious order, a fact that makes Angelico's frescoes even more extraordinary.

Although no references to the Medici intrude on the friars in their personal cells, Cosimo de' Medici was nonetheless a presence at the convent. He had his own quarters, reserved for his use whenever he wanted to spend time praying and meditating or merely retreating there to escape the pressures of his life. This was a most unusual privilege, granted only to royalty in places other than Italy, and only one Florentine before Cosimo had enjoyed a private space in a religious institution. Well aware of this, Cosimo made sure his quarters were modest—two interconnected cells (numbers 38 and 39) on the north corridor where the lay brothers lived, so his presence would not interrupt or interfere with the lives of the Dominican clerics.

Although there's nothing luxurious about Cosimo's quarters, the paintings in them make clear references to the Medici. The first of Cosimo's cells (number 38) has a Crucifixion painted on its wall, quite similar to others in the convent, but with unique features that associate it with the Medici family. In addition to the customary figures of the Virgin and St. John the Evangelist, St. Cosmas and St. Peter Martyr kneel at the foot of the Cross—the patron saints of Cosimo and his son Piero. John the Evangelist does double duty, both as a traditional figure and as the patron saint of Cosimo's younger son and his father, both named Giovanni.

The second cell (number 39) is somewhat larger and, with a vaulted ceiling, may have been Cosimo's private oratory, a miniature chapel. Against the back of a small, arched niche in the center of the north wall is a painting of Christ as the Man of Sorrows. This niche may have held the Sacrament, which by papal decree Cosimo was allowed to have in his chapel. On the wall above, and rising to the vaulting, is a large, detailed painting of the Adoration of the Magi. This subject was especially popular with the Medici, since the precious gifts given by the Magi to the Infant Jesus legitimized the serving and glorifying of God through liberal giving in the cause of faith. The artist—most probably Angelico's chief assistant, Benozzo Gozzoli—later painted a brilliant and much more elaborate version of the subject on the walls of the chapel in the Medici Palace, which Cosimo began building shortly after the dedication of San Marco in 1443.

Although the Magi themselves are not saints, the Florentines celebrated the Feast of the Epiphany (January 6) with elaborate pageantry, and the Medici regarded the Three Kings as their special patrons. The men of the family took an active part in the Confraternity of the Magi, and the city's annual Magi Procession on January 6, which began at the cathedral and ended at San Marco, was an occasion when Medici power was much in evidence. The inclusion of Orientals and Africans in the entourage of the Magi in the San Marco fresco may be a reference to the Church Council that took place in 1439 in Florence (thanks to Cosimo's success in having it moved there from Ferrara), and which attempted to reconcile the Eastern and Western branches of Christianity. The presence of the *Adoration* in Cosimo's cell can therefore be seen as an expression of the seamless blending of politics and religion the Medici were so accomplished at sponsoring.

There's one more painting by Fra Angelico at San Marco where the Medici are much in evidence: the panel that once adorned the high altar of the convent church. No longer in the church, the painting is now displayed in the Museo

di San Marco, located in what used to be the convent's guest quarters, just to the right of the entrance. Along with many other paintings by Fra Angelico, brought there from churches and convents in and around Florence, we find what once must have been a spectacular work of art now severely damaged by a disastrous nineteenth-century cleaning with caustic soda. Despite its sad state, the altarpiece is worth examining both for its unusual formal qualities and for its connections with the Medici.

The San Marco altarpiece displays a traditional subject, the Virgin and Child enthroned with saints and angels, but that's its only traditional aspect. The more conservative friars at San Marco may have been startled, perhaps even disapproving, of an altarpiece with no gold ground behind the sacred figures to suggest heaven, no disparity of scale to make the Virgin and Child larger than the other figures, and most surprising of all, an entire sacred scene set in a realistic environment with a convincing sense of three-dimensional space. At bottom center there appears to be a small panel of the Crucifixion overlapping the painting, but this is an ingenious illusion—a painting within a painting—that's meant to be understood as vertical, in contrast to the flat floor that extends behind it.

The composition is designed so that the viewer seems to look down on the richly patterned carpet that leads up to the steps of the Virgin's throne. On this carpet the artist has arranged with great care a group of eight saints. Closest to the Virgin and Child are St. Mark (on our left), the patron saint of the church and convent, and on our right, St. Dominic. Once again, the rest of the saints refer to the Medici. St. John the Evangelist, patron of Cosimo's father and son, stands next to St. Mark. Next to St. Dominic is Francis of Assisi, a surprising inclusion in a Dominican altarpiece, but understandable because he and the third monastic saint on the right, Peter Martyr, were the co-patrons of Cosimo's elder son, Piero. St. Lawrence, patron of Cosimo's brother Lorenzo, who had died in 1440, is farthest from the Virgin on the left. Cosimo's own patron saints, Cosmas and Damian (seeming larger than the others because of their placement), kneel in the foreground. Cosmas, on the left, turns and looks out toward the viewer, indicating the Virgin and Child with his right hand, while Damian remains in adoration. Like a pair of pillars, the two Medici saints literally support the scene, just as the Medici brothers supported the Dominican convent and its church.

The face of St. Cosmas is so strongly individual that some scholars have claimed it's a portrait of Cosimo de' Medici. This is unlikely, since the features

bear no resemblance to portraits of Cosimo, but the sad, haggard visage is un-like any other painted by Fra Angelico. A further unusual feature is the saint's contemporary Florentine clothing, which is distinct from the tunics and toga-like garments worn by the other saints on the left side of the painting. His flat red hat is equally unique. What remains indisputable is that the name saint of Cosimo de' Medici quickly attracts the viewer's attention, and that the saint then directs our attention to the Virgin and Child. By this means, the artist links the patron's benevolence with the hoped-for benevolence of the Mother of God, which would include both the Medici and the monas-tery. This emphasis on Cosimo's patron saint—and, by extension, the donor family—must have been a deliberate decision by Fra Angelico, the artist's and the community's response to the new political realities of Florence under the indirect but unmistakable rule of Cosimo de' Medici.

The support offered by Cosimo to San Marco was unprecedented in both its scope and its duration. For one family and, after the death of Cosimo's brother Lorenzo, one man to sponsor a project as extensive as the rebuilding and decorating of San Marco, was extraordinary enough, but Cosimo also pledged continuing support to the community. Every week until his death in 1464 he ordered generous amounts of food for the convent; he allocated money for things as disparate as wood, salt, footwear, and medicines; from time to time he provided money for the purchase of feathers, linen, and cotton for pillows and beds, and fabric for the making of habits; for festivals he gave money for candle wax; and he was always willing to pay for any books needed by the monks for their studies.

Cosimo's motives for such largesse have been much discussed by historians. Vespasiano da Bisticci, Cosimo's contemporary and earliest biographer, sug-gested that the Medici patriarch financed the rebuilding of San Marco and many other projects to atone for his guilt about usury—lending money at interest —as this was considered a sin by the Church. But there must have been other reasons for Cosimo's patronage, among them both sincere piety and sound political judgment. To sponsor the construction of fine, beautifully decorated buildings intended to honor God was a civic virtue as well as a religious one, an act of generosity and benevolence that brought credit both to himself and to his city. San Marco, so little changed since the 1400s, is a site where this subtle interrelationship of politics, religion, and art remains on full display.

Chapter 9

The MEDICI PALACE *and Its* CHAPEL

THE ARCHITECTURE OF SUBTLE AUTHORITY

In the Florence of the 1400s, a palazzo was much more than a place to live. Building a large, impressive family home was one way in which prominent families could both improve the appearance of their cities and put their personal stamp on those cities. The Medici were the first to do this, but numerous other families followed their example, and today Florence has many fine palazzos from the mid-1400s and 1500s, built in imitation of, and in competition with, the Medici Palace.

Construction of the Medici Palace began around 1445, and it was completed in the late 1450s, following a plan of Michelozzo, a longtime associate and assistant of the prominent architect Brunelleschi. For almost twenty years, the Medici family had been buying up properties in the neighborhood, a total of twenty-two houses, and they had all of them torn down to construct their new forty-room residence, which would be the largest in Florence. In 1445 a Medici associate described the clearing of the site in awestruck terms: "You wouldn't believe the size of it . . . and the destruction of the neighborhood. . . . [E]verything has been torn down, which is a magnificent thing to see."

But we might wonder why the Medici failed to hire Brunelleschi to design their residence. He was the city's leading architect, and the Medici had already employed him in designing their parish church of S. Lorenzo. It seems odd that such a choice commission could wind up instead in the hands of one of Brunelleschi's assistants. Two sixteenth-century sources pass on a story, which probably has some truth, about how Cosimo de' Medici initially had hired Brunelleschi, but the plan he submitted was too much like a royal palace, so

Michelozzo, Medici Palace,
exterior.

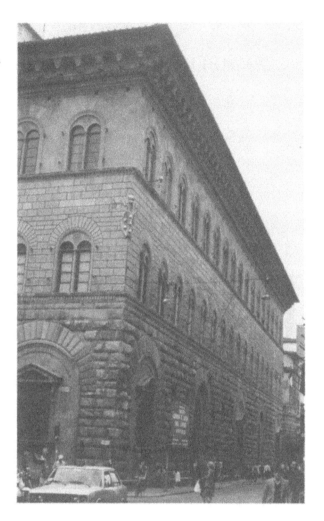

Cosimo rejected it, telling the astounded and outraged architect something to the effect that "envy is a plant one should never water." According to this story, Brunelleschi—always a sore loser—smashed the wooden model he'd made at Cosimo's feet and stormed off in a huff. Cosimo already knew Michelozzo, who had done other architectural work for the Medici, including designing the monastery of San Marco, and so he decided to hire him instead.

What were Cosimo de' Medici's motives for the construction of this large and impressive but not excessively luxurious-looking family residence? Throughout the 1400s the idea developed that it was the duty of wealthy

men to patronize architecture, that their superior position obliged them to embellish the city with splendid buildings as examples of their personal "magnificence," a word that means "doing great things"—in this case the commissioning of grand, expensive buildings. But rich men hoping to do great things in the field of architecture had to be careful. On one hand they ran the risk of not being impressive enough in what they undertook, while on the other they faced the problem of overstepping themselves in sponsoring projects so vast they roused popular resentment and envy or, worse, bankrupted the builder. Writing about Cosimo de' Medici's architectural projects in 1463 while Cosimo was still alive, Pope Pius II noted that, although the buildings Cosimo commissioned were excellent, certain people in Florence "hurled insults" at him for appearing too powerful. Evidently not even the cautious Cosimo always succeeded in walking that fine line between not enough and too much.

The theory of Magnificence goes back to ancient Greece, to Aristotle, who emphasized that major expenditures by the rich can bring those individuals greatness and prestige. St. Thomas Aquinas, basing his arguments on Aristotle, also concluded that Magnificence is a virtue. But Magnificence doesn't merely mean throwing money around. It was the Florentine intellectual Leon Battista Alberti in particular who connected Magnificence to the patronage of architecture. In his book on architecture, Alberti notes the praise that comes to a man who has erected a fine building. He has enhanced not only his own life but public life and brought honor to himself, his family, his descendants, and his city. It's interesting to note that the biographies of men who were important patrons of architecture often fail to mention the names of their architects. As in ancient Rome, the patron is considered the true "author." Perhaps this is the reason no documents have come to light naming Michelozzo as architect of the Medici Palace. We have to take the word of later sources that he was.

The original plan of the Medici Palace featured a symmetrical arrangement of apartments and offices around a central courtyard. In the early 1500s, Michelangelo added the heavily framed and pedimented windows on the ground-floor corner, where originally the arches were open. In 1659 the Riccardi family bought the palace from the Medici, who no longer used it. The new owners enlarged the building, extending it by seven bays and one portal, thus changing the building's proportions, and they also refurbished the interior, destroying nearly all the fifteenth-century décor.

To modern eyes, there's nothing very palatial about the Medici Palace as seen from the outside, although we should keep in mind that the Italian word *palazzo* has no connotations of royalty, and it can mean any large building. The structure is the grayish-beige shade of its masonry—no paint or stucco was ever used to color or conceal the stonework—and the rough, irregular stone blocks of the ground floor make the building look less like a private residence than like a fortress or a prison. Despite its size, the building doesn't call attention to itself, or to the great wealth of its original owners.

The exterior of the Medici Palace is a subtle blending of elements from both domestic and public architecture. The ground-floor exterior features "rustication," which means rough or rustic-looking stonework, a style found on some earlier public buildings in Florence but also imitated from ancient Roman monuments. Here, the architect used rough stone to suggest the strength and stability of the Medici family and their bank. Both the rustication and the doubled windows on the upper stories appear in the architecture of the Palazzo della Signoria, linking the Medici home with the city's main site of political sovereignty. The heavy cornice at the top gives the building a sense of weightiness, another element derived from ancient Roman architecture that adds to the impression of stability and strength.

The decoration of each story becomes more ornate as the building rises. Rusticated stonework appears only on the ground floor, the location of the Medici bank offices. The second floor, which contained the main apartments as well as large reception and banquet halls, has smoother but still strongly marked masonry. On the third level, the location of smaller living quarters and miscellaneous rooms, the masonry is smoothed to the point where the edges of the stone blocks almost disappear.

On the corner of the exterior, where the modern via Cavour and via de' Gori intersect, and right above the location of the original entrance to the Medici bank, is the family coat of arms: seven balls on a shield. This emblem, instantly recognizable to anyone in Florence, identified both the owner and his principal place of business. The idea of living upstairs from the family business goes back to the ancient Romans, and it's still to be found in many Italian cities, including Florence.

The interior of the Medici Palace was strikingly different from its grim exterior. Inside, the family spared no expense in order to include the greatest luxuries. More than one visitor remarked on a feature almost unheard of in other residences of the time: complete private bathrooms, known as *agiamenti*

(comforts), were a feature of each apartment. In that era individuals much grander than the Medici—dukes, princes, kings, and even popes—had to make do with chamber pots and portable bathtubs lugged in and out of their bedrooms by servants.

In 1459, shortly after the completion of his palazzo, Cosimo de' Medici played host to the fifteen-year-old Galeazzo Maria Sforza, son of the duke of Milan. A court official who accompanied the Sforza heir on his visit to Florence—a man well accustomed to the luxuries of the ducal residence in Milan—nonetheless wrote in dazzled terms of Palazzo Medici, reporting that it was

> decorated on every side with gold and fine marbles, with carvings and sculptures in relief, with pictures and inlays done in perspective by the most accomplished and perfect of masters even in the very benches and floors of the house; tapestries and household ornaments of gold and silk; silverware and bookcases that are endless.

In addition, some of the ceilings were made from carved and gilded wood and others of glazed terra-cotta tiles laid in intricate patterns; some walls had fresco paintings on them, and on others hung the family's collection of paintings. But unfortunately, with the exception of the family chapel, all the decoration from the 1400s disappeared in later remodelings, and we know about it only from the descriptions of admiring visitors and from inventories made for Piero di Cosimo de' Medici in 1456, as well as another inventory put together shortly after the death of Lorenzo il Magnifico in 1492.

These inventories, which are long and detailed, give the best impression of what the interior of the palazzo was like during the mid- to late 1400s, when it was occupied by the art-loving Medici: Cosimo, his son Piero, and Piero's son Lorenzo il Magnifico. They describe rooms adorned with innumerable works of painting and sculpture. They also mention jewelry, tapestries, collections of ancient cameos, gems, medals and coins, manuscripts, embroidered linens, luxurious clothing, and an impressive collection of weapons and armor. But to the disappointment of those trying to visualize the rooms, the inventories rarely note precisely where or how works of art were displayed.

The one exception to such vagueness is the description in the inventory of 1492 of the decorations in the *sala grande*, the large hall on the second floor. There, subjects from antiquity, Christian images, and images representing the republic of Florence combined in an ingenious way to express the subtle

political mastery of the Medici. Painted shields, hung on the walls, displayed the coats of arms of both the commune and the Medici family. Over the main doorway was Andrea del Castagno's painting of St. John the Baptist, the patron saint of Florence, and over the secondary entrance was a painting of the lions—shown behind the grillwork of a cage—that were kept near the city hall as living symbols of the republic. On three separate walls of the room hung three enormous paintings on canvas (now lost) by the Pollaiuolo brothers, favorite artists of the Medici family, showing several of the most dramatic Labors of Hercules. That ancient Greek hero also appeared on the seal of the Florentine republic, but here the Medici claim him as their own.

The palace is built around a large central courtyard and a smaller inner courtyard containing a garden—not new ideas, but executed in a neater and more symmetrical manner in Michelozzo's design than in medieval buildings. The lower story is an arcade that extends around the courtyard, the second story has double windows, and the third story originally featured an open loggia, which is now glassed in.

The Medici Palace reflects Cosimo de' Medici's masterful political mind. The building projects both power and modesty, reminding those who see it of the family's influential position in Florence but not flaunting Medici wealth and influence. Instead, its strong, austere exterior reminds people that the Medici were businessmen who worked hard, not only for themselves but also for the good of Florence. Various details display their interest in classical antiquity, but without parading such erudition.

Some parts of Palazzo Medici are now open to the public, but most of the spaces the viewer sees today are rooms decorated in the florid style of the 1600s and 1700s for the Riccardi family. All that remains from the time of the great Medici of the 1400s are Benozzo Gozzoli's exquisite frescoes in the family chapel and—if you have a good imagination—a lot of lively ghosts.

THE MEDICI AND THE MAGI

Tucked away in a corner of the Medici Palace, a floor up from street level, is one of the most enchanting spots in Florence: a little chapel whose walls display a series of colorful paintings relating the journey of the Three Magi to Bethlehem to present their gifts to the Infant Jesus. Although the scenes unfold before the viewer like a continuous, painted Christmas card from the Renaissance, they are a lot more than that.

Gozzoli, *Procession of the Magi,* chapel, Medici Palace. Scala / Art Resource, NY

The festive subject lends itself to lavishness, and Piero de' Medici, who commissioned the cycle of wall paintings around 1460, enjoyed elaborate displays of his family's wealth. His personal tastes had little in common with those of his cautious, politically astute father, Cosimo, the banker and behind-the-scenes politician who had guided the Medici to the summit of political

power in Florence. In the private spaces where the Medici entertained visiting ambassadors, princes, prelates, and popes, the family spared no expense to create a luxurious environment whose main purpose was to impress. The private chapel where the family attended mass, often in the company of their distinguished guests, and where they sometimes also entertained important visitors, was the perfect spot to showcase Medici artistic interests and, at the same time, underline their wealth and political power. What better subject for this purpose than the gorgeous retinue of the Magi?

The chapel is small, and more than a couple of dozen worshipers would make it seem crowded. But the modest size emphasizes its exclusiveness—only a chosen few would be privileged to enter there. The decoration is elaborate throughout. Floor tiles form intricate patterns in dark-red porphyry, green serpentine, and white marble, all expensive varieties of stone. Framing the entrance to the alcove containing the altar are fluted and gilded pilasters with elaborately carved capitals. Above an altar constructed of deep-red marble, a richly carved and gilded frame surrounds a lyrical painting of the Virgin Mary adoring the newborn Jesus. (A copy has replaced the original by Fra Filippo Lippi, which is now in Berlin.) Painted on the side walls of the altar alcove, hosts of angels adore the infant Savior. But outshining all other decorations are the frescoes on the east and west walls of the chapel, where Benozzo Gozzoli painted a vast landscape populated by the glittering, seemingly endless retinue of the Three Kings.

Gozzoli was in some ways an odd choice of a painter. In a city known for its progressiveness in the arts, Gozzoli was a rather old-fashioned artist, with little interest in the system of one-point perspective that Brunelleschi had invented a generation earlier and even less enthusiasm for the rediscovery of Roman antiquity that characterizes so much of Renaissance culture. What interested Gozzoli were the same princely splendors that interested his patron, Piero de' Medici: thoroughbred horses, liveried servants, richly brocaded fabrics, gleaming gold, and sparkling jewels. Although the Bible narrative merely describes the arrival of "wise men from the East," a long tradition in Christian legend and art identified them as both kings and "magi" (wise men); concluded on the basis of their gifts of gold, frankincense, and myrrh that there must have been three of them; and named them Melchior, Balthazar, and Caspar. In Gozzoli's paintings there can be no doubt that we are witnessing the arrival of royalty.

The sequence begins on the west wall, where in the foreground the oldest king, Melchior, seated on a white mule, pauses on the banks of a little stream spanned by a log. He bears a striking resemblance to portraits of the Byzantine

emperor John Palaeologus, who had visited Florence and been entertained by the Medici twenty years earlier. The log spanning the stream may refer to a legend, an embellishment of the Old Testament story of the visit of the Queen of Sheba to King Solomon. In that tale the queen pauses to worship the wood of a bridge, because she recognizes it as the wood from which Christ's Cross will someday be made. Christian theologians often drew a parallel between the visit of Sheba to Solomon and the journey of the Magi to pay homage to Christ. On the other side of the bridge, restless horses turn in various directions, giving the artist a chance to show off his ability to paint these spirited animals with their jeweled and embroidered fittings from various angles.

A young man dressed in bright-red leggings and a red tunic embroidered with gold sits on his black horse, facing away from the viewer and toward a group of three young boys mounted on white horses. Farther to the right, another gorgeous youth, dressed in blue, reins in his spirited brown horse. He is holding the leash of a baby leopard wearing a gold collar and sitting just behind him. No wonder the horse is nervous! Sometimes identified as Giuliano, the younger of Piero de' Medici's two sons, the figure is also said to be a gently humorous representation of Castruccio Castracani, who in the early 1300s was the cruel and fearsome lord of nearby Lucca. A leopard was the Castracani family symbol.

A bit further to the right and behind an outcropping of gray rock stands a close-packed group of men with highly individualized faces—no doubt these are portraits of members of the Medici circle. From among them, one man smiles out at us and raises his large right hand as if waving to friends in the chapel—an assertive self-portrait of the artist. The procession then moves off into the background, climbing up a steep road filled with camels and donkeys loaded down with trunks and bundles and tended by dozens of servants.

The scene now shifts to the east wall. Here, we have to imagine that the procession has wended its way up through the hills, perhaps stopped for refreshments at one of the Medici family's fortified country villas, visible on a hill in the distant background, and then made its way down to the actual location of the stable, where the Three Kings deliver their gifts and adore the Infant Jesus—pictured in the painting above the chapel altar. The Kings then move off toward the door of the chapel, their mission completed. In this scene we see the Medici's special identification with the Magi made explicit through portraits of family members. Many members of the family belonged

to the Company of the Magi, an important Florentine religious and charitable organization that flourished in the Renaissance. One of the annual activities of the company was a lavish reenactment of the arrival of the Three Kings in Bethlehem, performed on the Feast of the Epiphany.

In the foreground, to the right of an African attendant, are portraits of the two leading members of the Medici family. On a mule, the same kind of modest mount ridden by the eldest Magus, sits the soberly dressed, white-haired Cosimo de' Medici, the family patriarch. Although he wears a plain black tunic and a soft red hat no different from that worn by many of the other men pictured, the trappings of his mount leave little doubt of his identity—they're heavy with gold and bear the Medici family symbol: gold balls. The middle-aged man next to him must be his son, Piero, the patron of the work. His black tunic embroidered with gold, his red hat larger than his father's (or anyone else's), and his high-stepping white horse led along by a balding but handsomely attired groom, he forms a considerable contrast to his father. Some scholars think, however, that the middle-aged Piero should be identified as the middle-aged Magus, as there are no other likely candidates for that role. In the group of men behind the two Medici, Gozzoli has inserted his self-portrait a second time, and in this one he identifies himself by showing the words *opus benottii* (the work of Benozzo), embroidered in gold thread on his red hat.

Just below and slightly to the left of Gozzoli's self-portrait is an inconspicuous portrait sometimes identified as the eleven-year-old Lorenzo de' Medici, Piero de' Medici's elder son. The heavy brow, slightly slanted eyes, protruding lower lip, and above all the indented nose (indicated by a shadow on the left side of the nose) suggest that this is a genuine image of the youthful Medici heir. While the faces of the other boys in the painting seem generic and their expressions blank, this one is individualized, and it conveys a seriousness beyond the boy's years.

The dominant figure in the right foreground must be Caspar, the youngest of the Magi. Although a tradition persists that this is a portrait of Lorenzo, in reality Lorenzo had tawny skin, straight jet-black hair, and a flattened nose, none of which appear on this fair-skinned, straight-nosed, blond youth. But as with the mount ridden by Cosimo, the trappings of the boy's horse bear the *palle* (balls) of the Medici coat of arms, and behind his head is a laurel tree (*lauro* in Italian), related to the name Lorenzo, so perhaps we really are intended to think of the heir to the Medici fortune when we look at this splendid

young prince. This is the kind of ostentatious display of family heraldry by a non-noble family that prompted a disgruntled Florentine citizen to growl the vulgar observation that the Medici were trying to "ram their wretched *palle* down everyone's throat."

Although the Medici were bankers who rose from modest beginnings and had not a drop of royal or noble blood, with works of art like this one, full of courtly imagery and personal identification with royalty, the Medici made clear their aspiration to be perceived on a par with dukes, counts, and kings. The rulers of Italian princely states, other royal houses throughout Europe, and even the papacy would have to reckon with the Medici as their equals in wealth, prestige, and power. Despite religious content and visual charm, the paintings in the Medici family chapel proclaim far more than piety—they are documents of a relentless political ambition.

Chapter 10

A MAN, *a* PLAN, *a* PALAZZO

Giovanni Rucellai and His Family Palace

There's something familiar about Giovanni Rucellai—a solid citizen and successful businessman devoted to his family, active in his church, generous to charities, but also interested in letting the world know about his success by means of his splendid residence. This excellent example of a Renaissance man whose life and accomplishments have a decidedly modern ring to them was a fifteenth-century Florentine merchant, banker, builder, and tireless moneymaker. Economic historians cite him as a perfect representative of early capitalism. Social historians delight in the survival of his *Zibaldone*, a handwritten hodgepodge containing several decades of Rucellai's personal reflections and observations on his life and fortunes. In addition, art lovers celebrate his contribution to the architecture of Florence. Palazzo Rucellai, on via della Vigna Nuova, is still one of the city's most elegant private residences, and one of the few still inhabited by direct descendants of its builder.

Although Giovanni's family was neither poor nor obscure, his own early life was difficult. In 1406, when he was only three years old, his father died, leaving a nineteen-year-old widow with four young sons to raise, boys who had been born in astonishingly rapid succession, all four of them in forty months—as Giovanni later reported in the brief family history contained in his *Zibaldone*. This notable mother lived to be over eighty, and she must have been a remarkably strong and determined woman. She resisted her birth family's efforts to convince her to remarry and, instead, found refuge for herself and her sons

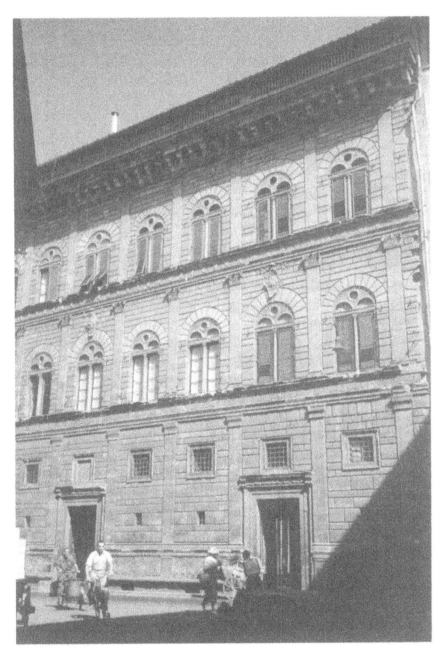

Alberti, Rucellai Palace, exterior.

among distant Rucellai relations who lived near one another in the neighbor-
hood where, decades later, Giovanni would build his famous palazzo.

In 1431 Giovanni Rucellai married Jacopa, a daughter of one of Florence's
wealthiest and most prominent citizens, Palla Strozzi, in a splendid match
that helped secure the capable and ambitious Giovanni a place in Florentine
high society. By that time he was already a successful businessman in the cloth
industry and a partner in one of the city's banks. Perhaps because he'd never
really known his own father, Giovanni formed a strong emotional bond with
his father-in-law, and we can easily imagine his distress, in 1434, when the
Medici family had Palla Strozzi exiled for his alleged part in a plot to overthrow
Cosimo de' Medici. Much of Giovanni's own sense of security disappeared with
his father-in-law. Giovanni himself was considered under suspicion because
of his close connection with Palla Strozzi, but he was neither prosecuted nor
exiled. Giovanni's three brothers—all less talented than he was—were no help,
and they increasingly became his responsibility, along with his own growing
family. Giovanni and Jacopa had seven children, two sons and five daughters.

Although the details are obscure, it was largely through his own efforts that
Giovanni made his fortune in the 1430s through the 1450s. In a society where
having influential kinfolk, friends, and patrons was deemed essential for suc-
cess, he had none of these: no father or other close male relatives to pave the
way for him, his once powerful father-in-law in exile, and at least in the early
years of his career no known connections to any of the city's most important
families. In modern terms, Giovanni Rucellai was a self-made man. Moderately
well-off in 1427, the first year Florence collected an income tax, whose records
tell us so much about the city's economic life, by 1458 Giovanni was the third-
richest man in Florence, behind only Cosimo de' Medici and the Medici bank
manager. Rucellai successfully combined mercantile and banking activities. In
1451 he invested in a wool firm, and soon he had seven wool shops bringing in
a steady income in addition to the profits from his banking interests.

But as sometimes happens to restless, highly successful individuals today,
as he continued to make money Giovanni enjoyed it less and less, and he took
diminished satisfaction in acquiring still more. He began to think of holding
public office as a way of expressing his success and having it acknowledged by
others. But the long shadow of his father-in-law's conflict with the Medici fell
over his fledgling political career. In a city where the Medici pulled the political
strings, he could make little headway, and he found his ambitions subtly but
effectively frustrated. It may have been the thwarting of his political ambitions

that caused Giovanni to turn to another avenue of self-expression: building.

Since 1428 Giovanni had been buying adjacent properties along the street where he still lived in the same house where he'd grown up. But despite his wealth, Giovanni couldn't simply buy up a whole neighborhood. Although he bought several of the houses when the owners needed quick cash, in other cases he had to wait for changes in his neighbors' circumstances before he could discuss buying their homes. Since most of his purchases were from members of the extended Rucellai family, he wanted to stay on good terms and not antagonize them by appearing too eager to get his hands on their houses. Just what he was planning to do with those properties, other than renting them out and making still more money, was unclear at first.

Then a trip to Rome for the Jubilee of 1450 sparked Giovanni's interest in Roman antiquities, especially the awe-inspiring remains of imperial Roman architecture. In 1448, before his pilgrimage, Giovanni had thought of founding a modest little chapel in a monastery that adjoined his family's property, but he returned from Rome with much more ambitious plans. He would use the land he owned to build a true and lasting monument to himself and his family—a palazzo.

We know nothing of Giovanni's formal education, but like many wealthy men of his time and place, he had acquired a smattering of classical learning. He emulated the spirit of ancient Rome as he understood it, copying into his *Zibaldone* a paraphrase of Cicero in which the Roman writer mentions with approval a wealthy man who "attained great honor because he built a beautiful palace . . . [that] brought him much good-will and esteem." Like most palace builders, Giovanni sought the admiration and approval of his fellow citizens. He also must have shared the conviction, still prevalent today, that the place where a man lives is the most significant indicator of his social standing. From the 1200s onward, Florence's wealthy citizens had been building themselves good-sized but undistinguished houses, usually three or four stories high, squeezed into the city's narrow, dark, often winding streets, cheek by jowl with their neighbors' properties.

Giovanni Rucellai no doubt devoted considerable thought as to just how large and "magnificent" he wanted his palazzo to be. Patrons had to walk a fine line between ordering a building too modest to express the family's social status effectively and the opposite hazard of overreaching themselves and inciting envy. A palazzo, and most especially the façade, had to convey specific messages about the owner and convey them clearly.

For all his fascination with architecture, Giovanni Rucellai never tells us who designed his palazzo. No doubt he would have wanted to hire Brunelleschi, the celebrated builder of the cathedral dome and several of Florence's major churches, but Brunelleschi had died in 1446. Instead, Rucellai evidently hired a much younger and more classically educated architect, Leon Battista Alberti. Although there are no documents that connect him directly with Palazzo Rucellai, Alberti was the city's leading architect in the mid-1440s and it's unlikely Rucellai would have settled for less than the best. Perhaps Giovanni's silence concerning the identity of his architect reflects the belief of both the ancient Romans and many of his own contemporaries, including Cosimo de' Medici, that a building's true "father" is the patron who commissioned it and not the architect who provided the designs.

When Rucellai entered the field as a patron of architecture, he was joining an intense but unspoken competition—a kind of architectural status contest—among Florence's wealthiest families. Around 1445 Cosimo de' Medici had begun a huge palazzo from the ground up, tearing down anything that stood in the way. This put Giovanni in a delicate position. He didn't want to appear to be competing openly with the Medici family—in his writings, Alberti advised that it is prudent to imitate but not to exceed one's superiors. Yet at the same time he was eager to assert his own hard-earned position as one of the city's leading citizens. What he needed was a palazzo design that would combine the flattery of imitation with the subtle provocation of originality: just a touch of competitiveness, to let the Medici know he wasn't a threat but that he was nonetheless a presence to be reckoned with.

Giovanni devoted the 1450s to his new passion, his building campaign, although the way he went about building his palazzo may seem surprising. With only two exceptions, he didn't have the previous buildings on the rambling, irregular site torn down. Instead he had them connected, by removing walls and adding a warren of passageways and staircases to bring together what had once been six separate residences. Finally, toward the end of the 1450s, he was ready to proceed with the façade, a clever false front that conceals the bewildering architectural tangle behind it.

This is where the talents and classical training of Alberti must have come into play. There was no other Florentine architect of the mid-1400s who could have conceived of such an ingenious and elegant façade. Like the Medici Palace, the front of Rucellai's residence is three stories high, with windows on each level, and topped with a heavy cornice, or overhanging roof. But there

the resemblance ends. The Medici Palace looks like a forbidding fortress, with rough, irregular stones blocks on the ground floor while, in contrast, the Palazzo Rucellai—one-third the size of the Palazzo Medici—appears elegant and graceful. The front of the Rucellai Palace consists of a thick cushion of mortar that conceals any inconsistencies among the various house fronts beneath, with smooth stone blocks embedded in the mortar to make up the façade. We might think of the façade as drawn on the surface, so delicate is the linear design.

Each of the three stories is divided into units called bays, separated by pilasters. A favorite architectural motif of the ancient Romans, pilasters are two-dimensional columns without supporting function that serve as decoration. Alberti, familiar with the principles of Roman architecture, made sure his pilasters conformed to Roman practice, as seen on the Colosseum: the tops, or capitals, of the pilasters reflect their place in the architectural scheme. Those on the ground floor are the simplest in design, as simplicity is reflective of strength, and the first floor supports the stories above. On the second level the capitals become more decorative, and on the top level, which supports only the roof, they become quite fancy. Their presence provides a rhythmic framework for the façade.

In between, the stone blocks are of differing widths, but with their proportions calculated as carefully as if they were part of an abstract painting. Even the motifs carved into the tops of the door frames and the horizontal cornices that divide the stories add to the elegance of the whole. These are decorated with sculpted images of jeweled rings (a motif borrowed from Rucellai's Medici relatives by marriage) and billowing sails, the latter a favorite motif of Giovanni, who saw a wind-filled sail as a symbol of good fortune.

Despite all Alberti's efforts at harmony, balance, and beautiful proportions, there's one jarring feature to the Rucellai façade: on the right side is a ragged edge of masonry, part of an incomplete eighth bay. Close study of the façade by modern architectural historians has revealed that the original design consisted of only the first five bays, with a single, central entrance. At an unknown point, but surely after Alberti had completed his work, Rucellai decided to have his palazzo expanded by three more bays, to conceal another house he had acquired. But he then encountered a problem. In order to complete the third of the added bays and make the palace façade symmetrical, Giovanni would have to purchase yet another relative's house. But the owner refused to sell. That ornery Rucellai relative did more than merely rebuff all Giovanni's attempts to buy the property. He also included in his will a statement forever prohibiting

the sale or even the rental of his house to Giovanni or any of his descendants. So the jagged edge remains, reaching out aggressively like teeth poised to bite into the adjoining property, a permanent reminder of Giovanni's defeat.

Deeply devoted to his family, Rucellai lived in his palazzo as the patriarch of a four-generation household that consisted of himself and his wife, his mother, his son Pandolfo (a widower with five children), and his son Bernardo with his wife Nannina de' Medici and their children. A staff of servants lived in a section at the back of the palazzo, where the service rooms were also located. In his *Zibaldone*, Giovanni counseled his sons to be generous and courteous to servants, whose loyalty he believed should be rewarded with humane treatment and help when needed. He preferred to be loved than feared—not a common sentiment among wealthy men of that era. In his unusual attitude we can perhaps sense something of the frightened, fatherless boy of decades earlier, who knew the terror of being powerless and unprotected.

Although he never built anything else on the scale of his family palazzo, Giovanni did not ignore the religious institutions of the city. He built the monastery chapel noted earlier, and in the late 1450s he agreed to finance the completion of the façade of the Dominican church of S. Maria Novella, the largest and most important in the city after the cathedral. He again hired Alberti to produce the design. Near the top is a Latin inscription in large Roman capitals that mentions neither the Dominican order nor the Virgin Mary, to whom the church is dedicated, but instead commemorates the patron. It translates as "Giovanni Rucellai, son of Paolo, 1470."

In his later years Giovanni suffered a series of financial reverses. During the year 1474 several of his wool companies collapsed, and he was forced to sell one of his country estates, Poggio a Caiano, to Lorenzo de' Medici, to whom Rucellai was related through the marriage of his son Bernardo to Lorenzo's sister Nannina. The sale of the property saved Rucellai from financial ruin, and it confirmed his belief in the value of the bonds of kinship and marriage.

Giovanni Rucellai died in his Florentine palazzo in 1481, at age seventy-eight, and he died a happy man, surrounded by his family and the building that was almost an extension of himself. His will, ensuring ownership and occupancy by his descendants, conveys the message that the man is mortal but his house will endure, and because of it his memory will live on—as indeed it has. As he wrote in his *Zibaldone*: "I think I have not given myself as much pleasure in earning money so much as in spending it, above all in the building I have done."

The SASSETTI CHAPEL *in* S. TRINITA

POLITICS, RELIGION, AND PERSONAL REPUTATION

Walk down the center aisle of almost any Florentine church and you'll see it flanked by a series of small side chapels that once belonged to local families wealthy enough to purchase the rights to use and decorate them. The Sassetti Chapel in the church of S. Trinita is one of the most interesting, a place where Renaissance art, religion, and politics intertwine. As noted in Chapter 4, the patronage of chapels was more than just a religious exercise. It was also a way of conveying social and political messages about the donor families.

Monks of the poetically named Vallombrosan order (the name means "shadowy valley") founded the church of S. Trinita in the eleventh century. It has since been rebuilt several times, and today the church is a rather undistinguished-looking place with a late sixteenth-century façade attached to a thirteenth-century building. The interior doesn't look too promising either, and it attracts few tourists. But a treat awaits visitors near the altar end, on the right side of the transept. Here, in the 1470s, Francesco Sassetti purchased a chapel, and in the mid-1480s he had it decorated by the most popular painter in Florence, Domenico Ghirlandaio, who turned the walls into one of the masterpieces of Florentine Renaissance painting.

Actually, Sassetti had his sights set even higher. He had hoped to acquire a chapel in the much larger and more prominent Dominican church of S. Maria Novella, but this plan foundered, so Sassetti settled for S. Trinita. He secured

the rights to a chapel belonging to a family that had become insolvent, his quest no doubt helped by his knowledge that the Vallombrosans of S. Trinita needed the support of Sassetti's employer, the Medici family, in a dispute with a dissident faction of their own order that had taken control of several Vallombrosan abbeys in Tuscany.

Francesco Sassetti was wealthy enough to command the services of Ghirlandaio, one of the best and most expensive painters in Florence. Born in 1421 and a member of an old and prosperous Florentine family, Francesco had been employed almost since childhood by the Medici bank. In 1438, at age seventeen, he began as a clerk in one of the bank's French branches, in Avignon, where he rose to become a junior partner. In 1453 he was transferred to Geneva, and in 1458 he returned to Florence, where he married the fifteen-year-old Nera Corsi, a member of an ancient Florentine family also closely allied with the Medici. From this point on, Francesco worked in the bank's home office.

A decade later he was appointed to the highest position in the Medici bank that could be held by a nonfamily member: he became what we'd call the general manager. Three generations of Medici held him in high regard. He'd begun his career working for Cosimo, and he continued under the brief tenure of Cosimo's son Piero. He later functioned as the financial right-hand man of Lorenzo, who became the head of the bank as well as the de facto ruler of Florence in 1469, the year his father, Piero, died. Sassetti continued in the employ of the Medici for the rest of his life. Loyal to the end, the aging and ailing Sassetti made a final trip abroad, to a French branch of the Medici bank in Lyons, in order to see what he could do to straighten out its tangled affairs. Not long after his return he suffered a stroke and died in March 1490.

During those decades, more than half a century of faithful service, Francesco Sassetti amassed an immense fortune, and he spent it lavishly on antiquities such as Roman coins and ancient texts as well as jewels, silver plate, luxurious clothing, fancy furnishings for his family palazzo, and land. In addition to his palazzo in Florence, he owned three country estates. He and his wife had ten children: five boys and five girls, all of whom survived to adulthood, an extremely rare event in an era of high infant mortality.

A man of Sassetti's social stature needed a permanent monument to himself and his family, and Francesco's acquisition of a chapel in S. Trinita provided that opportunity. Here, when the time came, Sassetti and his wife and descendants would be buried and masses said for the repose of their souls. But the chapel also served an important political function: it broadcast Sassetti's

connection with the Medici. Despite the chapel's dedication to St. Francis of Assisi, the saint plays second fiddle to the Sassetti. Through sculptural details, but above all through Ghirlandaio's paintings, the chapel celebrates the Sassetti family's friendship with Lorenzo de' Medici and his family, a social pinnacle few others in Florence had achieved. They proclaimed through such intimacy that the chapel's patron shared Lorenzo's political positions, his reverence for classical antiquity, and his vision of Florence as a brilliant cultural capital, a new Rome on the banks of the Arno.

The altarpiece of the chapel, also by Ghirlandaio, shows the Nativity combined with the Adoration of the Shepherds. The artist's portrayal of the rough, astonished shepherds indicates that he had studied a painting of the same subject by the Flemish master Hugo van der Goes—the *Portinari Altarpiece*, in Florence by 1483 and today in the Uffizi (discussed in Chapter 13). The subject of the altarpiece was no doubt chosen because the chapel has a double dedication to St. Francis and to the Nativity, the latter theme perhaps chosen because the death of Sassetti's adult son Teodoro had been followed shortly afterward by the birth of his youngest son who, as customary in such cases, was given the name of his deceased older brother.

Ghirlandaio's *Nativity* is quite erudite and may be intended to show that Sassetti shared the Medici family's interest in classical antiquity. Its theme is the successive defeats of the kingdoms of the Jews and the Romans that preceded the triumph of Christianity. The Christ Child lies in an unusual manger, an ancient Roman sarcophagus with a Latin inscription on it, which conveys the message that it once held the bones of a Roman named Fulvius, who predicted that his coffin would one day serve to hold a new god. In the background, an inscription on a triumphal arch mentions Pompey, the first Roman general to conquer Jerusalem. The Holy Family and the adoring shepherds therefore gather in front of ruins referring to two previous civilizations, Hebrew and Roman, where they celebrate the advent of Christ, in fulfillment of the prophecy of Revelation 11:15: "The kingdoms of this world are become the kingdom of our Lord, and of his Christ."

The tombs of Nera Corsi and Francesco Sassetti are not in the floor or outside the chapel entrance, as was usual in Florentine churches, but are enclosed in half-circle-shaped niches embedded in the sidewalls of the chapel. Their painted portraits appear on the back wall, kneeling on either side of Ghirlandaio's altarpiece of the Nativity, which is inscribed with the year 1485, a date when both the patron and his wife were still alive. Although the artist

who carved the tombs and the relief sculptures framing them is unknown, the tombs have many classical details such as cherubs and centaurs, the latter flinging small stones (*sassetti*), a pun on the patron's name. Some details have been copied from ancient objects in the Medici collection and others from Donatello's bronze pulpits in the church of S. Lorenzo, also a Medici commission. Along with demonstrating Sassetti's interest in classical culture, such borrowings suggest that imitation has always been the sincerest form of flattery.

Above the tombs and the altar are six scenes from the life of St. Francis, two on each of the three walls, one above the other. The cycle begins at the top left, with *St. Francis Renouncing His Patrimony*. Although the event occurred in Assisi, the background is a view of Geneva where Sassetti, far from renouncing worldly gains, enjoyed his first great financial successes. The next episode is on the upper portion of the altar wall and shows the *Confirmation of the Franciscan Rule by Pope Honorius III*. This too has an unusual setting; instead of the papal curia in Rome, it takes place in the Piazza della Signoria in Florence, with the Loggia dei Lanzi (then known as the Loggia della Signoria) visible in the background. On the top right wall is St. Francis's Trial by Fire, which has no identifiable setting.

The story then continues in the lower register on the left where, above the tomb of Nera Corsi, we find the *Stigmatization of St. Francis*, whose setting is the Franciscan site called La Verna. Directly above the altar, Ghirlandaio's altarpiece, and the praying figures of the patrons is the miracle of *St. Francis Reviving the Roman Notary's Son*. Instead of the piazza in Rome where the miracle is said to have taken place, the fresco shows the Piazza S. Trinita in Florence, the space in front of the same church where the frescoes are located. The subject must have had a particular personal relevance for Sassetti and his wife, as it contains portraits identified as Sassetti's adult daughters and their spouses. The central image, directly above the Nativity, shows the formerly dead child sitting up on his funeral bier, most likely a reference to the "miraculous" birth of Sassetti's son Teodoro II when Francesco was nearly sixty and his wife in her mid- to late thirties. The final scene, the *Funeral of St. Francis*, is over Francesco's tomb. Like the *Trial by Fire*, it has no specific setting.

Although none of the miracles shown have any actual connection with Florence, several of them are presented to the viewer as if they'd taken place in Sassetti's home city. The Florentine settings somewhat arbitrarily establish a relationship between these Franciscan miracles and the city of Florence. Placing some of the miracles in familiar settings underlines their relevance,

relating them specifically to the lives and fortunes of the Sassetti family.

On the vaulted ceiling Ghirlandaio painted four pagan prophetesses, known as sibyls, seated on clouds with a dramatic sunburst behind each. The texts on the sibyls' scrolls prophesy Christ's birth, which is fulfilled in the Nativity altarpiece below. Above the chapel entrance is a fresco of *Augustus's Vision on the Capitoline Hill*, a reference to a legend that the emperor Augustus had a vision of Christ, as well as to the tradition that Augustus was the founder of Florence. Painted on the same outside wall, to the left of Augustus, is David with the head of Goliath at his feet. Below is a Latin inscription: "To the safety of the fatherland and Christian glory." The patriotic ring of this is a reminder that the Florentines saw David as the defender of civic liberty.

What makes several scenes in the St. Francis cycle so memorable is the number of contemporary portraits they contain. Ghirlandaio was the greatest visual biographer of Renaissance Florence. Although the participants in the religious events are stock figures based on artistic tradition, the onlookers are all contemporary portraits, a small number of which are identifiable. There's no difficulty in identifying the patrons, whose life-size painted images kneel on either side of the altar. Directly above, in the scene of *St. Francis Reviving the Roman Notary's Son*, the attractive, beautifully dressed young people on the left are, as noted above, most likely several of Sassetti's adult children. On the far right of that scene, among some unidentified male figures, stands Domenico Ghirlandaio himself, his handsome, confident face looking out boldly at the viewer. It says a lot about Ghirlandaio's prestige as a painter that he felt free to include himself in the distinguished company assembled in Sassetti's frescoes.

The most famous, and the most revealing, portraits appear in the scene directly above: the *Confirmation of the Franciscan Rule*, a composition where the ostensible subject is relegated to the middle ground. The proud-looking young men on the left are probably Sassetti's three adult sons. His youngest son, about six at the time, was perhaps considered too young to be included, and a fifth son (Teodoro I) had died by the time the frescoes were painted. On the right is the most famous group. Here, Francesco Sassetti appears again, in the company of the elderly Antonio Pucci (on the left), a high government official who was another loyal Medici supporter as well as the father-in-law of Francesco's daughter Sibilla. The boy on the far right is Sassetti's twelve-year-old son Federigo, whose sober robes indicate he was already destined for the clergy. Between Pucci and Sassetti stands Lorenzo il Magnifico—the head of the Medici family and the unofficial head of the Florentine state.

Ghirlandaio, *Confirmation of the Franciscan Rule.* On the far right side, left to right: Antonio Pucci, Lorenzo de' Medici, Francesco Sassetti. Sassetti Chapel, S. Trinita. Scala / Art Resource, NY

What a coup for Sassetti to have Lorenzo's portrait in his fresco, with himself standing right next to the most powerful man in Florence! But the image is more than social braggadocio. It also reflects the Renaissance concept of friendship, in which alliances between men are earthly reflections of the bonds between God and humanity. Aside from whatever advantage Sassetti gained from being portrayed in the company of Il Magnifico, the image is also of great historical value, as it's the only surviving full-length portrait of Lorenzo de' Medici made while he was alive. The artist has captured Lorenzo's homely but alert and engaging face to perfection, and his jet-black hair makes him stand out between the elderly, grizzled Pucci and Sassetti.

A curious feature of the composition also may be related to Sassetti's eagerness to show off his association with the Medici. In the center foreground, Ghirlandaio painted a staircase coming up from a room below the scene. Climbing the stairs are Lorenzo de' Medici's three young sons— Piero, Giovanni, and Giuliano—accompanied by their tutors, the cleric Matteo Franco and the poet Angelo Poliziano, and a third man, usually identified as Medici client and comic poet Luigi Pulci. Even though these identifications aren't absolutely certain, it's difficult to imagine who else the children could be, as Sassetti's older brood has already been accounted for in the paintings, and it would be logical for Lorenzo's lively little boys to be accompanied by their tutors. Although it's uncertain which boy represents which of Lorenzo's sons, scholars generally agree that the middle one is Lorenzo's eldest, Piero, whose facial expression already displays the arrogance that would characterize him as an adult. The younger boy, holding the hand of the adult in the lead and looking out at the viewer, may be Giovanni, and the boy at the back Giuliano, Lorenzo's third son, although this is uncertain.

Recent examination of the fresco has shown that both the group of Sassetti with Lorenzo and the group at the bottom were later additions; the original plaster was torn out and replaced so the portraits could be added, probably around 1484–1485. Several events around that year might account for the change of plans. In August 1484 Pope Sixtus IV died. Although they'd reconciled in the end, Sixtus had long been a bitter adversary of the Medici, and of Lorenzo in particular. He was succeeded by a milder man, Innocent VIII, and Lorenzo was eager to ingratiate himself with the new pope. He sent an embassy to Rome to congratulate Innocent, a group that included his son

Piero and his tutor chaperone Poliziano. Lorenzo also had ambitious plans for his second son, Giovanni, which involved courting the goodwill of the pope. Although only nine years old in 1484, Giovanni had already taken minor orders, and Lorenzo sought papal approval for the lucrative benefices—clerical offices that provide an income without any real responsibilities—that the boy needed in order to pursue a career in the Church.

Lorenzo could be ruthless in his pursuit of benefices for his son, and it's likely that he had his eye on S. Trinita, especially when he got wind of a lurid scandal that rocked the monastery in the mid-1480s: the elderly abbot, Don Matteo Lapini, had resigned after being caught writing obscene letters to nuns. But Lorenzo had reckoned without the formidable force of the Abbot-General of the Vallombrosan order, Biagio Milanesi, who had no intention of allowing a Medici child to hold the important office of abbot at S. Trinita. He ordered the terrified and humiliated Don Matteo to meet with him and, instead of punishing the abbot, told the cringing man he was forgiven and ordered him to burn the incriminating letters, which had somehow come back into his possession. This he did, in the abbot-general's presence, and then retracted his resignation, which effectively foiled any plans Lorenzo might have had for adding S. Trinita to his son's growing list of benefices.

Although this is more speculation than fact, it remains possible that Lorenzo was particularly interested in having his son Giovanni appear in Sassetti's frescoes in S. Trinita. After all, Don Matteo was an old man who wouldn't live forever, so Lorenzo might still have the opportunity to install Giovanni as abbot after Don Matteo's death. The boy's appearance in the fresco could serve as a way of introducing him to the congregation that used the church and visited the Sassetti Chapel. And Francesco Sassetti naturally would have been more than eager to please Lorenzo.

Still another factor that may have led Sassetti to add these flattering portrayals of the Medici to his fresco was his own precarious position in the first half of the 1480s. Most of the Medici bank's foreign branches failed during those years, and many blamed Sassetti for not overseeing them properly. At the end of 1484, Lorenzo dismissed Sassetti from his post as general manager of the bank and gave the position to a Medici relative, his uncle Giovanni Tornabuoni, who'd been agitating for the position for reasons of his own (see Chapter 12, on the Tornabuoni Chapel).

But Lorenzo kept Sassetti in his employ and remained convinced of Sassetti's essential honesty and competence. He wrote letters expressing those sentiments, for which Sassetti was deeply grateful. We can appreciate the depth of Sassetti's devotion when he wrote to Lorenzo in 1486: "To you I would dedicate my life, my children, and everything I have in this world." In the *Confirmation of the Franciscan Rule*, although other motivations may have played their part, Sassetti's own, most personal reason for having the fresco altered may well have been so that he and his family could stand with Lorenzo and his family in that same spirit of personal and political loyalty.

The TORNABUONI CHAPEL *in*
S. MARIA NOVELLA

DUELING DONORS

When three wealthy and prominent fifteenth-century Florentine families vie for the privilege of becoming the patrons of a prestigious chapel, the intrigues can become complicated. Pity the poor Dominican friars at the church of S. Maria Novella, who had to contend with the Ricci, Sassetti, and Tornabuoni families, each claiming the right to decorate the *cappella maggiore*, the main chapel, which is in fact the entire apse, the altar end of the enormous church. The site was particularly choice because the area around the main altar is considered the most sacred part of a church, so having worship and burial privileges there would bring spiritual merit as well as great social prestige to the family that claimed it.

S. Maria Novella is called Novella (new) because it stands on the site of an earlier church in an area that in medieval times lay outside the city limits. In 1221, when the Dominican order arrived in Florence, they received the pre-existing church, which had been built by a man named Jacopo Tornaquinci. (The reader should keep the surname in mind—it will occur again in this story.) The friars tore down the old church, and in 1246 they began replacing it with a much larger and grander one. The cathedral is the only church in Florence bigger than S. Maria Novella.

Even though S. Maria Novella contains many interesting works of art, by far the most striking are the two cycles of colorful frescoes by Domenico

Ghirlandaio that cover the walls of the high and spacious apse. Giovanni Tornabuoni was the patron who commissioned them in 1486. Among the wealthiest and most influential men of Florence, his power derived from his connection to the Medici. He was related to the Medici through the marriage of his sister Lucrezia to Piero de' Medici, and their son—his nephew—was Lorenzo the Magnificent, since 1469 the ruler of the city. Thanks to these connections, Giovanni became the general manager of the Medici bank in Rome, the most profitable branch because of its lucrative business with the papal curia. This was the source of Giovanni's vast fortune.

Given all these advantages, Giovanni Tornabuoni should have sailed into S. Maria Novella and without any difficulty acquired patronage rights to its most important chapel. Instead, he had to wage a long and sometimes bitter battle with several other families, whose members also claimed they had rights to the same chapel. Who is to decide when would-be donors disagree?

A further historical fact needs to be clarified before proceeding: Giovanni Tornabuoni belonged to one branch of an old and large aristocratic family whose original name was Tornaquinci. In the mid-1200s the government of Florence, disgusted with the feuds and other excesses of the city's noble families, had barred aristocrats from holding public office, and in response some families changed their names in order to reenter the political arena. At that time a branch of the Tornaquinci changed its name to Tornabuoni.

With this in mind, we can easily see why Giovanni Tornabuoni thought he had a right to the church's main chapel—after all, one of his Tornaquinci ancestors had founded the original church on the site. No other family could have an earlier claim than that. But priority concerning the site of the original church was insufficient to assure patronage rights to such a prestigious chapel. Another family, the Ricci, insisted *they* had been granted rights to the chapel. Although they had paid for the round window in the façade in 1365 and had made a few other modest bequests to the church, their grounds for claiming the chapel are no longer clear.

But the Ricci, whatever the validity of their claims, were no match for the Tornabuoni. By the late 1400s, they were a declining lineage: few in number, politically insignificant, and financially strapped. They were in no position to assert their possession of the chapel, which—as Giovanni Tornabuoni pointed out to the Dominicans—was poorly maintained and its frescoes in a deplorable state. Furthermore, those frescoes had been commissioned in the 1360s

by a Dominican friar named Jacopo Passavanti, whose mother was a Torna-quinci. In 1485 the Ricci were finally persuaded—or more likely forced—to sell their rights over the chapel to Giovanni Tornabuoni.

The coast was still not clear for Giovanni to proceed, however, as there was another claimant to a portion of the chapel, a much more formidable adversary than the Ricci family—Francesco Sassetti. Like Giovanni Tornabuoni, Sassetti was a rich and powerful banker in the employ of the Medici, and he was equally eager to assert his position in the city by commissioning works of art that would be visible to the public. The two men were ostensibly coworkers as both were high-ranking officials of the Medici banking empire, but they had never liked each other, and in the highly competitive world of Florentine business they were intense but undeclared rivals.

In 1470, the Dominicans had granted Sassetti patronage rights to the church's main altar, which is located in the apse—that is, right smack in the middle of what, in 1486, had become Giovanni Tornabuoni's chapel. But Sassetti had made several serious mistakes. For one, he committed the tactical error of telling the Dominicans he also had an interest in claiming rights to the chapel walls, where he intended to commission frescoes on the life of his patron saint, Francis of Assisi—not a subject attractive to the rival Dominican order. He also promised more than he delivered to the Dominicans, since he failed to follow up on his acquisition of the altar as a patronage site, commissioning no works of art to adorn it. (The present pseudo-Gothic altar is from the nineteenth century.)

Sassetti had overextended himself. Having lost the battle for the chapel walls, since the early 1480s he'd been occupied with the lavish decoration of his family chapel in the Vallombrosan church of S. Trinita (discussed in Chapter 11), and therefore he couldn't be as generous to the Dominicans of S. Maria Novella. Furthermore, Sassetti must not have hired a very good lawyer to draw up his contract with the Dominicans of S. Maria Novella, because the document failed to note his deed to the altar area as "irrevocable."

When Giovanni Tornabuoni realized his competitor's weaknesses, he knew just what strings to pull and where to deploy his enormous wealth. He began a calculated campaign designed to impress the Dominicans with his piety, generosity, and deep involvement in the activities of their church. Although he was the manager of the Medici bank in Rome, where he had lived for years, he made it known that he wished to relinquish that post and reside permanently

in Florence. It may not be entirely coincidental that, just at this time, Sassetti was dismissed from his post at the Medici bank in Florence and the position given to Tornabuoni.

Back in his home city by 1484, Giovanni joined and became active in the Dominican religious confraternity of St. Peter Martyr. For the anniversary of the church's founding, celebrated on September 1, 1486, he purchased and donated a whopping 203 pounds of wax for the torches to be used in the celebratory procession. Along with further generous monetary gifts, Tornabuoni pointed out to the Dominicans his own family's historic prestige in the city, along with its long history as benefactors of the church. He no doubt also pointed out to the friars that Sassetti's claim to the high altar could be—and should be—revoked.

Sassetti was beaten. Already committed to S. Trinita, a church belonging to a rival religious order, he had shown himself a disappointing patron of the high altar of S. Maria Novella. The Dominicans saw him as a man whose paltry and unreliable patronage could be dispensed with. And that's exactly what they did, revoking Sassetti's claim to the high altar and turning it over to Tornabuoni. On October 13, 1486, Tornabuoni signed a contract with the Dominicans in which he's referred to as "magnificent and generous" and which gave him patronage rights to the entire chapel, including both the altar and the walls. Francesco Sassetti was furious, but helpless. Tornabuoni had totally outmaneuvered him.

Tornabuoni must have been very confident he'd emerge as victor in the contest for patronage of the chapel, because slightly more than a year earlier he had already signed an elaborate contract with Domenico Ghirlandaio, the leading painter of Florence and (ironically) the artist who had just completed the frescoes in Sassetti's chapel in S. Trinita. The contract, which survives in its entirety, is an extremely detailed statement of the exacting patron's demands.

The frescoes would cover the vaulted ceiling, the sidewalls, and the portion of the back wall not devoted to windows. Tornabuoni stipulates what materials the artist is required to use for certain colors, such as precious and expensive lapis lazuli on some of the figures' robes and a less costly form of blue pigment for the backgrounds. He orders the use of gold for decorations, in order to "make them magnificent." He even gives instructions on how the subjects shown should be presented. Beyond the usual biblical figures he insists on "buildings, castles, cities, villas, mountains, plains, water,

rocks, garments, animals, birds, and beasts." Ghirlandaio didn't disappoint. Completed in 1490, just a few months before Giovanni Tornabuoni's death, the frescoes form the largest such commission in Florence and without any doubt the most splendid.

THE TORNABUONI TRIUMPHANT

GHIRLANDAIO'S FRESCOES IN THE CAPPELLA MAGGIORE

When, in 1486, Giovanni Tornabuoni won his battles against the Ricci and Sassetti families for patronage rights to the *cappella maggiore* in Florence's great Dominican church, he knew exactly what he wanted. He had already hammered out a detailed contract with Ghirlandaio, and he planned to fill the cavernous spaces of his chapel with two cycles of frescoes: one on the life of the Virgin Mary, to whom the church is dedicated, and one on the life of John the Baptist, the patron saint of Florence and also Giovanni's own patron saint. In these frescoes Ghirlandaio produced a brilliant combination of religious imagery, classical allusions, contemporary portraits, and numerous details that reflect—we could almost say trumpet—his patron's wealth, power, and social status.

The organizing of such a large space into a series of recognizable and readable pictures was a daunting task. Ghirlandaio met that challenge by dividing each of the tall sidewalls into six horizontal rectangles, two on each of three levels, each side topped by a picture field in a triangular space that follows the arch of the vaulted ceiling. Three magnificent stained-glass windows, also designed by Ghirlandaio, dominate the back wall of the chapel, leaving only narrow strips on each side and another triangular area above. The ceiling, divided into four parts by ribbed vaulting, offered more spaces to be filled with paintings.

Ghirlandaio didn't work alone. His shop consisted of himself, his brothers Davide and Benedetto, his brother-in-law Sebastiano Mainardi, and a flock of apprentices, among them possibly the very young Michelangelo. Ghirlandaio no doubt designed all the compositions, but he assigned the paintings on the ceiling, in the narrow spaces flanking the windows, and those highest up on the walls to members of his shop and reserved the most visible scenes on the lower levels for himself. Therefore, unless you have a passion for seeing every scene and binoculars to zero in on the highest ones, it's best to give most of your attention to the scenes in the lower registers, which are the most interesting.

For purposes of completeness, though, let's note that the ceiling contains images of the Four Evangelists, and that the small scenes on either side of the windows consist of two stories of Dominican saints in the top registers (a bow to the Dominican monks to whom the church belongs), in the middle on the left an *Annunciation*, and in the middle on the right *St. John the Baptist in the Wilderness*. These last two scenes cleverly unite the back wall with the sidewalls, since the Annunciation is part of the Life of the Virgin series on the left and the scene of John in the Wilderness forms part of the cycle of John's life on the right.

On the bottom level of the back wall, the donors—Giovanni Tornabuoni and his wife, Francesca Pitti, who had died in childbirth in 1477—are shown kneeling in prayer. Their eyes are downcast and their poses humble, but the grandiose chapel around them tells a different story. In this enormous, magnificent chapel the fabulously wealthy Tornabuoni could distinguish himself from his merely affluent contemporaries. In comparison, the chapel in S. Trinita of Giovanni's defeated rival, Francesco Sassetti, seems puny. Furthermore, Sassetti's effort to associate himself with the Medici by including himself standing next to Lorenzo il Magnifico in one of the S. Trinita frescoes here receives a silent sneer. Giovanni Tornabuoni had no need to portray himself with Il Magnifico, since he held a status Sassetti had never attained. He was a Medici relative by marriage: the ruler of Florence was Giovanni's nephew. In S. Maria Novella we see the Tornabuoni—and the Tornabuoni alone—triumphant.

As the detailed contract between patron and painter demonstrates, Ghirlandaio had not only to illustrate biblical narratives but also to glorify the Tornabuoni family. In the words of the contract, Giovanni commissioned the frescoes "as an act of piety and love of God, to the exaltation of [my] house and family and the enhancement of said church and chapel." Ghirlandaio solved the problem of how paintings of biblical subjects can glorify a Renaissance family by setting many of the biblical scenes in palatial buildings that recall classical Roman architecture as interpreted in the Renaissance; by placing other scenes inside rooms richly decorated in the manner of a contemporary palazzo; and above all, by including a great number of portraits of the Tornabuoni and their associates. The artist illustrates the Bible narratives in a manner that makes them easily recognizable, even as some of them are witnessed by swarms of fifteenth-century Florentines.

Each cycle is meant to be read from the bottom up. Beginning on the left with the cycle devoted to the life of Mary, the first scene is the *Expulsion of Joachim from the Temple*. Although not strictly biblical (the story is from the

Apocrypha, texts not part of the present-day Bible), the tale of Mary's parents was very popular and often illustrated, because it fulfilled the desire of worshipers to envision the life of Mary and her family—the extended family of Jesus—with a degree of detail not found in the canonical Gospels. Here, the Hebrew temple appears as a lofty arched structure decorated with classical motifs. In the right foreground Joachim hurries away, clutching a lamb, his sacrifice that has just been rejected because of his childlessness. Flanking the episode are two groups of male figures in Renaissance dress. Those on the left can't be positively identified, although scholars have suggested that the two in the foreground may be Giovanni Tornabuoni's son Lorenzo and his friend Alessandro de' Nasi, the future husband of Lorenzo's sister Lodovica, who appears in the adjoining fresco. The group on the right also eludes positive identification, except for one figure: the man second from the right with one hand on his hip, who looks directly at the viewer, is Ghirlandaio's assertive self-portrait. As in Francesco Sassetti's chapel in S. Trinita, the artist confidently portrayed himself in the company of his patrons.

Next to the *Expulsion of Joachim* is the most famous picture in the cycle: the *Birth of the Virgin Mary*. This delightful scene takes place in the bedroom of a luxurious Renaissance palazzo, probably not so different from those in the Tornabuoni residence. St. Anne sits up in bed while young women care for the newborn Mary, a chubby cherub contentedly sucking on her finger as she lies in the arms of a smiling servant. The chamber walls are painted to look like they're paneled with intarsia—wood inlaid with intricate designs here picked out in gold paint. Above, a sculptured frieze in white marble of music-making children (a classical motif) is set into the wall, and separating it from the intarsia paneling is a band with a familiar text from the Breviary that speaks of the joy Mary's birth brings to the world. On the left side stands a group of women in Renaissance attire, four of them simply dressed and one resplendent in gold brocade and jewelry. The richly dressed young woman can be identified as Lodovica, a daughter of Giovanni Tornabuoni. Ghirlandaio must have been particularly proud of this scene, as he included his signature, worked into the gold scrollwork of the intarsia panels.

The other scenes in the Life of the Virgin cycle become increasingly difficult to see, as they are set higher on the wall. None contain contemporary portraits; obviously, such portraits were meant to be easily visible and identifiable, so hiding them in the higher registers would defeat the purpose of including them, namely, the glorification of the Tornabuoni family. Nonetheless, the two

Ghirlandaio, *Birth of the Virgin Mary*, Tornabuoni Chapel, S. Maria Novella. Scala / Ministero per i
Beni e le Attività culturali / Art Resource, NY

in the second register, the *Presentation of Mary in the Temple* and the *Marriage of Mary and Joseph*, are Ghirlandaio's own work, beautifully painted and set within majestic architecture. The scenes in the third register—the *Adoration of the Magi* (severely damaged), the *Massacre of the Innocents*, and the *Assumption of the Virgin* at the very top—are of lesser quality and no doubt are the work of Ghirlandaio's assistants.

On the right side of the chapel, the narrative sequence moves from right to left, so that the scenes on both sides bring the viewer's eyes inward toward the altar. The opening scene of the John the Baptist cycle begins on the lower right with the *Annunciation to Zacharias*, in which an angel informs John's future father, Zacharias, of the impending birth of his son. This is the most important scene of the entire chapel, as it contains three inscriptions (discussed below) and a veritable gallery of twenty-one contemporary male portraits.

Although this scene, too, is set within grandiose classical-style architecture, both the architecture and the biblical event at its center are overwhelmed by the portrait figures that crowd in from both sides. Nearly all can be identified, thanks to a list compiled in 1561 at the request of a Tornabuoni family member. An elderly gentleman with an excellent memory, who had seen and known the people in the painting, named them all. The men are dressed in the sober robes of honorable citizens and holders of public offices, as they are the leading statesmen and elders—the political elite—of the Florentine republic.

The group at lower left shows figures in half length, as if to indicate they're less important than the now forgotten political big shots shown at full length above them. But the half-length figures in animated conversation include some of the most eminent intellectuals of Renaissance Florence: the philosophers Marsilio Ficino and Cristoforo Landino, theologian and Medici family tutor Gentile Becchi, and poet-scholar Angelo Poliziano, the latter easily recognizable from other portraits by his enormous nose.

The episode to the left of the *Annunciation to Zacharias* is the *Visitation*, the joyful encounter of the pregnant Mary with her cousin Elizabeth, the future mother of John the Baptist. The scene takes place in front of a wall painted in deeply receding perspective and with the spires and buildings of Florence visible in the background. Of the eight female onlookers, two are tentatively identifiable portraits. The woman on the far right edge, wearing the dark robes of a widow, is probably Lucrezia Tornabuoni, Giovanni's sister, who had died in 1482. She was the widow of Piero de' Medici and the mother of Lorenzo the Magnificent. The regal young woman on the right, gorgeously dressed in the same style as Tornabuoni's daughter Lodovica in the *Birth of Mary*, is Giovanna degli Albizzi, the first wife of Tornabuoni's son Lorenzo. She can be positively identified through an independent portrait of her, also by Ghirlandaio. The couple had married in 1486 and in 1487 she gave birth to Giovanni's first grandson, who bore his grandfather's name. By the time Ghirlandaio painted her here, she had already died, in 1488, from complications of a second pregnancy. The fresco thus serves as a memorial to the two women: one a Tornabuoni by birth and the other by marriage.

Like the scenes from the life of the Virgin, the subsequent scenes from the John the Baptist cycle contain fewer portraits and less of Ghirlandaio's own work as the cycle rises toward the vaulting. In the second register, however, the scene of the *Birth of John the Baptist* resembles the Birth of Mary in the cycle on the opposite wall, although the birth room is somewhat less ornate. In the

foreground a wet nurse suckles the newborn Baptist and a young woman in fluttering garments hurries in from the right, with a *desco da parto* (birth tray) laden with luscious fresh fruits balanced on her head. The young Tornabuoni woman at the center of the composition remains unidentified, although she's as finely dressed as Lodovica Tornabuoni and Giovanna degli Albizzi, and therefore she must be a family member. The subsequent scenes in the cycle— the *Naming of John the Baptist*, the *Preaching of the Baptist*, the *Baptism of Christ*, and the *Feast of Herod*—are largely the work of Ghirlandaio's assistants and contain no portraits.

It's worth noting that these scenes do more than present biblical episodes and contemporary portraits. They also reflect the distinct roles assigned to men and women in the Renaissance. The portraits of austerely dressed Florentine men appear in public spaces, as they are the serious political protagonists and economic energies of the city. The opulently dressed and bejeweled women, in contrast, mostly occupy the private spaces of the home, a world concerned with marriage and childbirth.

The scene of the *Annunciation to Zacharias* is of particular importance. On the lowest level where it can be most easily seen, it contains three Latin inscriptions. A frieze to the left, just above a group of four older men deep in conversation, displays words from Isaiah 49: "The Lord has called me from the womb." In the apse behind Zacharias and the angel runs a frieze containing a text from Psalm 141: "Let my prayer be like incense duly set before Thee." But the most significant text here has no biblical source, and it may have been composed by Angelo Poliziano. Above a segment of a stone arch at the upper right and painted to look like an ancient Roman carved inscription are these words: "In the year 1490, when the most beautiful of cities, famed for its deeds, victories, arts, and buildings, enjoyed wealth, health and peace."

In these inscriptions the public and private, the political and personal, the sacred and secular, all converge. "The Lord has called me from the womb" refers to John's prophetic mission, but it may also allude to Tornabuoni's own pious sense of election and entitlement. The Psalm text, "let my prayer be like incense duly set before Thee," refers both to Zacharias's plea to God for offspring and to Tornabuoni's own hopes that his offering of this sumptuous chapel will find favor with God. The final, entirely secular inscription gives the date for the completion of the frescoes, as well as expressing Tornabuoni's civic pride and his optimistic belief in the continued greatness and prosperity of Florence.

Chapter 13

The MUSEO DEGLI UFFIZI

THE BUILDING AND SOME HIGHLIGHTS OF THE COLLECTION

HISTORY OF THE BUILDING

Aside from its status as a museum, one of the oldest and most renowned in Europe, the Uffizi is also among the architectural masterworks of Renaissance Florence. The name Uffizi comes from the Italian word *uffici*, which means "offices" and refers to the building's original purpose. Commissioned in 1560 by Duke Cosimo I de' Medici to gather under one roof all the numerous tribunals, archives, and magistrates' offices of the ducal administration, and thus to concentrate power near the Palazzo della Signoria, it was built from a design of Giorgio Vasari.

But the origins of the Uffizi go back to 1546, when Cosimo initiated an ambitious plan to transform the neighborhood. He had a long straight street cut through the crowded district between the Palazzo della Signoria, a portion of which he had recently adapted for his living quarters, and the Arno River. The original plan approved by Cosimo called for a building that would have eliminated, among other structures, one of the most important buildings associated with the medieval Florentine government: the Loggia dei Lanzi, or Loggia della Signoria, as it was known at that time.

Just before construction was to begin, Cosimo changed his mind and rejected the plan, having decided to spare as much of the surrounding neighborhood as possible, preserving not only the Loggia della Signoria but also the Mint and the ancient church of S. Pier Scheraggio. He called on Vasari to come up with a new design. Although better known in his own time as a painter, and

in ours as the first biographer of Italian artists, Vasari produced a handsome, original plan, creating a narrow U-shaped four-story structure with two long wings that extend from the Piazza della Signoria all the way to the Arno River, linked at the far end by a short façade that faces the river, with a corridor above and a triple archway on ground level. The courtyard is not a yard at all but preserves Cosimo's street between the two wings. The wings remain open on the short side that connects the building with the Piazza della Signoria.

Vasari's plan didn't require as much demolition and expropriation of property as the previous plan, and it better integrated the Uffizi into its urban context. Cosimo was perfectly capable of being autocratic, but he was also a shrewd enough politician to know when it was important to show respect for the city's traditions. By preserving buildings closely associated with the Florentine republic of past centuries, he could demonstrate that he honored the city's communal heritage. The new building would embody the general welfare of the state and not merely Cosimo's own convenience in having his *uffici* next door to his residence.

From the start, Duke Cosimo planned to use the *piano nobile*, one floor above ground level, for the display of important works from the Medici art collections, a project carried out by his son and successor, Duke Francesco. Over the years, other parts of the building also became display spaces for works commissioned or collected by the Medici. When the dynasty died out in the eighteenth century, the last Medici heiress willed the family's treasures in the Uffizi to Florence, in perpetuity, thereby founding one of the first modern museums. It opened to the public in 1765.

Today, the *uffici* of the vanished ducal regime are long gone, and the entire, vast building is devoted to the display, storage, and conservation of art. The Uffizi owns thousands of works of art, most—although not all—of them collected by generations of the Medici family. Its holdings include not only panel paintings, in particular those created during the Italian Renaissance, but also a variety of sculptures and many frescoed ceilings.

Beginning in the 1300s, Florence was part of an international mercantile and banking network that led to all kinds of cultural exchanges, which eventually enriched the collections of the Uffizi. A Medici bank representative in Bruges sent home to Florence one of the greatest works of fifteenth-century Flemish painting, the *Portinari Altarpiece* by Hugo van der Goes, which several centuries later found its way to the Uffizi. Gifts from diplomats and prelates courting Medici favor, the dowries of Medici brides, and inheritances

from both Italian and international marriages of the Medici dukes enlarged the collections still further. Duke Ferdinand II (1621–1670), for example, inherited Titian's *Venus of Urbino* from his wife, Vittoria della Rovere, a member of the ducal family of Urbino.

So much art, too little time! Although the Uffizi contains one of the greatest art collections in the world, going through it can sometimes seem like an attempt to consume at one sitting an Italian meal with an infinite number of courses. Just to look at—never mind appreciate—such an enormous amount of art in a single visit is impossible. But there are ways to survive the Uffizi without developing a case of aesthetic indigestion.

The secret is to be selective. Don't try to see, or even glance at, everything. The works discussed below represent only an extremely small fraction of the museum's collections; obviously there are many other works of great interest as well, and visitors are free to look at any that engage their interest, but those included here are among the most famous and fascinating. And they're all works that include intriguing combinations of religious, political, and sexual meanings. With one exception, the works discussed appear in chronological order, which is the same order in which the viewer will encounter them in the numbered galleries of the museum. The one exception is the work of the Venetian master Titian discussed here, his *Venus of Urbino*, which is about a decade earlier than the Florentine painter Bronzino's portrait of Eleonora di Toledo. Since the galleries devoted to Venetian painting follow those containing the works of Florentine artists, however, Titian's work is the last one covered.

UCCELLO'S *BATTLE OF SAN ROMANO*

Paolo Uccello's *Battle of San Romano* bears no resemblance to the bloody reality of an actual battle—it looks more like the illustration of a fairy tale or a decorative tapestry. Known for preferring the study of perspective to sex (he's supposed to have rejected his wife's suggestion that he come to bed in favor of consorting with his "sweet mistress," perspective), the artist here indulged his peculiar passion to the point of obsession. But there's more to the *Battle of San Romano* than is evident at first glance. Embedded in this seemingly fantastic work—where armor and headdresses are ceremonial, combatants' splintered lances fall precisely on the lines of the perspective grid, and horses' bodies form segments of perfect circles—are fragments of actual history, and

Uccello, *Battle of San Romano*, Galleria degli Uffizi. Erich Lessing / Art Resource, NY

a political significance powerful enough that struggles for possession of the painting were almost as fierce as the battle it portrays.

The panel in the Uffizi, signed by the artist, is one of a set of three; the other two are in the Louvre, Paris, and the National Gallery, London. Although they don't form a continuous visual narrative, they were created as an ensemble. All three show incidents from the battle of San Romano, which took place on June 1, 1432, when the Florentine forces confronted the Sienese. For many years scholars assumed that Cosimo de' Medici had commissioned the paintings, since the hero of the event is the condottiere Niccolò da Tolentino who (as noted in Chapter 2) was a friend and ally of Cosimo. Furthermore, the paintings appear in the inventory of the contents of Palazzo Medici, compiled after the death of Lorenzo il Magnifico in 1492, and they were hung in an impressive ground-floor room used by Lorenzo to conduct state business. Although these factors were long assumed to be conclusive evidence of a Medici commission, new material brought to light in 2001 proves that the works were instead commissioned by a Medici supporter in Florence, Lionardo Bartolini Salimbeni, probably in the late 1430s. They came into the possession of Lorenzo de' Medici only around 1484.

The actual battle of San Romano was still recent history at the time Uccello received the commission. It was part of a larger ongoing struggle between Florence on one side and Lucca along with its allies Siena and Milan on the other, a struggle in which Lionardo Salimbeni played a part. Although he'd enjoyed a modestly successful political career in Florence, his highest achievement was his membership on the city's ten-man war council (*dieci di balia*), the body that oversaw the war that included the battle of San Romano. Commemoration of the Florentine victory would have provided an obvious motivation for commissioning the paintings.

Another series of events also occurred in the mid- to late 1430s that may have further increased Lionardo Salimbeni's interest in the battle. In 1433, Cosimo de' Medici helped negotiate an end to the war with Lucca, a war that had cost Florence an enormous amount of money while fomenting a lot of civic unrest and bringing little in the way of territory. Shortly after the truce, Cosimo's enemies, led by Rinaldo degli Albizzi, succeeded in having Cosimo arrested and later exiled. Cosimo was accused of paying Niccolò da Tolentino and his soldiers in order to set himself up as a tyrant rather than to serve the republic. The Albizzi regime, distrustful of Tolentino because of his Medici connections, sent the condottiere off to fight in support of Bologna against

Milan, apparently hoping he might be killed in combat. Instead, his troops lost the battle and Tolentino was captured by the Milanese. In Florence, the defeat caused an uproar and strong criticism of the Albizzi regime. Voices began calling for the return of Cosimo de' Medici.

In 1434 Cosimo returned from exile, and he quickly consolidated his power as the behind-the-scenes ruler of Florence. In 1435 Niccolò da Tolentino died while a prisoner of the Milanese. At the request of the Florentine government, Milan returned his body to Florence for burial, but the Medici-dominated government did more than just inter Tolentino—they gave him an elaborate funeral, buried him in the cathedral, and some years later sponsored a painted monument there to his memory. Perhaps Salimbeni concluded that a series of paintings of the battle of San Romano that showed Tolentino as its hero would be a reminder of a glorious moment in a conflict that had included all too few such moments. It would be a fitting episode to decorate his newly renovated home (he had just remarried), since it would both commemorate his own part in the victory and advertise his support for the now firmly established regime of Cosimo de' Medici.

It's not easy to figure out the relationship between Uccello's panels and the actual battle, since what took place on the battlefield is no longer clear, and Uccello hardly qualifies as an objective illustrator. The artist relied on written (and possibly oral) reports on what had taken place and then used his imagination to fill in the details. Several contemporary chroniclers left descriptions of the battle that vary widely, depending on the writer's biases. One, who disliked the Medici, described Tolentino as "foolhardy" and claimed that when the battle went against him the craven condottiere burst into tears and had to be rescued by his co-commander. Another writer, Neri di Gino Capponi, cast Tolentino as the hero of the battle, although his account may be colored by his having been one of the Medici supporters who had hired Tolentino. Matteo Palmieri, also a Medici partisan, penned a fuller account shortly after the battle took place. He describes it in some detail and praises Tolentino for both bravery and strategic skill, making him the individual most responsible for the Florentine victory—which was announced in Florence that same day, when according to Palmieri, "a holiday was celebrated and the exultation of the common people was beyond measure." Palmieri's account may have provided Uccello with some of the details that appear in his paintings. For their part, the Sienese claimed they hadn't done too badly in the encounter, and they refused to concede a Florentine victory.

The Florentine government, though, clearly considered Tolentino's exploits a victory worth celebrating. A year later, in 1433, when we might think that interest in this less than crucial battle had faded, the distinguished Florentine scholar and political leader Leonardo Bruni delivered an oration. Speaking in Tuscan rather than Latin, so everybody could understand him, Bruni delivered his speech in the Piazza della Signoria in the presence of government officials, ordinary citizens, and the guest of honor himself, Niccolò da Tolentino. He praised Tolentino in glowing terms for his service to Florence, comparing him to the great ancient Roman generals, the highest compliment the scholarly Bruni could offer. Bruni hailed Tolentino as the defender of Florence's liberties against the duke of Milan. The Sienese, against whom Tolentino was fighting, were allies of the Milanese and so, by extension, Tolentino was defending democratic, republican Florence against the aristocratic tyranny of Milan.

It appears that the Medici looked very positively on all this glorification of Tolentino's defense of the republic. Beginning with Cosimo, the fifteenth-century Medici rulers of Florence were eager to associate themselves with the republic, so it's clear that Cosimo must have approved of casting his friend and ally Niccolò da Tolentino as a republican hero. Given Tolentino's subsequent death at the hands of the Milanese, which occurred after Cosimo's brief exile and triumphant return to Florence, Cosimo may have been willing to see the condottiere considered a martyr in the cause of Florentine liberty. With this in mind, Lionardo Salimbeni's multiple motivations for commissioning Uccello's series of paintings become clearer—he could please himself with some handsome additions to his home while also pleasing the most powerful man in Florence by making a hero of the man they'd both been involved in hiring to defend the liberties of Florence.

The panel in London shows Niccolò da Tolentino launching an attack on the enemy; the Louvre panel displays the arrival of Tolentino's co-commander Michelotto da Cotignola, and the Uffizi episode shows the unhorsing of a figure usually identified as Bernardino della Ciarda, the condottiere who had defected from Florence and who now led the Sienese troops. According to contemporary chronicles, though, this incident never took place, since della Ciarda prudently kept his distance from the field of battle. Perhaps the figure represents the defeated enemy, in general, rather than any identifiable individual. The warrior's white horse rears at the center of the composition, with a Florentine lance thrusting the darkly armored rider from the saddle. Other horses fall about, turn away, or fling up their rear legs, their abdomens and

hindquarters forming those segments of circles so beloved by Uccello.

If the central figure in the Uffizi panel really does represent della Ciarda being unhorsed, it would be a fitting counterpart to the more faithful condottieri, Niccolò da Tolentino and Michelotto da Cotignola, celebrated in the other two panels. In the open countryside in the background a dog chases rabbits that flee in all directions—a mocking and easily understandable reference to the defeated enemy and a further reason to conclude that the unhorsed warrior may represent della Ciarda, the leader of those scattered Sienese forces, no matter whether he was actually present during the battle.

How Lorenzo il Magnifico got hold of these paintings in the 1480s is not a pretty story, but it offers a rare glimpse of the ruler of Florence using something close to brute force to acquire certain works of art. After Lionardo Salimbeni's death in 1479, his sons launched complex efforts to claim parts of his estate, but the issues became so contentious they consumed several years without any resolution. Finally, family members called upon the head of the Medici family, Lorenzo il Magnifico, to act as the principal executor and to settle the problems—not an unusual request, and one of many similar ones addressed to Lorenzo, who had a reputation for fairness in such matters.

The Salimbeni heirs must have been rudely surprised by Lorenzo's behavior in this case, however. As Il Magnifico looked over their inheritance, he expressed a strong interest in acquiring Lionardo Salimbeni's three panels of the *Battle of San Romano* by Uccello, probably because of their connection with the Medici family through Cosimo's sponsorship of Niccolò da Tolentino. Lorenzo may already have been familiar with the paintings, since the Medici had enjoyed the Salimbeni family's hospitality in the past. Lorenzo "persuaded" one of the Salimbeni heirs, an employee of the Medici bank in Milan, to give him the portion of the series he'd inherited (the man was no doubt afraid of losing his job if he refused), but when Lorenzo encountered resistance from the owners of the rest of the series, he resorted to an uncharacteristically open display of power. He sent a group of his own workmen to the Salimbeni's Florentine palazzo where, in the dead of night, they forcibly removed the remainder of the large paintings (each 6 feet high by 10.5 feet wide) and carried them to Palazzo Medici. One suspects the men involved in this act of artistic piracy were not your average servants but, rather, strong-arm types hired for the occasion, as they were led by a well-known and presumably burly woodworker named Francione (Big Frank), whose job it must have been to pry the paintings out of their settings without damaging them.

What could Salimbeni's sons do when the ruler of Florence walked off with a portion of their inheritance? Nothing, as it turned out, at least not while Lorenzo was alive. After 1483 the panels disappear from the Salimbeni inventories, so we assume that 1484 was the year they entered the Medici collections. The fact that no one in the Salimbeni family made any attempt to reclaim the panels until after the Medici had been exiled in 1494 is a clear indication of Lorenzo's enduring power. The Salimbeni were part of the patronage network maintained by the Medici, and they knew better than to defy their padrone and his family.

One obvious reason that Lorenzo was so eager to acquire Uccello's *Battle of San Romano* series is that the paintings represented a historic military victory closely associated with his own family; his grandfather Cosimo had been a key figure in both the financing and the planning of the war during which the battle took place, and its hero, Niccolò da Tolentino, had been a close associate of Cosimo's. Furthermore, the large ground-floor room where Il Magnifico displayed the paintings originally had been used by Cosimo as a place to conduct the group meetings and one-on-one encounters where the real economic and political business of Florence took place.

Lorenzo used the room for similar though not identical purposes. It was there that he welcomed foreign dignitaries into his home. Although he sometimes kept his fellow Florentines waiting for hours in the courtyard of the Palazzo Medici, important foreigners—diplomats and rulers from Italian states and abroad—gained quick admittance to this politically potent room adorned with scenes of hunts and battles. In a grand room, surrounded by the artistic achievements of Florentine artists and with Uccello's imposing panels reminding those who entered of Florentine military prowess (more fiction than fact), Lorenzo could present himself to his foreign visitors as a ruler whose political power equaled that of any prince.

BOTTICELLI'S *DEL LAMA ADORATION OF THE MAGI*

One way an affluent man could repay the Medici for favors granted was through flattering portrayals of leading members of the family in a work of art, and this was the route taken by an otherwise obscure individual named Guaspare di Zanobi del Lama. Around 1475 he hired Botticelli to paint an Adoration of the Magi that later decorated his funerary chapel in S. Maria Novella. The panel is a small but beautifully realized work that contains an intriguing collec-

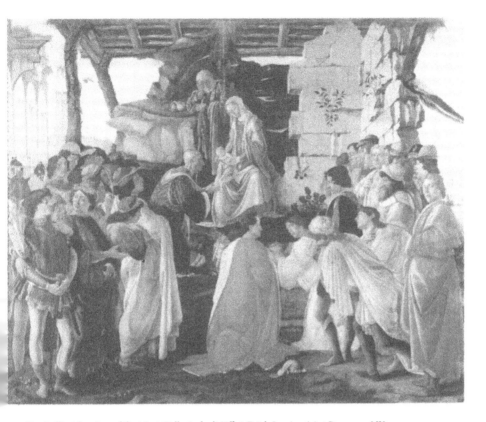

Botticelli, *Adoration of the Magi*, Galleria degli Uffizi. Erich Lessing / Art Resource, NY

tion of portraits. Along with del Lama himself, there's an assertive self-portrait of the artist, as well as several portraits of Medici family members.

The dispensing of patronage—in the form of political favors, financial assistance, business advantages, employment opportunities, professional advancement, dowry funds and marriage negotiations, written recommendations, or just a word dropped into the right ears—was a cottage industry for members of the Medici family, and the dense network of people indebted to them was among the family's principal sources of power. In return for their efforts, the Medici received the personal gratitude and political support of those they assisted. Although we don't know what help the Medici gave del Lama, a man of humble origins (his father was a barber) and a somewhat shady reputation, we know he somehow became a successful broker and a fellow member with the Medici of the Guild of Money Changers and Bankers. Why del Lama chose to

include Cosimo de' Medici and his two sons Piero and Giovanni, who were all dead by the time the work was painted, is uncertain. Perhaps those elders had given del Lama the assistance that enabled his financial success. Clearly, del Lama wanted to make sure the Medici knew how grateful he was, and he no doubt intended his tribute as a way of assuring continued good relations with Florence's most powerful family.

Although the painting measures only 3.5 by 5.5 feet, it was a perfect size for del Lama's small chapel, long ago destroyed, which was squeezed in against the inner wall of the church of S. Maria Novella, to the right of the main door. Several factors explain the subject chosen. The del Lama chapel was dedicated to the Epiphany (Adoration of the Magi) because the patron's name, Guaspare, is an Italian form of Caspar, one of the Three Magi. But there's another and equally important reason for the choice of subject: it was a favorite of the Medici family. The story of the Magi decorates one of Cosimo de' Medici's private cells at the monastery of San Marco as well as the Medici Palace chapel, and male members of the family were active in the prestigious Company of the Magi, one of Florence's major religious confraternities.

In his biography of Botticelli, Vasari mentions the existence of three Medici portraits in del Lama's *Adoration of the Magi*. He identifies the elder Magus, who tenderly kisses the Child's foot, as a portrait of Cosimo (d. 1464) and, kneeling on the right in the guise of the youngest Magus, Cosimo's younger son, Giovanni, who died in 1463. But Vasari misidentified the middle-aged Magus, in red at the lower center of the scene, claiming the figure is a portrait of "Giuliano de' Medici, the father of Pope Clement VII." That's impossible, as Giuliano was barely twenty years old at the time the work was painted. The middle-aged Magus is more likely a portrait of Cosimo's older son, Piero, who died in 1469.

Even if we assume these are posthumous tributes to Medici family members who had helped del Lama, it still seems odd that Vasari, having misidentified the middle-aged Magus as Giuliano de' Medici, made no mention of any portrayal in the painting of Giuliano's older brother, Lorenzo, the head of the family and the ruler of Florence in 1475. We might expect that Lorenzo would have a prominent place in a composition where the Medici have literally *become* the Magi.

The absence of any mention by Vasari of Lorenzo and his mistaken identification of Giuliano has not stopped modern scholars from speculating on which figures among the spectators might be correctly identified as Lorenzo and Giuliano de' Medici, although there's little agreement on which figure

represents which brother. Several scholars identify the cocky youth portrayed leaning on his sword in the extreme left foreground as Lorenzo; another claims Lorenzo is the serious-faced man portrayed in profile, third in on the left, wrapped in a long, pale-blue robe trimmed with gold and staring raptly at the Virgin and Child. Giuliano is sometimes thought to be the young man in red and black, shown at half length and in profile on the right, just next to the kneeling Magus identified by Vasari as a portrait of Giovanni de' Medici.

Several objections can be made to these identifications. Although scholars who identify the youth on the far left as Lorenzo claim he's recognizable by his distinctive facial features, the young man portrayed is handsome—the opposite of Lorenzo, who was notoriously homely. That distinctive face bears a much closer resemblance to portraits of Giuliano than to any portrait of Lorenzo. Furthermore, for Botticelli to have given Lorenzo's features to the frivolous young dandy who gazes off into the distance, and who seems so inattentive to the Adoration that two companions have to call his attention to it, would hardly have been taken as a compliment by the ruler of Florence.

Giuliano, on the other hand, was much handsomer than his brother but less powerful and less deeply involved in politics. Perhaps kept away from the center of power by Lorenzo, Giuliano was the perfect young gentleman of leisure, a bachelor devoted to hunting, athletic pursuits, and attentions to women. His friends called him *il principe della giovinezza*—the prince of youth. His reputation for romance may have some relevance to the suggestive pose of the youth on the left, with his sword pommel propped prominently in front of his groin. This is the kind of visual pun Giuliano might have enjoyed, but which would have insulted Lorenzo, who was married and more discreet about his love affairs.

Where *is* Lorenzo, then? A good guess is that he may be the more mature man in black and red who remains modestly to one side, among the group on the right but a little apart from them, with his head slightly bowed and his eyes lowered, his profile silhouetted against the wall behind him. Without in any way spotlighting him, the space around the man's head subtly draws attention to him. His dark skin and jet-black hair accord well with contemporary descriptions of Lorenzo. The plant growing out of the wall near him is sometimes identified as laurel (*lauro* in Italian), a play on the name Lorenzo that also appears in the poetry of the Medici circle. If informed of del Lama's artistic plans, which he probably was, Lorenzo may have asked not to be displayed too prominently. Such calculated modesty, no doubt learned from his grandfather

Cosimo, would have made good sense in the mid-1470s, when Lorenzo was still learning his role as head of the family and behind-the-scenes head of state.

A further reason to identify this figure as Lorenzo is the presence, just behind him and to the right, of an elderly man with white hair who gazes out at the viewer and points to himself. This is most likely Guaspare del Lama, who was well into his sixties when he commissioned the work. If Guaspare aspired to remain in the good graces of the Medici, what better way of demonstrating his continuing loyalty than by having himself shown right next to the current head of the Medici family?

We might suspect that Guaspare was a bit startled, though, when the painting was delivered to him, and he noticed the bulky blond man in a gold-colored cloak on the far right, who stares arrogantly outward, a pendant to the aristocratic-looking youth with a sword on the left side. Although Vasari says nothing about it, the figure is usually taken to be Botticelli's self-portrait. Even though it's not common to find the painter shown more prominently than his patron, perhaps Guaspare was practicing some Medicean modesty.

Despite the emphasis on portraiture in the scene, Botticelli never forgot that he was portraying a religious subject. The elevated setting for the Holy Family emphasizes their difference from the ordinary mortals around them and replicates the position of the altarpiece itself, which would have been positioned above the altar of del Lama's chapel. The event takes place in a shed constructed on an outcropping of rock, with ruined masonry on the right and the weedy remains of an ancient Roman arcade in the left background. Crumbling classical architecture was a traditional symbol of the old pagan order shortly to be replaced by Christianity. A hole in the roof allows the gold rays of the star of Bethlehem to enter the shed and fall on the Christ Child.

Vasari comments at some length on Botticelli's portrayal of the oldest Magus, noting the deep emotion displayed by the elderly man "as he kisses the foot of Our Lord with wonderful tenderness and conveys his sense of relief at having come to the end of his long journey." The elder Magus does not hold the Child's foot directly in his hands but has covered both of Christ's feet with a veil that drapes around his own shoulders, an action imitating that of a priest at the benediction of the Sacrament, when he covers his hands with a veil to hold up by its foot the vessel, called a monstrance, that contains the Eucharist, the body of Christ, for the adoration of the faithful. Cosimo de' Medici, whose portrait Vasari identifies in the person of the old Magus, was one of the rare laymen granted papal permission to keep a consecrated host in his chapel,

an indication not merely of Cosimo's piety but of his power and exceptional status in the Florentine community. Along with the other presumed portraits of the Medici family, the identification of the eldest Magus with Cosimo can be seen as an instance of religious imagery that reinforces both the impression of Cosimo's deep piety and the reality of Medici political power.

BOTTICELLI'S *PRIMAVERA*

"Venus, that is to say, Humanitas, is a nymph of excellent beauty, born of heaven and beloved by God. Her soul and mind are Love and Charity, her eyes Dignity and Generosity; her hands Liberality and Magnificence; her feet Comeliness and Modesty. Her whole form is Temperance and Honesty, Charm and Splendor. My dear Lorenzo, a nymph of such nobility has been wholly given into your hands! If you were to marry her and claim her as your own, she would make sweet all the years of your life."—Letter of Marsilio Ficino to Lorenzo di Pierfrancesco de' Medici, ca. 1477

"[T]his enchanted world, permeated by mute music, silent song."—Paul Barolsky, 2000

When the distinguished Florentine intellectual Marsilio Ficino penned a letter to his fourteen-year-old pupil Lorenzo di Pierfrancesco de' Medici, he wasn't advising the young man about his love life but, rather, urging on him the study of philosophy. By identifying the Humanities with the goddess of erotic love, perhaps he hoped to make studying more attractive to the boy, as well as showing him the value of *humanitas*, the sum of all the fine qualities most valued in a Renaissance gentleman. Ficino personified this abstract concept through Venus, with each part of her body standing for a virtue that his pupil should strive to attain.

About five years later, in 1482, someone—we still are not certain who—gave Lorenzo di Pierfrancesco an extraordinary wedding gift, which at times has been interpreted in terms of Ficino's letter as the world's most beautiful painted philosophy lesson: Botticelli's *Primavera*, or Springtime. Today, though, the belief that the painting is merely the visual equivalent of Ficino's letter is no longer accepted; instead, art historians regard the work as both a poetic and sensual dreamworld and a complex symbolic statement that reveals different levels of meaning to different viewers. Nevertheless, disagreement persists about how the painting should be understood. Scholars have cited a variety of possible sources for its imagery, ranging from rarified intellectual texts to

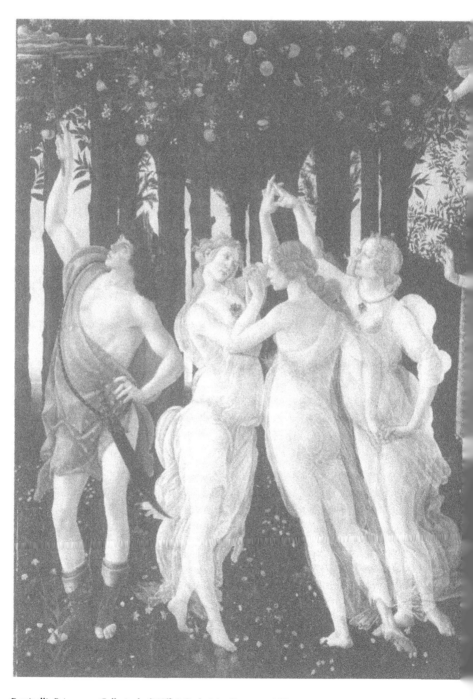

Botticelli, *Primavera*, Galleria degli Uffizi. Scala / Art Resource, NY

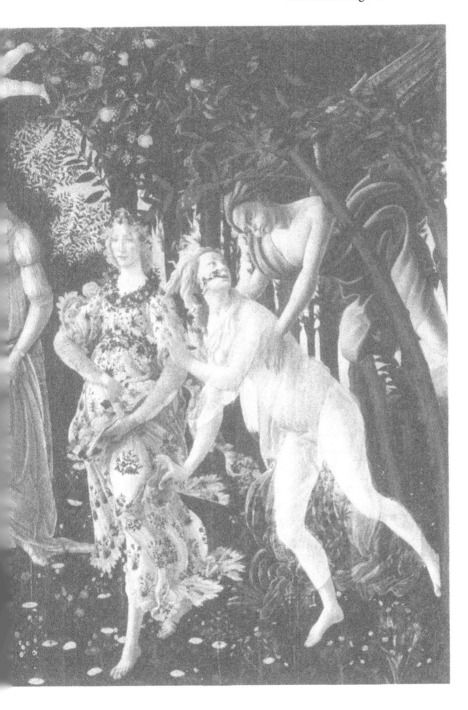

poetry, marriage manuals, and popular pamphlets on astrology. There's no doubt that the painting is rich in literary, familial, political, sexual, religious, and mythic associations, but as one present-day scholar commented wryly, the painting "has been affected by an obvious crisis of over-explanation." We should remember, however, that none of the evidence is definitive—the painting may celebrate marriage, in general, and its importance for family continuity rather than any one particular marriage.

Arguments also continue about who commissioned the work, for what purpose, and at what precise date, although a good case can be made that the painting was commissioned around 1480 by Lorenzo il Magnifico as a wedding gift for his young second cousin Lorenzo di Pierfrancesco de' Medici, an orphan who had grown up surrounded by art and classical culture in the home of Il Magnifico. We know that the elder Lorenzo arranged the marriage of his youthful ward, and that his reasons were political. The bride, Semiramide degli Appiani, was the sister of Jacopo IV degli Appiani, the lord of Piombino and Elba, and the Medici needed the military and economic support of the Appiani family. Lorenzo di Pierfrancesco, though still in his teens, was the only available Medici bachelor who'd reached a minimum age for marriage; in the early 1480s the male children of Lorenzo the Magnificent were still too young. Lorenzo di Pierfrancesco appears to have been less than pleased by the arrangements made on his behalf, and he professed indifference to his upcoming nuptials, so the gift of such an extraordinary painting by a favorite Medici artist may have been part of the elder Lorenzo's efforts to placate the young man.

Visitors to the Uffizi are often spellbound by the beauty of the *Primavera* but mystified by its enigmatic content. The individual figures and groups of figures have no apparent relationship to one another. Although reading the painting from left to right as if it were a written text enables us to identify the figures, all from classical mythology, this fails to produce a coherent narrative. On the far left is the god Mercury, clad in a rose-red cloak and recognizable by his winged sandals and caduceus (a staff intertwined with serpents), which he holds in his right hand and uses to dispel clouds that might disturb the painting's idyllic atmosphere. Next to him the Three Graces, classical embodiments of beauty, perform a sinuous dance, their long blonde hair and gauzy white garments rippling around them.

At the center stands a modestly clothed Christianized Venus, whose rose-red cloak echoes the color of Mercury's garb, reminding us of the connection between those two planetary deities. We might mistake Venus for the Virgin

Mary rather than the goddess of sexual love but for the presence of the winged and blindfolded Cupid who hovers above her, aiming his fire-tipped arrow at one of the Graces. Although Cupid's paternity remains uncertain, in some versions of the ancient myth he was the child of Venus's affair with Mercury. On the right side is the only real narrative: the wind god Zephyr, puff-cheeked and blue-skinned, pursues the nymph Chloris, from whose mouth issues a stream of flowers as she is transformed into Flora, or Primavera, the flower-bedecked personification of Spring. The exquisite figures inhabit a lush, shadowy garden where dark green trees laden with oranges form a backdrop, and flowers carpet the grassy meadow.

The work abounds in painted images that most likely refer to the Medici family. The round golden fruit would have suggested to fifteenth-century Florentines the well-known family emblem of the Medici: the *palle*, six red or gold balls on a shield. Around the figure of Zephyr the orange trees give way to laurel, *lauro* in Italian and traditionally in the Medici family a reference to the name Lorenzo. Among his activities in classical myths, Mercury bore a special responsibility for doctors; the Italian name Medici means doctors, and the god's serpent staff is still the symbol of the medical profession.

The myth of Zephyr and Chloris, Greek in origin, comes to us from the Roman poet Ovid, who describes the month of May by telling the story of Flora, whose feast the ancient Romans celebrated in early May. Ovid relates how Zephyr, the west wind, pursued Chloris, the nymph of fields, and how, at his touch, she was transformed into the far more splendid Flora. After capturing her, Zephyr raped her, but eventually he regretted his lustful excess and married her, making Flora the mistress of flowers and the patroness of springtime. There can be little doubt that Botticelli illustrates this story on the right side of his painting. The flowers streaming from the mouth of Chloris blend into the flower-embroidered dress of Flora, which in turn melts into the flowers of the meadow, creating an almost cinematic sequence, an imaginative visual translation of a verbal description.

But what relationship exists between this ancient nature myth and the rest of the painting? Poetry and philosophy from the Medici circle in Florence may offer some clues, but they don't provide a definitive explanation. Many of the poems composed by Lorenzo the Magnificent and his friend Angelo Poliziano evoke the gods and spirits of the ancient world, and they abound in evocations of springtime and love. We don't need to assume that Botticelli

read Ovid in the Latin original, since either Lorenzo or Poliziano could have suggested Ovid's story as a starting point for Botticelli's images, perhaps along with handing over copies of their own poems. But it's also possible that the artist never intended to illustrate a narrative—the painting can be seen as a series of loosely connected poetic "stanzas" about springtime that don't produce a continuous story line. Botticelli was a creative spirit, a visual poet, who possessed an unparalleled ability to transform words and ideas into unforgettable painted images.

The philosopher Ficino interpreted Venus as Love in its broadest sense—as that which both gives physical life and has the power to soar beyond the senses, into the realm of the intellect and the spirit. Although Ovid doesn't mention Venus or Mercury in his telling of the Primavera story, the goddess of love was associated with spring because she presided over growth, flowering, and fertility. In ancient Greek art Mercury often appears as the leader of the Graces, a connection that survived into the fifteenth century. Even though the figure of Flora-Primavera has given her name to the painting, the central placement of Venus, the halo-like circle of light that surrounds her head, her hand gesture of regal invitation, and her gaze directed at the viewer all suggest that she may hold the key to the work, welcoming the viewer into her magical springtime garden.

The resemblance of Botticelli's Venus to the Virgin Mary surely isn't accidental. From the center of her garden of love, Venus presides over her classical court as a haloed queen, very much as Mary—pictured in religious art as the Queen of Heaven—presides over the celestial Garden of Paradise. Even the relationship between Zephyr and the nymph he's pursuing may have a quasi-religious dimension. A close look at the face of Zephyr reveals fine gold lines representing his breath as it flows from his mouth to that of Chloris. Religious paintings of the Annunciation often show the progress of the Holy Spirit toward Mary the same way: as golden rays of light that extend from the Dove to Mary. But unlike the Angel Gabriel, who is merely the messenger, Zephyr takes physical possession of Chloris, though Botticelli wouldn't have dreamed of showing an actual rape. Instead, in one of the most ingenious and daring details of the painting, he may be illustrating what art historian Paul Barolsky calls an imaginative form of oral sex: as the personification of the spring wind, Zephyr impregnates Chloris by blowing into her mouth. And her mouth, in turn, gives birth to her new, transformed self: beginning as a stream of flowers, Chloris becomes Flora.

Another way to understand the painting is through the seasonal imagery that pervades it. Spring begins when Zephyr transforms Chloris into Flora and brings forth the first flowers. The Graces dance in celebration of the season, while Venus and Cupid remind us that spring is the time of love, fecundity, and their consequence—procreation. Venus is the astrological deity who rules the spring season from April 21 through May 21, just as Mercury rules the later spring, from May 22 through June 21, the first day of summer. Although today few people take astrology seriously, in the Renaissance it was still considered by many to be a valid science. Ficino wrote about it extensively, and in the early 1500s Pope Leo X, a son of Lorenzo the Magnificent, endowed a Chair of Astrology at the University of Padua.

Clearly, a painting as dense with visual imagery as this one doesn't appear out of nowhere. In addition to its relationship to religious traditions and classical mythology, the work is also part of a Tuscan tradition of depicting the Garden of Love, a subject featuring Venus as the central figure that's often depicted on birth trays—a popular gift to new mothers—and other objects related to marriage and childbirth. In that context the function of such imagery is clear: Venus brings love, and love brings marriage and children.

The elegant, courtly qualities of the painting may be related to the festivals sponsored by Lorenzo the Magnificent, celebrations that formed an important part of Lorenzo's political activity. Botticelli was directly familiar with those events, as he's known to have produced banners and other decorations for them. Such pageants, performed by gorgeously costumed members of the city's elite but intended for everyone to enjoy, were part of the Medici family's long-standing political program of keeping the common people happy by keeping them entertained. May Day celebrations were particularly elaborate.

Although the *Primavera*, a private commission, wasn't meant as a public political statement, even paintings of mythological subjects may have a political dimension. The unusually large size of the painting (nearly seven feet high and more than ten feet wide) places it on a scale with other large paintings owned by the Medici: Uccello's series of battle pictures and the now lost Labors of Hercules series by the Pollaiuolo brothers. It's easy to see how scenes of battles and heroes might be used to support the Medici political agenda, but a celebration of fertility and procreation that implies the continuation of the family dynasty could have formed another part of the same agenda.

Mythic stories about the season were also a way of linking Florence to its classical past and the city's contemporary life—to the peace and prosperity

that Lorenzo wished to associate with his reign. The hundreds of flowers scattered about in the painting as well as their personification as Flora remind us that the name Florence means "flowers," and that the city's cathedral was dedicated to St. Mary of the Flower. If Il Magnifico himself commissioned the painting as a gift to his ward on the occasion of the younger Lorenzo's wedding (uncertain, but possible, even probable), then such a reminder would not have been out of place.

The youthful Lorenzo di Pierfrancesco might have drawn further from Botticelli's painting the moral that passionate physical love, the province of youth and Springtime seen in the Zephyr-Chloris-Flora myth, is transformed by the influence of Ficino's "heavenly" Venus and the chaste Graces into a higher, more mature, and more spiritual love that is ultimately the love of God. By this route, classical deities could be revived in a Christian context, because they're no longer dangerous pagan gods but have been transformed into benevolent symbols and personifications with Christian significance.

Since the work was most likely a gift to Lorenzo di Pierfrancesco on the occasion of his marriage, the work also may be related to the marriage customs and beliefs of the time. According to a Medici inventory of 1498–1499, the work hung over a *lettuccio*, or daybed, in a ground-floor room of Lorenzo di Pierfrancesco's town house, an older dwelling next door to the famous Palazzo Medici in Florence. The painting's theme of fertility and procreation would make it an appropriate decoration to be placed over a bed, and although a daybed isn't the same as a marriage bed, it could have been a place where, in the evening after the servants had gone to sleep, the young couple could doze, dream, and perhaps even make love, under a picture of the enchanted garden of Venus, the goddess of love.

Along with whatever philosophical inspiration and sexual stimulus the painting provided for the groom, it may have conveyed very different messages to the bride. Italian Renaissance marriage manuals endlessly repeat the ideal behaviors expected of an upper-class wife: chastity, submissiveness, and childbearing. Chastity refers to the necessity that the bride be a virgin at her marriage and that she maintain a demure appearance and virtuous behavior as a wife. Submissiveness was essential because aristocratic marriages were political and economic alliances between families, not love matches, and the bride, usually between fourteen and sixteen years old, had little say in choosing her husband, and an ironclad obligation to obey him.

The manuals further emphasized that for women the purpose of marriage was procreation, and that the wife's pleasure, happiness, and satisfaction must come from childbearing and motherhood. Art historian Lillian Zirpolo relates each of these lessons for the bride to Botticelli's *Primavera*. She sees the Three Graces as personifications of the ideal behavior of a Renaissance wife: chaste, demure, graceful, and decorous. She interprets Flora's smile and Venus's contented expression, as well as the bulging abdomens of the two women, as expressions of their satisfaction with motherhood. In seductively beautiful painted form, the work may offer a lesson in female familial duty.

Zirpolo further relates the story of Zephyr and Chloris to a more alarming aspect of Renaissance marriage manuals, all of them written by men: they find the origins of marriage in the story of the mass kidnapping and rape of the Sabine women by the Romans. That tale, one of the fundamental myths of ancient Rome, claims it was necessary for the Romans, who had a severe shortage of women in their own tribe, to carry off the women of the Sabine tribe, against the women's will, in order to marry and procreate with them, thus saving the Roman race. Renaissance brides were instructed to submit to their husbands for similar reasons.

Zephyr and Chloris, viewed from this perspective, take on quite a different meaning. Zephyr becomes truly menacing, and Chloris becomes a frightened and defenseless woman, the panic-stricken prey of a determined assailant. For the Renaissance bride, the lesson was clear: resistance to her husband's will was both futile and dangerous, but submission to him would bring the rich rewards embodied in the contented and literally flourishing Flora. It's easy to imagine Semiramide degli Appiani—probably no more than fifteen at the time of her marriage, but already well schooled in proper behavior for her important new role as a Medici wife—having little difficulty in absorbing the message *Primavera* held for her.

How should modern viewers, both male and female, regard this many-leveled work? Today, few people of either sex read the Roman poems and Renaissance philosophical treatises that provided Botticelli with his material. Even fewer women would want anything to do with marriage manuals that celebrate kidnapping and rape as a model for the beginning of a happy marital union. Perhaps the best option is to acknowledge the work's various possible meanings to its Renaissance viewers and then to step back from those meanings and appreciate the painting for the deep spell cast by the sheer physical beauty of Botticelli's painted forms: the palette of rich, muted colors, now

restored after a recent cleaning; the elegant, studied poses of the figures; the rich patterns of curving, interlocking lines and intricate surface patterns that resemble the tone-painting and complex, interweaving voices of a Renaissance madrigal. To appreciate such musical magic, we don't need to understand every last one of the words; and to appreciate Botticelli's visual magic, we don't have to accept—or even understand—every idea that his images convey.

In the end, the *Primavera* leaves us with more questions than answers. The fact that several centuries of scholarly efforts have not provided any definitive answers to what the painting means should alert us to the possibility that the work was never intended to have just one meaning. Perhaps the very elusiveness of its meanings and the many possible interpretations of its imagery were all part of the "game"—the intellectual exercise so enjoyed by the artist's sophisticated clientele. As a contemporary of Botticelli commented about the meaning of one of the artist's works: "Some give one explanation and some another; no one is of the same opinion, so that it is the most beautiful of painted images."

BOTTICELLI'S *BIRTH OF VENUS*

"From the midst of the sea there emerged a divine face of an appearance worthy of veneration even by the gods. Then gradually I saw the whole shining figure rising out of the sea. Her hair, most abundant in its richness, flowed yieldingly about her divine neck in slight curves, fluttering luxuriously."—Apuleius, *The Golden Ass*

The *Birth of Venus* is Botticelli's most famous and beloved painting, a marvelous mixture of classical mythology, Renaissance poetry, and Christianity, fused by the artist's ability to transform even the most unpromising material into magically beautiful images. As told by the ancient Greeks, the birth of the goddess of erotic love is a gory family saga that features infanticide, parricide, cannibalism, and castration. And yet, Botticelli's charmed brush purges the final chapter of the story of all such associations and turns it into a triumph of elegance and delicacy.

Unlike Botticelli's *Primavera*, the *Birth of Venus* may not have been a Medici commission. Although at a later date both paintings belonged to Duke Cosimo I de' Medici, the original patron of the *Birth of Venus* is unknown. The two works are not a pair and most likely never hung next to each other as they do today in the Uffizi. The *Birth of Venus*, probably from around 1485,

is painted on canvas rather than on a wood panel, and it is somewhat smaller in its dimensions, although the figures are larger. The central figure is Venus, here newly born from the sea foam and wafted to shore on a pale pink shell by the breath of the winged wind god Zephyr, shown cozily entwined with Chloris, the nymph of flowers whom he had abducted in Botticelli's slightly earlier *Primavera*.

The ancient Greek story of the birth of Venus begins at a much earlier moment than the one Botticelli shows. Back in the shadowy beginnings of the world, the father god Saturn ruled by terror. Warned by some primal instinct that his children would eventually kill him, he developed the nasty habit of eating each of them as they were born. But the various mothers managed to save a few of their offspring, and eventually a group of the god's children rebelled against him and killed him. Fearing that his powers would survive even death, they dismembered their father's corpse and castrated him, flinging his genitals into the ocean. But the grisly old god was so prodigiously fertile that his severed genitals mated with the sea foam, and the unlikely result of that union was Venus.

Not a trace of the legend's savagery remains in Botticelli's painting. His source wasn't the ancient myth itself but one of the retellings that appeared during the Renaissance. Perhaps Botticelli had read *The Golden Ass*, an ancient Roman novel that appeared in an Italian translation in 1469, which contained a more refined description of the birth of Venus, or perhaps he'd read Renaissance poems that treat the subject with equal delicacy. In any case, Botticelli's sophisticated patron—whoever this was—wouldn't have been satisfied with a slavish copy of a literary text.

Botticelli met the challenge brilliantly. He does not show the actual birth of Venus but, rather, the moment of her landing on shore. For the pose of his Venus he used the classical *Venus pudica*, or modest Venus type, where the goddess appears with one hand covering her breasts and the other concealing her sex, an image that appears in Italian art as early as the 1300s. Although ancient Roman statues show Venus as a mature and worldly woman unconcerned with being seen in the nude, Botticelli portrayed the goddess as a wistful, virginal-looking girl sincerely interested in preserving her modesty. She uses the curling streams of her long, taffy-blonde hair, lightly touched here and there with gold pigment, to conceal her nakedness, and she looks more than ready to receive the flower-embroidered pink cloak in which an attendant on the right side of the painting is about to wrap her. The latter—

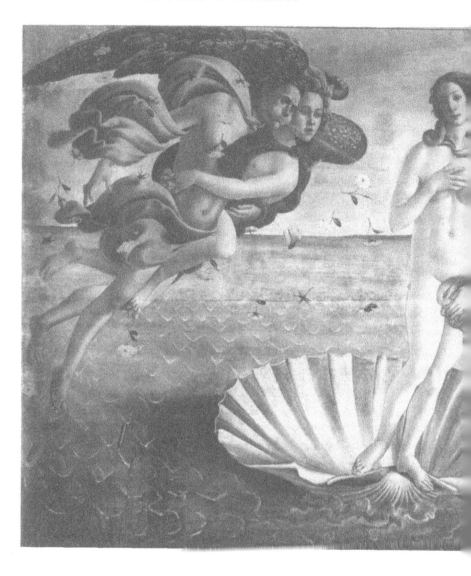

identified as one of the *Horae*, or Hours of the Day, in classical mythology among the attendants of Venus—hurries toward the goddess with the grace of a dancer, her garments and the cloak she carries billowing around her body.

Despite similarities of pose, Botticelli's Venus bears little resemblance to a classical goddess. Her body is oddly shaped, with an elongated neck, sloping shoulders, circular breasts, high waist, and thick ankles, and yet such is the authority of Botticelli's style that most viewers barely notice these aberrations.

Botticelli, *Birth of Venus*, Galleria
degli Uffizi. Erich Lessing / Art
Resource, NY

Instead, the artist enchants us with the gentle melancholy of Venus's face, the sinuous play of line in her abundant hair, and the contrast of her simple, somehow modest nudity with the complex draperies of the clothed female attendant on the right and the decidedly carnal tangle of Zephyr and Chloris on the left.

Behind the figures are a body of water and a landscape. The trees on the far right have absolutely straight, parallel trunks touched, like the strands of Venus's hair, with highlights of gold. The waves of the chalky green sea

form perfect little V-shapes or, closer to the shore, swirl into prominent patterns of foam that more closely resemble lace than water. Considering the circumstances of Venus's birth, the artist was no doubt aware that the Italian word *schiuma*, which can mean "sea foam," was—and still is—slang term for semen. A flat blue sky provides the kind of summary background that caused Leonardo da Vinci to accuse Botticelli of creating landscapes by throwing a sponge at his pictures. But realism wasn't Botticelli's goal. The flat, almost tapestry-like composition is part of the painting's magic, creating a dreamlike atmosphere in which the figures seem to float.

Modern viewers familiar with the ghastly Greek myth of the origins of Venus are sometimes puzzled by the determination of Renaissance humanists and art patrons to ignore that aspect of the legend. But despite the enthusiasm for classical culture that prevailed in elite circles in Florence in the late 1400s, it was still a Christian society, and stories such as the birth of Venus required some reinterpretation before they were considered fully fit for Christian consumption.

The group of humanist scholars who gathered around the Medici family included several whose ambition was to reconcile classical culture with Christianity—a tall order, given such stories as the birth of Venus and numerous others that enliven Greek and Roman mythology. Nonetheless, the philosopher Marsilio Ficino, one of the most talented of the group, offered a reinterpretation of the story of the birth of Venus that was rarified enough to satisfy even the most sensitive Christian minds. He suggested that we shouldn't take the story literally but, instead, should interpret it symbolically. The birth of Venus, he declared, is really about "the birth of beauty in the human mind, fertilized by divinity." The idea that beauty can be born in the human mind only when that mind is "fertilized" by God is certainly a most imaginative transformation of the Greek myth of the ocean impregnated by the severed genitals of Saturn.

The possibility that the painting can be interpreted on more than one level, and that the literal meaning is perhaps the least important, is an approach that would have appealed to Botticelli's highly educated and cultured circle of patrons, a group that included poets, linguists, and philosophers as well as wealthy merchants and bankers like the Medici family. As noted in the essay about Botticelli's *Primavera*, the same Marsilio Ficino who came up with the ingenious reinterpretation of the birth of Venus had also written to Lorenzo di Pierfrancesco de' Medici in enthusiastic terms a few years earlier, equating Venus with *humanitas*, a concept embodying all the desirable traits of a

Renaissance gentleman. In Ficino's flexible philosophical categories, Venus could also personify ideal beauty—and beauty, according to Plato, is identical with truth. Still adapting Plato, Ficino claimed that the contemplation of earthly beauty could lead the soul upward to divine beauty and ultimately to the contemplation of God. With these ideas in mind, it would be inaccurate to conclude that Botticelli's painting is purely pagan in its subject matter. Although it tells the pagan story of the birth of Venus, the painting is also resonant with Christian meanings.

On the visual level Botticelli made his own references to Christianity. For members of his cultured Renaissance audience the modest pose of Venus and the running female figure on her right would bring to mind paintings of both the Baptism of Christ and the Annunciation to Mary that they'd seen as altarpieces in churches. As if to emphasize the latter parallel, Botticelli often used the same face for his images of Venus and the Virgin Mary, providing a vivid illustration of another idea of Ficino's: that both Venus and the Virgin Mary are emanations of Divine Love, with Venus representing its earthly aspect and Mary its heavenly one.

According to a charming but unprovable legend, Botticelli fell in love with the famous Florentine beauty Simonetta Cattaneo, the wife of a compliant fellow named Marco Vespucci and reputed to be the favorite mistress of Il Magnifico's younger brother, Giuliano de' Medici. As a result of Botticelli's infatuation, it is supposedly Simonetta's lovely face that appears in the artist's paintings of the goddess of love and the Virgin Mary, including the *Birth of Venus*. Several portraits by Florentine artists, said to be of Simonetta, reveal an attractive young woman, but one who lacks the ethereal loveliness of Botticelli's Venuses and Virgins, whose appearance no doubt owes as much to the artist's imagination as to his alleged passion for Simonetta.

There's something about the dreamy, otherworldly beauty of Botticelli's work that has given rise to all kinds of misconceptions about the artist, extending even to his name. The nineteenth-century English art critic and esthete Walter Pater used to repeat the name "Botticelli" over and over, enchanted by the sound of it. The unromantic truth is that Alessandro di Filipepi (the artist's baptismal name) had a portly older brother, Giovanni, a successful pawnbroker whose friends nicknamed him "Il Botticello," the Little Barrel. Since the young Alessandro appears to have been raised in his brother's home, it was natural that people would begin to refer to the boy as "Sandro del Botticello," which in time became the more familiar Botticelli. A

possible picture of Botticelli as an enthusiastic partygoer emerges from a playful poem by Lorenzo de' Medici, devoted to Florence's best-known drinkers. The following ditty, a portion of that poem, may refer in punning terms to the artist:

> Botticelli, little barrel . . . Where'd they get the "little" from?
> Cramming food and talking nonsense; fat and full and quite at home.
> Here to lunch and there to dinner, never misses, never doubt.
> He's Botticelli on arrival, and full to the brim goes rolling out.

The picture of the artist that emerges from Lorenzo's affectionate lines suggests a man who enjoyed good food in good company, but it appears that Botticelli may have been part of the Medici intellectual circle as well, an unusual honor in an era when most artists were still treated like servants or tradesmen. Where else, if not from these intellectuals, would Botticelli have acquired his sophisticated and detailed knowledge of classical mythology and its possible levels of meaning? Botticelli may have listened to and perhaps even participated in wide-ranging discussions of the dialogues of Plato, ancient Roman poetry, and classical mythology, as well as the efforts to reconcile all of those with Christianity. But the written works produced by the scholars of the Medici circle are little read today, except by specialists. Only Botticelli possessed the gift of turning their ideas into ravishing visual images.

It appears that the Medici valued Botticelli as both a painter and a loyal supporter of their regime. In the aftermath of the Pazzi Conspiracy of 1478 they called upon him to produce "disgrace pictures"—portraits of the bodies of the hanged conspirators, painted on the exterior walls of the city hall, a commission that must have left the sensitive artist shuddering but which he executed without hesitation. Although the payment—the considerable sum of forty gold florins—came from the government, there's little doubt that Lorenzo the Magnificent was behind the choice of a painter and his generous remuneration.

For all his success with the Medici and other wealthy clients in the 1470s and 1480s, Botticelli outlived his own popularity. During the later 1480s Florence fell under the spell of the fanatical Dominican preacher Fra Girolamo Savonarola, who railed against the city's materialism and the fascination of its intellectuals with pagan ideas and attitudes. He urged the Florentines to burn their "vanities"—jewelry, tapestries, paintings, luxurious clothing—in a huge bonfire in front of the city's cathedral. Lorenzo de' Medici died in 1492, in some accounts begging on his deathbed for Savonarola's blessing, and two years later

the family that had so consistently patronized Botticelli was forced into exile.

According to Vasari's report, Botticelli became such a dedicated follower of Savonarola that he repented of his interest in classical subject matter and later gave up painting entirely. Here too, legends have replaced less dramatic facts. Botticelli continued to paint for various clients into the early years of the 1500s, although he was no longer in such great demand. His later works took on an austere appearance, and his subject matter became exclusively religious and moralistic. We may believe Vasari's sad description of the aged Botticelli, crippled and impoverished at his death in 1510. The world the Medici had nourished, where pagan ideals coexisted with Christianity and where Botticelli's *Primavera* and *Birth of Venus* had found success, was gone from Florence, and Botticelli was by then too old and ill to participate in its spectacular revival in Rome in the 1500s.

HUGO VAN DER GOES'S *PORTINARI ALTARPIECE*

"And there were in that same country shepherds abiding in the fields, keeping watch over their flocks by night. And lo, the angel of the Lord came upon them, and the glory of the Lord shone round about them, and they were sore afraid. And the angel said unto them, Fear not, for behold, I bring you glad tidings of great joy, which shall be to all people. For unto you is born this day in the city of David, a Savior, which is Christ the Lord. . . . And suddenly there was with the angel, a multitude of the heavenly host, praising God and saying: Glory to God in the highest, and on earth peace, good will to men."—Luke 2:8–14

Certainly the strangest—and some would say the most profound and powerful—image of the Nativity of Christ ever painted is a work created by a troubled Flemish artist for an ambitious and unscrupulous Florentine patron. Today this huge, somber painting, which combines a Nativity with the Adoration of the Shepherds, occupies a prominent place in the Uffizi, looking odd in a room filled with lyrical panels by Botticelli.

The painting is the *Portinari Altarpiece*, the masterwork of Hugo van der Goes, the leading painter of Flanders (present-day Belgium) in the second half of the 1400s. It takes its name from the man who commissioned it: Tommaso Portinari, a well-connected Florentine financier in charge of the Bruges branch of the Medici bank. The descendent of a long line of wealthy bankers, Tommaso was something of a protegé of Cosimo de' Medici, who had raised Tommaso

Van der Goes, *Portinari Altarpiece* (Nativity and Adoration of the Shepherds), Galleria degli Uffizi. Scala / Art Resource, NY

and his two brothers in his own home. All three brothers later assumed positions of responsibility in the Medici banking empire. In 1470 the forty-year-old Tommaso married the fifteen-year-old Maria Baroncelli, who also came from a rich Florentine banking family. Their union produced six children, born in rapid succession between 1471 and 1477.

But behind the dignified exterior of the respectable banker and family man Tommaso Portinari beat the daredevil heart and ruthless greed of a pirate. Although mutual trust and friendship among associates lay at the heart of the Medici banking organization, Portinari was always ready to tie his own financial fate, and that of the bank he represented, to the unreliable destinies of an array of aristocratic debtors. Both Tommaso's original employer, Piero de'

Medici, and Piero's son and successor as head of the Medici bank, Lorenzo il Magnifico, warned Tommaso against making loans to royalty. Princes, kings, dukes, and courtiers, they reminded him, had no respect for contracts made with commoners, and money loaned to such individuals was all too often lost.

By ignoring his employers' advice, Tommaso at first amassed extraordinary wealth and power through his position with the Medici bank in Bruges. Today a quaint medieval relic in the midst of modern Belgium, Bruges in the 1400s was one of the richest cities in Europe, a seat of the glamorous and extravagant court of the dukes of Burgundy. Tommaso Portinari was a favorite of both Duke Philip the Good, who died in 1467, and his son Charles the Bold, because of his willingness to lend them enormous sums of money. When

Charles was killed in battle in 1477, he was deeply in debt to the Medici bank.

Although, just as Piero and Lorenzo de' Medici had predicted, the ducal family defaulted on the loan, Portinari continued his reckless policies. Further loans to Charles's daughter Mary and her husband, Archduke Maximilian of Austria, also proved disastrous, resulting in the collapse in 1479 of the Bruges branch of the Medici bank. Portinari, who had cleverly managed to save most of his personal fortune while losing that of his employer, was fired in 1480 by a furious Lorenzo de' Medici. After prudently removing himself to Milan in the wake of the Bruges bank debacle, Tommaso continued his wheeling and dealing from there. A few years after the death of Lorenzo in 1492, Portinari returned to Florence, where he died in 1501.

In the mid-1470s, when Tommaso was married, the father of a growing family, and at the height of his financial success, he decided to commission an altarpiece. As befitted a man of wealth and social standing who wished to raise his status even higher, he chose the most famous artist in Flanders, the painter Hugo van der Goes, and ordered from him a work on a grand scale—the eight-by-ten-foot center panel is the largest single painting of its kind created in Europe in the fifteenth century. Not even the Medici could match that.

Like Portinari, Hugo van der Goes was no stranger to the rich and powerful, and he had executed commissions for the Burgundian court. But unlike the suave and sociable Portinari, Hugo was a moody and disturbed man. In 1478, just a few years after completing his work for Portinari and at the height of his own fame and success, he renounced the world and entered a monastery, but he failed to find there the peace that he sought. In 1481 he suffered a severe mental collapse, making repeated suicide attempts and claiming the devil was in possession of his soul. Mentally and physically broken, he died in 1482.

The altarpiece executed by the unhappy Hugo for Tommaso Portinari isn't likely to appear on a Christmas card. Not always an easy work to appreciate, it rewards those willing to look at it closely. It is unlike any other painting of the birth of Christ in its relentless insistence that the viewer confront the terrors as well as the joys inherent in the great mystery of faith celebrated at Christmas. Across the three panels that make up the altarpiece, Hugo wove a complex visual and symbolic fabric in which we perhaps can sense something of the crisis of spirit that would soon wrack the artist.

Flanking the central panel of the Nativity and Adoration of the Shepherds are two side panels containing portraits of the Portinari family and their patron saints, each with a background scene related to the Christmas story. But

in Hugo's hands, even these traditional scenes become vehicles for the expression of fear and uncertainty. In the left panel we see Tommaso Portinari kneeling with his two sons, Antonio and Pigello. Behind the diminutive figures of the donor and his children loom their patron saints, Thomas the Apostle and Anthony Abbot. Pigello was born while the work was in progress, and Hugo managed to squeeze him in, but there was no room for any further patron saints (in any case, there's no St. Pigello). Although Thomas makes a hand gesture toward Tommaso Portinari, both saints appear gloomy, distracted, and spiritually troubled. The disparity of scale between the donors and the sacred figures harks back to medieval practice, which is unusual in a work created in the latter part of the fifteenth century.

The barren mountain landscape behind them reveals Mary and Joseph on their way to Bethlehem. Mary, conspicuously pregnant, has dismounted from the donkey and seems hunched over in pain as Joseph grips her arm and regards her with anxiety. Here, Hugo's image borders on blasphemy, for he suggests that Mary was merely a human mother-to-be, exhausted and travel weary, suffering the discomforts of a long journey in the final days of her pregnancy. Although there are a few works of medieval devotional literature, such as the thirteenth-century *Meditations on the Life of Christ*, that portray Mary in a similar way, urging empathy with her condition, Hugo ignored generations of Christian writers who insisted on the wholly miraculous nature of Mary's pregnancy, along with the total absence of any of the normal pains and discomforts associated with childbearing.

On the right panel, Hugo's strange obsessions continue. In the foreground kneels a pale and hollow-cheeked Maria Baroncelli Portinari, with the couple's daughter, Margherita. Like Tommaso and the Portinari sons in the left panel, they seem dwarfed by their enormous, stern patron saints, Margaret and Mary Magdalene. St. Margaret stands atop a dragon of fearsome ferocity, and although according to legend Margaret defeated a dragon, this one seems very much alive. Its head, with huge gleaming eyes and long teeth, is right next to little Margherita, a startling and disquieting juxtaposition.

In the background we discover the Three Magi on their way to Bethlehem. But in contradiction of both the biblical text and every known legend, in Hugo's version of events it looks like the kings have gotten lost. Dressed like Burgundian aristocrats, they sit on their horses in the far background while one of their retinue appears to be asking directions from a toothless peasant. Behind this figure lurks another group of peasants so gaunt, starved, and

desperate-looking they bear a disturbing resemblance to modern concentration camp inmates. They stare at the richly dressed kings as if to suggest that murdering and robbing these overprivileged riders might be an excellent idea. The Star of Bethlehem, usually a prominent feature of scenes involving the Three Kings, is nowhere to be seen.

Even the somber and anxious mood of the side panels hardly prepares us for Hugo's treatment of the events in the center panel. Strange disparities of scale among the figures, odd spatial inconsistencies, weird lighting effects, unexpected contrasts of emotions, and the most complex symbolism to be found in any fifteenth-century painting of the Nativity, all combine to create a strange but compelling composition.

Viewers often viscerally feel the many tensions that pervade the panel. The figures of Mary, Joseph, and the shepherds are larger than life size, while the attending angels seem unusually small, a contrast repeated in the architecture. The massive column that separates Mary from Joseph looks inconsistent with the spindly shed it supports. The rationally constructed three-dimensional space we expect from a Renaissance painting is absent here, replaced by a sharply tilted foreground that seems to spill the contents of the painting into the viewer's space. Although this sharply raked angle may be related to the stage sets used in the presentation of mystery plays, religious dramas devoted to incidents in scripture such as the Adoration of the Shepherds, the visual effect remains startling to modern viewers.

Brilliant light fills the panel, not from natural sunshine but from the divine radiance that emanates from the body of the Christ Child. That same light illuminates the face of the angel floating above Mary with a phosphorescent glow, and it suffuses the foreground but leaves the depths of the stable in shadow, almost but not quite concealing a clawed, fanged demon that lurks there. In Hugo's mind, even the most sacred space isn't immune to invasion by the forces of evil.

To modern viewers, the least expected aspect of the *Portinari Altarpiece* is its mood or, rather, several moods. A deep, but restrained, silent sadness pervades much of the work: Mary, Joseph, and the angels contemplate the newborn Jesus as if they were witnesses to a tragic rather than a joyous Christian event. But the three shepherds who come barging into the painting from the upper right corner offer a complete contrast. Their forward motion and emotional intensity are so great that they disrupt the tableau of sober and motionless contemplation created by the sacred figures. They aren't charming,

picture-book rustics but rough, hulking, homely men transfigured by their encounter with divinity. The Annunciation to the Shepherds appears in the far right background, bathed in an eerie pale green light.

Viewers in the late 1400s would have been less surprised than we are by this interpretation of the Christmas story. The modern secularization of Christmas has caused many people to lose track of the other levels of meaning this holy day held for people in past centuries. For Hugo van der Goes in particular, the Christmas story was not one of unmixed jubilation. His joy, like that of the holy figures he represented, must have been tempered with sadness and foreboding, because throughout the scene he included symbols that remind the viewer of Christ's future role as sacrifice. These symbols are no longer as obvious as they were to people five hundred years ago, but once we become aware of them, the work reveals its message with great clarity.

Woven seamlessly into the structure of the painting, the symbols refer to the Eucharistic sacrifice—that is, to the Mass that would have been celebrated on the altar above which the painting originally hung. What might seem to us a beautifully painted, but irrelevant, still life of flowers in two vases in the center foreground is more than mere decoration. They speak in the now vanished language of flowers, still understood in Hugo's day: scarlet lilies symbolized the blood of Christ; the three carnations (called *nagelbloem*, or nail-flower, in Flemish) symbolized the three nails that held Christ to the Cross; the purple columbines with their drooping flowers stood for the sorrows of Mary, whose robe is the same color as the flowers; and the iris, whose Latin name is *gladiolus* (sword lily), referred to the prophecy in Luke 2:35, made to Mary while Jesus was still an infant: "A sword shall pierce through thy soul also." All these allusions to the sacrifice of Christ are made even more explicit by the sheaf of wheat just behind the flowers. This is a reference to the bread of the Eucharistic celebration. In the Gospel of John 6:51, Jesus referred to himself as "the living bread which is come down from heaven," and "the bread of life," adding that those who ate that bread would have eternal life.

Viewers today might also fail to pay much attention to the precise nature of the clothing worn by the angels in Hugo's panel. It took a present-day Jesuit priest to notice that all of them are robed in the vestments worn by the assistant ministers (archpriest, deacon, subdeacons, and acolytes) present at the first solemn high Mass celebrated by a newly ordained priest. But none of the angels wear the chasuble, the vestment of the celebrant, for here Christ himself is both celebrant and sacrifice: like a living host wafer he lies on a paten of light, wearing the chasuble

of human flesh. Hugo underlines the sacrificial role of Christ by eliminating the swaddling clothes and manger of the biblical narrative and placing the fragile, tiny Savior naked on the bare earth, directly above the symbolic sheaf of wheat. Little wonder, then, that the sacred figures respond with such solemnity.

Tommaso Portinari's personal reaction when Hugo delivered his immense altarpiece remains unknown, but we know that Portinari kept the painting with him until 1483 when, at great expense, he sent it home to Florence, to be placed on the high altar of the hospital church of S. Egidio, an institution founded some two hundred years earlier by Tommaso's ancestor Folco Portinari (the father of Dante's beloved Beatrice). The huge altarpiece was so heavy it required eleven men to carry it into the church. It created quite a stir among Florentine painters, who'd never seen anything like Hugo's detailed depiction of flowers and other objects or the stunning realism of his shepherds. A look at Ghirlandaio's *Nativity* of 1485 in the Sassetti Chapel of S. Trinita (discussed in Chapter 11) shows the impact of Hugo's work on a major Italian painter.

Although it would be almost two decades before Tommaso again laid eyes on the work, by having it set up in Florence while he was still in the bad graces of Florence's ruler, Lorenzo de' Medici, the disgraced banker could at least make a statement in absentia about his status as a Florentine citizen and art patron, thereby perhaps salvaging something of his ruined reputation and honor. Wholly religious in content, Portinari's altarpiece nonetheless has a significance that is in the literal sense *political*: through it the patron hoped to improve his status in the polis, or city-state, of Florence, a stature lost through his own rash and corrupt behavior.

RAPHAEL'S *POPE LEO X WITH CARDINALS GIULIO DE' MEDICI AND LUIGI DE' ROSSI*
DYNASTY, DESTINY, AND THE POLITICS OF RELIGION

The intricate and intimate connections of religion and politics in the Renaissance are never more numerous than in images of popes and prelates. Although many Renaissance portraits offer no clues to either the identities of the sitters or their motivations for commissioning a portrait, in the case of Raphael's masterly portrayal of Pope Leo X with two cardinals, we can dip into a rich trove of Renaissance history to fill out the political context, as well as the lives of the three men in the painting and the supremely gifted artist who immortalized them.

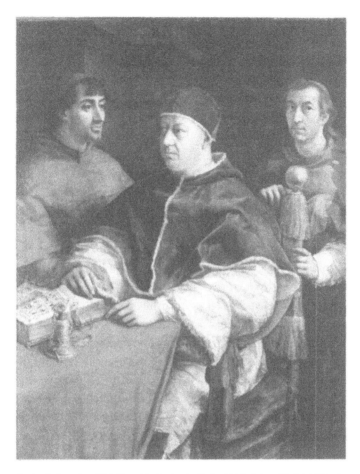

Raphael, *Pope Leo X Medici with Cardinals Giulio de' Medici and Luigi de' Rossi*,
Galleria degli Uffizi. Erich Lessing / Art Resource, NY

Always a consummate portraitist, Raphael was at the peak of his pow-
ers when, around 1517–1518, he created this image of Leo X Medici in the
company of two cardinals who are also his cousins.* Raphael had come to

* Although some otherwise reliable sources state that Giulio de' Medici and Luigi de' Rossi were the pope's
nephews, both were Leo's first cousins. They were the sons, respectively, of the brother and half sister of
Leo's father, Lorenzo il Magnifico. Giulio was the son of the pope's uncle Giuliano de' Medici, and Luigi
was the son of the pope's aunt Maria de' Medici. The three men were close in age; at the time the portrait
was painted the pope was forty-two, Luigi de' Rossi forty-three, and Giulio de' Medici thirty-nine.

Rome from Florence around 1509, called there by Pope Julius II. While Michelangelo labored almost alone, painting the ceiling of the nearby Sistine Chapel, Raphael, helped by a troop of assistants, frescoed the walls of several important rooms in the Vatican Palace. When Leo X succeeded Julius in 1513, the new pope soon sent the irritable, intimidating Michelangelo home to Florence to work on Medici projects there, but Raphael remained in his employ in the Vatican. Leo liked the gracious, diplomatic artist as well as the work he produced, and he must have been especially satisfied with this portrait, as he kept it among his personal possessions. After the pope's death it passed to another member of the Medici family, was later owned by Duke Cosimo I de' Medici, and except for a brief exile in Napoleonic France, it has always been displayed in Florence.

Raphael's genius in capturing the character of his sitters is on full display in what amounts to a dynastic portrait of Leo X and his two cousins. This is not the usual official papal portrait—we don't see the politically oblivious pope occupied with affairs of state, which interested him very little. Instead, he is about to examine, through a gold-framed magnifying glass, a splendid illuminated manuscript, a Bible opened to the beginning of the Gospel of John, perhaps in honor of the pope's baptismal name, Giovanni. Raphael depicted the page so accurately that the book has been identified as a manuscript now preserved in Berlin. Next to the manuscript sits a finely worked bell of gold and silver, topped with a red silk tassel. The brilliant rendering of textures—the shimmering dark-red velvet and lustrous white silk brocade of the pope's vestments, the glossy crimson silk of the cardinals' robes, the gleaming gold and silver of the bell, the magnifying glass frame, and the decorated manuscript page, as well as the differing skin tones of the three men—stands as evidence of Raphael's complete mastery of the art of painting.

Although the seated pope is at a slightly lower level than his two standing companions, Leo's large head and bulky, richly clothed body dominate the composition. Raphael succeeded in giving the homely and somewhat timorous pope a commanding, even majestic presence—his corpulence becomes an expression not of indolence but of authority. Contemporary sources report that Leo was extremely proud of his elegant white hands, prominently posed in the painting and without rings that might distract from their beauty. Those same sources also relate that the pope was severely myopic and that he could read only with the help of a magnifying glass. But Raphael knew better than to portray him squinting through the glass. Instead, Leo holds it, not like a

reader but like a connoisseur, ready to have a closer look at a work of art. Raphael often idealized his subjects, but this doesn't mean he made them better-looking than they were in reality. In this portrait the idealization consists of emphasizing the pope's attractive qualities and transforming his unattractive features into advantages that showcase his power.

How Giovanni de' Medici, Lorenzo il Magnifico's second son, became Pope Leo X is a story that reveals much about the problems facing the Roman Catholic Church in the fifteenth and sixteenth centuries. Born in 1475, since childhood Giovanni had been destined by his father for an ecclesiastical career, because Lorenzo believed that a presence in the highest echelons of the Church would be a great political advantage to the Medici family. The boy received his monastic tonsure at age seven, and by the time he was ten his father's tireless efforts had acquired dozens of benefices for him—income-producing Church offices that required no responsibilities. In 1489, after a great deal of pressure, bribes, and persuasion exerted on Pope Innocent VIII by Lorenzo de' Medici (actions that included giving his teenage daughter Maddalena in marriage to the pope's dissolute forty-year-old illegitimate son), the thirteen-year-old Giovanni was named a cardinal. His formal investiture was delayed until 1492, but even for that lax period the appointment was considered premature.

Although Giovanni had been educated by the finest minds in Florence and later studied theology and canon law at the university in Pisa, he'd also received a very different kind of education during his youth, when he learned to take for granted that all the benefits and favors at the disposal of the Church could be bought and sold though influence, barter, or gold and that this was perfectly normal. To enter the Church was not to begin a life dedicated to spiritual matters but to embark on something more like a profitable career in business or politics. His later inability to grasp that the trading or selling of Church offices, benefices, pardons, and indulgences was inappropriate—and could even be seen as sordid—is a reflection of what he'd experienced throughout his childhood, as he witnessed his father using every means at his disposal to assure his son's advancement in the Church. Perhaps some of the seeds of the Reformation sprouted in the garden of the Palazzo Medici.

After the death of his influential father in 1492, Giovanni's promising clerical career was nearly ruined by his older brother Piero, Lorenzo il Magnifico's successor as the unofficial head of the Florentine state. By 1494 Piero had made his family so detested in Florence that the people revolted and forced

the Medici to flee the city. Giovanni passed the next years in wandering exile, spending time at the court of Urbino, as well as in Germany, the Netherlands, and France. After the election of Julius II in 1503 and Cardinal Giovanni's return to Rome, the young prelate's career prospered, and he was able to contribute to the restoration of Medici rule in Florence in 1512.

At the death of Julius II in 1513, Giovanni de' Medici was elected pope, taking the name Leo in honor of the lion (*leone*) known as the Marzocco that was one of the symbols of Florence. But Leo X was no lion in his personality or his papacy. An easygoing, luxury-loving man only thirty-seven years old and not yet ordained as a priest at the time he assumed the papal office, Leo is supposed to have responded to his election by saying: "God has given us the papacy; now let us enjoy it." And enjoy it he did, filling the Vatican not only with artists, poets, and philosophers but also with actors, dancers, acrobats, animals (including an elephant) and their trainers, gourmet cooks, clowns, and courtesans.

To the relief of many both within and outside the Vatican, Leo X abandoned the aggressive militarism of Julius II, but he lacked his predecessor's energy and determination, and he failed to understand the seriousness of the religious unrest stirring in northern Europe. He dismissed Martin Luther's now famous protest of 1517—his posting on the church door in Wittenberg of the *Ninety-Five Theses* challenging the Church's sale of indulgences—as nothing more than "monkish squabbles" that would soon fade away. Raphael may well have been painting this work at the very moment Luther set off the spark that ignited centuries of religious resentments and led to the Protestant Reformation.

Fate had very different destinies in store for the two cardinals who attend Leo in Raphael's portrait. On our right, the tense and watchful Luigi de' Rossi meets the viewer's eye with a sharp, suspicious glance of his own. Born in 1474, he was the son of Lorenzo il Magnifico's illegitimate half sister, Maria, wife of Leonetto de' Rossi. Luigi had been raised and educated along with Giovanni de' Medici, and the two had become close friends. Leo made his cousin a cardinal in 1517, which indicates that the painting cannot have been begun before that year.

Rossi had reason to look nervous. He was one of thirty-one cardinals Leo created in 1517, an unusually large number to be appointed at one time. The explanation for the sudden expansion of the College of Cardinals was the uncovering of a plot by certain members of the Curia to assassinate the pope. After having the perpetrators executed or exiled, Leo decided it would be prudent to weight the College in his favor, and among those friends and

relatives he promoted was his cousin Luigi. Cardinal de' Rossi died in 1519, so Raphael's painting must have been completed before that date. Although Rossi accomplished little during his short life, his presence in the painting gives us a firm time frame for one of Raphael's masterpieces.

Cardinal Giulio de' Medici, the handsome, sad-eyed man on our left, was the illegitimate son of Lorenzo il Magnifico's brother Giuliano, who was murdered in 1478 during a plot against the Medici known as the Pazzi Conspiracy. Giulio was raised by Lorenzo among his own children, and he formed an especially close bond with the slightly older Giovanni. When Giovanni became pope in 1513, Giulio was one of the first cardinals he created. After serving his cousin in various capacities, in 1523 he was himself elected pope, as Clement VII. Expected to be at least competent, he instead proved to be among the most disastrous pontiffs in the history of the Church. His inept diplomacy and his inability to make decisions and stick to them brought down on the Eternal City in 1527 the worst attack since the barbarian invasions of a thousand years earlier: the Sack of Rome.

But those events—de' Rossi's death, the crises of the Reformation, the stormy papacy of Clement VII—were all in the future. Although we don't know the pope's precise motivations for commissioning this portrait, the fact that he chose to have himself portrayed in the company of two cousins who had been his companions since childhood, and whom he'd raised to the cardinalate, suggests he considered the work the clerical equivalent of a traditional dynastic portrait, an expression of his desire to have the Medici family remain as potent and enduring a force in the Church as they were in the Florentine state. Although the Medici coat of arms—six balls on a shield—doesn't appear in the painting, the brilliantly reflective gold knob on the back of the pope's chair serves as a reminder of the *palle*, a word that was also a rallying cry for Medici supporters.

The symbolic significance of the portrait as a stand-in for the pope is attested by its presence at several important Medici weddings in which the family of bankers who'd become rulers allied themselves with the aristocracy and even with royalty. Shortly after the painting was completed, it was rushed from Rome to Florence and given a prominent place at the festivities following the wedding in September 1518 of Lorenzo di Piero de' Medici, duke of Urbino and grandson of Il Magnifico, to Madeleine de la Tour d'Auvergne, a niece of King Francis I of France. The same portrait also occupied a place of honor at the wedding in 1533 of Alessandro de' Medici, the first hereditary duke of Florence, and Margaret of Austria, an illegitimate daughter of Emperor Charles V.

The most important appearance of the portrait was at the marriage in 1539 of Duke Cosimo I de' Medici and Eleonora di Toledo. Cosimo had obtained the painting shortly after he became duke in 1537, and in displaying it he paid homage to Leo X, his relative who had providentially fated him for fame and power by baptizing him with the potent name of Cosimo. He was named after the great Cosimo de' Medici of the fifteenth century, who had attained such authority and respect in Florence that after his death the city declared him *Pater Patriae*, the father of his country. By coincidence, one of Duke Cosimo's godparents, Cardinal de' Rossi, is also in the portrait.

Although Leo X proved no match for the wily German princes when it came to dealing with Martin Luther and his adherents, the major goal of his papacy had nothing to do with either international diplomacy or the religious conflicts in northern Europe. The pope's main interest was in supporting and consolidating the recently reinstated Medici government in Florence and in assuring the protection and advancement of Medici family members. In this quest he succeeded. Not only did his cousin Giulio eventually become the second Medici pope, but Giulio's illegitimate son Alessandro (fathered on an African slave some years before the future pope was named a cardinal) became the first Medici duke, the beginning of a dynasty that would endure for more than two hundred years.

BRONZINO'S *ELEONORA DI TOLEDO AND HER SON GIOVANNI DE' MEDICI*
THE FERTILITY GODDESS OF FLORENCE

"Cum pudore laeta foecunditas" ("Joyful fertility with modesty")
—Personal motto of Eleonora di Toledo

When you first encounter Bronzino's portrait of Eleonora di Toledo, it's easy to see why the artist's portraits with their icily off-putting stares can elicit in the viewer what the English writer Somerset Maugham described as "an unreasoning terror." This particular work still has the power to freeze you in your tracks. Such a frigid put-down of the viewer isn't often encountered in a painting, but in this work the artist has come close to turning a mortal woman into a divinity whose haughty look could kill. What kind of circumstances would require such an extreme transformation?

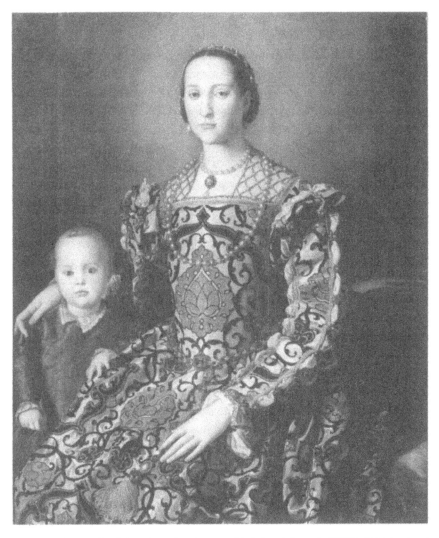

Bronzino, *Eleonora di Toledo and Her Son Giovanni de' Medici*, Galleria degli Uffizi. Erich Lessing / Art Resource, NY

In order to understand the intended impact of this portrait, the determination to present the sitter as a personage as distant, awe-inspiring, and inscrutable as a goddess, it can be helpful to keep in mind the Medici court for which it was created. As noted above, previous attempts to establish an enduring Medici dynasty had failed: Duke Lorenzo died in 1519 without a male heir, and Duke Alessandro, assassinated in 1537, fathered only illegitimate children. It

therefore fell to Duke Cosimo I to establish the first genuine aristocratic court in Florence, one that would reflect the hugely increased and now hereditary power of the Medici. Equally vital was the duke's obligation to produce enough children to guarantee the fulfillment of the family's dynastic ambitions.

The seventeen-year-old Cosimo de' Medici had come to power in perilous circumstances. After the murder of Duke Alessandro, the teenage Cosimo had been hastily appointed in Alessandro's place. Although the powerful elders of the city believed they could manipulate the boy duke into doing whatever they wanted, they were soon in for a great surprise. Within a few years this politically sophisticated son born from the union of the two branches of the Medici family had eliminated resistance to his rule, along with whatever remained of the persistent dream of an independent Florentine republic.

Among the first priorities of Duke Cosimo was the establishment of his own family as a genuine aristocratic dynasty, something previous generations of Medici had never succeeded in doing. Along with Cosimo's many astute political maneuvers, an important route to achieving this goal was through state portraits of himself and his wife that effectively expressed his dynastic ambitions. A portrait by Bronzino of Duke Cosimo—also in the Uffizi and hung near the portrait of Eleonora—shows the duke in armor. Despite his lack of military experience, the portrait cloaks him in the role of defender of the state and commander not only of his troops but of his subjects. In the right foreground is a traditional heraldic device of the Medici, dating back to the days of Lorenzo il Magnifico: a tree stump with a laurel twig sprouting from it, a way of visually suggesting the renewal of the Medici lineage, in this case through Cosimo himself.

But the only males who have ever given birth are gods—one thinks of Athena springing full-grown from the head of Zeus—so Cosimo could hardly reestablish the Medici dynasty alone. For this he needed a fertile wife, and he found her in Eleonora di Toledo. Cosimo probably first saw the thirteen-year-old Eleonora when he visited Naples in 1535, and although he continued his international efforts to find an appropriate wife, he never forgot the beautiful girl he'd glimpsed at the Neapolitan court. When offered her plain older sister as a wife, Cosimo refused, insisting he wanted Eleonora. He even turned down an offer from Pope Paul III, who suggested one of his granddaughters as Cosimo's consort.

But it wasn't only Eleonora's looks that captured Cosimo's attention. Ever aware of political considerations, he was intent on a marriage that would forge lasting political connections with the imperial family and important Spanish

nobility. In that regard, Eleonora's aristocratic pedigree was impeccable. She was a daughter of Don Pedro di Toledo, the immensely wealthy Hapsburg viceroy of Naples, and himself a member of the politically powerful Alba family of Spain. Through Eleonora's father, Cosimo could consolidate his ties with Spanish royalty, and thanks to Don Pedro's close connections with Charles V, the young duke would gain a protector in the person of the emperor.

Cosimo chose the right woman. In addition to her bloodlines and her beauty, Eleonora was young, energetic, and in excellent health. Although most aristocratic marriages of the time were unions of purely political convenience, Cosimo and Eleonora were a rare instance of a princely couple with a genuine, mutual passion for each other that expressed itself in both physical attraction and deep emotional attachment. They were also a model of mutual fidelity. As expected, Eleonora was a faithful wife, but what is unexpected is that while Eleonora was alive, Cosimo was a faithful husband—almost unheard-of behavior for a Renaissance prince. Between their marriage in 1539 and her death in 1562, Eleonora bore Cosimo eleven children. Although three perished in infancy and several more died in childhood, Eleonora gave Cosimo what he needed: a male heir, enough surviving children of both sexes to secure the family's position through advantageous marriages, and one son destined for a career in the Church, the child who appears with Eleonora in Bronzino's Uffizi portrait.

Agnolo di Cosimo di Mariano, known by the nickname Bronzino, was among the finest Italian painters of the sixteenth century and a leading exponent of the highly sophisticated, artificial style known as Mannerism. His portrait of Eleonora di Toledo is one of his greatest works. Bronzino first received Medici patronage in 1539, when he was among the artists who created the elaborate but ephemeral decorations for Cosimo's wedding to Eleonora. The duke, who understood how powerfully the arts could contribute to his political agenda, soon named Bronzino his court painter, a post the artist held for the rest of his life. Cosimo could not have made a better choice. No other artist so perfectly conveyed the pretensions to royal splendor and absolute authority, as well as the icy aloofness, of these newly minted Medici aristocrats.

The portrait of Eleonora with her son Giovanni was painted around 1545, when the boy was between two and three years old. The duchess was painted with her second son, rather than with the couple's oldest son and heir, Francesco, because Giovanni was important in a different way. As the son dedicated to the Church, he was the one Cosimo expected would be appointed a cardinal and eventually elected pope. After all, it had happened

before—Lorenzo il Magnifico's second son, also named Giovanni, had become a cardinal in his teens, and later he became the first Medici pope. Duke Cosimo's son Giovanni was made a priest in 1550, at age seven, and named a cardinal ten years later. Evidently, even the ecclesiastical housecleaning of the Catholic Counter-Reformation, which began in 1545 and was undertaken to combat the advance of Protestantism, hadn't yet made much headway in preventing powerful rulers from planting their sons high up in the Church hierarchy. But Giovanni died suddenly in 1562 when he was only nineteen, thereby ending his family's hopes of having a cardinal who might one day become another Medici pope. Already ill and overwhelmed by grief, Eleonora died a few months later.

Bronzino's portrayal of Eleonora with little Giovanni is far more than a family portrait, and there are good reasons why it so notably lacks maternal warmth or sentimentality. Along with the painting of the duke and his sprouting laurel tree, the work is less a record of likenesses or motherly attachment than an eloquent and elaborate image of fertility and dynastic ambition. As Gabrielle Langdon expressed it, the painting is "a tissue of expressions of Medici power, ideology, cultural hegemony, wealth, imperial affiliation, and moral superiority." Every aspect of the composition—and every detail, rendered with Bronzino's dazzling skill—is intended to convince the viewer of the validity of those claims.

The artist had no precedents for such an ambitious image of an aristocratic consort accompanied by a child, so it was up to him to invent a suitable one. Eleonora's personal motto, "joyful fertility with modesty," would have pointed him in the desired direction. Bronzino knew he had to emphasize Eleonora's modesty, chastity, and piety along with her fecundity, a combination that might seem contradictory to modern viewers but in that era a married woman's chastity did not refer to her abstinence from sex but to her fidelity to her husband. This remarkable image succeeds in conveying all of those qualities along with another central quality: power. The composition, showing Eleonora at three-quarter length and turned slightly to our left, with one arm around her son's shoulder and the other posed elegantly on her lap, is unique in Florentine painting of the period. She sits outdoors, apparently on a high, open loggia, which allows her figure to loom above the landscape and dominate it. Although the vague background often goes unnoticed, so hypnotic is the image of the duchess herself, it may allude to the territories that were part of Eleonora's dowry, the agricultural riches they provided, and her dominion over them.

Eleonora's lineage and its imperial connections provided Cosimo with an opportunity to express through this portrait an idea that was still foreign to his Florentine subjects, but one he intended to make more familiar to them: his God-given right to rule. Although Cosimo, a man of humbler origins than Eleonora's, didn't wish to identify himself directly with such a privilege, his wife proved the perfect vehicle to make the association. Sixteenth-century viewers of the painting were likely to notice the resemblance of this pairing of regal mother and young son to images of the Madonna and Child, enthroned "in majesty," to be seen in Florentine churches. Eleonora and Giovanni are furthermore posed against a deep-blue background—a color traditionally associated with the Virgin Mary—that lightens around Eleonora's head to form a natural halo. Such associations suggest the ducal couple's ambitions toward a divinely approved absolutism.

The elaborate and valuable jewelry Eleonora wears, some of it perhaps created by the great Florentine goldsmith Benvenuto Cellini, suggests vast wealth and even royalty. (A later inventory valued Eleonora's jewelry and clothing worn for one specific occasion at 300,000 scudi—the staggering sum of $10,500,000 in today's currency.) In Bronzino's painting, an exquisitely fine pearl-studded gold net covers her hair, and a thicker gold netting, also studded with pearls, covers her shoulders. At her throat she wears a short necklace of pearls from which hangs an enormous diamond set in gold, with a pendant pearl below it. Another rope of large pearls falls across her chest, and a heavy gold, chain-link belt set with an enormous topaz, rubies, diamonds, more pearls, and other stones encircles her waist. The belt ends in a swirling tassel composed of hundreds of tiny pearls that lies prominently displayed in her lap, at a spot near the lower edge of the painting that places the tassel directly between her knees. At the time the portrait was painted, Eleonora was already the mother of four children, and there's perhaps a hint of her husband's continuing potency to be discerned in the presence and location of that profuse cascade of "seed" pearls.

But what may be a subtle reference to ducal sexuality should not lead us to any similar ideas about Eleonora. There are no known portraits of Eleonora— and certainly not this one—that give her even a hint of sensual attractiveness. The rigid bodice of her dress encases her like a suit of armor and flattens her chest, evoking the impenetrable steel armor worn by Cosimo in his portrait, and keeping the spectator at a respectful distance. It never for a moment suggests the sensuous softness of confined female breasts, or the attractions

of rounded hips and abdomen. The ivory skin of Eleonora's face and hand also contribute to an air of stone-cold majesty. Armored against any possible lustfulness in the viewer's eye, a frigidly expressionless Eleonora offers not a hint of the private passion that surely colored and warmed her relationship with Cosimo. Only the little boy at her side reminds us of the procreative part of Eleonora's motto.

The artist's concentration on Eleonora's remarkable dress is also related to the idea of the portrait as an image of both fertility and power. Painted with Bronzino's typical virtuosity, the dress is of white silk with pomegranate motifs in black and gold brocade, which makes the duchess a permanent advertisement for Florence's luxury textiles, an industry that Duke Cosimo supported and promoted. The wearing of brocaded fabrics was in itself a sign of nobility and magnificence, and the pomegranate was an emblem rich in symbolic associations. The fruit is an ancient symbol of fertility, and the largest one appears directly over Eleonora's womb. It was furthermore an emblem of the Holy Roman Empire presided over by the Hapsburgs—the fruit's many seeds symbolized the unity of many nations under one authority. Emblazoned so prominently on her gown, the pomegranate reminds the viewer of Eleonora's fertility while at the same time proclaiming the imperial patronage and favor that Eleonora brought to her marriage with Cosimo. The fruit was also an emblem of Spanish royalty, to which Eleonora was related. It didn't hurt to have a reminder of that worked into a portrait of Duke Cosimo's wife, especially since the emperor Charles V was also of Spanish background on his mother's side, and Charles was Cosimo's overlord.

Eleonora's gown, which takes up most of the space in the painting, is so spectacular that it inspired legends. One story claims the gown was greatly loved by Eleonora, that she asked to be buried in it, and that when her tomb was opened she was wearing it—the duchess was dust and bones, yet the dress had remained intact. But modern scholars have disproved this myth. When Eleonora's tomb was opened in the 1950s, the crumbling remains of the dress she'd worn at her burial bore no resemblance to the gown Bronzino painted. Others have gone to the opposite extreme, suggesting the material is Bronzino's invention, or that perhaps he worked from a mere swatch of the fabulous fabric.

Whether the gown is fact or fable, it has become inseparable from our image of Duchess Eleonora. Bronzino's shop produced numerous versions of the painting, so this iconic work could carry Eleonora's presence throughout Flo-

rentine territories. The portrait announces that, thanks to the duke's beautiful, regal, and reliably fertile wife, the lineage of Cosimo I de' Medici will continue into future generations—as indeed it did.

TITIAN'S *VENUS OF URBINO*
SEX TOY OR SATISFIED WIFE?

Among the paintings of nude women in the Uffizi, Titian's *Venus of Ur-bino* is the best known, the most controversial and mysterious, and without a doubt the most overtly sexual. The work has elicited strong reactions from viewers, ranging from rapturous arousal to satirical indignation. In 1864 the English writer Charles Algernon Swinburne wondered in a private letter: "how any creature can be decently virtuous within thirty square miles of it passes my comprehension." Mark Twain, in his humorous travelogue *A Tramp Abroad*, huffed in mock horror that the painting is "the foulest, the vilest, the obscenest picture the world possesses," too strong even for display in a brothel and, the author concludes with a barely concealed snigger, fit only for "a public art gallery."

For much of the 1500s, the Venetian painter Titian was the most famous and sought-after artist in Europe, especially well-known for his portrayal of voluptuous nude females, so why the fuss about this one? The artist portrayed a nude woman in a luxurious sixteenth-century Venetian interior, reclining on a couch or bed on top of what appears to be—to judge by its sheen—a rumpled silk sheet. In the background a woman in white rummages in a chest, and another stands nearby, holding a richly brocaded garment. The reclining woman regards the viewer with a direct and candid gaze. In her right hand she holds a bouquet of roses so casually that one has dropped onto the embroidered red velvet cushion revealed beneath the disordered sheet. A small, sleeping dog lies curled up at the foot of the bed. But what aroused the intense reactions of Swinburne, Twain, and many other viewers over the centuries, is the position—or more precisely the activity—of the woman's left hand.

Twain confined himself to spluttering about the hand, without further explanation of his pretended outrage, while Swinburne, whose considerable command of English didn't seem adequate to what he was seeing, resorted to French, describing the woman as having "four lazy fingers buried *dans les fleurs de son jardin.*" Generations of historians and art historians have ignored or blandly explained away that hand, placed at the center of the painting where

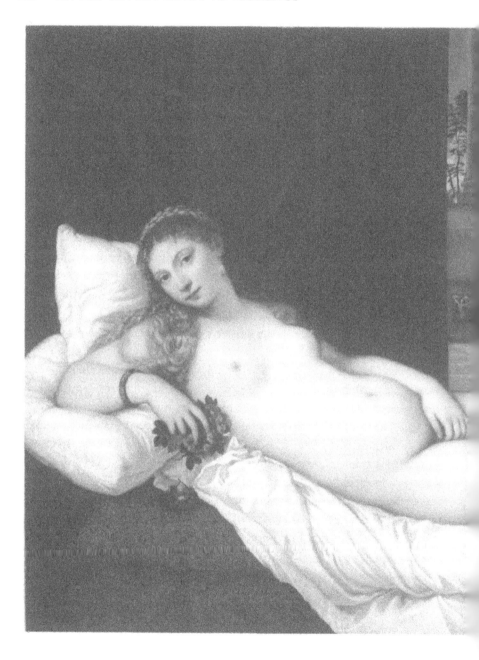

Titian, *Venus of Urbino*, Galleria degli Uffizi. Scala / Ministero per i Beni e le Atdtivita culturali / Art Resource, NY

focusing on it is unavoidable. Some concentrate on the formal qualities of the work: its beautifully constructed composition, the luscious colors and sensuous textures, without a word about what Venus is doing. One art historian even claimed the hand "recalls the gesture of modesty found in antique statues." *Modesty*? Only in the last years of the twentieth century and the first years of the twenty-first have a few scholars at last expressed what many viewers suspected all along: that the woman isn't concealing her private parts—she's doing something that calls attention to them. In a word, the lady is masturbating.

Before exploring this at once obvious and surprising aspect of the painting, it can be helpful to know the history of the work and the social context in which it was created. Although the painting is documented in the archives of the ducal palace at Urbino, since it's the subject of several letters written by Guidobaldo II della Rovere, who succeeded his father, Francesco della Rovere, as duke of Urbino at the latter's death in 1538, this evidence leaves certain questions unanswered. In his correspondence Guidobaldo seems afraid that Titian might sell the painting to someone else (which would be odd if Guidobaldo had commissioned it), and the young man eventually had to borrow money from his mother in order to purchase the painting in 1538. A decade or so later, in the first edition of his *Lives of the Artists*, Vasari identified the work, which he saw at the ducal palace in Urbino, as an image of "a youthful recumbent Venus"—the origin of the modern title *Venus of Urbino*. In his correspondence, Guidobaldo refers to the painting simply as "a nude woman." So, despite evidence that Guidobaldo was the first owner, we don't know if he commissioned the work, nor do we know what, or who, he thought the nude woman represented.

Other questions left unanswered by the documents concern the purpose of the work and the identity of the woman, and as a result controversies have swirled around the painting. Is it merely high-priced pornography, as Mark Twain implied—a picture of a Venetian courtesan in a suggestive pose, intended for the entertainment and titillation of Guidobaldo and his male friends? Or did it serve some more refined and intellectual purpose? Does it represent Venus, the goddess of love, or an actual woman, or both at once? Or might the painting be something else entirely: an image that celebrates a marriage, a picture of a bride preparing to receive her new husband, or alternatively, a mature, responsive wife, eager for her husband's embrace?

Viewers today might be tempted to reject the notion that a painting this overtly and explicitly sexual could have anything to do with the chaste virtues of marriage, and we may be more apt to agree with Frederick Hartt's description

of the woman as "a Renaissance prince's lover idly reclining while her lady-in-waiting and maidservant find a garment splendid enough to clothe her." But we shouldn't be so quick to assume that our own attitudes are identical with those of almost five hundred years ago. Rona Goffen, the first art historian to deal frankly with the issue of what the woman is doing with her left hand, also proposed that the painting is the furthest thing from pornography: a wedding picture intended to celebrate the mutual pleasures of marital intimacy.

Even while admitting that Titian's Venus "seems far too sexy to be chaste," Goffen points out that there are certain features of the painting that sixteenth-century viewers would recognize as referring to marriage. The background contains two identical chests of a type known as *cassoni*: these always came in pairs, and in the Renaissance they were exclusively associated with married couples. Commissioned by the future husband or his male relatives and intended to hold the bride's trousseau, they later became part of the bedroom furnishings of the married couple. Goffen adds that the roses held by the woman and the myrtle plant blooming in a pot on a windowsill in the background were well-known bridal attributes in the Renaissance, and the little dog that dozes at the woman's feet was a traditional symbol of marital fidelity.

But what about the way the woman looks directly at us, while displaying and caressing herself without a trace of shame or modesty? This is precisely the action that has led so many viewers to assume that the woman must be a prostitute, concluding that no respectable woman would ever allow herself to be portrayed in such a way. But Goffen found a different interpretation of her action, one consistent with sixteenth-century customs and morals.

Although for centuries masturbation was severely condemned by both theologians and doctors, what is less widely known is that certain doctors and theologians of the past endorsed the practice in one particular circumstance, based on a misunderstanding of conception. These so-called experts believed that both men and women emitted a "seed" necessary to conception, and that the female "emission"—what we'd call an orgasm—was necessary for conception to occur. Since conception, or its possibility, was the only justification for intercourse according to Church teaching, in order to achieve the desired result, some considered female masturbation in marriage acceptable and on occasion necessary. A few even thought it encouraged the conception of male children. Although the practice was by no means universally endorsed, medical treatises from classical Greece to sixteenth-century Italy offer the same recommendation, and Goffen suggests that this is what Titian represented in his image.

Nonetheless, it remains impossible to determine whether either the artist or the patron intended the woman's activity to convey that meaning, and other scholars have questioned Goffen's interpretation, asking if the woman's action was really an indication of her enjoyment of sex or merely of her willingness to fulfill the true purpose of a Renaissance wife, to produce children. In any case, the explanation Goffen offered saved her from having to deal more directly with the male responses exemplified by Swinburne and Twain: the idea that the picture has to do with intense male sexual interest in a beautiful, nude, and sexually uninhibited woman.

If the work really was intended to celebrate a marriage, this still leaves the question of whose marriage the painting celebrates. Guidobaldo della Rovere was married in 1534, at age twenty, to the ten-year-old Giulia Varrano da Camerino, a union almost certainly unconsummated before the bride was at least thirteen or fourteen—not an unusual age for an aristocratic bride in that era. If Guidobaldo commissioned the painting, he may have done so in anticipation of the moment, presumably around 1538, when the marriage would be consummated.

Another possibility is that the painting celebrates not a marriage but an anniversary: that of Guidobaldo's parents, Francesco della Rovere and Eleonora Gonzaga, whose thirtieth anniversary occurred in 1538. This might account for the relatively mature and sexually sophisticated appearance of Venus— hardly a figure with whom a girl of thirteen or fourteen would identify herself, much as her husband might wish her to. Although in no way a portrait of Eleonora Gonzaga, whose appearance is known from other sources, the Venus of Titian's painting might suggest a secure and sexually responsive wife, relaxed and ready to enjoy marital relations, but this interpretation is no more certain than any of the others. The painting continues to mystify as well as mesmerize—and scandalize—its viewers.

If modern men can meet the woman's inviting glance and enjoy projecting themselves into the painting as her husband or lover, present-day women might equally enjoy identifying with a beautiful woman who need not be viewed as a passive pinup but, instead, as an alert and confident individual in control of her own sexuality. In the end, though, we don't know which she is, so the viewer is welcome to project his or her fantasies onto the work. The very definition of a masterpiece such as the *Venus of Urbino* is that it's inexhaustible—not just visually compelling but also always revealing new possibilities of interpretation and enjoyment.

Chapter 14

The MUSEO NAZIONALE
del BARGELLO

HISTORY OF THE BUILDING

Many museums find a home in places that once served other purposes. The Louvre and the Hermitage are former royal residences, and the Uffizi once held the administrative offices of the Florentine ducal government. But the building that houses the Bargello has a more sinister history. Among the oldest public buildings in Florence, the twelfth-century structure first served as the home and headquarters of the *capitano del popolo*, a military leader usually hired from a foreign city to prevent him from favoring one side or the other in Florence's numerous factional disputes. In 1574, however, under the autocratic rule of the Medici, the building assumed a new function: it became the headquarters of the city police as well as a prison and a place for torture and executions. The chief of police was called the *Bargello*, a name later extended to the building that held his office.

Changes during the subsequent three centuries seriously disfigured the structure. Its handsome loggias were enclosed, rickety staircases constructed, and large imposing rooms broken up into tiny cells. Even the chapel was divided into two floors, with the upper one housing still more cells, and its lower portion turned into a storage room. Lacking minimally adequate space and sanitary facilities for its ever-increasing number of prisoners, the shabby old building became notorious for its filth and squalor.

Toward the middle of the 1800s, a rebirth of interest in the city's former splendors led to a campaign to rehabilitate the Bargello. The building ceased

to serve as the city's police headquarters in 1859, and restoration work began in 1861. When Florence briefly served as the capital of the united Italian republic, beginning in 1865, a decision was made to complete the restoration and turn the Bargello into a museum. Today, it's famous for a fine collection of minor arts—carved ivories, medals, cameos, jewelry, textiles, glassware, small bronzes, and ceramics, most of them from the late medieval period and the Renaissance. But the Bargello also houses some superb sculptures, chief among them works by Donatello and Michelangelo. The original of Donatello's *St. George* is in the Bargello, and its copy has been placed in the niche on Orsanmichele. (For discussion of this work, see Chapter 6.)

DONATELLO'S BRONZE
DAVID WITH THE HEAD OF GOLIATH

A great deal of mystery and even notoriety surround Donatello's bronze statue of *David with the Head of Goliath*. It is the first freestanding, life-size bronze nude since Roman times, and much about it remains uncertain. Although no one disputes Donatello's authorship, scholars continue to argue about the date of the work. Suggestions range from the 1420s to the 1460s, with a consensus that it's from the 1440s. Often said to be based in a general way on ancient Roman or Hellenistic Greek statues of youthful heroes and athletes, an exact model for the figure has yet to be discovered. It's not out of the question that the model was a flesh-and-blood boy, since the figure doesn't conform to any classical ideal, and it's too realistic to be considered fully "antique" in form. The most likely patron is Cosimo de' Medici, but here, too, no definitive proof has come to light showing the statue was a Medici commission. All we know with certainty is that the statue's recorded history begins in 1469, three years after Donatello's death. In that year a chronicler of the fabulous reception held in honor of the marriage of Cosimo de' Medici's grandson Lorenzo (later to be known as Lorenzo the Magnificent) described food-laden tables in the middle of the courtyard of the Palazzo Medici as arranged "around the beautiful column on which stands the bronze David."

Anyone familiar with the biblical story of David and Goliath, told in detail in First Samuel 17, will be puzzled by Donatello's work, for the artist made no effort to re-create any particular moment described in the narrative. Furthermore, despite the lack of any indication that David performed his heroic deed unclothed, Donatello's David is nude, which is unprecedented—all earlier

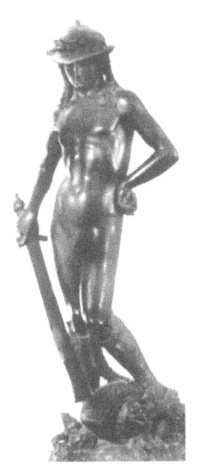

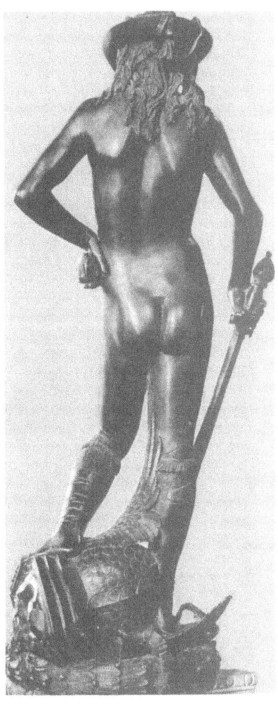

(above) Donatello, *David with the Head of Goliath*, front view, Museo Nazionale del Bargello.

(right) Donatello, *David with the Head of Goliath*, rear view. Museo Naztionale del Bargello.

images of David, including a marble one by Donatello, show him clothed. Actually he's not fully nude—he wears a broad-brimmed hat decorated with gilded ribbons and laurel leaves and a pair of elaborate sandals with greaves (shin guards) that extend nearly to his knees, details that make the figure appear less like a classical nude than an enticingly not-quite-naked boy.

Italian historian Giovanni dall' Orto has offered the controversial suggestion that the biblical story of David's friendship with Saul's son Jonathan (Second Samuel 1:26) contains homoerotic overtones. The two young men's souls are described as knit together with a love "surpassing the love of women," and the name David in Hebrew means "beloved." It's possible that Donatello was aware of this aspect of David's life and personality and expressed it through the statue's suggestive pose and its numerous erotic details, although we have no way of knowing if, or to what extent, the artist was familiar with the biblical text.

Many aspects of the figure are sensually suggestive. David's back arches inward at the waist, causing the softly curving buttocks to protrude slightly, the kind of provocative pose that caused a fifteenth-century Florentine admirer of a young male prostitute to exclaim: *"Che è di questo culazzino!"* ("What sort of a pretty little bottom is this!") The boy's stance, with his left hip thrust out to the side, lends his pose a sinuous, sexual quality. His right hand holds Goliath's huge sword in a loose, backhanded grip, while his left hand, resting near his waist, clasps the fatal stone. The highly polished, satiny surface of the bronze gives David's skin the sensuous softness of living flesh and invites the viewer to caress it—an activity strictly forbidden in the current museum setting and impossible in its original setting atop a tall column. This is a work both enticing and untouchable, one that invites and yet forbids physical contact.

Like the biblical David, Donatello's figure is a preadolescent boy but, unlike the aggressive youth in the Bible who shouts insults and defiance at his adversary and exults in Goliath's death, Donatello's David is a dreamy and contemplative victor. The wide brim of his hat casts a shadow on his face, adding mystery to his expression. The elaborate hat, which draws still further attention to the figure's near nudity, is as unprecedented as David's lack of bodily covering. Why Donatello gave his figure such a conspicuous hat is unknown, but we know that jaunty hats played a part in the homosexual culture of Florence during Donatello's time. There was a game of hat stealing, in which men seeking sex with adolescent boys would swipe the hats off the heads of the boys who attracted them and then refuse to hand them back until the boys agreed to sexual relations. When a youth refused to give up his hat, this would signify

that he had rejected the man's advances. Perhaps David's firmly planted hat is meant to suggest that this particular boy, although desirable, is not available.

Triumphant yet emotionally detached, he stands on Goliath's severed head, the toes of his left foot toying idly with his defeated adversary's beard. Thanks to Donatello's exquisite attention to detail, we can see the individual hairs of Goliath's beard curling up between David's toes, an effect that creates an almost tactile, empathetic sensation in the viewer and subtly suggests some sort of relationship between the two figures that is more than just a simple contrast of victor and vanquished.

Another and more prominent detail is even more suggestive. David's right foot crushes a feathery wing that extends from the side of Goliath's helmet, but the youth seems unaware that the other wing has crept up the entire length of his right leg and caresses the inside of his thighs at the level of his buttocks and genitals. Here, too, the extraordinary skill of the artist is breathtaking: he has re-created in hard, heavy bronze the light, soft touch of feathers on a sensitive stretch of human skin—an extremely intimate and potentially arousing sensation. We might also note that the Italian word *penne*, which means "feathers," is almost identical to the word *pene*, which means "penis." This is an association further underlined by the bulging, phallic pommel of Goliath's sword, cradled in David's right hand, and by an awareness that the Italian word for sword (*spada*) is also a slang term for the male organ. In the sensuous atmosphere the artist created, it's possible almost to forget that the source of these bold erotic associations and advances is a severed head. As Frederick Hartt memorably expressed it, Donatello created a David "untroubled by the web of desire and violence in which he stands."

What did Donatello think he was doing in offering his patron such an unorthodox—some might even say outrageous—portrayal of a biblical character? The longer we look at Donatello's soft, androgynous boy the less he resembles the "action hero" of the Bible. The overall sensuality, as well as the sexually suggestive details of the work, demand explanation. After all, the artist included them, so they must have some purpose and meaning.

The daring qualities of the David make it likely that the statue resulted from a deep understanding between artist and patron. If the patron was Cosimo de' Medici, as seems probable, nothing in his biography implies he was attracted to young boys, but Cosimo never displayed personal hostility or moral objection to those who felt such attractions. When Antonio Beccadelli, known by the peculiar nickname Panormita, penned a collection

of sexually explicit poems called *L'ermafradito* (The Hermaphrodite), which covers all kinds of sexual activity both hetero- and homosexual, he dedicated the work to Cosimo, who accepted the unusual gift with good humor. Cosimo also harbored a strong interest in ancient philosophy, and several of Plato's *Dialogues* celebrate the love of an older man for a beautiful youth as morally superior to the love of man for woman, because the contemplation of youthful male beauty is said to lead the older man's mind gradually from earthly to heavenly love.

A tiny detail of the work suggests that a Platonic interpretation may be useful in understanding the work. A relief on the side of Goliath's helmet, based on an ancient cameo in the Medici collection, shows an allegory of heavenly love: Eros (or Cupid) on a chariot drawn upward by other winged children. Perhaps we are meant to see in the youthful David and the more mature Goliath the classic example of an exquisite boy—Eros personified—whose beauty symbolically slays his older admirer but, at the same time, inspires the more mature partner to begin the Platonic ascent toward heavenly beauty that is ultimately the contemplation of God. This also may account for why Goliath's face is not ugly or brutal. Instead, he appears as a dignified and handsome middle-aged man.

But even the most determined admirer of ancient philosophy would be hard put to find a place in a Platonic scheme for the sensually suggestive and sexually explicit details of Donatello's *David*. Here we must take account of an aspect of Donatello that's often ignored and on occasion vehemently denied: his reputation as a homosexual. We know of this from a book of racy stories collected in Florence in the 1470s (about a decade after Donatello's death) and first published in 1548. There are several hundred of these tales, and many don't bear retelling in polite company. Those concerning Donatello are among the tamer ones, but all suggest the never-married artist's attraction to beautiful boys. Although it's a good idea to be cautious about taking these gossipy tidbits at face value, it would be equally foolish to dismiss them entirely, since they tell us something about how the artist was seen in his own time, even though they don't definitively establish what we'd call his sexual "identity." The image of David that Donatello created fits the image of the youths in the tales just noted: not a classical god but a pretty boy, not a Platonic ideal but an object of homoerotic desire. Perhaps Cosimo de' Medici, a wise and tolerant man, understood and accepted Donatello's personal obsessions without necessarily sharing them.

In order to have a clearer understanding of Donatello's apparent sexual preferences and Cosimo's attitude toward them, it's helpful to be aware that Florence in the Renaissance was known throughout Europe as what we'd call "gay friendly," rather like San Francisco today. The German term for a homosexual was *ein Florenzer*, and in German the verb *florenzen* meant to engage in homosexual relations. Although condemned by both the Church and secular authorities and—at least in theory—severely punished, sexual relationships between men, known in that era as sodomy, not only were widespread and widely tolerated in Florence but also formed a part of the normal experience of most males. Florentines of the Renaissance didn't regard homosexuality as a permanent identity characteristic. When a man had sex with other men, he was a sodomite while the act was taking place. Afterward, he was someone who had committed sodomy. Although there were men who displayed a lifelong preference for male sexual partners, the concept of an exclusively homosexual identity didn't exist—in fact, the word didn't exist. "Homosexual" is a term invented in the nineteenth century.

After studying the records of the *Ufficiali della Notte* (Officers of the Night), a special governmental force responsible for identifying and prosecuting sodomy, historian Michael Rocke concluded that a majority of Florentine males were at least once in their lives officially incriminated for engaging in homosexual relations. Such relations were so common that they affected the lives of just about everyone in Florence: either as willing participants or as defendants, victims, witnesses, or prosecutors in trials, or as both male and female relatives and friends of any of those.

According to the records, these relations took place not just in private homes but also in and around certain taverns, at the city's public baths, in dark streets and alleys, in artists' studios, and even in churches. Florence's cathedral was a favored place—court documents reveal that the sanctuary, the bell tower, and even the space between the shells of Brunelleschi's dome served as sites for male-male couplings. Given what we now know about Florentine sexual attitudes and experiences in that era, the suggestive details of Donatello's *David* no longer seem so far outside the mainstream of life in the fifteenth-century city.

But despite evidence that Donatello's *David* is most clearly understood in the context of Florentine attitudes toward homosexual relations, some modern scholars still prefer to see the statue in exclusively Christian terms, insisting that David's triumph over Goliath must be interpreted as it is in

Christian theology, as a prefiguration of Christ's triumph over sin and death. If Donatello's *David* is interpreted simply as a symbol of Christ, however, then its obvious sexual aspects become not only inexplicable but also extremely problematical, and this in turn has led some scholars to deny vehemently that any such aspects exist. One described the feathered wing that caresses David's thigh as nothing more than a support for the statue, ignoring the weighty base in the form of a classical victory wreath that makes such a support unnecessary. Another wrote in furious indignation that such claims leave a "trail of slime on a great work of art," as if any imputation of homosexuality associated with the work somehow soiled and devalued it.

If we were to conclude that the statue is simply a straightforward portrayal of a biblical hero, we hardly would be doing justice either to the complexity of Donatello's work or to the complexities of its probable Medici patronage. There are too many details of a sexual nature that demand explanation and too many political implications to the figure's history for us to ignore those aspects of the work.

The political significance of the work is much less controversial than the sexual implications. David was small and inadequately armed, yet he was able to overcome a much larger and better-armed enemy with the help of God, so it's little wonder the Florentines, who had repeatedly fended off more powerful adversaries, identified with this particular biblical hero. An earlier statue of David, in marble and also by Donatello, already stood in the council chamber of the Palazzo Vecchio and bore a patriotic inscription. By displaying a statue of that same hero in their own home, the Medici could associate themselves with the government, suggesting that they shared those same ideals and the same commitment to maintaining the republic.

A discovery published in the 1960s proved that the bronze David, like Donatello's earlier statue of the same biblical hero, also once had on its pedestal (now lost) a Latin inscription that encouraged viewers to identify the young warrior hero with the fight against tyranny. The inscription read: "The victor is whoever defends the fatherland. All-powerful God crushes the angry enemy. Behold, a boy overcame a great tyrant. Conquer, O citizens." The Medici, nominally still private citizens in the mid-1400s, evidently took over for their own purposes an image traditionally associated with the Florentine republic. The message the Medici wished to communicate through the statue of David was that their family's role in Florence was akin to that of David, a revered and holy Old Testament tyrant slayer and savior of his people, a message that turns upside-down the persistent accusations that the Medici themselves had

become—or were in the process of becoming—tyrants who had drained all real power out of Florence's republican form of government. The lines further imply that the Medici family was defending rather than taking away the Florentines' prized political liberties, and they suggest that someone in the family, probably Cosimo's son Piero, wished the work to convey a militant political message that seems entirely at variance with the statue's appearance.

Given the extraordinary and—to some viewers—disturbing sensuality of the work, it's not surprising that Piero de' Medici sought to blunt the statue's sexual impact by attaching a political inscription to its pedestal. This is a statue that invites more than one interpretation, and perhaps it was never intended to be understood in only one way. For the educated and cultured individuals who would have viewed the work in the courtyard of the Palazzo Medici, one of the pleasures the statue no doubt provided was the opportunity to discuss and speculate on its many possible levels of meaning—religious, political, and sexual.

MICHELANGELO'S *BRUTUS*

Known for his aversion to making portraits of living people (aside from his unflattering self-portrait as a flayed skin and his savage caricature of an enemy as Satan, which he tucked into his fresco of the *Last Judgment*), Michelangelo here sculpted a "portrait" of a person dead for more than fifteen hundred years: Brutus, the man who murdered Julius Caesar. Although modern historians of ancient Rome tend to side with Caesar and consider Brutus a criminal, in Michelangelo's time there were those who saw Brutus as a hero for his assassination of a tyrant. Among them were friends of the artist who found a parallel between Brutus's killing of Caesar and the murder, in 1537, of the unpopular Duke Alessandro de' Medici.

In order to understand what motivated Michelangelo to create this unprecedented work, so resonant with political meaning, it can be helpful to glance again at some of the events that led to the final overthrow of the Florentine republic and its replacement by a hereditary succession of Medici dukes. First, there was the expulsion of the Medici in 1494; then their return, under the leadership of Cardinal Giovanni de' Medici, in 1512; their second expulsion in 1527, followed by the brief restoration of the republic; the government taken over again by Medici authority in 1530; and finally the appointment of Alessandro de' Medici as duke of Florence in 1531. Alessandro—according

Michelangelo, *Bust of Brutus*,
Museo Nazionale del Bargello.

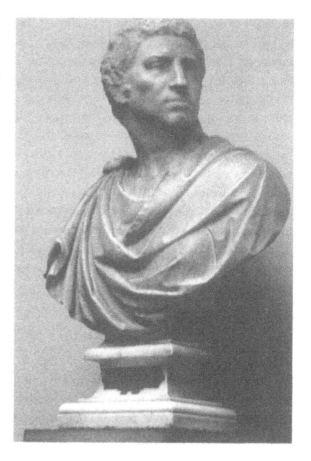

to most reports a vicious and dissipated young man—had been passed off as an illegitimate son of Lorenzo di Piero de' Medici and thus a great-grandson of Lorenzo the Magnificent. He was more probably the result of a youthful indiscretion of Pope Clement VII (Giulio de' Medici), himself the illegitimate offspring of Lorenzo the Magnificent's murdered brother Giuliano.

To opponents of Medici rule, the killing of Duke Alessandro by his distant relative—a young man called Lorenzino (Little Lorenzo), or sometimes Lorenzaccio (Bad Lorenzo) to distinguish him from other Medici of the same name—at first seemed to herald the end of Medici power in Florence. Lorenzino fled to northern Italy, where it took the relentless agents of Alessandro's successor, Duke Cosimo I de' Medici, until 1548 to hunt him down and kill him. But before he died, Lorenzino wrote a lengthy explanation of his deed, declaring that he'd killed Alessandro for the sake of restoring the

Florentine republic. Hailed by Florentine exiles in Rome and elsewhere as the new Brutus, he commissioned a medal to commemorate his assassination of Alessandro, showing himself in the guise of Brutus.

When news of Alessandro's death reached members of the anti-Medici faction resident in Rome, several of them hurried to Florence in the futile hope of overthrowing the young and newly appointed Duke Cosimo I de' Medici. Among the rebels was Cardinal Niccolò Ridolfi, himself a close Medici relative; he was the son of Lorenzo il Magnifico's daughter Contessina. Nonetheless, Ridolfi had despised Alessandro, considered him unworthy to rule, and was among those who supported the restoration of the republic.

In Rome, the exiled Florentine writer and politician Donato Giannotti, who had been among the leaders of the short-lived Florentine republic of 1527, had become a friend of Michelangelo. The two men first met during the artist's long stay in Florence, beginning in 1516, and their relationship continued after Michelangelo moved to Rome in 1534. Giannotti entered the service of Cardinal Ridolfi in 1539, and according to Vasari's biography of Michelangelo, it was Giannotti who suggested to Cardinal Ridolfi the idea of commissioning a bust of Brutus from the artist, probably around 1540. The work would serve as a tribute to the Florentine republic and, indirectly, to Lorenzino, the man who had attempted to restore it by the same means that Brutus had used: tyrannicide, the morally justified killing of an unjust ruler.

But Vasari, writing during the reign of Alessandro's successor and his own employer, Duke Cosimo I de' Medici, had to be careful about what he said concerning the motivations behind this particular work of Michelangelo. Although he surely knew of Michelangelo's republican sentiments, which remained consistent throughout the artist's life, he avoided any political reference, claiming the artist based the work on a portrait of Brutus engraved on an antique cameo. No such cameo has ever been found, and in any case, the work is clearly based on an ancient Roman portrait bust of the emperor Caracalla, a tyrannical ruler whose atrocities far exceeded those of Alessandro de' Medici, although Michelangelo probably knew little about the details of Caracalla's reign.

In sculpting his image of Brutus, Michelangelo made no attempt to reproduce the actual features of Lorenzino, whom he most likely had never seen. Instead, he carved the image that fulfilled his picture of an ideal republican hero, a burly, rough-hewn man of rude strength and fortitude, whose face and posture also express a sense of inner torment at his action—a subtlety of expression that only the greatest artists are capable of conveying.

Rather than facing the viewer directly, the head of Brutus turns sharply to the viewer's right, revealing taut muscles in the short, thick neck, suggestive of both physical strength and nervous tension. The hair is barely carved at all but instead resembles a thick mat, through which the ears are barely visible. The coarseness of the hair contrasts with the more smoothly finished surface of the face, but both are remarkably rough in comparison with the detailed locks of hair and satin-smooth finish given to the skin of ancient Roman portraits. Although the bust is sometimes said to have been left unfinished by Michelangelo, it's also possible that the rough surfaces were a conscious decision of the artist, as they add to its impact and to the impression of power the work conveys.

There are a number of ironies involved in Michelangelo's portrayal of Brutus as a hero of the anti-Medicean faction and an exemplar of the artist's ardent support of the doomed Florentine republic. The Medici family, and Lorenzo il Magnifico in particular, had nurtured Michelangelo's gifts when the artist was still a boy, allowing him to live at the Palazzo Medici almost as a member of the family and granting him access to the family's notable collection of ancient sculpture. Pope Leo X, a son of Il Magnifico who had known Michelangelo when both were in their teens, had hired Michelangelo to create tombs for Medici family members at the church of S. Lorenzo. But the Medici whom Michelangelo had known as a youth were a different breed from the arrogant autocrats of the mid-sixteenth century, determined to rule like princes and actively hostile to the survival of the republic.

Michelangelo, passionate in his political convictions and a champion holder of grudges, never forgave the Medici for their political transformation, and his rancor lasted the rest of his life. As late as 1546, when he was in his seventies, he was still snarling at them. He offered to create, at his own expense, a colossal statue of King Francis I of France and set it up in Florence's Piazza della Signoria, if that king would chase the Medici out of Florence forever. We can only imagine how Michelangelo would have reacted if he'd known that in 1590, long after his death, the Medici Grand Duke Fernando I bought the *Brutus* and installed it as a decoration in one of his villas. But Duke Fernando had an inscribed bronze plaque attached to the base, declaring that Michelangelo's inability to finish the work was due to his horror at the homicidal act Brutus had committed. This blatant distortion of the artist's intentions suggests that, even half a century later, the political significance of the work had not been entirely forgotten.

Chapter 15

Il GIGANTE

Michelangelo's *David*

I t's among the most famous statues in the world, so easily recognizable that advertisers use images of it to sell everything from cigarettes to soap, from motorcycles to men's cologne. At the moment of its unveiling some five hundred years ago it created a sensation, and every year people still flock to Florence to stand looking up at it in awe. Michelangelo's towering marble statue of David has the quality that defines greatness in art: no matter how often one sees the work, its impact never lessens.

Although since 1873 the statue has been inside the Accademia delle Belle Arti, at the center of a domed rotunda specially designed to hold it, the *David* was never intended for such a sheltered and "arty" location. For almost four centuries Michelangelo's masterpiece stood in the thick of Florentine politics, outdoors in the Piazza della Signoria, in front of the city hall. There it was subject not only to weather but also to the changing fortunes of the Florentine state. Opponents of the government often expressed hostility by hurling stones at the statue, and in 1527 a bench thrown out a window of the city hall during a civic disturbance damaged the left arm and hand. A teenage boy rescued the pieces and kept them until they could be reattached. In the Piazza della Signoria an inferior copy has replaced the original, luring ill-informed tourists and serving as a roost for the city's pigeons.

The origins of such a famous statue should be easy to trace but instead we're confronted with as many myths as facts. Part of the problem lies in the stories spun by Giorgio Vasari, the man who, as a boy, saved the shattered pieces

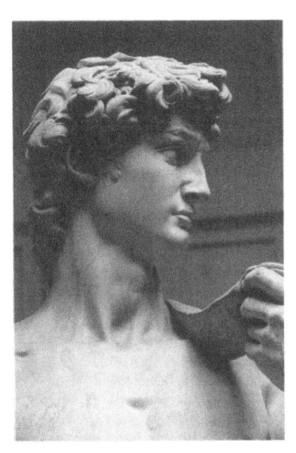

Michelangelo, *David*, Accademia delle Belle Arti.

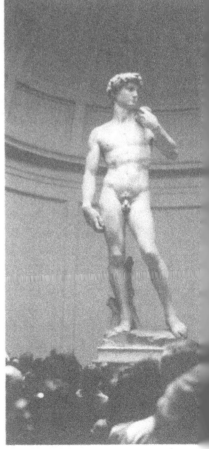

of David's arm and who by the mid-sixteenth century had become the first biographer of Italian artists. His adoration of Michelangelo sometimes led him to embellish his anecdotes. Vasari claimed that Michelangelo returned to his native Florence in 1501 at the urging of friends, in order to work on a seventeen-foot-long block of marble that had been "spoiled" by the incompetence of a certain Simone da Fiesole. Vasari also stated that this botched block had previously been offered to Leonardo da Vinci, and he implied that Leonardo wasn't up to the challenge, but that Michelangelo sought out and received it as "a useless thing" that nobody else could have transformed into a credible human figure.

Scholars have reconstructed a different story. Rather than coming back to Florence from Rome at the urging of friends, what drew Michelangelo to Florence was his acceptance of a commission: a contract drawn up by the Operai (Board of Works) of the cathedral, which stipulated the subject, the artist's payment in relationship to a time schedule, and a requirement that the work meet a stringent standard of quality. There's no evidence that the Operai first offered the commission to Leonardo, and no indication that Simone da Fiesole damaged it—as far as anyone can tell, no such person as Simone ever existed. Vasari did have one thing right, though. An earlier artist had begun to carve the huge block and had left it incomplete. Who was he, and why was the project abandoned for nearly a generation before Michelangelo took it up again? Here, modern archival researchers studying the records of the Operai and the city government have uncovered a fascinating story unknown to Vasari.

Since the early years of the 1400s, cathedral authorities had envisioned a series of colossal statues of Old Testament heroes that would be placed high up on the buttresses of Florence cathedral. Although the project had never been fully carried out, it was never quite abandoned. Donatello, among the greatest sculptors of fifteenth-century Florence, had provided a huge terracotta statue of Joshua (destroyed in the 1600s), and in the 1460s he also received a commission for a second over-life-size figure, to be carved in marble. By that time Donatello, nearing eighty years old, was unable to tackle such a large commission without assistance, so a younger sculptor named Agostino di Duccio began the work under his direction. When Donatello died in 1466, official interest in the project ended, although the unfinished statue—barely roughed out—remained in the cathedral workshop. It was still there thirty-five years later.

When Michelangelo took up the project in 1501 he was not, as Vasari implied, striking out in an exciting new direction. Instead, he was following a time-honored path, joining the ranks of his distinguished predecessors by contributing to the sculptural program of the cathedral. We know that Michelangelo admired the work of Donatello, which included several statues of David, and here was a real challenge: to complete a statue begun under the direction of the earlier master in a way that would not just be worthy of Donatello but would surpass him.

It's probably no coincidence that the Operai of Florence cathedral offered Michelangelo this commission in 1501, exactly a century after the famous competition that resulted in the creation of Ghiberti's first set of bronze doors for the cathedral baptistery. Vasari's recollection of the rivalry between Lorenzo Ghiberti and Filippo Brunelleschi for the commission to execute the baptistery doors may have inspired him to invent a similar competition between Leonardo and Michelangelo over which one of them would carve the statue of David.

Furthermore, by 1501 Florence had fallen on hard times. The short-lived theocratic republic led by Savonarola had ended with his being burned at the stake in 1498. The city was being threatened militarily by the army of Cesare Borgia, a son of Pope Alexander VI notorious for his brutality and unscrupulousness. France had invaded Italy and was menacing Florence from the north. The treasury of the republic was running low, leadership was weak, and pro-Medici partisans were intriguing to overthrow the precarious anti-Medici republic. To the Florentines, beset with both immediate and impending problems, the cathedral still embodied their most cherished ideals of spiritual and civic dignity, and it was the perfect focus for patriotic impulses. Hence the reopening of the sculptural program that had been dormant for almost forty years and the decision to hire Michelangelo, a native son fresh from a series of successes as a sculptor in Rome.

Michelangelo had lived in Rome from 1496 until 1501, absorbing ideas and inspiration from the Eternal City's wealth of classical antiquities and making contacts among Rome's wealthy art collectors. Around 1497 he'd executed an uncannily antique-looking statue of the *Drunken Bacchus* (now in the Museo del Bargello), and by 1499, on commission from a French cardinal, he'd finished his exquisite *Pietà* for Old St. Peter's. He had spent time in Europe's first museum of Roman antiquities, the collection founded by Pope Sixtus IV and housed in the Palazzo dei Conservatori on the Capitoline Hill. Like many a

modern visitor, he must have entered the courtyard of the Conservatori and stood in amazement before an eight-foot-high marble head and an equally gigantic hand, foot, and kneecap, fragments of a statue of Constantine discovered in 1486 in the ruins of the Basilica of Constantine in the Roman Forum. With such experiences behind him, Michelangelo returned to Florence in 1501 well prepared to think big.

The statue Michelangelo created during the next three years of steady labor proved far too magnificent to be hauled up onto one of the cathedral's buttresses. Although the *David* stands almost seventeen feet high, the immense architectural forms of the cathedral would have dwarfed it, and nobody would have been able to view it adequately from forty feet below. At that point, in 1504, the republic stepped in and took control of the project. From surviving documents it appears that, even before the open meeting held to discuss the statue's location, government officials had already decided that the most effective place for the statue to be displayed was in the Piazza della Signoria, in front of the city hall.

Despite its outcome being something of a foregone conclusion, the Signoria considered the public meeting important enough to hire a secretary to record the discussion, and the secretary's notes give us a glimpse of Florentine political processes in action. Although women weren't allowed any such freedom, male citizens of all ages and classes addressed the committee. A number of the city's best-known architects and artists spoke, including Leonardo da Vinci, who recommended an inconspicuous place for his rival's work. The only person not consulted, oddly enough, was Michelangelo. The committee finally agreed with what the Signoria had wanted all along: that the statue of David, which the Florentines had taken to calling *il gigante* (the giant), should be placed on a platform near the front entrance of the Palazzo Vecchio, in the Piazza della Signoria, the political heart of the city, where it would serve as a proud symbol of the Florentine republic.

The minutes of the meeting, which survive in the archives of Florence cathedral, reveal the meaning of the *David* for Florentines of the early 1500s. Nobody who spoke showed any interest in the statue's religious identity, and there's no sign of our modern tendency to see the statue as a great work of art. Rather, it was regarded as a powerful symbol, almost magical in its potency, full of political associations of great significance for viewers of that time. The head in particular, with its large intense eyes staring in the direction of an unseen Goliath, caused one participant to warn that the statue should not be

placed so those eyes glared at Florentine passersby. The figure, he insisted, should not "look at us." The final placement of the statue reflects that concern, as well as a political one—David stares off to the south, away from the heavily used piazza and toward Rome, where enemies of the Florentine republic, in particular the exiled Medici, continued to hatch their plots.

The second most popular location suggested for the statue was inside the Loggia dei Lanzi, where it would be better protected from the weather but where it would lose much of its visual impact as well as its political weight. Putting the figure squarely in front of the government headquarters made it into a clear statement of pro-republican, anti-Medicean sentiments, while tucking it into the Loggia dei Lanzi would have blunted that message by having David's stare directed at a blank wall, thereby turning the statue into a less partisan and more general civic symbol. With this factor in mind, it becomes easier to see the political significance of the final choice for the location of the *David*.

Although the distance is only a couple of blocks, it took four days to move the statue from Michelangelo's studio in the workshop of the cathedral to its final position. Securely wrapped and suspended horizontally on ropes from a strong wooden frame provided with rollers, the muffled marble giant inched through the streets toward the Piazza della Signoria. And then, during the course of a week, while hundreds of gaping Florentines looked on in amazement, the largest statue most of them had ever seen was raised into place.

From such a distance in time it can be difficult to imagine what was going through the minds of the citizens of Florence who witnessed the placement of the statue in front of their city hall. Many of them, like the city's leaders and those who participated in the meeting concerning the location of the work, surely would have recognized the statue's patriotic and political significance: the watchful warrior hero who stands guard, ready to defend the city against a specific set of enemies, namely, the Medici and their supporters. To the city's intellectuals, imbued with ideas derived from ancient Greek philosophy, the statue no doubt conveyed the life of the spirit through the beauty of the body. Citizens who had traveled to Rome may have recognized echoes of antiquity in the statue's enormous size, magnificent musculature, and unabashed nudity. The artist's closest friends may have seen in it something much more intimate: Michelangelo's own passion for perfect male bodies and masculine beauty, a passion seen also in the artist's love poetry addressed to handsome young men. But did any of them realize they were present at the birth of a new era in the arts?

Michelangelo's *David* is the first colossal statue of a male nude since antiquity, and a far cry from the preadolescent shepherd boy of the biblical story. Never much interested in literal realism or the mere illustration of stories, Michelangelo strove toward an ideal of human perfection in his art that went far beyond what any previous artist had accomplished. His David is not really "doing" anything, although some have suggested he's looking toward an unseen Goliath and is about to launch a stone from his slingshot. But the slingshot hangs limp across David's shoulder and his right hand only loosely cradles a rock. The figure stands tense but motionless, an eternal image of superhuman beauty, what Frederick Hartt called "humanity raised to a higher power." *David* is the earliest example in sculpture of the lofty and grand artistic style known as High Renaissance.

Modern viewers are sometimes startled by the intensity of the expression on David's face. The large, deeply drilled eyes, sharply defined lips, frowning forehead, and the wedge of thick curly hair combine to create an impression of *terribilità,* an Italian term roughly translatable as "awesomeness." We need to remember, however, that when Michelangelo was working on the statue he thought it would be placed high up on a buttress of the cathedral, and that such strongly defined features would be necessary in order for the face to convey any expression at all to those who viewed it from the street.

Other seemingly odd features of the *David* are the figure's large feet and hands. Although some scholars claim Michelangelo carved them that way to indicate David was an adolescent boy who hadn't yet quite grown into all his body parts, a glance at the rest of the figure shows the absurdity of this notion. Michelangelo's David is a mature young man, not the boy of the biblical narrative and certainly not a gangly adolescent. The large feet, and the ancient Roman motif of a carved tree trunk behind the right leg, serve to anchor the statue securely and prevent it from toppling over. The large hands are most likely an expressive device intended to convey a sense of physical power and even menace. The fact that this ancient Hebrew hero is uncircumcised is another indication of Michelangelo's indifference to historical accuracy.

That a statue so thoroughly imbued with the values of the Florentine republic survived the final downfall of that government and remained in its original location until the late nineteenth century is a tribute both to the iconic stature of the work and to the tremendous prestige of the artist who created it. The ducal government of the reinstated Medici appears never to have considered moving, much less destroying, the *David.* Aside from the backbreaking effort

involved in moving such a large statue and the possibility of damaging it in the process, Duke Cosimo I de' Medici was shrewd enough to realize that, as a work of "the divine Michelangelo," the statue transcended the meaning assigned to it when it was put in place in 1504. Over time it had ceased to be a symbol of the vanished republic and had become an emblem of Florence itself. Whatever political messages it had once conveyed, it was now an artistic treasure, an emblem of Florence's cultural preeminence.

Those who go to see the *David* today must first make their way through a museum of mediocre paintings and then down a long gallery lined with unfinished sculptures by Michelangelo, remnants of several of the artist's ill-fated projects. Those shadowy figures seem to be struggling to break free from the blocks of marble that imprison them. Then, at the end of the corridor, the *David* looms on its pedestal, as fully realized and free from its stone block as any statue ever made, dwarfing the mere mortals who mill about below it. The gigantic figure raised six feet off the ground seems to belong to another, higher, more perfect world than our own, a vision of transfigured humanity so overwhelming that the sight of it often brings visitors to a dead stop, gasping with shock at the sheer concentrated power and beauty of the statue. Whether on the first visit or the hundredth, Michelangelo's *David* is one of those works of art that never disappoints.

Chapter 16

MICHELANGELO'S MEDICI CHAPEL

The Tragedy of Time in a Time of Tragedy

When Pope Leo X Medici and his cousin Cardinal Giulio de' Medici hired Michelangelo to design a funerary chapel for members of their family, they were thinking more of a monument to the family's endangered dynastic ambitions than a place of worship. What the artist delivered was neither. The Medici Chapel, attached to the right side of the church of S. Lorenzo and at times inaccurately called the New Sacristy, was planned as an architectural pendant to Brunelleschi's Old Sacristy on the left side, but it was never intended to function as a second sacristy. The building is hardly a chapel in the conventional sense, either, and although it contains two never-completed Medici tombs with sculptures by Michelangelo, nothing about the sculptural ensembles makes any obvious gesture of glorifying the family for which the artist created them. The chapel as it stands today is a monument to Michelangelo. Unfinished though it is, it remains the closest the great artist ever came to realizing his dream of an integrated ensemble of his own architecture and sculpture.

Scholars have offered a wide variety of interpretations of this high, somehow intimidating room, full of cool light, containing Michelangelo's strange and compelling sculptural groups. Some insist the main purpose of the chapel is religious, and it's true that priests offered Masses there into the nineteenth century, although it was never used as a church that served a congregation. Others claim it has a solely secular political purpose, namely, the glorification

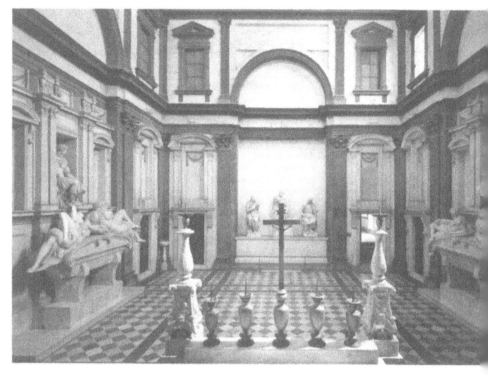

Michelangelo, Medici Chapel, general view, with Medici tombs, church of S. Lorenzo. Scala / Art Resource, NY

of the Medici family. Still others argue for cryptic, complex, ultra-intellectual meanings accessible only to small numbers of highly educated initiates, attempting to understand the chapel through sources as diverse as the *Dialogues* of Plato, Neo-Platonic texts, hymns composed by St. Ambrose, writings attributed to St. Clement, and fifteenth-century carnival songs. How is the modern visitor to make sense of the place?

One approach to the Medici Chapel is through an understanding of the circumstances and motivations that led to its construction and the identities of those commemorated within it. Although Michelangelo began work on the project in 1520, the commission was the culmination of an earlier series of events that involved the changing fortunes of the Medici family. Having an idea of what those events were and of who is commemorated in the chapel makes it easier to understand why the family considered the site so important and may also shed light on its meaning.

Ever since 1494, when the Medici were expelled from Florence because of the incompetence of Lorenzo il Magnifico's son and successor, Piero, other family members had been scheming to return themselves to a position of power they had come to consider theirs by right. They finally succeeded in 1512, thanks to the efforts of the ablest of Il Magnifico's sons, Cardinal Giovanni, along with help from the warrior pope Julius II and the Spanish troops under his command. The Florentine republic fell, and the Medici again ruled Florence, this time in the person of Giuliano de' Medici, the young-est son of Lorenzo il Magnifico. Giuliano was a mild-mannered, somewhat melancholy man who once wrote a poem about suicide and who preferred a life of ease to the exercise of power. When pushed into a position of authority, he believed in ruling from behind the scenes and having some contact with ordinary citizens, as his father had done. A contemporary described him as "kindly, humane, affable, courteous, witty, mild, amiable, of a weak constitu-tion, compassionate and most liberal." In 1515 he married Filiberta, a princess of the House of Savoy, and in that same year King Francis I of France invested him with a largely honorary French title: Duke of Nemours. He died in 1516, at age thirty-seven, having fathered an out-of-wedlock son named Ippolito but without legitimate heirs.

The election of Cardinal Giovanni de' Medici as Pope Leo X in 1513 brought a dramatic change in the family's fortunes. With real power now in his hands, Leo replaced his brother Giuliano as the ruler of Florence with his nephew Lorenzo (son of the pope's deceased brother Piero), a man with a much sterner and more autocratic view of how Florence should be governed. In sharp contrast to his uncle Giuliano, Lorenzo wanted nothing to do with ordinary Florentines. He appeared in public only with an armed guard and he required people to remove their hats when addressing him.

In 1516 Leo X had his papal army attack the duchy of Urbino, driving out the rightful duke. The pope then made Lorenzo the duke of Urbino. Finally—a Medici with a noble title that had Italian territory behind it, something no member of earlier generations of the family had ever attained. For three years Lorenzo enjoyed his position of power, behaving as if he were duke of Florence, to the dissatisfaction of most citizens—although one, Niccolò Machiavelli, had high hopes for his success. Machiavelli participated in that great collective fantasy of Italian Renaissance intellectuals: the hope for the appearance of a brilliant leader who could unite the peninsula. The statesman-philosopher dedicated his masterpiece, *The Prince*, to Lorenzo—who ignored it.

Then Lorenzo also died, in 1519, only twenty-seven years old and leaving just one child—his infant daughter, Caterina, who would one day become Queen Catherine de' Medici, the wife of King Henry II of France. But this was far in the future and in another country. With Lorenzo's death, the legitimate male line descending directly from Cosimo de' Medici *Pater Patriae* had become extinct. "Henceforth we belong no more to the House of Medici, but to the house of God!" mourned Leo X when he heard of Duke Lorenzo's death, a cry with as much panic as sorrow in it. He knew that the lack of male heirs could spell the end of the Medici family dynasty and thus the end of Medici rule in Florence.

For the next four years, power in Florence was in the hands of Pope Leo's cousin Cardinal Giulio de' Medici, who continued to uphold the empty shell of the Florentine republic. After the death of Leo X in 1521 and the brief pontificate of the feeble Dutchman Adrian VI, Giulio de' Medici was elected pope in 1523, taking the name Clement VII, and Florence again came under the rule of the Medici, this time exercised through the pope's nephew Ippolito. Once among the proudest and most independent of Italian republics, the city had sunk to being little more than a captive province of the papacy and the Medici.

While all this was going on, Michelangelo had returned from Rome to Florence in 1516, with a commission from Pope Leo X to design a façade for the church of S. Lorenzo. Built by Brunelleschi with Medici money in the early decades of the 1400s, S. Lorenzo was *the* Medici church in Florence, the focus of dynastic devotion as it was already the burial place of four generations of the family: Cosimo's parents, Cosimo himself, his two sons, Giovanni and Piero, as well as Piero's two sons, Giuliano and Lorenzo il Magnifico. Michelangelo produced drawings and a wooden model for the church façade, but the project was never executed. To the artist's indignation the contract was annulled in 1520.

There's a simple reason for the abandonment of the façade: the money was needed for a more important project. Pope Leo and his cardinal cousin had decided that a tomb chapel should be built to hold the bodies of the two recently deceased Medici dukes, as well as the pair of brothers of the preceding generation who were also the fathers of the two clerical Medici—Giuliano, Cardinal Giulio's father, murdered in the Pazzi Conspiracy of 1478; and Pope Leo's father, Lorenzo il Magnifico, who had died in 1492. Il Magnifico was also the father of Duke Giuliano and the grandfather, through his son Piero,

of Duke Lorenzo. The tombs in the chapel thus would represent a tight web of family connections. The two patrons wanted Michelangelo, whom they both admired, to be in charge of such an important commission. With Medici dynastic ambitions in doubt because of the lack of legitimate heirs, an impressive monument to three generations of the family would serve to remind everyone of the Medici's continuing significant presence in the city.

Scholars disagree over whether the Medici Chapel had already been begun by a previous architect, but even if this is true, the building as it exists now, begun in 1520, is Michelangelo's. The chapel is a story higher than Brunelleschi's sacristy, and although Michelangelo paid tribute to the earlier master in his use of white walls articulated by strong outlines in brown *pietra serena*, the local stone used in a similar fashion by Brunelleschi, Michelangelo's architectural forms are much grander, more powerful, and less conventional than those of his predecessor.

Work progressed irregularly, interrupted by political and military upheavals in both Florence and Rome, with the result that the ensemble of architecture and sculpture was never completed. Michelangelo had been making good progress until May 1527, when the diplomatic ineptitude of Pope Clement VII brought about the Sack of Rome by imperial troops, a disaster that killed thousands and forced the pope to flee. It was five months before he dared creep back into the burnt-out and depopulated remains of the Eternal City.

A disaster for Rome and the Medici pope meant an opportunity for Florence once again to expel the Medici and reestablish the republic. But the republican triumph was short-lived. In 1530 a combination of papal and imperial forces captured Florence. The perfidious Pope Clement had reached an agreement with the emperor Charles V—the same man whose armies had nearly destroyed Rome three years earlier—to restore the Medici to power in Florence. The republic was now definitively dead, and the new pro-Medici government ordered Michelangelo put to death as a traitor. An ardent supporter of the republic, he had designed fortifications against the invading armies. The terrified artist hid in—of all unlikely places—an underground room at the church of S. Lorenzo. But for Clement, the artist's politics were irrelevant, and his genius irreplaceable. The pope had the charges dropped, and Michelangelo went back to work on the Medici Chapel, with what ambivalence of mind and bitterness of heart we may easily imagine.

In 1531, with the continued aid of Emperor Charles V, Clement installed his own illegitimate son Alessandro as the first hereditary duke of Florence,

with the young man's illegitimacy canceled by papal decree and his title pur-chased from that same emperor, whose illegitimate daughter Alessandro then married. To preserve at least a trace of propriety, Alessandro was passed off as the illegitimate son of the deceased Duke Lorenzo. Appalled by all the sordid political horse-trading going on around him, disgusted with the city's govern-ment, and furious at the Medici for what he considered their betrayal of the republic, in 1534 Michelangelo departed Florence forever. News had reached the artist that Clement VII was dying, and this was the signal for Michelangelo to abandon a project that had probably long ago ceased to engage his loyalty. He left the Medici Chapel with its architecture finished but its tomb ensembles incomplete. Although the tombs intended for the two Medici dukes were nearly finished, he had never started those for the two Medici of the previous generation, Lorenzo il Magnifico and his brother Giuliano. Not even the as-sassination of Duke Alessandro in 1537 could persuade the embittered artist to return to his native city.

At the time Michelangelo began work on the Medici Chapel in 1520, it seems that neither Pope Leo nor Cardinal Giulio de' Medici had any specific program in mind for the monument, and so they entrusted Michelangelo with both the design and the meaning of the tomb complex. "We will agree with whatever you think appropriate," Cardinal Giulio wrote to Michelangelo, and even when he became pope he remained in awe of the formidable artist. Left with such a remarkable degree of artistic autonomy, Michelangelo could give free rein to his imagination, although exactly what he had in mind remains unclear, as does the extent of Pope Clement's participation. From his letters it appears that Clement had spurts of intense interest in the project alternating with periods of indifference. The artist, for his part, neither wrote out nor sketched out a complete plan for the chapel, leaving only tantalizing hints and baffling fragments.

Whatever experience Michelangelo intended for the visitor to the Medici Chapel, it's not the one we have today. Originally, people entered the chapel from inside the church of S. Lorenzo, through an inconspicuous door in the right transept. Now, the visitor has to enter through what may be the ugli-est and most oppressive structure in Florence: the Capella dei Principi, or Chapel of the Princes, a dingy, overdecorated monument to the excesses of subsequent generations of Medici dukes. To enter Michelangelo's soaring architecture after passing through that grotesque place is like breathing fresh, cold mountain air after being trapped in a dusty crypt.

Once inside the Medici Chapel, the visitor sees two tombs facing one another on the east and west walls, with the altar on the north end, and statues of the Virgin and Child flanked by the Medici patron saints Cosmas and Damian completing the ensemble on the south wall. Beneath the statues of the two saints and the Madonna, an inscription marks the burial place of the elder Giuliano de' Medici and Lorenzo il Magnifico, whose bodies were brought from the Old Sacristy and reburied here in 1559.

Although the sculptures of Cosmas and Damian are the work of Michelangelo's assistants, the Madonna and Child is Michelangelo's last version of a theme he had worked on throughout his life, and it's one of his most beautiful and moving. Nonetheless, in Michelangelo's hands at this moment in his career even the nursing Madonna appears less than lyrical. Her head twists to one side; her body seems almost to lurch forward; her legs are crossed, and a muscular Christ Child astride her left thigh twists himself around strenuously to grab hold of her breast. Only in the infinite sadness of Mary's face do we glimpse a traditional aspect of the Virgin: her foreknowledge of her Son's fate.

The sculptural ensembles that have puzzled and intrigued generations of viewers are the elaborate wall tombs of Giuliano, duke of Nemours, and Lorenzo, duke of Urbino. We may wonder why Michelangelo began with the tombs of those two insignificant Medici, men who accomplished almost nothing in their brief lives, rather than with the tomb of Lorenzo il Magnifico. The earlier Lorenzo had been Michelangelo's first patron, a man with whom the artist had enjoyed a close relationship and who had been a leader of outstanding, almost legendary achievements.

Although we can never be certain of what was in the artist's mind, we know that the two Medici dukes were anything but insignificant in the mind of Pope Clement, who must have made it clear to Michelangelo that the tombs of the dukes took priority, and that he wanted their monuments to be the most splendid in the chapel. The two "Magnifici," as the earlier Lorenzo and Giuliano were called, had been merely the first citizens of the fifteenth-century Florentine state; Lorenzo il Magnifico had exercised leadership from behind the scenes, with the forms of the republic always scrupulously maintained. The two dukes, on the other hand, had been something like princes, the first Medici with aristocratic titles to rule Florence. But Clement knew that neither man had ever been a true duke in the legal sense. Duke of Nemours was an honorary title tossed to Giuliano de' Medici by the king of France, and the

younger Lorenzo had held the title Duke of Urbino only while Leo X was pope. After Leo's death the legitimate duke, Guidobaldo della Rovere, promptly won it back. With such weak claims to authority, it was all the more important for Clement to establish a solid base for Medici succession. The grander the tombs Michelangelo created for the two would-be dukes, the better they would serve Clement's dynastic aims.

The two tombs are identical in format: each consists of a sarcophagus on the lower level, the curving lid surmounted by nude male and female statues that, as we know from Michelangelo himself, represent the Times of Day, and in a niche above these, an over-life-size statue of the seated duke, dressed in ceremonial armor. When Michelangelo left Florence in 1534, he had completed and put in place the two statues of the dukes, but he had left the four statues of the Times of Day (Night and Day, Twilight and Dawn) scattered around on the floor of the chapel in various stages of completion. He had never begun the statues of Rivers that were to complete the ensembles on the ground level. Although Michelangelo's assistants arranged the statues in their present positions in 1545, nobody dared to complete any of the statues that Michelangelo had left unfinished.

The question persists: what was Michelangelo thinking when he created the two imposing tombs? The overall meaning he assigned to these statue groups remains uncertain, although there have been numerous scholarly attempts to figure out what he intended. A confusing passage scribbled by the artist on a sheet of paper that also contains a preliminary sketch for the tombs may offer a clue, but its meaning remains obscure. Even though translating the fragment presents still further problems, the attempt is worthwhile for the glimpse it offers into the complexities of Michelangelo's mind. In a translation by Michelangelo scholar Frederick Hartt, it reads:

> The heavens and the earth, Night and Day, are speaking and saying, We have with our swift course brought death to the Duke Giuliano; it is just that he take vengeance upon us as he does, and the vengeance is this: that we having slain him, he thus dead has taken the light from us and with closed eyes has fastened ours so that they may shine forth no more upon the earth. What would he have done with us then while he lived?

Whatever *that* might mean! It's difficult to imagine what the artist thought the good-natured but ineffectual Giuliano would have done had he lived longer. Perhaps he was thinking that he might have become a leader in the

mold of his famous father? In any case, when Michelangelo came to sculpt the actual tombs, he ignored his own notes, since the eyes of all the figures except Night are open.

Another puzzling aspect of the tombs is the positioning of the figures atop the sarcophagus of each of the dukes. They are placed at such a sharp downward angle that they appear to be sliding off, a pose that makes them appear unstable, uncomfortable, and struggling—although against what, other than the force of gravity, we don't know. Nor is anyone certain if this is the position Michelangelo intended for his marble figures, since his assistants put them there after the artist had left Florence. As far as we know, the artist never provided any instructions concerning the placement of the statues.

On the tomb of Duke Giuliano, to the left of the Madonna and Child group, the female figure of Night is a mature woman who has borne children—her breasts sag, her stomach muscles are slack and stretched. Head bowed and eyes closed, she appears sunk in restless sleep. Night is the only one of the Times of Day supplied with attributes. An owl lurks beneath her left thigh and a grotesque mask sits below her left shoulder, perhaps to suggest nightmares. A bunch of poppies, a symbol of death and the source of opium, rests under her left foot. Opposite her, Day is a titanic male whose face is only partially roughed out—it looks more like a mask as he turns to glare toward the viewer over the powerful muscles of his right shoulder. The figures on the tomb of Duke Lorenzo are more fully finished, although neither is entirely completed. Dusk is another muscular male, glancing downward as if in thought, and Dawn is a youthful female with firm breasts, a flat stomach, and a melancholy face.

The four figures have one peculiar quality in common: they appear to be in mental or emotional distress, writhing helplessly and seeming entangled in their own limbs, or drooping in weariness and depression. Are they mourning a specific tragedy, the premature deaths of the promising young dukes? Or, as representations of Time, are they varying aspects of the ultimate tragedy that includes us all—human mortality, the relentless passage of time that leads everyone inevitably to death? In his biography of Michelangelo, written with the artist's active cooperation, Ascanio Condivi declares that the figures on the tombs signify "time which devours all," adding that Michelangelo wanted to express the idea of the transience of all earthly things. It is worth keeping Condivi's words in mind—they're as close as we're likely to come to a statement of Michelangelo's own intentions.

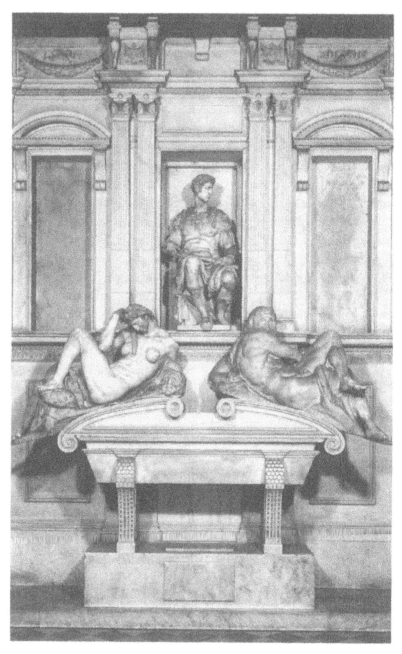

Michelangelo, Tomb of Giuliano de' Medici, Duke of Nemours, Medici Chapel, church of S. Lorenzo. Alinari / Art Resource, NY

The statues of the two dukes also have puzzling aspects. Portraits exist of both men, so we can easily ascertain that Michelangelo's muscular figures with their clean-shaven faces do not even remotely resemble the actual Medici dukes, both of whom were bearded, and neither of whom was an especially striking physical specimen. The faces of the two statues display a somber beauty, but also a strange slackness and lack of energy. They bear a general resemblance to the face of Michelangelo's *David*, but without the energy and the fiercely watchful vitality of that earlier work. Although neither duke distinguished himself on the battlefield, both are shown in ancient Roman–style armor. The costumes have some slight basis in reality, however, as the two men had been appointed Captains of the Church, but the title was honorary, with little or no basis in military experience.

That portraiture never interested Michelangelo is well-known. His goal from his earliest days was the creation of ideal, perfect forms, not the reproduction of ordinary, imperfect bodies and facial features. In 1544 a contemporary of the artist recorded Michelangelo's attitude on the matter: "He did not take from [the two dukes] the model just as nature had drawn and composed them, but he gave them a greatness, a proportion, a dignity . . . which seemed to him would have brought more praise, saying that a thousand years hence no one would be able to know they were otherwise." One suspects the writer may have cleaned up Michelangelo's comment. The biting rancor of the artist toward the later generation of Medici rulers more likely resulted in his snapping the sixteenth-century Tuscan equivalent of "In a thousand years, nobody will give a damn what either one of them looked like!"

When we try to understand the Medici Chapel as a whole, we shouldn't forget the religious aspect—the site isn't just a glorification of individuals and family or an illustration of some esoteric philosophical program. Despite the dynastic obsessions of the patrons, it is a funerary chapel dedicated to the Resurrection—an appropriate theme for the deceased Medici buried there, a sign of their hope for salvation through the intercession of SS. Cosmas and Damian and the Virgin and Child. There's some evidence that Michelangelo had planned to paint a fresco of the Resurrection on the wall above the chapel's altar. Time may consume the flesh, as Michelangelo's somber statues of the Times of Day remind us, but there still remains the promise of eternal life in the world to come—the very essence of the Christian faith.

And yet, the Medici Chapel isn't a place that offers the visitor spiritual comfort and peace. Its gigantic architectural forms, sometimes defined as

Mannerist in their unconventional style, do not produce the effect of harmony and rationality so clearly sensed in Brunelleschi's sacristy. Instead they often strike the visitor as dissonant and irrational. The strange despondency of the Times of Day combined with the equally peculiar sense of lassitude and sadness in the statues of the two dukes produce a disconcerting effect.

Although we may never know what overarching theme—if any—Michelangelo pondered while he was working on these monuments, what we know about the circumstances surrounding their creation suggests the artist's intense anger, bitterness, and disillusion with the world in which he was living and working, and his profound disappointment with the Medici in particular. Although he obviously couldn't use his art to make a mockery of his patrons and the individuals they'd assigned him to commemorate, he certainly did choose an odd and obscure way of glorifying them. Unaware of the artistic triumphs awaiting him in Rome, what Michelangelo created in the Medici Chapel seems to me less a celebration of religious faith or a monument to the Medici than a tomb where he buried his own best hopes.

EPILOGUE

The firm establishment of the ducal regime in Florence under Duke Cosimo I de' Medici brought the city a stability and continuity in government that it had lacked, historically, but it also sounded the death knell for Florence as the capital city of the Italian Renaissance. Although Cosimo had the brilliant Bronzino as his court painter and the services of the equally accomplished Cellini as a sculptor, many of the other artists he hired came nowhere near their level of talent. And even before Cosimo became duke, Florence had lost its greatest artist when Michelangelo departed in 1534 and never again set foot in his native city.

Despite his undoubted political acumen, Cosimo made a major aesthetic mistake when he appointed Giorgio Vasari as his artistic impresario. Vasari was a talented researcher and writer (it's difficult to imagine what historians of Italian art would do without his *Lives of the Artists*), but he was only a modestly talented painter. He directed a large studio of assistants and either supervised or created a considerable body of work in Florence, most of it mediocre in quality. He's responsible, among other works, for the gaudy tomb of Michelangelo in S. Croce and for the enormous cycles of frescoes glorifying the Medici that cover so many of the walls inside the Palazzo Vecchio. In addition to the ubiquitous Vasari and his followers, Cosimo also commissioned sculptural works from Baccio Bandinelli, whose lumpen marble creations—including a seated statue of Duke Cosimo's father now located in front of the church of S. Lorenzo—the critical Florentines often ridiculed.

Michelangelo's definitive departure from Florence and his permanent transfer to Rome was far from the first sign that Florence had lost its status as a major center of the arts. Well before Duke Cosimo established himself as the ruler of Florence, the focus of artistic energies had begun the shift to

Rome, beginning as early as 1503, the first year of the papacy of Julius II. Like a magnetic force field this aggressive and ambitious pope drew artists into his orbit. After Michelangelo completed his stupendous statue of David, we might expect that the artist would have remained in Florence, and that he soon would have received further commissions there, but instead he went to Rome in 1506 to work on Julius's tomb and subsequently on the Sistine Chapel ceiling. Raphael—not a native, but well established and popular in Florence—soon followed.

The subsequent Medici dukes descended from Cosimo presided over a declining city, and they failed to distinguish themselves as art patrons. Although several added to the family's art collections through works that came to them through their marriages, others were indifferent or downright hostile to the arts. One, Duke Cosimo III (1670–1723), was so fanatically puritanical that he ordered Michelangelo's *David* covered with a tarpaulin. Monuments of the later Medici dot the city, but the only one that receives much attention is the enormous gloomy mausoleum known as the Chapel of the Princes, part of the architectural complex of the Medici family church, S. Lorenzo. Begun in 1604 from a design provided by Duke Cosimo I's illegitimate son Giovanni, it's a monument to Medici excesses, an overdecorated monstrosity lined with dark-colored marbles and glittering with lapis lazuli, mother-of-pearl, and semiprecious stones. Six Medici grand dukes are buried there, in elaborate tombs. The construction proved so costly that none of the dukes could ever see it to completion, and work continued into the late nineteenth century, well after the ducal regime had died out. The floor wasn't finished until 1962.

When no heirs could be coaxed from the last, utterly dissolute Grand Duke Gian Gastone, who died in 1737, the final Medici heir was his sister Anna Maria Luisa. To her eternal credit, she made a will that left all the accumulated properties and treasures of the House of Medici to the Florentine state, on the condition that nothing from that collection was ever to be removed or sold. Thanks to her farsighted stewardship, the priceless collections of earlier generations of the Medici became the common artistic heritage of Florence and they—along with so many other artistic treasures—remain among the glories of the city. To this day Florence is the ultimate art lover's paradise.

ACKNOWLEDGMENTS

R esearch can be a solitary activity, but it's one made easier and more enjoyable by the help of colleagues and the encouragement of friends. My first debt of gratitude is to the staffs of the libraries that provided access to so many of the books and articles I consulted: Founders Library at Northern Illinois University, DeKalb, in particular its Information Delivery Services department; the library of the Netherlands Academy in Rome, where librarian Janet Mente repeatedly located materials I'd been unable to find on my own; and the library of the American Academy in Rome, where I've spent many happy days.

Although I'd like to think I know Italian and have a working knowledge of Latin, I'm grateful to Prof. Chris Nissen of Northern Illinois University and Leofranc Holford-Strevens of the Oxford University Press for their willingness to check my translations of texts in both languages. They also on occasion untangled Latin syntax for me. Since I have no knowledge of Hebrew, my friend and expert on Judaica, Solomon Mowshowitz, answered my questions concerning what biblical texts *really* say about David the shepherd boy and future king who is the subject of two of the works discussed here.

My thanks to Prof. F. W. "Bill" Kent of Monash University, Australia, for his generous help sadly come too late, as he died while this book was in progress. He was one of those wonderful scholars who was never too busy to take time from his own work to open his e-mail and answer, in detail, my frequent questions.

Paul Basile, the indefatigable editor of *Fra Noi,* the Italian American news magazine of the greater Chicago area, was his usual generous and gracious self, allowing articles I'd published in *Fra Noi* to reappear in revised and expanded form here, without any copyright restrictions. Mary Lincoln was kind enough to read and offer comments on a preliminary draft of this book. Dorothy Mills did the same for the Introduction.

The staff of the Northern Illinois University Press—Alex Schwartz, director; Susan Bean, managing editor; Amy Farranto, editor; and Julia Fauci, graphic designer—all played a crucial role in shaping this work, from first

proposal to finished product. Anonymous external readers of the manuscript, chosen by the Press, also made important contributions by correcting errors and offering constructive suggestions.

I am also grateful to Art Resource for the vast archive of high-quality photographs they make available to authors.

And although I hate to be caught contradicting Dante, in the time I've spent in Florence over the years, prowling endlessly around buildings and sculptures, gazing at paintings, and sometimes parking myself for hours in front of particular works of art, I've never once found the Florentines vile.

SELECTED BIBLIOGRAPHY

GIVING CREDIT WHERE DUE

Although there are whole libraries devoted to books and articles about the art of Florence, those works provide more information and more detail than even the most intellectually curious traveler to Florence is likely to want or need, and furthermore they are often burdensomely large and heavy. Therefore, in addition to offering my own observations, I've summarized some of the insights provided by leading scholars of Renaissance art and history.

Scholarly habits die hard. This isn't a work of original research but one that relies heavily on the research of others, which makes the issue of sources important. Since footnotes have no place in a guidebook, it's difficult to give proper credit to the many sources consulted in the writing of these essays. Furthermore, over the years that I've studied, researched, and taught Renaissance art, I've consulted many more works than are cited in this bibliography, works whose authors and titles I've forgotten but whose content I've absorbed. I hope that mention here will serve to acknowledge any inadvertent borrowings. The following selective list of sources given for each essay indicates at least some of my debts to the scholars whose research helped form many of my own conclusions concerning the works discussed. With one exception, I cite only works in English.

There are a few books I've used so often that listing them repeatedly for each chapter would be redundant. It's impossible to write about Italian Renaissance art without referring to Giorgio Vasari's *Lives of the Artists*, first published in 1550 and still an essential source. Chief among the modern works I've consulted is Frederick Hartt's magisterial *History of Italian Renaissance Art: Painting, Sculpture, Architecture*, coauthored by David G. Wilkins and now in its seventh edition. Alta Macadam's *Blue Guide: Florence* remains a reliable source for basic information, as does Gloria Fossi's guide to the collections of the Uffizi. I should also mention Laurie Schneider Adams's fine textbook *Italian Renaissance Art*. The work contains much valuable information, and some of it no doubt has found its way into this book.

Ross King's *Brunelleschi's Dome: How a Renaissance Genius Reinvented Architecture* was the most important source for the material that appears in my discussion of the dome of Florence cathedral. I've borrowed the beginning of the title of Janet Cox-Rearick's study, *Dynasty and Destiny in Medici Art*, for one of my chapters. In common with most researchers in the twenty-first century, I've also used the Internet, sometimes merely to find basic information such as the birth and death dates of an individual, and at other times to consult sources unavailable elsewhere. Internet sites consulted extensively are noted in the bibliography.

General Works and Historical Background

Acidini Luchinat, Cristina. *Renaissance Florence in the Age of Lorenzo de' Medici, 1449–1492*. Florence: Charta, 1993.

Ames-Lewis, Francis, ed. *The Early Medici and Their Artists*. London: Caltra House, 1995.

Brion, Marcel. *The Medici: A Great Florentine Family*. New York: Crown Publishers, 1969.

Brown, Allison. "Piero's Infirmity and Political Power." In *Piero de' Medici "Il Gottoso" (1416–1469): Art in the Service of the Medici*, ed. Andreas Beyer and Bruce Boucher, 9–19. Berlin Akademie Verlag, 1993.

Bullard, Melissa Meriam. *Lorenzo il Magnifico: Image and Anxiety, Politics and Finance*. Florence: Leo S. Olschki Editore, 1994.

Clough, James. *The Medici: A Tale of Fifteen Generations*. New York: Dorset Press, 1990.

Duggan, Christopher. *A Concise History of Italy*. Cambridge: Cambridge University Press, 1994.

Fulton, Christopher B. *An Earthly Paradise: The Medici, Their Collection and the Foundations of Modern Art*. Florence: Leo S. Olschki Editore, 2006.

Guicciardini, Francesco. *History of Italy*. Translated and edited by Sidney Alexander. New York: Collier Books, 1969.

———. *History of Italy and History of Florence*. Translated by Cecil Grayson; edited and abridged by John R. Hale. New York: Washington Square Press, 1964.

Hartt, Frederick. "Art and Freedom in Quattrocento Florence." *Essays in Honor of Karl Lehmann*, ed. Lucy Freeman Sandler, 114–31. New York: New York University Institute of Fine Arts, 1971.

Hartt, Frederick, and David G. Wilkins. *History of Italian Renaissance Art: Painting, Sculpture, Architecture*. 7th edition. Upper Saddle River: Prentice Hall, 2011.

Hibbert, Christopher. *Florence: The Biography of a City*. London: Penguin Books, 1994.

———. *The House of Medici: Its Rise and Fall*. New York: William Morrow, 1975.

Hook, Judith. *Lorenzo de' Medici*. London: Hamish Hamilton, 1984.

Kent, Dale. *Cosimo de' Medici and the Florentine Renaissance: The Patron's Oeuvre*. New Haven: Yale University Press, 2000.

———. *Friendship, Love, and Trust in Renaissance Florence*. Cambridge: Harvard University Press, 2009.

Kent, Francis William. *Lorenzo de' Medici and the Art of Magnificence*. Baltimore: Johns Hopkins University Press, 2004.

Levey, Michael. *Florence: A Portrait*. Cambridge: Harvard University Press, 1996.

Macadam, Alta. *Blue Guide: Florence*. 7th edition. London: Blue Guides, 2005.

Machiavelli, Niccolò. *History of Florence*. Edited by Myron Gilmore, translated by Judith Rawson. New York: Twayne Publishers, 1970.

Vasari, Giorgio. *Lives of the Artists*. Translated and edited by George Bull. London: Penguin Books, 1987.

The Cathedral and Its Dome

King, Ross. *Brunelleschi's Dome: How a Renaissance Genius Reinvented Architecture*. London: Chatto and Windus, 2000.

Manetti, Antonio. *The Life of Brunelleschi*. Introduction, notes, and critical text edition by Howard Saalman; translated by Catherine Engass. University Park: Pennsylvania State University Press, 1970.

Prager, Frank, and Giustina Scaglia. *Brunelleschi: Studies of His Technology and Inventions*. Cambridge: MIT Press, 1970.

The Hawkwood and Tolentino Frescoes

Borsook, Eve. *The Mural Painters of Tuscany from Cimabue to Andrea del Sarto*. Oxford: Clarendon Press, 1980.

Hale, John R. *Artists and Warfare in the Renaissance*. New Haven: Yale University Press, 1990.

Horster, M. *Andrea del Castagno*. Ithaca: Cornell University Press, 1980.

Hudson, Hugh. "The Politics of War: Uccello's Equestrian Monument for Sir John Hawkwood in the Cathedral of Florence." Found at http://hughhudson.net/pdg/hugh_hudson_paper08.pdf.

Mallett, Michael. *Mercenaries and Their Masters: Warfare in Renaissance Italy*. Totowa: Rowman and Littlefield, 1974.

"Note biografiche di capitani di guerra e di condottieri di ventura operanti in Italia nel 1330–1550." Found at http://www.condottieridiventura.it/condottieri/t/1969.

Richter, G. M. *Andrea del Castagno*. Chicago: University of Chicago Press, 1943.

Saunders, Frances Stonor. *Hawkwood: Diabolical Englishman*. New York: HarperCollins, 2004.

Wegener, Wendy. "'That the practice of arms is most excellent declare the statues of valiant men:' The Luccan War and Florentine Political Ideology in Paintings by Uccello and Castagno." *Renaissance Studies* 7, vol. 2 (1993): 129–67.

The Cathedral Baptistery and Its Bronze Doors

Fengler, Christie Knapp. "Lorenzo Ghiberti's *Second Commentary*: The Translation and Interpretation of a Fundamental Renaissance Treatise on Art." PhD dissertation, University of Wisconsin, 1974.

Krautheimer, Richard, and Trude Krautheimer-Hess. *Lorenzo Ghiberti*. 2 vols. Princeton: Princeton University Press, 1970.

Paolucci, Antonio. *The Origins of Renaissance Art: The Baptistery Doors, Florence*. Translated by F. P. Chiarini. New York: George Braziller, 1996.

Radke, Gary, ed. *The Gates of Paradise: Lorenzo Ghiberti's Renaissance Masterpiece.* New Haven: Yale University Press, 2006.

The Tomb of Pope John XXIII (Baldassare Coscia) inside the Baptistery

Caplow, Harriet McNeal. *Michelozzo.* New York: Garland Publishing, 1977.
Janson, H. W. *The Sculpture of Donatello.* Princeton: Princeton University Press, 1979.
Kent, Dale. *Cosimo de' Medici and the Florentine Renaissance: The Patron's Oeuvre.* New Haven: Yale University Press, 2000.
Lightbown, Ronald W. *Donatello and Michelozzo.* London: Harvey Miller, 1980.
McHam, Sarah Blake. "Donatello's Tomb of Pope John XXIII." In *Life and Death in Fifteenth-Century Florence,* ed. Marcel Tetel, Ronald G. Witt, and Rona Goffen, 146–73. Durham: Duke University Press, 1989.
Strocchia, Sharon. *Death and Ritual in Fifteenth-Century Florence.* Baltimore: Johns Hopkins University Press, 1992.

The Brancacci Chapel in S. Maria del Carmine

Casazza, Ornella. *Masaccio and the Brancacci Chapel.* Florence: Scala, 1990.
Forsinini, Cecilia. *Masaccio.* Translated by Michael Sullivan. Florence: Giunti Gruppo Editoriale, 2003.
Goffen, Rona. "Adam and Eve in the Brancacci Chapel, or Sex and Gender in the Beginning." In *The Brancacci Chapel: Form, Function and Setting,* ed. Nicholas A. Eckstein, 115–38. Florence: Leo S. Olschki, 2005.
Kent, Dale. "The Brancacci Chapel Viewed in the Context of Florentine Culture of Artistic Patronage." In *The Brancacci Chapel: Form, Function, and Setting,* ed. Nicholas A. Eckstein, 53–71. Florence: Leo S. Olschki, 2005.
Ladis, Andrew. *The Brancacci Chapel, Florence.* New York: George Braziller, 1993.
Molho, Anthony. "The Brancacci Chapel: Studies in Its Iconography and History." *Journal of the Warburg and Courtauld Institutes* 40 (1977): 50–98.
Nelson, Jonathan K. and Richard J. Zeckhauser. *The Patron's Payoff: Conspicuous Commissions in Italian Renaissance Art.* Princeton: Princeton University Press, 2008.

The Statue Groups in the Piazza della Signoria

Even, Yael. "The Loggia dei Lanzi. A Showcase of Female Subjugation." *Woman's Art Journal* 12, no. 1 (1991): 10–14.
Johnson, Geraldine A. "Idol or Ideal? The Power and Potency of Female Public Sculpture." In *Picturing Women in Renaissance and Baroque Italy,* ed. Geraldine A. Johnson and Sara F. Mathews-Grieco, 222–45. Cambridge: Cambridge University Press, 1997.

Donatello's *Judith Beheading Holofernes*

Avery, Charles. *Donatello: An Introduction.* New York: HarperCollins, 1994.

Janson, H. W. *The Sculpture of Donatello.* Princeton: Princeton University Press, 1979.

Cellini's *Perseus and Medusa*

Cellini, Benvenuto. *The Autobiography of Benvenuto Cellini.* Translated by George Bull. Baltimore: Penguin Books, 1966.

Cole, Michael. "Cellini's Blood." *Art Bulletin* 81, no. 2 (June 1999): 215–35.

Gallucci, Margaret. *Benvenuto Cellini: Sexuality, Masculinity, and Artistic Identity in Renaissance Italy.* New York: Palgrave Macmillan, 2003.

———. "Cellini's Trial for Sodomy: Power and Patronage at the Court of Cosimo I." In *The Cultural Politics of Duke Cosimo I de' Medici,* ed. Konrad Eisenbichler, 37–46. Burlington: Ashgate Publishing, 2001.

Pope-Hennessy, John. *Cellini.* New York: Abbeville Press, 1985.

Giambologna's *Rape of a Sabine Woman*

Avery, Charles. *Giambologna: The Complete Sculpture.* Mount Kisco: Moyer Bell, 1978.

Carroll, Margaret. "The Erotics of Absolutism: Rubens and the Mystification of Sexual Violence." *Representations* 25 (winter 1989): 3–33.

Cole, Michael. "Giambologna and the Sculpture with No Name." *Oxford Art Journal* 31, no. 3 (2008): 339–59.

Wolfthal, Diane. *Images of Rape: The "Heroic" Tradition and Its Alternatives.* Cambridge: Cambridge University Press, 1999.

Orsanmichele and Its Statues

Artusi, Luciano, and Silvano Gabbrielli. *Historic and Artistic Guide to Orsanmichele in Florence.* Translated by Phyllis Peerless. Florence: Editrice Giusti, n.d.

Butterfield, Andrew. "The Christ and St. Thomas of Andrea del Verrocchio." In Dolcini, *Verrocchio's Christ and St. Thomas,* 53–79.

Dolcini, Loretta, ed. *Verrocchio's Christ and St. Thomas: A Masterpiece of Sculpture from Renaissance Florence.* New York: Harry N. Abrams, 1992.

Kreytenberg, Gert. *Orcagna's Tabernacle in Orsanmichele, Florence.* New York: Harry N. Abrams, 1994.

Landucci, Luca. *A Florentine Diary from 1450 to 1516.* Translated by Alice de Rosen Jervis. New York: Arno Press, 1969.

Zervas, Diane Finiello. "The Building and Decoration of Orsanmichele before Verrocchio." In Dolcini, *Verrocchio's Christ and St. Thomas,* 39–51.

The Ospedale degli Innocenti

Battisti, Eugenio. *Filippo Brunelleschi: The Complete Work*. New York: Rizzoli, 1981.

Gavitt, Philip. *Charity and Children in Renaissance Florence: The Ospedale degli Innocenti, 1410–1536*. Ann Arbor: University of Michigan Press, 1993.

Saalman, Howard. *Filippo Brunelleschi: The Buildings*. University Park: Pennsylvania State University Press, 1993.

Trexler, Richard. "The Foundlings of Florence." In *The Children of Renaissance Florence: Power and Dependence in Renaissance Florence*, 1:7–34. Ashville: Pegasus Press, 1998.

The Monastery of San Marco

Hood, William. *Fra Angelico: San Marco, Florence*. New York: George Braziller, 1995.

———. *Fra Angelico at San Marco*. New Haven: Yale University Press, 1993.

———. "Fra Angelico at San Marco: Art and the Liturgy of Cloistered Life." In *Christianity and the Renaissance: Image and Religious Imagination in the Quattrocento*, ed. Timothy G. Verdon and John Henderson, 108–31. Syracuse: Syracuse University Press, 1990.

Kanter, Laurence, and Pia Palladino. *Fra Angelico*. New Haven: Yale University Press, 2006.

Kent, Dale. *Cosimo de' Medici and the Florentine Renaissance: The Patron's Oeuvre*. New Haven: Yale University Press, 2000.

Lloyd, Christopher. *Fra Angelico*. London: Phaidon Press, 1992.

Miller, Julia L. "Medici Patronage and the Iconography of Fra Angelico's *San Marco Altarpiece*." *Studies in Iconography* 11 (1987): 1–13.

Morachiello, Paolo. *Fra Angelico: The San Marco Frescoes*. London: Thames and Hudson, 1996.

Pope-Hennessy, John. *Fra Angelico*. London: Phaidon Press, 1952.

The Medici Palace and Its Chapel

Acidini Luchinat, Cristina. *The Chapel of the Magi: Benozzo Gozzoli's Frescoes in the Palazzo Medici Riccardi Florence*. London: Thames and Hudson, 1994.

Beyer, Andreas, and Bruce Boucher, eds. *Piero de' Medici "il Gottoso": Art in the Service of the Medici*. Berlin: Akademie Verlag, 1993.

Hatfield, Rab. "Cosimo de' Medici and the Chapel of His Palace." In *Cosimo "Il Vecchio" de' Medici: Essays in Commemoration of the 600th Anniversary of Cosimo de' Medici's Birth*, ed. Francis Ames-Lewis, 221–44. Oxford: Clarendon Press, 1992.

———. "Some Unknown Descriptions of the Medici Palace in 1459." *Art Bulletin* 52, no. 3 (September 1970): 232–49.

Kent, Francis William. "Palaces, Politics, and Society in Fifteenth-Century Florence." *I Tatti Studies* 2 (1987): 41–70.

Saalman, Howard, and Philip Mattox. "The First Medici Palace." *Journal of the Society of Architectural Historians* 44, no. 4 (December, 1985): 329–45.

Palazzo Rucellai

Kent, Francis William. *Household and Lineage in Renaissance Florence: The Family Life of the Capponi, Ginori, and Rucellai.* Princeton: Princeton University Press, 1977.

Kent, Francis William, et al. *A Florentine Patrician and His Palace.* London: University Of London, Warburg Institute, 1981.

Lindow, James R. *The Renaissance Palace in Florence: Magnificence and Splendour in Fifteenth-Century Italy.* Aldershot: Ashgate Publishing, 2007.

Thomson, David. *Renaissance Architecture: Critics, Patrons, Luxury.* New York: Manchester University Press, 1993.

The Sassetti Chapel in S. Trinita

Borsook, Eve, and Johannes Offerhaus. *Francesco Sassetti and Ghirlandaio at S. Trinita: History and Legend in a Renaissance Chapel.* Doornspijk: Davaco, 1981.

Cadogan, Jean. *Domenico Ghirlandaio: Artist and Artisan.* New Haven: Yale University Press, 2000.

Gombrich, Ernst. "The Sassetti Chapel Revisited: S. Trinita and Lorenzo de' Medici." *I Tatti Studies* 7 (1997): 11–35.

Rubin, Patricia. *Images and Identity in Fifteenth-Century Florence.* New Haven: Yale University Press, 2007.

Turner, A. Richard. *Renaissance Florence: The Invention of a New Art.* New York: Harry N. Abrams, 1997.

Welliver, Warman. "Alterations in Ghirlandaio's S. Trinita Frescoes." *Art Quarterly* 32 (1969): 269–81.

The Tornabuoni Chapel in S. Maria Novella

Cadogan, Jean. *Domenico Ghirlandaio: Artist and Artisan.* New Haven: Yale University Press, 2000. Simons, Patricia. "Patronage in the Tornaquinci Chapel, Santa Maria Novella, Florence." In *Patronage, Art and Society in Renaissance Italy*, ed. F. W. Kent and Patricia Simons, 221–50. Oxford: Clarendon Press, 1987.

Tinagli, Paola. *Women in Italian Renaissance Art: Gender, Representation, and Society.* Manchester: Manchester University Press, 1997.

The Museo degli Uffizi

Fossi, Gloria. *The Uffizi. Official Guide.* Florence, Giunti, 2010.

Van Veen, Henk. *Cosimo I de' Medici and His Self-Representation in Florentine Art and Culture.* New York: Cambridge University Press, 2006.

Uccello's *Battle of San Romano*

Bibby, Samuel. "Changing Perspectives: The Florentine Histories of Uccello's *Battle of San Romano* Panels." *Object* 10 (2008): 5–24.

Griffiths, Gordon. "The Political Significance of Uccello's *Battle of San Romano*." *Journal of the Warburg and Courtauld Institutes* 14 (1978): 313–16.

Botticelli's *Adoration of the Magi*

Ettlinger, Leopold, and Helen Ettlinger. *Botticelli.* New York: Oxford University Press, 1977.

Hatfield, Rab. *Botticelli's "Adoration": A Study in Pictorial Content.* Princeton: Princeton University Press, 1976.

Lightbown, Ronald. *Sandro Botticelli: Life and Work.* 2 vols. Berkeley and Los Angeles: University of California Press, 1978.

Boticelli's *Primavera* and *Birth of Venus*

Baldini, Umberto, ed. *Primavera: The Restoration of Botticelli's Masterpiece.* New York: Harry N. Abrams, 1986.

Barolsky, Paul. "Botticelli's *Primavera* and the Poetic Imagination of Italian Renaissance Art." *Arion*, 3rd series, 8, no. 2 (Fall 2000): 5–35.

Botticelli from Lorenzo the Magnificent to Savonarola. Exhibition catalog. Paris: Musée du Luxembourg; Milan: Skira Editore, 2003.

Dempsey, Charles. *The Portrayal of Love: Botticelli's "Primavera" and Humanist Culture at the Time of Lorenzo the Magnificent.* Princeton: Princeton University Press, 1992.

Ettlin, Ross Brooke. "The Venus Dilemma: Notes on Botticelli and Simonetta Cattaneo Vespucci." *Source* 27, no. 4 (2008): 3–10.

Gombrich, Ernest. "Botticelli's Mythologies: A Study of the Neoplatonic Symbolism of His Circle." *Journal of the Warburg and Courtauld Institutes* 8 (1945): 7–60.

Levi d'Ancona, Mirella. *Botticelli's* Primavera: *A Botanical Interpretation including Astrology, Alchemy, and the Medici.* Florence, Leo S. Olschki Editore, 1982.

Schumacher, Andreas, ed. *Botticelli: Likeness, Myth, Devotion.* Exhibition catalog. Frankfurt: Städel Museum, 2009.

Smith, Webster. "On the Original Location of the *Primavera*." *Art Bulletin* 57, no. 1 (1975): 31–40.

Hugo van der Goes's *Portinari Altarpiece*

De Roover, Raymond. *The Rise and Fall of the Medici Bank*. Cambridge: Harvard University Press, 1965.

Dhanens, Elizabeth. *Hugo van der Goes*. Translated by Catherine Warnant. Antwerp: Fonds Mercator, 1998.

Koch, Robert. "Flower Symbolism in the Portinari Altarpiece." *Art Bulletin* 46 (1963): 70–77.

McNamee, M.B. "Further Symbolism in the Portinari Altarpiece." *Art Bulletin* 45 (1963): 142–43.

Walker, Robert M. "The Demon in the Portinari Altarpiece." *Art Bulletin* 42 (1960): 218–19.

Warburg, Aby. "Flemish Art and the Early Italian Renaissance." In *The Renewal of Pagan Antiquity*, trans. David Brill, 281–303. Los Angeles: Getty Trust, 1999.

Raphael's *Pope Leo X with Cardinals Giulio de' Medici and Luigi de' Rossi*

Beck, James H. *Raphael*. New York: Harry N. Abrams, 1976.

Cox-Rearick, Janet. *Dynasty and Destiny in Medici Art: Pontormo, Leo X, and the Two Cosimos*. Princeton: Princeton University Press, 1984.

Davidson, Bernice F. *Raphael's Bible: A Study of the Vatican Logge*. University Park: Pennsylvania University Press, 1985.

Ettlinger, Leopold, and Helen Ettlinger. *Raphael*. Oxford: Phaidon Press, 1987.

Meyer zur Capellen, Jurg. *Raphael: A Critical Catalogue of His Paintings*. Vol. 3. Landshut: Arcos Verlag, 2008.

Sherr, Richard. "A New Document concerning Raphael's Portrait of Leo X." *Burlington Magazine* 125 (January 1983): 31–32.

Bronzino's *Eleonora di Toledo and Her Son Giovanni de' Medici*

Eisenbichler, Konrad, ed. *The Cultural World of Eleonora di Toledo*. Burlington: Ashgate Publishing, 2004.

Falciani, Carlo, and Antonio Natale. *Bronzino: Artist and Poet at the Court of the Medici*. Exhibition catalog, Palazzo Strozzi. Florence: Mandragora, 2010.

Langdon, Gabrielle. *Medici Women: Portraits of Power, Love, and Betrayal in the Court of Duke Cosimo I de' Medici*. Toronto: University of Toronto Press, 2007.

Parker, Deborah. *Bronzino: The Renaissance Painter as Poet*. New York: Cambridge University Press, 2000.

Titian's *Venus of Urbino*

Clark, David Lang. "The Masturbating Venuses of Raphael, Giorgione, Titian, Ovid, Martial, and Poliziano." *Aurora: The Journal of Art History* 6 (2005): 1–16.

Freedberg, David. *The Power of Images: Studies in the History and Theory of Response*. Chicago: University of Chicago Press, 1989.

Goffen, Rona. "Renaissance Dreams." *Renaissance Quarterly* 40, no. 4 (winter 1987): 682–706.

———. ed. *Titian's Venus of Urbino*. New York: Cambridge University Press, 1997.

———. *Titian's Women*. New Haven: Yale University Press, 1997.

Reff, Theodore. "The Meaning of Titian's Venus of Urbino." *Pantheon* 21 (1963): 359–66.

The Museo Nazionale del Bargello

Tomasello, Bruna. *Museum of the Bargello: Guide to the Collections*. Translated by Anthony Brierley. Florence: Scala, 1991.

Donatello's *David with the Head of Goliath*

Ames-Lewis, Francis. "Donatello's Bronze *David* and the Palazzo Medici Courtyard." *Renaissance Studies* 3 (1989): 235–51.

Avery, Charles. *Donatello: An Introduction*. New York: HarperCollins, 1994.

Crum, Roger. "Donatello's Bronze David." *Journal of Renaissance Studies* 10 (1996): 440–50.

Dall'Orto, Giovanni. "'Socratic Love' as a Disguise for Same-Sex Love in the Italian Renaissance." *Journal of Homosexuality* 16, no. 1–2 (1988): 33–65.

Dixon, John. "The Drama of Donatello's David: Re-examination of an 'Enigma.'" *Gazette des Beaux-Arts* 93 (1979): 6–12.

Greenhalgh, Michael. *Donatello and His Sources*. New York: Holmes and Meier, 1982.

Janson, H. W. *The Sculpture of Donatello*. Princeton: Princeton University Press, 1979.

McHam, Sarah. "Donatello's Bronze David and Judith as Metaphors of Medici Rule in Florence." *Art Bulletin* 83 (2001): 32–47.

Randolph, Adrian W. B. "Homosocial Desire and Donatello's Bronze *David*." In *Engaging Symbols: Gender, Politics and Public Art in Fifteenth-Century Florence*, ed. Adrian W. B. Randolph, 139–92. New Haven: Yale University Press, 2002.

Rocke, Michael. *Forbidden Friendships: Homosexuality and Male Culture in Renaissance Florence*. Oxford: Oxford University Press, 1976

Rubin, Patricia. "'*Che è di questo culazzino!*' Michelangelo and the Motif of the Male Buttocks in Italian Renaissance Art." *Oxford Art Journal* 32, vol. 3 (2009): 429–46.

Saslow, James M. *Ganymede in the Renaissance: Homosexuality in Art and Society*. New Haven: Yale University Press, 1986.

Schneider, Laurie. "Donatello's Bronze David." *Art Bulletin* 55 (1973): 213–16.

———. "More on Donatello's Bronze 'David.'" *Gazette des Beaux-Arts* 94 (1979): 48.

Sperling, Christine. "Donatello's Bronze *David* and the Demands of Medici Politics." *Burlington Magazine* 134 (1992): 218–24.

Michelangelo's *Brutus*

Hartt, Frederick. *Michelangelo: The Complete Sculpture.* New York: Harry N. Abrams, n.d.

Hibbard, Howard. *Michelangelo.* New York: Vendome Press, 1978.

Wallace, William. *Michelangelo: The Complete Sculpture, Painting, Architecture.* New York: Hugh Lauter Levin Associates, 1998.

Michelangelo's *David*

Levine, Saul. "The Location of Michelangelo's David: The Meeting of January 25, 1504." *Art Bulletin* 56, no. 1 (March 1974): 31–49.

Parks, N. Randolph. "The Placement of Michelangelo's David: A Review of the Documents." *Art Bulletin* 57, no. 4 (December 1975): 560–70.

Seymour, Charles, Jr. *Michelangelo's David: A Search for Identity.* Pittsburgh: University of Pittsburgh Press, 1967.

Shearman, John. *Only Connect: Art and the Spectator in the Italian Renaissance.* The A.W. Mellon Lectures in the Fine Arts. Princeton: Princeton University Press, 1992.

Weinberger, Martin. *Michelangelo the Sculptor.* 2 vols. New York: Columbia University Press, 1967.

Michelangelo's Medici Chapel

Beck, James. *Michelangelo: The Medici Chapel.* London: Thames and Hudson, 1994.

Condivi, Ascanio. *The Life of Michelangelo.* Translated by Helmut Wohl. State College: Pennsylvania State University Press, 1999.

DeTolnay, Charles. *Michelangelo.* Vol. 3, *The Medici Chapel.* Princeton: Princeton University Press, 1958.

Hall, James. *Michelangelo and the Reinvention of the Human Body.* London: Chatto and Windus, 2005.

Hartt, Frederick. "The Meaning of Michelangelo's Medici Chapel." *Essays in Honor of George Swarzenski*, ed. Oswald Goetz, 145–55. Chicago: Henry Regnery, 1951.

———. *Michelangelo: The Complete Sculpture.* New York: Harry N. Abrams, n.d.

Tietze-Conrat, Edith. "The Church Program of Michelangelo's Medici Chapel." *Art Bulletin* 36, no. 3 (1954): 222–24.

Wallace, William. *Michelangelo at San Lorenzo: The Genius as Entrepreneur.* New York: Cambridge University Press, 1994.

Weinberger, Martin. *Michelangelo the Sculptor.* New York: Columbia University Press, 1967.

Printed in the USA
CPSIA information can be obtained
at www.ICGtesting.com
LVHW092016170624
783303LV00004B/307